EUROPEAN ART

AND THE CLASSICAL PAST

EUROPEAN ART

AND THE CLASSICAL PAST

Cornelius Vermeule

HARVARD UNIVERSITY PRESS · CAMBRIDGE, MASSACHUSETTS · 1964

DISTRIBUTED IN GREAT BRITAIN BY OXFORD UNIVERSITY PRESS

PUBLICATION OF THIS BOOK HAS BEEN AIDED BY A GRANT FROM THE FORD FOUNDATION

LIBRARY OF CONGRESS CATALOG CARD NUMBER 64–21248

✧ ✧ ✧

TYPOGRAPHY AND DESIGN BY BURTON J. JONES

COMPOSITION, PRINTING OF TEXT, AND BINDING BY THE RIVERSIDE PRESS
CAMBRIDGE, MASSACHUSETTS, U.S.A.

ILLUSTRATIONS PRINTED BY MERIDEN GRAVURE COMPANY
MERIDEN, CONNECTICUT, U.S.A.

CHANDLER RATHFON POST *In memory*

It is no light task, my friend, that you are setting me; for it is not the same thing to laud what is manifest to all, and to reveal in words what is invisible. I think that I too shall need fellow-workmen for the portrait, philosophers as well as sculptors and painters, so that I can make my work of art conform to their canons and can exhibit it as modelled in the style of the ancients.

Lucian, *Essays in Portraiture*, 12
(trans. A. M. Harmon)

PREFACE

What made European art in the half-millen-nium following A.D. 1200 so dependent on Greek and Roman art of the millennium from 500 B.C. to A.D. 500? The glory of Greece and the grandeur of Rome provide part of the answer. The continuity of Hellenistic and Latin civilization in the Christian church contributed much. The art of Greece and Rome in their great centuries of political, social, and literary creativity was an irresistible force of attraction. This art was revisited by artists from the early Renaissance on in a thousand old and new fashions. The Greco-Roman mastery of the human form was the foundation of art among people to whom representation of divinity in the image of man was basic. The ancient world left many tangible as well as cultural survivals from which artists after the Middle Ages drew their means to perfection. All these suggestions, even if resolved and developed, are hardly more than partial explanations for the close ties with the classical past. This book proposes to study the questions and analyze the major landmarks in the dependence of European art on the world of Greece and Rome.

The vast subject of classical influences in Western European art since the Renaissance is as old as the art itself, and modern scientific literature in the field has already been collected in more than one comprehensive analytical bibliography and several general monographs. Many studies of the great centuries of art since 1400 and of individual artists in these centuries have wrestled with the Antique in relation to schools and to specific masters. Recent monographs have treated attitudes toward classical antiquity in crucial periods, such as the age of Lorenzo Ghiberti, the dawn of the High Renaissance, or the decades of Gianlorenzo Bernini and Nicolas Poussin. Yet there is much to be done, in relating European art to Greek and Roman antiquity, and much already accomplished can be brought together in a fresh fashion.

Greek and Roman antiquity or classicism in European painting and sculpture must be examined from the standpoint of the quantity and quality, the mass and volume, of ancient sources available to painters and sculptors in the centuries from 1200 to 1900. The period before 1200 is no less significant but belongs more to the continuation of antiquity than to its revival. The early Middle Ages was surrounded by the crumbling remains of the ancient world. The factor of material survival, its influence on the arts, does not need to be indexed until the two centuries just before the Renaissance.

There is little of European architecture after 1400 for which direct, if unconscious, parallels cannot be found in antiquity. This statement might have seemed brash fifty years ago, but the imaginative Italian Baroque creations of Francesco Borromini at the height of seventeenth-century activity in Rome have now been placed alongside the façades and stagelike interiors of Greco-Roman Petra and Baalbek, symbols of eastern Roman architecture in the second and

third centuries A.D. Reconstructions of Roman Republican Praeneste or Hadrian's Villa at Tivoli evoke memories of the Vatican Belvedere in the sixteenth century, Versailles' gardens in the seventeenth, or English country seats such as Chatsworth and Kedelston in the age of George III. Northern Italian Mannerist villa decorators of 1530 to 1600 would have felt quite at home in the Titanesque decorations of Piazza Armerina in Sicily, an imperial villa of the early fourth century. Architecture as a setting for the fine arts, for painting and sculpture, cannot be excluded and recurs frequently in a lucid treatment of the subjects set forth here.

Interest in the subject of classical survivals is on the rise everywhere. Recent researches have made it possible to construct a coherent and consistent history of the various stages of classicism, and to determine in what way classical reminiscences contributed to the creation of new art during these centuries. Because this research is so active, no study undertaken at this time, however comprehensive, can aspire to finality in assessing Greco-Roman antiquity's influence on the art of Europe from 1200 to 1850. The material presented here is preliminary in character, if it is remembered that pertinent observations on antiquity's relations to European art are being published every day.

This attempt to add another to the vast series of essays on the classical sources of European art grew out of an invitation to give eight lectures under the auspices of the Lowell Institute. The lectures were given in the Museum of Fine Arts in the Fall of 1959. Certain scholars doubtless will say this publication is a case of dalliance with the impossible, but a general survey of methods and details can certainly contribute something to so complex a subject. A general work on the visual survival of antiquity, written from the archaeological standpoint, has been conspicuously lacking in this era of unlimited publication.

I should like to thank the authorities of the museums and the private collectors involved, also the directors of photographic services, for permission to use the photographs reproduced here. My colleagues at the Museum of Fine Arts helped in collecting material and in turning it into presentable form. At the time these chapters were being written, Professor Benjamin Rowland, Jr. was giving a course on similar subjects at Harvard, and I have profited from a number of discussions with him. I should also like to thank him particularly for delivering the eighth Lowell lecture for me, on Neoclassicism, from a difficult manuscript on a moment's emergency notice. His own book, *The Classical Tradition in Western Art* (Harvard University Press, 1963), approaches the survival of antiquity in a vastly different way, a tribute to the wealth of the subject. The use of quotations is particularly admirable, and, because I could only do differently not better, I have borrowed one of these for the beginning of the first chapter.

Professor Otto J. Brendel offered a number of important suggestions. Dr. Hanns Swarzenski generously made available notes of his lectures at the Warburg Institute and other valuable items. A great debt must be recorded to the authors of the basic monographs on the periods and artists discussed here; I have used their ideas freely, in ways which I hope will do their observations no injustice.

My notes at the end are no substitute for the comprehensive bibliographies on the survival of antiquity compiled by Ladendorf and others. They are a guide to the sources and archaeological parallels used in these essays. A number of ideas collected in these pages were first worked out in scattered articles and reviews, particularly on the Dal Pozzo–Albani drawings in the British

PREFACE

Museum and at Windsor Castle; reference to my own writings in the notes is designed to avoid larding the apparatus of these ideas. Appendix I gives the chronological and stylistic terms used throughout in reference to Greek and Roman art. The brief biographies of artists, antiquarians, archaeologists, and others in Appendix II include persons who are not widely known among historians of art. This avoids unnecessary bibliographical explanations in the text or in the obscurity of notes and allows inclusion of satisfying if somewhat extraneous pieces of information. The list does not include artists such as Nicolo Pisano, Andrea Mantegna, Raphael, Bernini, Watteau, Ingres, or Manet, discussed in some detail in this book, whose biographies can be found in every encyclopedia.

Miss Mary Comstock, Mrs. Philip McLaughlin, and Mrs. Emily Vermeule have tried to make these pages more comprehensible. Miss Collette Flynn and Miss Alice Graves aided in preparing the manuscript for publication.

Boston
December 1963

ix

CONTENTS

ILLUSTRATIONS

EUROPEAN ART

AND THE CLASSICAL PAST

The Survival of the Ancient World

Our business is to imitate the Beauties of Nature, as the Ancients have done before us, and as the Object, and Nature of the thing require from us. And for this reason we must be careful in the Search of *Ancient Medals, Statues, Gems, Vases, Paintings, and Basso Relievo's:* And of all other things which discover to us the Thoughts and Inventions of the *Graecians;* because they furnish us with great Ideas, and make our Productions wholly beautiful. And in truth, after having well examin'd them, we shall therein find so many Charms, that we shall pity the Destiny of our present Age, without hope of ever arriving at so high a point of Perfection.

—Du Fresnoy

The Artist's Approach to Classical Antiquity

Greek and Roman art passed through many stages of development from the generation before the battle of Marathon (492 B.C.) to the generation after the fall of the Empire in the west (A.D. 476). Stylistic changes were not only chronological but regional as well. Antiquity has offered a vast range of creative ideas to European artists from 1200 to the present. The scope is comparable to what is available in postmedieval art to a painter or sculptor of the twentieth century. The grand destruction of ancient civilization in the centuries following the fall of Rome, a process that still continues, has complicated the artist's approach to Greek and Roman art. The Renaissance painter was confronted with the nameless, undated torso or the mutilated frieze rather than the complete, inscribed monument in its original setting. The few ancient texts on art that survive could have been more confusing than helpful to the early enthusiast for the classical past. The artist's methods of using ancient painting or sculpture, therefore, have been conditioned by complex factors of taste, time, and chance.

Time and again, consciously or otherwise, artists have selected that segment of surviving antiquity which best suited their style.[1] Echoes are found of third- or fourth-century Roman sarcophagi in works of the thirteenth-century Pisani; of Neo-Attic and pseudo-archaistic reliefs in the sculpture of the Quattrocento Florentine Agostino di Duccio; of fourth-century statuary and classicizing Hellenistic reliefs in the repertory of the painter Giulio Romano in the age of Raphael and Michelangelo; of Pergamene and Pergamene Trajanic works in the creations of the French Baroque sculptor Pierre Puget toward

1

the end of the seventeenth century; and of the Hellenistic rococo in the corresponding art of the French eighteenth century. This reflects to a great extent two conditions: the accidental preservation of ancient paintings and sculptures and the timing of their rediscovery. The Cinquecento excavations in the Baths of Caracalla, the seventeenth-century work at Hadrian's Villa, and the second exploitation of the Palatine under Francesco Bianchini in the eighteenth century were hardly even high points in the activity produced by the process. The construction of the Villa Medici in 1590 and of the Villa Borghese in 1615 gave focus to collections and antiquities already known in less visible locations, for on these occasions statues and reliefs were gathered together for use as decoration on the buildings or in the gardens.

Ancient Paintings

The survival, rediscovery, and subsequent destruction of ancient wall-paintings in Rome and at Tivoli, Praeneste, and surrounding sites are crucial events in the influence of ancient subject, composition, and design on later art. Modern aestheticians are, to a certain degree, conditioned to think of these paintings as imaginative repetitions of the Pompeian Second to Fourth Style decorative repertories (the period from 50 B.C. to the late first century A.D.). This work in fresco and painted stucco would be the ceiling and secondary wall decorations which Raphael translated into the arabesques of the Vatican Loggie and which, over two centuries later, the architect Robert Adam in England used in his grand interiors designed to recall the vaulted palaces of imperial Rome and in his smaller rooms in the "Etruscan Style." These lost paintings were not all merely decorative pieces. Many monumental and complex mythological or historical compositions survived in Rome's *grotte,* those subterranean ruins that were once the halls of imperial buildings. The Bolognese painter and engraver Amico Aspertini in the early Cinquecento recorded a number in his peculiar proto-Mannerist style.[2]

Using older sketchbooks and an imaginative scrutiny of what still remained in the late Seicento, Pietro Sante Bartoli and his son Francesco working in Rome produced innumerable color drawings recording these Roman "subterranean" frescoes.[3] Late-nineteenth-century scholarship tended to question their accuracy but the reputation of the Bartoli as reliable archaeological draftsmen rises considerably (like that of the Cinquecento antiquarian-architect Pirro Ligorio) when, as modern critics, we put aside disappointment at imaginative "restorations" and sift the genuine from the inaccurate.[4] Here, older sketchbooks and watercolors known in several versions serve as a check.*

At the height of the Italian Baroque, when Alessandro Algardi and Francesco Duquesnoy were restoring ancient sculpture, Andrea Sacchi's protégé Carlo Maratti was called upon to restore the section of monumental wall-painting known as the Roma Barberini. This late antique fresco was found in 1650 in the Maxentian and Constantinian portions of the old Lateran Palace[5] and, from the date of its restoration to the Napoleonic era, exerted considerable influence as the iconographic ideal in representing the goddess of the imperial capital.

Dissemination of Classical Monuments

The dissemination of surviving ancient monuments is a basic factor in their use by artists.

* The importance of compositions in ancient fresco, lost and otherwise, at least to sixteenth- and seventeenth-century classicizing *quadrati riportati* (wall or ceiling panel) paintings, offers a rich field for investigation.

Until about 1650, most portable antiquities remained near their places of discovery or reuse in the Middle Ages. The exceptions can be readily explained. From 1200 on a number of sarcophagi from Roman Ostia were found in the Pisan Campo Santo as a result of medieval export of grain from the Arno Valley to the area around Rome. Ships sailed laden to the lower reaches of the Tiber; on their return voyage sarcophagi, fragments, and other ancient building material were used as ballast.[6] After 1400 there are records of antiquities brought from Rome to the Medici collections, especially the gardens in Florence. In the following century the Gonzaga connections (with the collaboration of Giulio Romano and other artists working with art dealers) enriched Mantua from the great ancient storehouse, and the Grimani family added to the material heritage of Venice by assembling there a collection of Greco-Roman marbles formed in Rome.[7] The great migrations out of Rome, however, were a phenomenon of the period between 1650 and the Napoleonic Wars. The Medici retired their Roman antiquities to their native Florence; the Farnese took theirs to the Spanish Bourbon kingdom of Naples which they had entered by marriage; the Aldobrandini sarcophagi left the Campidoglio for the family villa at Frascati; and Charles I, Lord Arundel, Cardinal Mazarin, and a host of other rulers, diplomats, or wealthy tourists began the transport of statues, reliefs, sarcophagi, and urns across the Alps and by sea to France and England.

Therefore, during the years when all styles from proto-Renaissance through high Baroque were exploited by European artists and architects, Rome possessed the overwhelming concentration of classical antiquities. By 1700, good copies—in marble, bronze, plaster, or the graphic media—were so widely scattered that the physical removal of ancient works of art to northern Continental and British palaces and country seats meant less than it had previously to artists flocking to traditional centers, such as the academies of Rome, for training. Then, too, a number of great Italian collections remained undisturbed in whole or in part, and there were eighteenth-century collectors in Italy who were forming new galleries from older collections on the market and from newly excavated material. The most influential among these latter-day Italian collectors were Cardinal Alessandro Albani and the popes themselves. But, before 1700, not every artist to whom antiquity was an inspiration could begin his training in Pisa, Florence, Mantua, Venice, Bologna, or Rome, the cities where antiquities were available. The way the ideas of antiquity circulated in the ages of humanism in consequence deserves considerable attention.

The Sketchbook

The sketchbook was the principal way in which an artist's notes on antiquity were recorded and circulated among his colleagues. As a stylistic link between the visual experience and the finished painting or sculpture, it was probably more important, as reproductions of given works, to the artist in his own work and later to art historians than to the world of art in general. For ordinary circulation among artists, a woodcut, etching, or engraving could spread a motif or design more widely. Other artists could study the draftsman's results without absorbing his style. This places a premium on the selfless copyist of antiquity who would either engrave and circulate his works for their profit alone or turn his drawings over to the engraver for publication. The elder Bartoli with his numerous publications of antiquarian material represented the culmination of this process, one which

Piranesi rescued from scientific mediocrity in his imaginative renderings of archaeological material. The modern antiquarian can trace the story from the French eighteenth-century collector-author the Comte de Caylus through a host of scholars who called ancient art to the attention of their contemporaries. The line goes back from Caylus to Montfaucon, to Beger, to Rossi, to Sandrart, to Ligorio, and to Giulio Romano in the second quarter of the sixteenth century. A glance at a library completed in the Neoclassic age—such as that of Sir John Soane (died 1837) in London—shows that, gradually, as the eighteenth century gave way to the age of Napoleon, an artist could study casts in an art school and spend afternoons in a dilettante's library to absorb all he needed of antiquity in its original forms.

From 1450 to 1550 the sketchbook was held in the esteem accorded a major illuminated manuscript in the Middle Ages. The annotated travel-pictures of the Quattrocento merchant Ciriaco d'Ancona (perhaps a heretical description of his work to the historian of epigraphy), the measured architectural inspirations of the immediate San Gallo circle (who included much architectural sculpture in their drawings, witness Castel Sant'Angelo), and the basic compilations of the sixteenth-century Codex Coburgensis (found again in the codex associated with the name of Pighius and in sketchbooks bought by Cassiano dal Pozzo) passed beyond the immediate intent or discipline of the masters who produced these works.[8] The literary and epigraphic value of Ciriaco's observations led his works through almost-Scriptural recensions; despite recent study of his methods of work, the value of his diaries remains in the architectural or figured works he sketched and in the precise location he recorded them—at a period when few such men of antiquarian precision ventured into the Turkish world east of Ancona.[9] The San Gallo family and their associates were not only canonical architects but progenitors of that great Cinquecento and Seicento point of creative reference: the setting of a work of art. This made their drawings a basis of study not only for architects and decorators in stone and plaster but for sculptors commissioned to fill a villa and painters finishing a building. Copies of their drawings made by and for students were circulated widely and have survived in considerable numbers. By 1550, ancient works of art were plentiful enough to demand their organization for the student unable to secure entree to every palazzo, castello, villa, and casa in his search for needed designs. Hence the beginnings of the big collections of drawings after the antique, the *Musea Chartacea*, and selective multiplication of their important discoveries, through engravings and other publications.

Before 1600, when paper became substantially cheaper, sketch-pads and single drawings were treated with the utmost reverence and care. Giorgio Vasari's *Vite* are full of references to artists' inspiration from the drawings of older masters. Cassiano dal Pozzo's giant *Museum Chartaceum* (1620–1650), a collection of nearly 1500 drawings, contains a number of much older recordings of antiquities (some sketches about 1480) which have been carefully preserved and remounted. Several generations of artists, from Filippino Lippi in the late Quattrocento through Girolamo da Carpi and Polidoro da Caravaggio after the middle of the Cinquecento, turned to these studies for information. Their presence in the Raccoltà Dal Pozzo kept them in the koine through to the times of the Bartoli and Winckelmann, that is, through the seventeenth century and almost up to the era of the great Neoclassic painters and sculptors.

Once a composition or group of motifs has

been recorded by a competent draftsman, it is hard to determine whether use of the designs depends on continual employment of the drawings (or engravings) or on fresh restudy of the actual monument. For example, if an ancient sarcophagus relief is known to have been mutilated or removed to some inaccessible location during the Renaissance, the former may be assumed. But, if the sarcophagus were a frequented and unmolested antiquity, the problem is not so simple. Late in the fifteenth century Andrea Mantegna took the motif of a suppliant barbarian woman and her child from an Antonine daily-life sarcophagus, for a number of years in the atrium of Old St. Peter's (figure 1), and used the group for the Roman matron of vision in the London *Triumph of Scipio* (figure 2).[10] The design, once employed, became a popular one. Raphael made it the basis of his *Madonna with the Fish,* and that instituted a prototype for a divine motif reoccurring frequently in the next two centuries. When Poussin used the composition he was copying Raphael and the intervening artists who had perpetuated the design; yet the sarcophagus was still visible in the Sacchetti collection, and giant drawings of it were prepared for Cassiano dal Pozzo by someone in the Poussin circle. In other words, any of the artists who exploited designs from this sarcophagus, from the early sixteenth century, when Amico Aspertini recorded it in the Wolfegg Codex, down to the age of Piranesi a quarter of a millennium later, could have derived their ideas from first- or secondhand sources.

The Influence on Artists of Post-Renaissance Damage to Classical Antiquities

The destruction of much Roman wall-painting known in the Renaissance has been mentioned in connection with artists who recorded and used these designs. Damage to ancient marble sculpture in the same period was more extensive than present-day connoisseurs, accustomed to the care modern museums and collectors in general take with classical antiquities, could possibly believe. In the first place, a sarcophagus in itself was of little more value than as a water trough or a storage chest; the reliefs of the sarcophagus were what collectors prized. When the Villa Medici, the Villa Giustiniani, the Palazzo Mattei, Cardinal Scipione Borghese's villa, the Vatican Belvedere, and a number of like "galleries" were built in the sixteenth and seventeenth centuries, otherwise perfectly complete sarcophagi were sawed apart, and the fronts and short sides and (if sculptured) the backs were used separately as decorative reliefs. Reliefs from a single sarcophagus were scattered about and often sold elsewhere if they were deemed inferior or did not suit a specific decorative ensemble. If an artist sketched the continuous narration of a sarcophagus from the left short side around the front to the right rear, his drawing assumed greater artistic and archaeological value if the sarcophagus were subsequently cut up and parceled out among collectors in Rome, Frascati, Florence, or Venice.

One of the best-preserved ancient sarcophagi in America, the sarcophagus with Contest of Muses and Sirens in the presence of the Capitoline Triad (in the Metropolitan Museum, New York), owes the preservation of its body to its reuse as a cassone chest (figure 3). The arms of the owners (the Del Nero family) were carved on the short sides and a lock was inserted behind the reliefs on the front.[11] The magnificent marble lid which originally belonged to the sarcophagus was drawn about 1610 in the Villa Nera gardens in Rome; however, it was soon broken up, scattered among several collections,

and is now lost.[12] The body went ultimately out of the Del Nero household to Florence, where late Neoclassic and Victorian antiquarians saw it in the Giardino Torregiani. The cassone lid, which was presumably of wood, has also vanished, perhaps when the piece was rehabilitated as a Greco-Roman antiquity for sale to America.

Visitors entering the exhibition galleries to the left and right of the front door of the Louvre are impressed by the rows of sarcophagi from the Borghese collection, lined up like dreadnoughts at a review off Spithead. This was a standard way of exhibiting sarcophagi from the late Neoclassic period through the Victorian era. This display is encountered in striking fashion outdoors on the lawn of Viscount Astor's country estate at Cliveden in Buckinghamshire. Several of these sarcophagi acquired by Lord Astor late in the last century are also from the Borghese collection.[13] A close examination of the Borghese sarcophagi in the Louvre and their counterparts at Cliveden reveals that they are really sarcophagus reliefs (usually only fronts) restored or remade in the rectangular shape of a marble coffin. When Napoleon forced his brother-in-law, Prince Camillo Borghese, to "sell" much of his collection to the new Musée Napoléon in Paris, the façades, walls, and garden houses of Cardinal Scipione's Pincian villa were ransacked and reliefs fashioned from whole sarcophagi before 1610 were remade in imitation of their pristine functions. Such museographic details were measures of the difficulties encountered by artists studying the Antique in the great centuries of Italian and French art. An upward glance at the garden façade of the Villa Medici today makes it evident that much of classical sculpture walled up by late Mannerist architectural exponents of decorative *horror vacui* was

lost to the craftsman with the sketchbook who lacked scaffolding or telescope.*

Freestanding statues often fared no better than reliefs in the outdoor garden museums of the High Renaissance. Michelangelo's *Bacchus* was scarcely a half-century old when, and still in the lifetime of the artist, the Dutch painter Marten van Heemskerck sketched it in the chaotic *Antikengarten* of the Casa Galli in Rome, with its crucial, cup-bearing hand broken off and lost.[14] The ancient torsos lying on their backs, or the various reliefs in the same drawing, suffered considerably between the time Raphael and Giulio Romano drew inspiration for the Farnesina frescoes from them early in the sixteenth century and their ultimate restoration and division among later collections in Rome, Florence, and Naples.

One of the most-sketched and most-used statues in the Cinquecento repertory was the heroic-scale seated Zeus placed at a focal point of the architecture in the Gardens of the Villa Madama near St. Peter's. This giant figure remained there until the middle of the seventeenth century (figure 4). The majestic, half-draped Father of the Gods, seated on an elaborate Roman cult throne, turns up over and over again in the frescoes of Raphael's school, of the monumental Mannerists, and of the Bolognese schools active in the early Baroque period. Between 1620 and 1650, when artists such as Poussin, Sacchi, and Duquesnoy were most interested in ancient art, the statue disappeared. In the early twentieth century, the German archaeologists Huebner and Huelsen found the body of the Villa Madama Zeus remounted as a draped

* This is why the only sketches of most of the Villa Medici reliefs in Dal Pozzo's *Museum Chartaceum* were executed before the reliefs were immured high on the garden façade in 1590.

term in the old Versailles collection (figure 5). They then found the mutilated legs and throne in the Museo Nazionale of Naples![15] Thus, if the statue inspired artists of the High Baroque and later, it could have been only through the pre-Poussin and Dal Pozzo drawings in the *Museum Chartaceum,* the incidental sketches of Heemskerck, and other such studies made in the Cinquecento. It demonstrates the manner in which statues intact in the first two centuries of the Renaissance could fall upon disastrous times if artists who might have been interested in a work as important as the Villa Madama Zeus could exercise no control over its preservation.

The Cinquecento artists who sought out the major Roman imperial state or historical reliefs of the late Julio-Claudian through Severan periods found much more for their creative repertory than their successors could discover a century later. Yet, after 1600 some of these reliefs migrated from Roman collection to Roman collection (or with the Borghese marbles to France under Napoleon), while a number of fragments and even complete reliefs were lost to the artists who habitually used them. If the motifs persisted it was because they entered the artists' vocabulary in such a way that physical loss of the actual monuments meant little to the persistence of their classical messages in art. Such must have been the case with Roman frescoes, which were ruined by neglect or hacked apart as souvenirs but which had been often recorded in watercolors.

The state reliefs of the major ancient triumphal arches in Rome generally fared better than those reliefs already detached from their ancient structures. Yet important sections of the so-called Arco di Portogallo on the Corso (Via Flaminia), an arch incorporating reliefs of the latter part of Hadrian's reign, were lost when it was pulled down under Alexander VIII in 1662 to widen the street.[16] Pierre Jacques of Rheims, sketching in Rome about 1577, saw a major section of the figured and enriched frieze and important secondary fragments of the Arch of Claudius in and near the house of the Fabii in the Piazza Sciarra just off the Corso. One of these fragments, a relief of a standard-bearer (signifer) with a bearskin cap, was lost soon thereafter and remained unknown until it reappeared a few years ago in the London art market, from an English private collection. It was acquired by the Museum of Fine Arts, Boston, in 1959 (figure 6).[17] Although only the signifer's head remains, the size twice that of life and the vigor of the face give some clue to the power of impression that must have been generated by the military panels of this arch.

The principal sculptured block surviving from the Arch of Claudius, showing scenes of combat between Romans and Britons above elaborate, enriched fasciae, was recorded by other artists, especially Pirro Ligorio (who was much concerned with the ancient topography of the area), but the relief itself has not been seen since the late Cinquecento.[18] Since motifs from the old drawings of this frieze were used in battle scenes as late as Giovanni Coli and Filippo Gherardi's great Italian Baroque ceiling of the Battle of Lepanto in the Colonna Gallery in Rome, the designs must have been found in sketchbooks accessible to young artists of the early and high Baroque periods. Cassiano dal Pozzo's *Museum Chartaceum* contained copies after Ligorio's sketches and after the drawings of the important Cinquecento collection known from its library inventory as Cod.Vat.Lat. 3439, a volume containing diverse material including much after Ligorio. This, alone, was a reliable measure of the fact that the reliefs were no longer accessible

to competent artists of the early Seicento. Their fate was no doubt similar to that of the Villa Madama Zeus, but unlike the Zeus they have never been rediscovered. The only other surviving fragment of the Arch of Claudius, the half of the attic inscription then in the Palazzo Barberini and now in the Conservatori, was carefully recorded by one of Dal Pozzo's best artists,[19] a sign of its availability in seventeenth-century Rome. About a century later Giovanni Battista Piranesi placed the inscribed block prominently in the right foreground of his large plate "Scenographia Campi Martii," the Campus Martius in ruins.

Historians of art must proceed cautiously in assuming that a given antiquity was the immediate inspiration to the creator of a work of art. The number of ancient reliefs incorporated in the engravings of Marcantonio Raimondi's early High Renaissance atelier and the accessibility of the plates of statuary by De Cavalleriis in the second half of the sixteenth century compensated for original sculptures beyond the sight of artists who could not journey to Rome, or for the antiquities lost to those to whom the Eternal City collections were familiar haunts. Yet, as in the instance of the Los Angeles sarcophagus with scenes of the life of a Roman general (figure 1), historians were not apt to report on those ancient monuments which went on inspiring painters and sculptors throughout the whole period under consideration. The more static the antiquity, the less writers commented on it; exceptions were the Roman showpieces: Laocoön, Apollo Belvedere, the Dioscuri of Monte Cavallo, and Marcus Aurelius on horseback.

The classic example of a static antiquity is the Della Valle sarcophagus relief of the Judgment of Paris and the Return of the Gods to Olympus, walled up in the garden façade of the Villa Medici in 1590 (figure 7). The relief, with its "restored" upper background of Helios driving his chariot through the zodiacal circle, has moved only once in its known postantique history—from the Palazzo Valle-Capranica to the Medici gardens on the Pincio. Unlike the Ara Pietatis reliefs incorporated in the same decorative scheme of the Medici villa, the Judgment of Paris sarcophagus was placed in a most accessible, visible spot on the bottom right of the façade. No wonder artists from Raphael to Rubens and Poussin used this sarcophagus front, in whole or in part, in paintings, drawings, engravings, and reliefs! The carving combines baroque power with mannerist proportions, a symptom of the classical breakup leading to late antique art. Because it included landscape (upper left), a dramatic myth (foreground), and violent movement (right), culminating in the enthroned majesty of Jupiter, there was something in the composition for every artist. Moreover, those who knew the relief directly could find every element of style from the late Quattrocento to the High Baroque in its details. Continuous narration played its part: divinities like Hermes, Athena, and Aphrodite appear twice. The sarcophagus exerted its influence in curious fashion into the very beginnings of modern art. Marcantonio's engravings after Raphael's almost verbatim drawing of the relief gave Manet the figures for his *Déjeuner sur l'Herbe* (figure 8). They were originally earth and water divinities watching the ascent to Olympus going on above their domains.[20]

The Influence of Minor Antiquities on Renaissance and Later Artists

My observations on ancient sculpture or painting have treated large works of art not generally considered under the classification of minor arts. It would be natural to assume that small bronzes,

painted vases, pottery, terracottas, lamps, and even coins would have been lost or damaged much more readily than historical, state, or sarcophagus reliefs and statues. Such was not the case. Small objects, even fragile ones like vases and terracottas, were surprisingly durable. Bronzes drawn for Dal Pozzo from the Barberini collection of the seventeenth century are still with the Barberini antiquities in the Louvre or the Vatican. Many bronzes in the "Musei" of Cardinal Scipione Borghese or the antiquarian-biographer Giovanni Bellori passed directly, or through other collections, to the Vatican Museums and other major European collections, particularly the Berlin Museum.[21] The Greek and South Italian vases drawn between 1600 and 1650 can to a great extent be traced through old and modern publications to known collections.*

Coins and medallions have the dangerous merit of existing in several specimens, but enough unique pieces can be traced to confirm their durability in collections maintained or shifted about since the Renaissance. Coins were well documented and published in the Renaissance because they appealed to historians as well as artists or archaeologists. In fact, small objects of interest and importance—vases, bronzes, and coins—had better chances of unaltered, indestructible preservation than many antiquities of greater size and comparable or, in most cases, greater material value. The Renaissance collector took much better care of the works of art in his bedroom than those in his garden. And most works in the Cinquecento garden would be exhibited today in museum galleries under the watchful eye of custodians and conservationists.

Small bronzes, in particular, are reflected in major paintings to a greater extent than is generally realized. Nicolas Poussin used them on a number of occasions that seem logical when his sources and habits of work are examined. He had access to the Barberini collection of minor antiquities and decorative arts, one of the best of its time, and his method of painting a figured composition almost demanded, or at least encouraged, the use of statuettes. Poussin made his preliminary and many later sketches from a series of models in wax or clay, with cloth draperies; these were of sizes which permitted him to group them in the poses and against the backgrounds sought in his ultimate canvas.[23] Poussin's classicism would have taken a disastrous turn had he known the vast numbers of terracottas, particularly so-called Tanagra figurines, discovered in and exported from Greek sites and those in western Asia Minor in the nineteenth century. Their "prettiness" could not have failed to affect his style in adverse fashion.

Ancient medallions and coins first appear in postclassical European art in connection with Roman imperial iconography. In the fifteenth century, the Florentine sculptor Antonio Filarete knew his Roman sestertii well enough to introduce obverse and reverse types of Nero in his Martyrdom of St. Peter on the bronze doors of St. Peter's, a piece of chronological accuracy.[24] Frescoed halls of illustrious men or Titian's portraits of the canonical Twelve Caesars were guaranteed a high degree of accuracy because inscribed portrait coins of these rulers were everywhere available for consultation and employment by painters. Bernini's equestrian Constantine or its ancestor in Raphael's *Vision of Constantine* (figure 60) may owe much to literary notions of that Emperor's appearance, but details

* They happen to be mainly in Bologna, a city with Roman connections never greater than in the age of the Carracci, the Ludovisi Pope, and Cassiano dal Pozzo. This great collector's family held important positions in Bologna, and the vases probably migrated there through his interest in these curiosities.[22]

such as the profile and the radiate crown bespeak study of Constantinian coin portraits, on medallions, gold aurei, aes, or folles. By about 1725, when the sculptor Pietro Bracci restored heads of Constantine in the Aurelian reliefs of the attic of the Arch of Constantine, he copied Constantinian coin portraits with a faithfulness, a precision, lacking even in surviving monumental heads of the Emperor, which were created with a freedom of conception not dependent on the die-cutter's art.

Neoclassicism supplies a splendid example of exploitation of an Antonine medallion reverse to produce a canvas. The principals of Jacques-Louis David's *Paris and Helen* are taken directly from a reverse type, struck in bronze under Antoninus Pius and his successors, showing Aphrodite and Adonis or Eros linked in languid pose. Roman and Pompeian archaeological studies have provided the detail and background which enframe the lovers. To complete the cycle and return to the High Renaissance, Raphael's *Vision of Constantine,* at least the left half of the fresco, could not have been designed without study of the *Adlocutio* medallic sestertii of the emperors Galba (A.D. 68–69) or Trajan (98–117). Similar reverses of Nero (54–68), with variations on the standard scene of the Emperor haranguing the legionaries, played a part in this fresco and in the pendent *Battle of the Mulvian Bridge,* a notion that must have amused numismatists in High Renaissance papal circles.

Restoration and its Artistic Influence

Did archaeological or artistic restoration of ancient sculptures and paintings create problems, altering, clouding, or confusing the vision of artists after 1400? Carlo Maratta's repainting of the "Roma" Barberini turned an ancient monumental representation of the Maxentian Venus Felix into the more comprehendable and acceptable Dea Roma, the cult-image of the imperial city. The so-called *Nozze Aldobrandini,* found in Rome in 1590, was extensively repainted; its influence on the early Seicento Bolognese school may have been more that of a classicizing late-Mannerist restorer than of the ancient color values and modeling. Of course, the repainting was not such as to rearrange the scenes of a mystic marriage and alter the significant contrasts of isolated, statuesque figures and uncluttered backgrounds, the traditional measurement of classicism in art.

The classic example of the alteration of an ancient statue by restoration is the Laocoön (figure 63). The ancient right arm of the old priest, bent back in the force of anguish, is a much more unified tour de force than the outstretched arm grasping the snake, which was placed on the ancient break by the sculptor Giovanni Angelo Montorsoli in 1532, twenty-five years after the statue's discovery.[25] Yet countless artists copying the Laocoön caught the irrational sense of leaping or almost dancing conveyed by this faulty attempt to complete the principal figure of the group. Others, from Michelangelo to the Mannerist painter Giovanni Battista Rosso (figure 64) to Bernini, used the statue before this disfigurement took place, or were able to "think away" the restoration. In either case artists seem to have been naturally inclined or were instinctively encouraged to employ parts of the figure of the priest rather than the whole.

Perhaps the inability to solve the action of the right arm or, later, the existence of this document of reconditioning caused more than one artist to refrain from using more than isolated details of the Laocoön group. Of the two sons

on either side, the older (escaping at the right) was much more frequently drawn by the Mannerists; the turn of his curly head suited their art admirably. Francesco Parmigianino sketched his features more than once during the years 1523 to 1527, and Rosso used him for the angels (reversing him on the left) of the somewhat enigmatic *Dead Christ with Angels* in Boston; the Dead Christ is a Mannerist version of the Laocoön himself, seen in reversal and with the head changed (figure 64).[26] Titian made frequent artistic reference to details from the Laocoön group but never used the whole ensemble.

The Laocoön was a case of minor rather than major restoration; the character and designation of the group were in no way changed. Other statues, however, were so altered by the restorers as to emerge with confusing new identities. Engravers working in Rome from 1550 to 1650, notably De Cavalleriis, prepared plates of a statue showing Hermes holding the infant Dionysos and leaning on a draped archaistic term of the elderly, bearded god of wine. These plates have been used by modern critics of Greek sculpture to identify and reconstruct the group of Hermes with the infant Dionysos by Kephisodotos, father or uncle of Praxiteles (about 375 B.C.). But what of the statue engraved with the caption *in aedibus Farnesii* (in the Farnese Palace) by De Cavalleriis? It still exists in the Museo del Prado in Madrid, but the infant Dionysos has vanished, and the statue is merely that of an athlete (who could be Hermes) leaning against a draped terminal figure. If artists desired the composition of a man holding an infant, at some point the engraving or drawings alone could supply the evidence once furnished by the statue. At an unknown date in the seventeenth century the statue suffered such damage

and alteration as to cease to bear relation to its original meaning.[27]

MYRON'S DISCOBOLUS

Another example of reconditioning which influenced and was influenced by the course of art since the Renaissance is interesting because the statue touches on all periods from 1500 to the eighteenth century. Lucian's unusually full description had long indicated to those familiar with ancient literature that Myron had sculpted a discobolus in the fifth century B.C. However, until the discovery of the Lancelotti copy in the Villa Massimi in 1781, a virtually undamaged statue, mutilated copies of Myron's discobolus had remained enigmas subject to the whims of restorers or the misplaced enthusiasm of antiquaries. Early in the eighteenth century, the French sculptor Pierre Etienne Monnot (1658–1733) came into possession of a torso of one of the replicas of Myron's statue. He restored the discobolus as a falling gladiator, tilting the torso radically to its left and adding a sword to the raised right hand and a shield to the left arm supporting the body as it falls to the ground. In this fashion Monnot created a late Baroque work, worthy of the Pergamene groups of fighting Gauls (figure 9). Monnot's Myronian torso was not a new discovery. It evidently appears in a drawing in Christ Church, Oxford, once attributed to Leonardo da Vinci. Aldrovandi in the middle of the century was the first to record the identification, *torso di gladiatore*, which obviously inspired Monnot's method of reconditioning the marble. The fact that the first notice is a drawing, *Cauato* ("drawn") *in casa di Zampolino* (Giovanni Ciampolini) *1513 in Roma*; the second, an attempt by the Pausanias of his day to name the figure; and the third, a restoration by an artist working in Rome when anti-

quarianism was at its height, speaks concisely of the progress of European art in relation to antiquity after the initial exuberance of the Quattrocento.[28]

Monnot's experience with Myron's discobolus was not the last word on the subject. The Neoclassic period, when Greek and Latin literature was widely read by princes and politicians, witnessed a restoration of a discobolus unparalleled for its imaginative relationship to what the literary taste of the age demanded. In 1772 the torso of another Roman copy of Myron's masterpiece was found by the Scottish artist-antiquarian Gavin Hamilton at Ostia. That master rejuvenator of ancient marbles, Bartolommeo Cavaceppi, is thought to have expended considerable time on its reconstruction as a complete statue. Hamilton sold the results to Lord Shelburne (Lansdowne) as Diomedes stealing the Palladion, assuring him that this restoration (Diomedes leaning to his left with the Palladion in place of the discus and right arm raised protectively) was perfectly certain and accurate, "because it would be to the last degree absurd to suppose it anything else!"[29]

Until about 1590 sarcophagi were restored only rarely. These years saw the setting of reliefs in the façades of villas and it was customary to complete only the major missing sections of the most important reliefs (usually state rather than funerary reliefs) in plaster. In the Villa Medici and the Palazzo Massimi alle Colonne, stucco or plaster backgrounds filled out the enframement above reliefs; these "restorations" did not involve tampering with heads, limbs, and other features. Up to 1700 artists generally saw ancient reliefs in unrestored form. Most sarcophagi drawn for Dal Pozzo between 1610 and 1650 are untouched by the modern chisel. Such restorations as were carried out in marble are extremely easy to distinguish. The era of careful restoration belongs

to the period of Winckelmann and the Neoclassic notion of the completeness of the work of the ancients.

In the era when Roman antiquities were migrating northward, the "Golden Age of Classic Dilettantism," English milords and their Continental counterparts demanded completeness and rational, Neo-Attic cleanliness of line or form in statues and reliefs. They demanded adherence in their ancient sculptures to the principles practiced by Antonio Canova, the foremost Neoclassic sculptor, in his creations based on the antique. To serve the fashion of the times, great ateliers of restorers—the foremost being that of Cavaceppi—sprang up in Rome. Sculpture known in Rome for several centuries, newly discovered statues and reliefs, and even damaged Cinquecento monuments that could pass for antique, whether destined for the export market or for newly formed Italian collections (like the Museo Chiaramonti) were hustled to the rejuvenators and given that comforting sense of finished perfection and Carrara marble whiteness which must have delighted an artist so Neoclassic as Ingres.

Bartolommeo Cavaceppi, Antonio d'Este, and others who rejuvenated ancient marbles did not mind combining two or more fragments into almost indecipherable *pasticcios*; and, when a series was incomplete, outright forgery could be called upon to supply what was missing. This was especially true of Roman funerary urns used decoratively or Greco-Roman decorative candelabra.[30] The commercial aspect of classical antiquity had always been present, but never were the arts so ill served as in the generation before the French Revolution, when innumerable ancient monuments were transplanted from Rome to inaccessible country estates throughout Europe.[31] But, perhaps by this time the direct study of much of Greek and Roman sculpture was of

far less importance to European art than it had been in the centuries immediately past.

The art of restoration reached its height just after the surge of antiquarianism brought about in connection with the imperial aspirations of Napoleon, precisely at the time when European art was growing restless under the yoke of Neoclassicism. The Danish Neoclassic sculptor Bertel Thorvaldsen did his superlative job on the Aegina pediments in Munich at this time. Canova had already made history in 1815 by condemning the sacrilege of tampering with the Parthenon frieze and pediments.[32] In a sense, restorers aimed at the same, almost mechanical, sculptured perfection with which archaeologically inclined Beaux Arts students filled their measured reconstructions of ancient Roman and Greek temples. The restorers looked at the statuary in the architectural drawings, and French and Italian antiquarian architects used the completed or repieced statues as props in their drawings.[33] The circle was made complete by the Neoclassic sculptures carved in emulation of canons of beauty set by these restored antiquities.

The classic collection of marbles restored in the first half of the nineteenth century is that of the Museo Torlonia in Trastevere. When the Italian archaeologist and critic Visconti the younger published his text to the album of photographs of this collection, he was forbidden by the Torlonia family from mentioning any of the restorations.[34] Many are obvious from the misunderstandings of well-known Roman copies of Greek originals, but others are so cleverly carried out as to be undetectable without firsthand examination. A nineteenth-century artist easily could be led astray by the work of the restorers, but only the least discerning of draftsmen would have been deceived by the restorations carried out on the column of Marcus Aurelius in 1590 under Sixtus V. Before 1780, restorations can be dated by their unconscious absorption of stylistic characteristics of the period in which they were executed: Mannerist restorations look Mannerist and Baroque work is unmistakable as is that of the French Rococo.[35]

Archaeological Knowledge in Relation to Artistic Activity in the Humanistic Ages

Artists exercised a process of selectivity in borrowing from the types of antiquities which suited their stylistic tendencies; their choices were not bound by archaeological or art-historical disciplines. That these borrowings could often be classed or grouped into a fixed, coherent whole is evidence that taste in adaptation often unconsciously ran parallel to taste of creativity. This is a powerful factor in understanding European art in relation to antiquity and is of particular importance from 1400 on.

It is easy for students nowadays to look at works of Agostino di Duccio and say how much Neo-Attic art influenced his style; as a phenomenon of art history, however, Neo-Attic art was not identified until the last quarter of the last century. The young Bernini was much drawn to Hellenistic sculpture, especially to works in the style of the First Pergamene school; yet, the schools of Pergamon and the relation of the Gaul groups to them were not identifiable until after 1800 and the German discoveries on the site of ancient Pergamon. The theory of a Hellenistic rococo was formulated by the German archaeologist Wilhelm Klein early in the present century;[36] when the French eighteenth-century sculptors Bouchardon, Falconet, and Pigalle gravitated to sculptures of the first or Hellenistic rococo for models, they had no way of knowing that they were choosing from the very period of

antiquity in which the climate of artistic creativity was most like their own.

David's *Death of Socrates* in the Metropolitan Museum of Art, New York, belongs to the years when Neoclassicism was beginning to demand archaeological "correctness" in paintings with classical themes (figure 10). The work of his successor, Ingres, leads to the feeling that this "correctness" killed the sympathetic understanding of the subjects themselves. Romanticism was hastened by public boredom with paintings which portrayed colored statuary moving amid the antiquarian paraphernalia of Pompeii and Herculaneum. In David's *Socrates* the zeal for archaeological detail has produced at least one howling inaccuracy. Socrates is a faithful portrait taken from one of the many marble heads, but he is about to drink the hemlock in his prison cell enframed by a large Roman arch. The architecture was unthinkable in Athens at the dawn of the fourth century B.C. Artists such as Raphael in the High Renaissance or the Carracci in the seventeenth century who borrowed from antiquity but were not enslaved by it produced works much more in the Greco-Roman flavor than did the academic Neoclassicists.

A review of what ancient art was unknown or unavailable between 1400 and 1800 is important because it is often mistakenly assumed that Renaissance and Baroque artists were familiar with at least samples of all the types of antiquities available to historians of art today. If Vasari's grandfather owned a Greek painted vase, it was one of the few known before 1600.[37] Between 1600 and 1750 the number of known Greek or South Italian vases probably did not exceed fifty, and drawings of them did not circulate beyond Cassiano dal Pozzo's circle.[38] Terracottas were available in fair numbers—Italic and Roman votive figurines, or Italo-Etruscan architectural terracottas, or Greco-Roman decorative "Campana" plaques—but not the rich, rococo works from Greece and Western Asia Minor—the Tanagra and Myrina figurines. These charming statuettes to a great extent came from tombs, and tombs were not exploited until the middle of the last century.

Minoan and Mycenaean art remained beyond the realms of knowledge until the startling discoveries of Heinrich Schliemann and Sir Arthur Evans, although some gems and a pot or two may have been in circulation as far back as the eighteenth century. The earliest Minoan and Mycenaean groups of objects came from Egypt or Cyprus, and were parts of collections of Egyptian antiquities formed in the years of travel and exploration from 1820 to 1860.[39] One or two Cycladic idols were collected by English visitors to Athens in the first two decades of the nineteenth century. Greek Geometric and Archaic art was little known until the same general period, with the possible exception of the few late Archaic sculptures brought to Rome by collectors in antiquity and excavated there. The grave stele of a man and his dog, in Naples, whether Boeotian provincial work of about 510 B.C. or a good Roman copy, could at least have given a Seicento artist some notion of Greek Archaic sculpture.

Good Archaistic works, the best of the freestanding korai or maidens (such as the statue in Boston, acquired as Archaic; figure 11) or the Dodekatheon reliefs adhering with some degree of faithfulness to the sixth-century models, could have completed the artist's understanding of early Greek monumental art. But there is little evidence Cinquecento or Seicento artists were interested in Archaic or Archaistic art, when Hellenistic works such as the Apollo Belvedere, the Laocoön, the Belvedere torso, and the groups of Dying Gauls abounded. Such is even true of the known Greek sculptures of the Golden Age of

Pheidias and the Parthenon. One of the finest surviving Attic grave reliefs of the fifth century B.C., the stele of a youth reading from a scroll, was available at least from the middle Quattrocento onward in the Abbey at Grottaferrata, but no recorded painting or sculpture reflects its Pheidian composition.[40]

The Renaissance knew Etruscan art fairly well. It was, quite naturally, the late phase of Etruscan art which interested artists in the period 1450 to 1750: the Volterra urns, fragments of architectural pediments and friezes with groups of gods and scenes of combat, bronze cista handles, utensils, and jewelry made under Hellenistic Greek influence. This late Etruscan or Italic art was generally mistaken in the age of humanism for Early Greek or Roman Regal and Republican, especially since the humanists knew early Italy chiefly through the eyes of Latin writers like Livy.* Some of the influences were slight and not readily noticed: Florentine High Renaissance architectural detail and the frames of paintings occasionally show palmette and other motifs which bespeak knowledge of Etruscan tomb decoration or (despite what was said above) the borders of Greek vases.[42]

Just as the Greek imperial traveler Pausanias and artists designing Roman imperial medallion reverses of the Antonine period thought that early Greek Archaic art (temple images of the Palladion type, or the Hera of Samos type) represented the prehistoric or Dedalic phase of Greek cult statuary, so Renaissance artists introduced early (late Archaic and Transitional) statuary types for the "pagan idols" before whom Christian martyrs refused offerings and sacrifices in many Renaissance and later fresco cycles and

* In the Dal Pozzo-Albani drawings there are occasional early or Archaic Etruscan bronzes, evidence that this phase of Greek art reached post-Renaissance Italy through the art of the peoples from whom early Republican Rome had originally received Greek art.[41]

canvases. In both cases it was the mysterious aura of age rather than historical knowledge and aesthetic principles which dictated the writers' or artists' interest in these examples of early Greek art.

The Roman copy gave the Renaissance artist knowledge of the best of Greek sculptures before he knew their chronological development or could sort out the vague references to specific artists and their work in Pliny the Elder's chapters on the history of art. The Parthenon might be lost behind the Ottoman veil, save to a few travelers such as Ciriaco d'Ancona, but the Athena Parthenos of Pheidias was available to early artists of the age of humanism in nearly full-scale marble copies, on gems, on coins (for example, the New-Style tetradrachms of Athens), and in reflections in various media. This was true also of the works of Polykleitos, Praxiteles, Skopas, Lysippos, and the host of little-known Greek sculptors who shaped the course of ancient art. It is too often the fashion to complain of the technical faults and lifeless qualities of the mass of Greco-Roman copies after famous works of Greek art, but, to painters and sculptors of recent centuries, they gave an accurate knowledge of what the ancients treasured as the best examples of their own artistic heritage.

Iconography and the Return from Art to History

Portraits of famous Greeks were often the works of the leading sculptors of the fifth century and later ages down into the reign of Augustus. Inscribed portrait-herms led to iconographic identification of Demosthenes, Socrates, Pericles, and others; statesmen (Alexander the Great, for instance) were singled out on the basis of inscribed coin portraits. Most Roman emperors were similarly honored, but Roman

literati, sought by Renaissance connoisseurs, were harder to identify. Mosaics from Africa and the East and late antique contorniates or jetons with lettered or inscribed portraits have helped identifications in recent years, but Virgil and Horace remain iconographic enigmas. On the other hand, Cicero was long known from the heavily restored bust with inscribed name-plate, once in the Villa Mattei on the Celian Hill in Rome and, since the early part of the last century, in the Duke of Wellington's collection at Apsley House, London.[43]

The study of iconography propels relations between the artist and classical antiquity from the realm of art to history. The true interest in ancient portraiture in the period 1450 to 1650 was the property of the historian and the epigrapher. Restoration of broken heads on alien bodies removed portraiture, that is portrait statuary, from any aesthetically consistent classification. Any heroic nude torso could supply any imperial head with a body, and any cuirassed statue could be Julius Caesar, Vitellius, or Septimius Severus. Scipio, Cato, Seneca, even the legendary Romulus, emerged in anonymous single heads or in groups of portraits found or arbitrarily classed together. For example, Scipio was identified with a class of bald-headed, scarred men of austere countenance, the so-called Isis Priests, portraits of Greco-Roman priests which run from the late Republic into the second century.[44] When the artist was as much at the mercy of the historian of antiquity as he was in dealing with ancient portraits, his art was not his own. For the purposes of this book, the discipline of iconography has very little to do with the problem of why the artist used ancient portraits in his painting and sculpture. The selection was out of his hands because critics and historians had misidentified too many ancients of note.

Investigations of the relation between artists and antiquity must be continued elsewhere than in portraiture; they must be pursued in realms where the artist of the centuries from 1200 to 1900 was on less confusing ground in his use of Greek, Etruscan, and Roman works of art. Whatever current taste may exclaim about a bit of ancient statuary or painting used by an artist since 1400, the choice was generally a personal one, decided by the sculptor or painter according to preference and conditioning. Ancient art of all types, from all periods, was fair game, and sometimes the modern critic can be too learned, too subtle in his eagerness to explain an artist's choice. Artists in the centuries since the dawn of the Renaissance—geniuses and otherwise—have been products of their age, and analysis of the works they brought into their original creations cannot fail to yield a variety of basic truths and generalities.

Forerunners of the Renaissance

THE early Middle Ages were so closely linked with the ancient world that it is impossible to speak of one as the revival rather than the survival of the other. The vision of classical antiquity was an intrinsic part of the art, or craftsmanship, of this period. Jumbled and confused though it became, the artistic force of the ancient world was carried on all levels in Western Europe past the year 1000 and into the centuries before the High Gothic. With certain exceptions, it is also difficult to investigate the art of Europe in the early generations of the second millennium from the standpoint of the survival of Greek and Roman sculpture, painting, and the minor arts. During these centuries of the Middle Ages at their height, the Eastern Roman Empire centered around Constantinople was still a cultural force, perhaps even more so after the sack of the city by soldiers of the Cross at the beginning of the thirteenth century. Countless treasures of antiquity found their way back to the castles and cathedrals of Western Europe in the decades following the establishment of the Latin kingdom in Constantinople. Thus, traditions of classical art were still descending on Western Europe from a source considered the direct continuation of Trajan's and Constantine's Rome.

Antiquity's survival in the art of the late Middle Ages is an elusive subject, for the sources of classical antiquity were as confused in the minds of painters and sculptors as they have been on many occasions in the minds of modern aestheticians. Artists of the later Middle Ages knew a vast repertory of ancient architecture with its decorative sculpture and wall-paintings; they saw statues and minor works amid ruins or in buildings converted to Christian worship. Only dimly comprehended pagan romances or moralizing Christian tales dictated their choices or inhibited their uses of ancient art. These artists could and did exploit all angles of antiquity with little concern for classical quality, mythological content, or iconographic importance.

The Carolingian Renaissance of the late eighth century stood out boldly in the minds and writings of scholars of the last generation because the forms it adopted were those of Hellenistic Greece sifted through the eyes of late antique Greece and Rome. The force of antiquity in other ages and areas of the Middle Ages could be comprehended only after historians came to understand the art of the periods from which these survivals were drawn. This was not the art of the classical period as defined by critics in the nineteenth century: the art of Athens before Alexander the Great or Rome under Augustus. Only after late antique sarcophagi, architectural ornament, minor arts,

and provincial sculpture had achieved an honored place in the modern catalogues and criticisms of ancient art, could the classicism of the thirteenth-century craftsmen Vassalletto at S. Paolo fuori le Mura in Rome and Peregrino at Sessa Aurunca in the Campania near Capua be explained as easily as that of their celebrated successors Nicolo and Giovanni Pisano in Pisa and Siena.

Currents of Classicism in Medieval Art

The three principal currents of antiquity's survival in the Middle Ages are: fresco painting and manuscript illumination; carving in wood, metals, ivory, semiprecious stones, and other works of craftsmanship in the minor arts; and architectural decoration and sculpture, monumental work in marble or stone. Besides these classifications there are the divisions of method of survival: ancient objects in a medieval setting; direct copying of an ancient work of art; and unconscious perpetuation of a motif. Manuscript illumination, together with the closely related monumental painting that survives, is a field much explored by art historians and paleographers. Contemporary criticism has surveyed the long tradition from fourth-century classical manuscripts based on Hellenistic sources down to the latest paintings of the International Style and the last vital products of the Greek Church in the East.[1]

The second current, sculpture on small scale, is more complex, not because it has not been explored in the sweeping fashion of manuscript illumination but because it lacks the partial explanation of literary purpose and the internal evidences of dating. The purpose can be purely decorative, and mythology can survive unexplained or without need of explanation where in the two other currents any viewer would expect adherence to a story or to the cyclic conventions of religious decoration. Ancient cameos were preserved not so much because of complex medieval philosophies as because they could be easily adapted to medieval imperatorial propaganda or the perpetuation of some uncomplex superstition.[2] It is natural to find a large sardonyx portrait of Augustus in the center of the tenth-century cross at Aachen, and the intaglio with the Three Graces immediately below this central cameo does not mean the goldsmith read them as Faith, Hope, and Charity. The gem was an heirloom, most fitted to enrich a great ecclesiastical ornament.[3] The number of Greco-Roman objects of decorative and intrinsic worth preserved from the sixth to the fourteenth century must have been greater than the sum of what preservation and excavation has left to the museums of today. And goldsmiths or gem-cutters did not need the organization of an imperial or ecclesiastical scriptorium to copy and circulate these precious objects (figure 12).

In the Carolingian Renaissance, Charlemagne's court exercised the selectivity of borrowing from classical art encountered in all periods of revival.[4] The form of these borrowings has not always been recognized or understood. Charlemagne's interest in continuing the empire of Constantine the Great and Theodosius resulted in a revival of late antique art that was early Christian in character. Styles and designs were sought from a period which is now considered vital and creative in its peculiar way, but which to High Renaissance or Neoclassic eyes was quaint, provincial, and even degenerate. This period was spoken of in the nineteenth century, and later, in terms of the "decadence of form." These styles and designs were used exclusively in the minor decorative arts, for the Carolingian Renaissance produced no large-scale

sculpture in the round or in relief. The Eastern Roman or Byzantine theological climate discouraged such a bold renewal of the past. Charlemagne was surrounded by men of taste who sought out and perpetuated the Hellenistic forms which in consequence became so understood and admired in manuscript illumination and ivory carving of the period.

This selectivity of borrowing in the Carolingian Renaissance must be multiplied by all the revivals and nonrevivals in the early Middle Ages, by all the "schools" of craftsmen from Alexandria to Constantinople to Rome and Arles, and by all the opportunities offered by a variety of media. When these factors are noted, it becomes foolish to speak of channels of development in the survival of classical themes in the decorative arts. The range of minor arts was too vast and opportunities for production and imitation too frequent to trace lines of descent in a manner comparable to those found in book illustration.

The interest in the classical art of a period— until this century hardly thought of as classical —was compounded (or confounded) in the Middle Ages by the lack of inhibitions in selecting and mixing myths and motifs based on myths. There is ample evidence for the mishandling of the myths themselves in the minor arts.[5] In *The Classical Tradition,* Gilbert Highet uses a dramatic example to illustrate the misuse of Greco-Roman history and myth in the Dark Ages, to demonstrate a curiosity of classical survival in the minor arts. The Franks casket in the British Museum, a work dated about the eighth century, "pictures on it six different heroic scenes from at least three very distant ages." The scenes include: Romulus, Remus, and two wolves (about 775 B.C.); the Adoration of the Magi (4 B.C.); the capture of Jerusalem by the Romans under the Emperor Titus (A.D. 79); the story of

Weland and Beadohild (about A.D. 400); and an unknown myth. The artist "saw one single unit, the Heroic Past; but some of that past was Graeco-Roman."[6] For the Wolves and Twins, the artist reached unconsciously back to Pergamene art of 200 B.C., when artists developed a schema for representing their hero Telephos, nursed by a hind in the mountains of Arcadia. About a century later this scene became the basis for Roman representation of Romulus, Remus, and the She-Wolf.[7] The iconography of the Adoration of the Magi came from scenes of Parthian tribute to the imperial court in the state art of Augustus, Nero, and the Antonines; the surviving bases of the lost triumphal arch of Lucius Verus show just such scenes of Eastern barbarians bearing offerings.[8] Finally, the capture of Jerusalem was treated in terms of fourth-century state reliefs and paintings, subjects such as were preserved in monumental art until the sixteenth century on the columns of Arcadius and Theodosius in Constantinople.[9] The overall style of the casket is, however, decidedly northern English or northern Gallic provincial, and the scenes as a whole are disposed in recollection of the reliefs on an Early Christian sarcophagus.

No wonder classicism as such is most difficult to sort out in the half-intellectual unplanned borrowings which occurred from 600 to 1300! However much classical rationality may have been carried into the intellect and organization of the medieval Church, the destruction of the Roman polity in the Latin West and the periods of iconoclasticism in the Greek East irrevocably jumbled the orderly rational of ancient art. The order of Greek and Roman art is generally accepted without much thought, and the breakdown of its fiber but not its forms in the Middle Ages leaves modern students as intellectually confused about its classification as were the

craftsmen of minor arts who turned to classical sources in their work.

The progress of classical art from the archaic to the high and later classical ages, thence to the Hellenistic, Greco-Roman, Roman imperial, and even the late antique periods is a well-known development. Its documentation is evident in the ease with which works of art can be grouped almost by decades. The homogenous quality of Neo-Attic, of archaistic, of Pergamene, of Antonine Pergamene art is the product of ateliers working on a large scale in periods of unified artistic activity. To project the survivals and borrowings of these periods into the Dark Ages and their successive generations is to throw light on ages no less interested in the Greco-Roman tradition but no longer bound in a cycle of artistic creativity related to the political and geographical unities of the ancient world, especially of the Roman Empire.

The Italian Renaissance of the Quattrocento differed from earlier "revivals" because the desire to recapture the intellectual qualities of the pagan past unconsciously revived the classical cyclic development of art—from archaicism, to high classicism, to late classicism or mannerism, to (Hellenistic) baroque, to rococo, to neoclassicism, and to periods of revival and planned abstraction. Classicism took the form of an unseen participant in art in the Renaissance, rather than a current preserved in designs, forms, and motifs. Its strength, which emerges as a great revival in the Renaissance, is the strength of a rebuilt foundation, not reuse of old materials in the superstructure. The architecture of the House of Cola di Rienzi in Rome, a patchwork of ancient fragments, as opposed to Brunelleschi's Pazzi Chapel in Florence, symbolizes this. A lack of organization in classical terms in the uses of antique design in medieval minor art does not make its current of classicism less

strong; it is only more challenging to the modern mind to understand its workings, requiring greater concentration not to see the things it contains in simple isolation.

The third current of medieval classicism is architectural sculpture and monumental sculpture in the round. The thread of architectural sculpture is woven around the continuing reuse of ancient architectural fragments and the copying of those fragments reused. Evidence indicates that Roman state reliefs stop with the Column of Marcianus (A.D. 465) in Constantinople and with possible now-lost sculptures of Justinian's time.[10] The real transition from late antique to medieval sculpture is made in the sixth century, when Early Christian sarcophagi of Roman type cease and the imperial sarcophagi in Constantinople and the Ravenna sarcophagi in the Latin West flourish. The classicism of Romanesque and early Gothic sculpture has been much analyzed and the fact that it is mixed with Western Roman provincial sources recognized. The striking factor in Romanesque sculpture in the Campania and the court of Frederick II is the abruptness with which it combined or concentrated numerous classical styles and motifs, using them in a manner more obviously antiquarian than that encountered in the Middle Ages.

Classical Survivals in Medieval Architectural Ornament

Architectural enrichment constitutes a major aspect of the sculptors' perpetuation of classicism in the Middle Ages. Few Italian buildings from 400 to 1400 can be studied without encountering reused ancient architectural enrichment or derivations. The porticoes of ancient Rome gave up their capitals and columns to the churches of the Middle Ages. In many Italian cities hardly a capital was carved or a column drum turned out

in these centuries, so abundant was the yield from ancient sources. Moldings and friezes offered the same rich harvest. Since friezes suggest sculptured scenes, it is not surprising that the artistic influence of the late Roman secondary architectural frieze in medieval times was far in excess of what such works had enjoyed in antiquity, when there were statues, paintings, or mosaics of quality to direct the course of the arts. Roman architectural friezes turned up in medieval buildings, and their copies occur not only here but in ivory carving, in metalwork such as jewelry, and in secondary manuscript illumination (such as borders and colophon letters). These late Roman architectural friezes mean, specifically, acanthus scrolls with hunting Cupids and animals, combats between Lapiths and centaurs (or Greeks and Amazons, or Romans and Gauls), marine divinities and marine motifs (Nereids, tritons, hippocamps, or entwined dolphins), and plain vegetable patterns of various types.

To understand the survival of this classicism in the Middle Ages, one must understand the type of antiquity which provided the source. Architectural ornament of A.D. 100 to 300 differed radically from Hellenistic and earlier Greco-Roman architectural detail, and it was the carved enrichment of this period which the architects of the Middle Ages used and which their sculptors copied. This later Roman imperial ornament, based on styles developed in the decades of Flavian illusionism and pictorial complexity (A.D. 75–95), was a marked contrast to the ordered, geometric simplicity and containment of Greek classical enrichment and its elaboration in the Hellenistic period.

The prototypes of later Roman ornament are found in Pergamene Baroque decoration (about 200–150 B.C.) but the extent to which the Flavian and Trajanic sculptors carried this Hellenistic repertory gave it little semblance of its Greek origins. The city of Pergamon played a considerable role in the development of architectural enrichment in the second century, for the greatest temple of the city was the Trajaneum constructed in honor of the deified emperor after A.D. 117. The Antonine and Severan periods saw revivalistic intensification of Flavian decoration, creating new heights in complexity and intensity of optic effects. The third and fourth centuries repeated these Flavian to Severan formulas, gradually freezing them into stylization from which the decorative arts of Byzantium could take over in the eastern part of the Empire and Romanesque decorative detail could emerge in the Latin West.

What of the influence of classicizing Augustan ornament and late Republican terracotta reliefs? What of the Parthenon and the Erechtheum in Athens, or other such temples in Greece and Asia Minor? Architectural ornament in Greece, particularly in Athens, was always more conservative, more classicizing, but the Library of Hadrian, the Roman Agora, or the fragments built into the Byzantine church known as the Little Metropolitan in Athens demonstrate how uniform styles became throughout the Roman Empire in the century A.D. 100 to 200. And building in Rome (and Italy in general) from about A.D. 70 to 235 swept away nearly everything older, much as the present-day tourist has to look hard to find colonial or federalist New York amid the generations of skyscrapers. The number of large, elaborately enriched buildings erected in all corners of the Roman Empire during this period was probably double or triple the sum of all public construction in the ancient world in the seven previous centuries.

This type of architectural decoration was adapted not only to the ivory, metalwork, and mosaic but to textiles. When Campanian sculp-

tors of the tenth to the twelfth centuries used patterns from Byzantine or possibly Sassanian textiles, carved with the customary summary reduction of planes to emphasize a flat, linear pattern, they were only giving back to architecture what architecture had borrowed from sculpture and lent to textile weaving in the sixth to ninth centuries.[11]

In the cloister of the cathedral of Monreale (1172–1189), some of the colonnettes are carved with putti scrolls, vine rinceaux and birds, and putti (figure 13). These colonnettes are like the central pair on the sarcophagus of Junius Bassus (about A.D. 363) in the cellar of the Vatican.[12] The motif of a putto slaying an animal is the old Flavian design of Erotes enacting the roles of Nikai, in this case of the Nike Tauroktonos (figure 14). The "putti" in the scrolls are the most nonclassical element, for birds, leaves, and berries have a timeless quality, here well understood in relation to the Roman prototype. The "putti," however, are little medieval old men, with harsh bodies and simian extremities. Their gestures and posturing go back to folk-art figures on Roman sarcophagi of the fourth century, the poor relations of the little humans in the Constantinian friezes on the Arch of Constantine in Rome. In the capital showing a bull being dispatched, the head of the slayer is female but the body conflates some Mithraic scene with the motif of Eros performing Nike's task. The acanthus leaves are well handled in late Roman terms, but the moldings above, the ovolo and waterleaf, have lost most touch with classical antiquity. This brand of classicism or classical revival at Monreale could be created only in terms of a civilization aware of monumental construction and decoration in the palaces and major public buildings of imperial Rome—the Domus Flavia, the Domus Severiana, and later work culminating in the Maxentian Basilica and the

Baths of Constantine. It can not be explained in terms of the simple, severe, and undecorated forms found in the late Republican Tabularium or the Augustan Theater of Marcellus.

The figured or peopled scroll was very well suited to the attempt of Campanian sculptors in the late twelfth and thirteenth centuries to organize three-dimensional form in plastic fashion, by selecting these Roman motifs based on nature and by the use of the human figure in this symbolic or purely decorative setting. Most of the church sites followed the custom of reusing capitals and columns. (Such instances have been observed at S. Giovanni del Toro, in the cathedrals at Ravello, Scala, Sessa Aurunca, and at Caserta Vecchia.) The pulpits were often built out of classical fragments gathered locally or brought from some distance. The mixture of reused materials at Minturno is an excellent example, including Roman second- or third-century veined marble columns, Julio-Claudian pilasters with delicately classical foliage, and reliefs of beasts which must belong to the Dark Ages.

At Salerno, in the Epistolary pulpit of the cathedral (1153–1181), lions, eagles, and Atlantids are arranged on one of the supporting capitals. These designs recall the Severan figured capitals of the type found in the Baths of Caracalla, or of the type which carries the Severan tradition into the reign of Diocletian. In the latter case, the chief example is the large, figured capital in the Giardino della Pigna of the Vatican, where the statuesque athletes and philosophers on the four sides have become so large as to crowd out most of the traditional foliage and moldings.

The capitals of church and cloister at Monreale are closely related to those of the Salerno pulpits and display the same motifs. A mixture of prototypes appears for the capitals, which are not all in the same classical style: there are half-

draped figures with arms outstretched, Atlantids supporting the abacus, late antique architecture for scenes such as the Annunciation, and a variety of imaginative animals of classical and later type. The colonnettes show a good understanding and handling of rich, but flat, acanthus peopled scrolls or shafts, in the manner of those at Hadrian's Villa near Tivoli.[13]

Ancient material surviving in the medieval cities south of Rome influenced other Campanian architectural sculptures, especially the architectural sculpture produced under the Hohenstaufen patronage. The new creations in styles of the antique included not only architectural enrichment but also monumental figures in the round and major reliefs. To the Middle Ages the Roman Imperium was the vision of antiquity in all aspects of the arts. Decorative carving of the Flavian through Constantinian periods served the medieval architects, designers, and craftsmen as the architectural commemoration of Roma Aeterna. It is natural, therefore, that Roman imperial architectural enrichment should have been a dominant expression of medieval aesthetics.

For example, a marble base of a pillar or pier now in Boston combines four designs from Flavian Rome in a style which speaks of Central Italy near the end of the twelfth century. The front of the base shows the Wolf and Twins in the orthodox schema of late first- and second-century imperial reliefs (figure 15); the back presents two griffins flanking a tripod (figure 16); and the two sides are enriched with river-god masks emerging from elaborate acanthus scrolls. The masks are flanked by tiny bulls' heads above the spots where their ears ought to be (figure 17). The Flavian or Severan quality of the over-all design is evident in the florid use of undercut acanthus around the figures and heavy water-leaf molding above and below the principal panels. The dry, frozen quality of the carving proclaims it medieval Campanian rather than Late Antique decoration. The classical sense of the third dimension has been replaced by a series of cut-outs more like weaving in marble than undercut relief. The wolf's eyes and teeth are sinister. The Flavian prototypes for the griffins, including their foliate tails, are two architectural reliefs in Boston from Torre Annunziata near Naples (figure 18). River-god masks are found in many decorative reliefs of Roman baths, in figured scrolls, and in mosaics dating from Flavian times. The masks of the medieval base in Boston are linked to the world of imperial Rome by some late Antique design such as the mosaic of the barbarian mask in the peristyle of the palace of the Byzantine emperors in Istanbul.

The Greco-Roman Sources of Monumental Sculpture

In the shift from architectural enrichment or decoration to monumental sculpture in the round, it is essential to note that most medieval works are not far removed from architectural associations: cathedral sculpture, pulpits, shrines, and an occasional tomb. Frederick II's triumphal arch at Capua stands apart not only because of the degree of classicism of its sculptures but because of the almost-forgotten Roman imperial vehicle through which they are presented. The very idea of such an arch connotes a deeper revival than mere random continuation of classical forms.

Roman copies of Greek originals, athletic and divine statuary of the fifth to the first centuries B.C., cease throughout the Roman Empire by A.D. 300, save as vehicles for portraiture. Through use as portrait statues, certain draped female types of the age of Pheidias are perpetuated as late as the sons of Constantine. The seated statue

of Saint Helena, based on an Aphrodite of about 425 B.C. and known in several replicas, is an excellent example. The colossal statue of Constantine the Great set up between 312 and 325 in the Basilica of Maxentius beside the Roman Forum represented the ultimate in heroic, half-draped marble statues based on the Pheidian Zeus or the Capitoline Jupiter. Early Christian sarcophagi, of which medieval sculptors must have seen considerable numbers, chronicled the shift in the canon of classical proportions toward the squat humans in circumscribed registers or planes of relief, who are evident in the *Oratio* and *Largitio* friezes on the Arch of Constantine and who are so frequent in medieval church sculpture.

The specific sources of Greco-Roman classicism in the Middle Ages are less easy to identify than the obvious means of perpetuation of late antique style in these periods. Minor works of ancient sculpture have a distressing similarity and are consequently difficult to trace. Since Rome was less the center of medieval sculpture than other cities in Italy, in Germany and in France, or Spain, these sources are no simple list of the major sculptures in the Eternal City, such as the columns of Trajan and Marcus Aurelius or the Dioscuri of Monte Cavallo, which stood throughout the Middle Ages. The classicism of the eight Hadrianic marble medallions with imperial hunting scenes on the Arch of Constantine was there for any medieval sculptor in Rome to see, but it is safe to state that sculptors did not look at the Roman state reliefs surviving in situ until the spirit of scientific inquiry in the Renaissance inspired them to do so. Polykleitan, Praxitelean, and Hellenistic classicism turns up in the work of Campanian or French Gothic sculptors because of contact with sources other than Roman state art or other than the fifteen-

odd statues never buried in the ruin of ancient Rome.

In the first place, Roman copies of good quality of Greek and Greco-Roman works of all periods have been found all over the Empire, as much in France and Spain as anywhere except Italy, southern Greece, western Asia Minor, and Tripolitania. (The last three areas were little exploited before 1800.) It can only be guessed what works of good quality were rediscovered and lost again in the Middle Ages, providing prototypes for sculptors which can no longer be traced. In the twelfth century Master Gregory saw a statue of Aphrodite near the Dioscuri on the Quirinal. He described it as nude and "subtly made." It has been suggested that this statue was the Capitoline Venus, found late in the seventeenth century near S. Vitale between the Quirinal and the Viminal (figure 19). An unproved tradition says that it was immured in a wall; a natural speculation is that the goddess was hidden to avoid destruction on account of its un-Christian beauty.[14] An Aphrodite signed by Lysippos was found at Siena and destroyed shortly after the middle of the fourteenth century; archaeologists have believed that the statue was a replica of the Medici Venus in the Tribuna of the Uffizi. Ambrogio Lorenzetti made a drawing, admired by Ghiberti, of the statue.[15] A century earlier Nicolo Pisano used such an Aphrodite, dramatically foreshortened and seen from above, for a soul at Judgment in the Pulpit of the Cathedral at Siena (1266); and his son Giovanni included a "Venus Pudica," undoubtedly copied from a small bronze, as one of the Cardinal Virtues (*Temperance or Chastity*) on his pulpit in the Cathedral at Pisa (1302–1310).[16]

In a number of instances from 1400 to 1700 artists drew inspiration from a source of pure classicism which modern critics can easily over-

look. This source, Roman sarcophagi, worked an equally strong influence in the art of the Middle Ages, particularly from 1100 to 1400. The best and most numerous Roman sarcophagi are the mythological and decorative examples from the Hadrianic period through the middle of the third century. Sarcophagi with scenes from the Greek tragedies, with mythological and real battle scenes, with mythological cycles of varying degrees of complexity, or merely with decorative designs such as Victoriae supporting a bust of the deceased or Cupids with garlands reached a high technical level of sculpture in the most prosperous centuries of the Roman Empire. Relief was high and figures very well finished; technically there is no greater piece of sculpture than the giant Ludovisi battle sarcophagus of about A.D. 253.[17] Many sarcophagi survived through the Middle Ages, as tombs or as water troughs; fragments of many more were incorporated for structural and decorative purposes in medieval buildings.

In borrowing from these sarcophagi, medieval artists absorbed only isolated figures; rarely did a man—such as Nicolo Pisano—see groups of figures or compositions in them. In a more general sense, the artists who made these sarcophagi in the second and third centuries A.D. did the same thing. For the carvers of these Roman works, Pheidian statuary types of about 440 B.C. became Phaedra, Concordia, Aphrodite, or Zeus in respective scenes; Niobids on sarcophagi with scenes of their slaughter were cast in the mold of the statues attributed by Pliny the Elder to Skopas or Praxiteles; and the type of the heroic female barbarian on battle sarcophagi traced back through the fourth-century group of Niobe and her daughter to the art of Kallimachos, about 420 B.C. In a thousand instances the carvers of Roman imperial sarcophagi preserved figures

from the golden age of Greek classicism, in monumental high relief, and they handed these compositions on to artists of the Middle Ages. These figures were often the most striking in the compositions on their respective sarcophagi, and it is more than coincidence that Concordia or Juno Pronuba on daily-life sarcophagi should turn up as a female saint on the frontal sculptures of High Gothic cathedrals.

In the period of Frederick II, the Pheidian Hera Ludovisi or the Athena Carpegna with her characteristic helmet removed (perhaps through the medium of a figure from a sarcophagus; certainly through a Roman copy) supplied the model for the head of the Capua personified, on the triumphal arch at the bridgehead north of the Volturno. The eyes are unexpressed, and the lips have the heavy classicism of Pheidian types. These Pheidian types re-emerge in the art of Nicolo Pisano, in the Madonna of the *Epiphany* and *Presentation* on the pulpit of the Baptistery at Pisa. Pisano derived his comprehension of isolated examples of the Pheidian form mainly from study of the monumental Roman sarcophagi in the Campo Santo at Pisa and in Florence.

The scene shifts back to the slightly earlier Romanesque sculpture of the Campania. In statuary and figured relief, rather than architectural detail, a return to or a revival of classicism often produced the same look of late antiquity found in fourth- or fifth-century works, when classicism was giving way to medievalism.[18] In the Evangelary pulpit of the cathedral at Salerno (about 1175), the male figures supporting the lectern on the east side recall fourth-century Roman *togati* of the type found at Ephesus, Ostia, and Lepcis Magna. Two-thirds lifesized, they are among the most monumental figures of antique type to survive in Southern Italy. In

the Epistolary pulpit of Salerno (1153–1181), the Atlantids with their puffy bodies and towel-like loincloths are taken from the corners of some second- or early third-century Bacchic sarcophagus. The Sileni on the Farnese sarcophagus in the Isabella Stewart Gardner Museum provide the perfect prototype. These figures at Salerno are too complex for Campanian sculptors, who prefer foliage and simple animal forms such as those already discussed in connection with architectural sculpture.

Parts of the pulpit in the cathedral at Sessa Aurunca (second and third quarters of the thirteenth century) comprise marble plaques with scenes of Jonah (now walled in the choir enclosure). Jonah has a body composed of plastic muscles, showing a "keen sense of proportion and articulation."[19] In visualizing this, the modern beholder must allow for the Byzantine treatment of the human figure. Jonah's gesture is a classic one of surprise or violent emotion like that of Hecuba or Andromache in back of the scene on the Hellenistic Death of Priam relief in Boston, or one of the Lapith maidens in the fifth-century frieze of the temple of Apollo at Bassae.[20] Both the northeast and northwest Caryatid figures of the pulpit at Sessa Aurunca are modeled on classicism of the Severan period (A.D. 193–235), an age when much older painting and sculpture was reinterpreted in mosaics and on sarcophagi. The first figure is modeled on a Severan version of a Spes or Kore of archaistic type. The pendant Caryatid, half-draped, combines the head and hair-style of one of the wives of Elagabalus with the mannered slimness of a Roman fountain figure after Praxiteles, of which there are excellent copies at Wilton House and in the Liverpool Museum.[21] The drapery enhances the figures, evidence of the great development in modeling in the classical manner reached at Sessa. These two figures are classic

illustrations of limitations in the choice of antique prototypes by medieval sculptors. They demonstrate that what is often attributed to postantique insertions in the creation after classical antiquity is really not latent but apparent in surviving ancient works.

Too much twentieth-century assessment of classicism in the art of later periods assumes that ancient sculpture, even of the ideal type, followed the best of Polykleitos or Praxiteles, rather than classical sculpture of inferior quality. Roman cities, towns, and villas were filled with Greco-Roman marbles of indifferent workmanship, amid which Greek originals or masterful copies were occasionally found. This garden sculpture often perpetuated poor distortions of good models, needless mannerisms, and empty dramatic force. Later artists frequently accepted the antiquities they encountered at their romantic rather than their face values, without stopping to sort out the excellent from the indifferent.[22] A forceful comparison is offered by an ideal head which very likely comes from the triumphal arch at Capua (figure 20) and a rather commonplace Greco-Roman marble (figure 21), perhaps a very general portrait of a Roman lady of the Julio-Claudian period. Despite its poor quality, its damages, and the reworkings it has suffered, the Greco-Roman sculpture is held together in a vibrant, cohesive classicism. The face is not too broad, not too thin, and the carefully arranged hair above is balanced by a longish, articulated neck below. In profile, there is a vibrant relation between eyes, nose, lips, and chin. The thirteenth-century head is more damaged, but weathering and abrasion do not conceal a flaccid face, an inarticulate tube of a neck, and eyes that have traded alert awareness for a bland transcription of the classical formula. These differences are minor, however. In general proportions the Hohenstaufen sculptor has felt

very carefully for the antique. His treatment of hair is particularly masterful, excelling the Roman model in softness and even suggesting the sensitive paring knife and claw chisel of Praxiteles in the fourth century.

Present-day students cannot expect medieval sculptors to have been critics of art in a period when criticism was confined to content. Good models were occasionally used; it is often startling to find these prototypes surviving in the thirteenth century. The features of the laureate bust of Frederick II's councilor Pietro della Vigna, from the triumphal monument north of the Volturno, are not derived from a Roman portrait, as might be suspected in view of the classical sources employed at this time. The model is some Roman version of a philosopher portrait in the style of the Transitional Period in Greek art (about 490–460 B.C.), such as the bust of the poet Anakreon in the Palazzo dei Conservatori in Rome.[23] The portrait of Pietro della Vigna even preserves the crisp curls of some Transitional work in bronze, such as the Arte-mision Zeus or the Tyrannicide Aristogeiton set up in the Athenian Agora shortly after 480 B.C. Copies of the latter have been known in Italy at least since the Renaissance.[24]

The Gold Coins of Frederick II

The gold Augustales of Frederick II, first minted in 1231, are the culmination of the classical style in the Campanian revival of the Hohenstaufen emperor (figure 22). The purpose of these new aurei or solidi is obvious, but the sources of inspiration are mixed. The flat order-liness of portrait, eagle on the reverse, and lettering in the field, as well as the symmetry of the flan, is modeled on imperial gold of the period from Constantius II (A.D. 337–361) to the middle of the sixth century, the age of Justinian

in Constantinople and Italy. But the eagle itself and the particular style of the lettering recall Antiochene silver tetradrachms of the period from Septimius Severus (193–211) to Gallienus (253–268).[25] The total picture presented by the various details is one from which the numismatist can extract all the classical sources. The concept depends on the antique, but this is not the coinage of antiquity. The effect created is something new; the style is readily identifiable as belonging in thirteenth-century Italy. This is true of all aspects of this so-called Campanian revival. A recently identified monumental marble portrait of Frederick II is unmistakably a product of its age, but the court portraitist has used a likeness of Augustus Caesar as his model.[26] It is fascinating to conjecture whether this was done consciously, with knowledge that Frederick was appearing as Novus Augustus; but the sculptor may have chosen an antiquity conveniently at hand, as many portraits of Augustus have been found in Italy and the Latin West.

The Classicism of Nicolo Pisano and Ambrogio Lorenzetti

PISANO'S SCULPTURE

Nicolo Pisano has been recognized as the artistic outgrowth of the Campanian revival. He brought his heritage from Southern Italy northward to Pisa and Siena, where major commissions were to be found and where ancient monuments were no less plentiful as sources of inspiration.[27] He stands as the high point in late twelfth- to early fourteenth-century classicism, higher than the circle of Frederick II, and his influence extended through the Trecento and into the early Renaissance. This was true particularly among the painters who followed Giotto.

Vasari tells one tale of Nicolo and antiquity

which is important as evidence that Nicolo went out of his way to study ancient works of art. Random, on-the-spot copying of ancient designs or motifs occurred regularly—matching a capital with an ancient capital, or reduplicating an ancient relief—but study and use on several separate later occasions of a single work was rare. The Hippolytus and Phaedra sarcophagus, now the tomb of Beatrice, daughter of Countess Matilda, and in the Campo Santo at Pisa, was brought back in Nicolo's time as booty by the Pisan navy (figure 23). Nicolo drew much profit from it, using heads, figures, and groups on several occasions. It was fortunate that such a handsome example of monumental Antonine to Severan figural carving, with stylistic currents going back to Greek art of the Parthenon period, should have fallen to the Pisans at a time when Nicolo was in their midst with eyes to appreciate it.

The sculpture of the pulpit in the Baptistery at Pisa, signed and dated 1260, has been termed "a powerful resurrection of antique figure style, transcending even those evocations accomplished by the artists of Frederick's [renaissance]."[28] The reliefs show that the style resurrected by Nicolo was the classicizing baroque of mythological sarcophagi of the Antonine and Severan periods, set off on occasions by excerpts from Hellenistic reliefs or the more bizarre among figures in Neo-Attic sculpture.

The *Birth of Christ* stresses dependence on the Phaedra sarcophagus. The perspective and compositional organization of third-century sarcophagi is caught in the angel behind the crib and in the continuous or compressed narration of the angel of the Annunciation. Many have noticed that the Junoesque Mary reclines with the noble serenity of a matron on an Etruscan sarcophagus. Joseph (?), seated at the lower left, has a head like those on monumental Constan-

tinian sarcophagi, such as that of Junius Bassus in the Grotte Vaticani.

The *Adoration of the Magi* presents a more simplified, more monumental composition, recalling certain Antonine Roman historical reliefs rather than sarcophagi (figure 24). Mary is the Junoesque Phaedra again, and she is seated on the Hellenistic philosophers' lion-headed throne. Here Joseph has the head of some Roman Zeus or Asklepios. The arrangement of the Kings' three horses is particularly Roman, catching the pictorialism of the steeds on the Arch of Titus and those in the Aurelian panel in the Conservatori. In the strong sense of rhythm from left to right, accented by the sweeping arms and draperies of the Magi and punctuated by several obvious verticals, the concept of design is borrowed from those sarcophagi closest in style and spirit to the Roman state reliefs of the second century. At first glance the hair, divided by running and circular drill-channels, seems Antonine in flavor; only with careful scrutiny are the irrational elements of rolled curls and lyre-form locks apparent. As in the broad, bold folds of drapery and polished surfaces of flesh, the over-all effect of a Roman imperial classicism is very evident.

In the *Presentation in the Temple,* the emphasis is on the heavy, cascading drapery in the manner of antiquity mixed with the Gothic style. The elderly, bearded men bring to mind the portraits in the Greek style on large sarcophagi of the third century, such as those of "Plotinus" in the Lateran and the two sarcophagi with people and philosophers in the Museo Torlonia. Tullio Lombardo was to observe two heads from the same sources over a quarter of a millennium later (1501–1525) in the center of his relief *The Miracle of the Miser's Heart* in the patron saint's chapel at S. Antonio in Padua.[29] In Nicolo's relief, one man is partly

bald, and bearded, giving a strongly Roman flavor to a type of portrait standard for elderly saints and prophets in the Middle Ages. Nicolo borrowed the motif of the intoxicated Dionysos supported by Ampelos the satyr for the group at the right. Since the large marble vase from which it was taken was undoubtedly in the Campo Santo at the time, this is another example of his awareness of specific ancient monuments. The architecture in the background is a view of contemporary Pisa, rendered in the "glimpses of architecture" manner used on certain monumental Antonine and Severan sarcophagi. The series with views of Ostia Harbor or the Portus provides the best parallels.

The break between Nicolo's more antiquarian and more Gothic styles is said to come with the *Christ on the Cross* and the *Christ Seated in Judgment*. In the first, it is a matter of subject: the dramatic qualities bring out the dramatic, which is inherent enough in Gothic sculpture. These dramatic qualities are enhanced by the massing of figures in massive drapery in the frontal plane and by the extensive drillwork in the hair, thus uniting the technique as well as the style of Roman sarcophagi with the present. The faces are still very much of the classical, Roman imperial, type; this form of classicism is noticed most in the heads of the three women in profile behind John and the Marys in the left foreground. In the *Christ in Judgment,* the organization of the figures in registers suggestive of a gradual depth and the selection of their types depend strongly on Roman sarcophagi of the third century or on large Early Christian sarcophagi of the late third and fourth centuries, such as those ranged so majestically in the Lateran. Certain figures are still startlingly antique and are in position according to the standards of sarcophagus composition: for instance, the recumbent river god in the left foreground. But, in

general, Gothic folds and cascades mold the over-all effect, and the iconography is mixed Gothic and Byzantine. The crowding of surfaces and the radically reduced scale of the myriads around Christ make the *Judgment* a more Roman composition, in the sense that the Romans of the late Empire preferred the struggles of smallness to the contemplative opportunities of a few grand figures.

Some of the single figures between the principal scenes are no less dependent on the antique. The winged *Fides* has a head with sightless eyes; the ample locks and beardless face are in the tradition of Hellenistic Apollos and the Christ-Helios type of the statue in the Museo delle Terme in Rome. His pose and costume are those of a late Roman magistrate on a consular diptych, and the motif of a lion devouring a stag (at his left) is taken directly from the curved end of a third-century sarcophagus, of a type represented by a powerful fragment in the Pisan Campo Santo. *Fortitudo,* on a capital between the "pendentives," is a Pergamene-Roman version of a Lysippic Herakles or related athletic figure. In the fashion of medieval reworkings of the classical "peopled scroll," the sculptor has made the hero's lionskin grow into the beast he is suppressing with his left hand. A statue in Berlin, or versions of the Hercules Farnese in the Uffizi, the Pitti and the Villa Borghese provide Greco-Roman comparisons.[30] In the *Paul,* of *Peter and Paul* in the area between *Caritas* and *Fortitudo,* the head of the Apostle to the Gentiles is taken from the philosopher identified as Socrates on the end of the Muse sarcophagus long in the Villa Mattei and now in the Museo delle Terme.[31] Finally, even the animals step forth from the world of antiquity; the lion under the base of one of the columns is Roman, in the Hellenistic tradition. He is the brother of the Roman lion long a familiar feature of the

Piazza della Signoria in Florence.[32] The introduction of another beast beneath his feet and those of his two brothers (under the other columns) recalls both Hellenistic decorative groups and the motifs on Roman sarcophagi of the second and third centuries.

There is less classicism of the startling sort in Nicolo's later work, the pulpit in the Cathedral at Siena (1266). Yet there is little diminution in his over-all dependence on monumental Severan mythological sarcophagi in the *Adoration of the Kings.* The arrangement of the horsemen in planes and registers, the filling of the upper background with trees and architecture, and the scale of the principals at the right are familiar devices of the narrative relief in the years following A.D. 190. It is in the postures of the Kings, the Virgin, and the Christ Child, and in their massive draperies, that critics can speak of a shift to French Gothic, rather than Roman antiquarian presentation of the human figure. The rather overwhelming corner figures dividing the reliefs emphasize this transition, although Moses (to the left of the *Adoration*) has the head of Plato and would not be out of place in the early Quattrocento.

The classicism of the pulpit in Siena is a link between antiquity and the tradition of Giotto. The figure in the right foreground of the *Paradise* is easily recognized as a Nereid with her back turned, a motif to be seen on a sarcophagus of this class long in Siena (figure 25).* The heads are portraits in the Hellenistic-Antonine tradition: old philosophers for men of the Church, market women turned into nuns, a Cupid's head incongruously used for a man amid elders, and even the Menander-Virgil portrait (at the right end of the second row). One of the Cherubs at

* It is the half-draped pose to be perpetuated by Poussin in the seventeenth century (figure 92) and made monumental in Courbet's *Reclining Nude* at the outset of modern art (figure 93).

the right derives from a marble vase, but the one below is taken from a Roman gem. In the *Massacre,* the man with outstretched arms and the old woman bending over come from a Death of Meleager sarcophagus, perhaps the one long in the Palazzo Montalvo in Florence and perhaps the example accessible to the Pisani.[33] The (Roman) soldiers in third-century imperial armor (with *pteryges* turned into acanthus enrichment) set forth about their horrid task in the manner of legionaries on the Ludovisi battle sarcophagus. These and other borrowings are from sarcophagi of types most exploited in the pre-Renaissance and Renaissance return to Greco-Roman art. The rhythmic pattern of Nereids on seabeasts and the painterly pathos of Meleager's untimely end will appear over and over again in various fashions in works to come.

LORENZETTI'S PAINTING

A return to painting brings these observations on classical borrowings up to the threshold of the Renaissance. Ambrogio Lorenzetti, probably born about 1295, died in the great plague of 1348.[34] Of him Rowley has written, "His genius is peculiarly difficult to estimate for it combined an almost antiquarian traditionalism with extreme originality. Both stemmed from the speculative quality of his mind." He infused pictorial Byzantine means of area with powerful forms and breadth of style, without depending on Giotto's more sculptural mass and plastic folds. "He seems less sculptural in a Gothic sense than any other major Trecento artist. On the other hand, his intellectual curiosity and ingenuity urged him to attack problems which we usually associate with the Renaissance, namely the individual, the nude, perspective, convincing setting, weather and seasonal conditions, and revival of Classical antiquity."[35] Lorenzetti's drawing of a statue of Aphrodite

signed by Lysippos was a noteworthy event not only because of the statue's discovery but because of the artist's concern with a pagan nude.

Lorenzetti shared with the Pisani and other artists interested in antiquity at the close of the Middle Ages the quality of making random borrowings from isolated works of ancient art. What sets him apart is the imaginative scope of his observations. For the figure of Pax among the six civic virtues in the Sala della Pace at Siena Roman bronze coins of the emperor Nero inscribed SECVRITAS AVGVSTI provided the model (figure 26). Securitas, draped only about her lower limbs, is seated holding a scepter in her left hand, right elbow resting on the back of her throne. An altar is in front of her.[36] Lorenzetti has caught the characteristic pose but has enveloped the figure in a long-sleeved garment. This garment conveys something of the artist's efforts to catch the diaphanous, clinging qualities of Julio-Claudian drapery based on Kallimachos' models of the late fifth century B.C., the so-called Venus Genetrix type and the Nike balustrade. The altar has disappeared, and the scepter of Securitas has become the olive branch characteristic of Pax.[37]

For Summer in the series of medallions of Seasons and Planets in the Sala della Pace, a Roman floor mosaic has been copied closely. The antique iconography (sickle, sheaf of wheat, and wreath of leaves) has been retained.[38] In other work, Ambrogio Lorenzetti gives evidence of understanding Roman illusionistic techniques. He may have seen Roman paintings now lost or a manuscript which has not survived. It is not difficult to think that he grasped these notions through a Carolingian copy of classical illumination. A considerable feeling of Roman illusionism was preserved in Peiresc's now lost Carolingian copy of the Chronograph of 354. An artist of the end of the Middle Ages could have comprehended Greco-Roman styles and techniques through faithful copies of ancient illustrations made in the early medieval periods of classical revival.[39] A manuscript of calendar type, such as the Chronograph of 354, with representations of the months and days of the week may have given Lorenzetti his figure of Summer, rather than the mosaic. The mask held in the left hand of Dialectic, in the Sala della Pace, may be copied from a Hellenistic or Roman satyr's head in terra cotta.[40] The Italian soil in 1340 must have yielded some proportion of the many objects of this nature unearthed in our own time.

Random but imaginative borrowings from the antique set Ambrogio Lorenzetti off from other Trecento painters. Nicolo Pisano intensified this pattern, in his work in the Baptistery at Pisa. He organized his literal and stylistic borrowings almost to the point of seeming to be a sculptor of the Renaissance. But he and his successors could not maintain the high level of relationship to the antique set in their earlier works. The identity of the artist with the subjects and style of Greek and Roman antiquity is first the property of the Italian Renaissance of the Quattrocento. However gifted painters and sculptors of the years 1200 to 1400 might be in relating their work to the classical past, these bonds were not reinforced by a general surge of humanism behind the artists. Therefore borrowings from antiquity could have no consistent, sustained series of subjects or style.

The Italian Renaissance to 1500

THE second and third decades of the fifteenth century witnessed an intensification of the role of classical antiquity in Western European art.[1] This is often presented as a minor miracle—the antiquities rising out of the ground to meet the artists who appreciated them. In truth, more ancient works of art were available for study than is generally realized, and more men of intellect stood ready through several generations of training to make use of them. The ever-broadening vision of antiquity led to the early Renaissance habit of work in the manner of the antique, without the artists' simply repeating a few ill-understood, unnatural borrowings.

In the early years of the century the Turkish advance and the disruption in the eastern Mediterranean made Italy, rather than the Hellenic lands, the source of new classical antiquities. At first there were few whole statues for artists to study; reliefs were more common, as had been the case in Nicolo Pisano's time. Many ancient sculptures, fragments of statues as well as reliefs, were walled up in medieval buildings, and Byzantine and early Christian sculptures in the antique manner had been assembled in the architecture and surroundings of S. Marco in Venice. After 1430, great collections were formed in which small bronzes, gems, and coins play an increased part. To artists and antiquarians they were the photographs of their time. Other discoveries of ancient works of art were made in Rome, Florence, and elsewhere, as excavating for foundations, the result of increased building activity, led to the quarrying of ruins.

In Florence the humanist background to exploitation of the antique reached back beyond 1390. In 1396, Manuel Chrysoloras was called to that city as professor of Greek, and in the following year Giovanni Malpoghini of Ravenna became professor of Rhetoric. Humanist studies became the discipline for training the noble youth and those aspiring to the advantages of a fully employed mind. Had Byzantium not been in her death throes, the reappreciation and renewed understanding of ancient art might have taken place in Constantinople as well as in Florence, Ravenna, and Venice. The mid-fifteenth-century fresco of *The Deceased before the Madonna and Child,* in the Kariye Djami in Istanbul, indicates that the last Byzantine artists solved problems of volume and space in a style similar to Mantegna's in the Ovetari Chapel of the Eremitani at Padua.[2]

Renaissance Sculpture

EARLY MASTERPIECES

The activities of late-Trecento humanists produced a demand for the antique in works of art commissioned in the decades preceding 1410.

The crucial monument of this humanism in Florence is the portal on the north side of the Cathedral, Porta della Mandorla (1391–1396), with the archivolt dating after 1405. One artist working here, the "Hercules Master" (perhaps Niccolò Lamberti), produced foliate pilasters with an excerpt from the Hercules cycle amid the vines and acanthus. The work is related in literature to Coluccio Salutati's completion of a dissertation on the Labors of Hercules.[3] The sculptor took his model directly from pilasters such as those in the Grotte Vaticani, the ancient caverns and storerooms beneath St. Peter's—examples of developed Severan work in the Flavian tradition and perhaps from the Severan constructions in Hadrian's Villa at Tivoli.[4] In type of decoration the Hercules Master's work is no radical departure from the decorations produced by Campanian sculptors in the twelfth century; but his high degree of faithfulness to the antique is. The importance of the Porta della Mandorla lies in the fact that for the first time in many centuries antique figures and motifs were carried over into postantique art without a change in iconography. Hercules remains Hercules, and the Abundantia of Giovanni d'Ambrogio remains the same Roman imperial personification.[5]

One of the touchstones of revived classicism in the early Quattrocento is Lorenzo Ghiberti's *Sacrifice of Isaac,* a competition relief for the North Portals of the Baptistery in Florence (figure 27). The principal figure is designed in a decidedly antique manner, although no specific model has yet been established.[6] Actually, it is possible to identify the figure of Isaac if it is considered a torso completed by the sculptor. As a torso, the sculpture is closer to work of about 460 B.C. than to a Praxitelean or post-Praxitelean original. The prototype is comparable to Boston's headless youth, an original of

the period just after the Kritios Boy of the Acropolis in Athens (figure 28).[7] In Ghiberti's relief the head of Abraham is a vague transcription of some Hellenistic Zeus, and the two servants have been identified as deriving from the figures of Pelops and his companion on a Roman sarcophagus showing the chariot race of Pelops and Oenomaos.[8] The foreshortened angel above Isaac is a classical figure in a pose of technical virtuosity which is to have a long tradition in the paintings of Titian and Tintoretto. The seated ram on the rocks in the upper left corner is as much a recording of Hellenistic sculpture as an observation drawn from nature. He is comparable to the Roman bronze ram in Palermo. The altar beneath Isaac incorporates a Roman panel of scrolled acanthus, probably one of the examples found in the Roman Forum at the outset of the Renaissance and scattered around Italy from Venice to Naples. Similar panels have always been features of the antiquities on view in Florence. If there is a nonclassical quality in the total view of the relief, it is in the restless rocks which draw together the disparate elements, the four parts of the scene.

BRUNELLESCHI

The quality of excerpting from the antique is even more evident in Filippo Brunelleschi's competition relief, *Isaac and Abraham.* Isaac, kneeling at the altar, is derived from a kneeling prisoner, such as those on the Arch of Constantine or on one of the Antonine sarcophagi depicting scenes from a general's career.[9] The servant on the left is taken from one of several thorn-extracting boys, Greco-Roman versions of a Pasitelean original of about 50 B.C. and perfectly in keeping with the dominating elegance of Quattrocento sculpture.[10] The servant on the right comes from "a Roman relief of the slaughtering of a pig," the design known now

only through a drawing made about 1560[11] and a late antique ivory plaque in the Vatican. Brunelleschi has been said to see antiquity "only through an overlay of Medieval transformations," and his poses taken from antique sculpture are presented in an antiquarian garb that is actually medieval.

In the next generation the Paduan scholar Giovanni Marconova views architecture, or topography, similarly, and Andrea Mantegna near the end of the century can be very medieval when seemingly very subservient to the antique.[12] Ghiberti's tradition, derived from this outburst of classicism on the part of the Hercules Master, will descend through the immediate and various byways of the Quattrocento to the premature monumentality of Jacopo della Quercia,[13] to the scientific virtuosity of Donatello, and to the craftsmen of stature, such as Antico (died 1528), Bartolommeo Bellano (died 1496/7), and Riccio (died 1532).[14] Ultimately this classical tradition reaches Michelangelo, and then the possibilities of ancient bronze and marble need only Mannerism, the Baroque, and the Rococo for an understanding born of full, practical exploitation.

The early reliefs of Ghiberti and Brunelleschi exemplify the Quattrocento approach to ancient art as a body of material more to be excerpted than absorbed. This is carried to a high degree of refinement later in the century, not only because of early curiosity or lingering medievalism, but because the first antiquities collected and studied were mutilated statues and fragments of reliefs, themselves excerpts of antiquity in terms of its classical completeness.[15] Ghiberti's career is the first of many which follow a pattern of selection from antiquity, partial rejection of its outward forms, and later return to antiquity through a full mastery in personal terms of some aspect of its form and content.

GHIBERTI

The popular and fashionable International Style rather than direct recourse to classical antiquity motivated Ghiberti in his work on the North Portals of the Baptistery. Borrowings are usually direct and easy to understand, but as the Quattrocento advances identification is made more difficult because of the reversed compositions resulting from woodcuts or engravings. In the *Nativity,* the sleeping shepherd is either a figure from a sarcophagus, Cleopatra mourning at Meleager's tomb, or a reversal of the mourning Dacia on the Cesi base, the keystone from a destroyed Arch of Trajan and now in the Palazzo dei Conservatori.[16]

Travels, postulated or actual, to Pisa and Rome influenced the development of Ghiberti's North Door (after 1416). At the right edge of the *Entry* a figure is taken from the corresponding part of the Fieschi tomb, a large Roman sarcophagus which, since the thirteenth century, had been in San Lorenzo fuori le Mura in Rome.[17] A Renaissance copy of the front of this important sarcophagus with an elaborate view of a marriage ceremony has long been preserved in France, an indication of how important the Roman monument was to artists of the Quattrocento.[18] Of the Prophets' heads on the corners of the lattice frame of the North Door, four are borrowed from the Phaedra sarcophagus in Pisa; other Prophets' heads are derived from battle sarcophagi in Rome, and several motifs can be traced to the Aurelian reliefs on the Arch of Constantine. This suggests that over the years from 1416, Ghiberti must have built up a large portfolio of drawings of antique motifs, of ancient works of art. Like his successors in the first generations of the Renaissance, he drew upon good and bad works with equal enthusiasm; on the other hand, he often sensed the Hellenistic

originals lying behind bad Greco-Roman sculpture. And he not only exploited relief compositions but utilized the techniques of depth and layers of carving in Roman historical reliefs, for example in the treatment of heads in shallow planes.

In Ghiberti's mature phase—the decade after 1430—the images of ancient art filled his mind even more intensely. In these years he turned to the Gates of Paradise. Not only did the range of his borrowings increase but their absorption or sublimation becomes more evident. This is the culmination of his constant relation to the antique, a development spoken of as occurring in the work of a number of later artists. Free copies and freer variants of antique figures and motifs characterize Ghiberti's work in the Gates of Paradise. Prototypes, such as the female symbolic of fate, are absorbed completely in the artist's designs. One of the Fates from the Daily Life sarcophagus once in St. Peter's and now in Los Angeles is even used for one of Noah's sons.[19] The group of figures in the marriage scene on the same sarcophagus becomes, in reverse, the group of servants in the panel devoted to Isaac's parting from his son Esau. From one antique motif Ghiberti would develop two, three, or possibly more variants, each recalling the original in some features but never in all of them and never in exactly the same way.

Ghiberti's systematic zeal in adapting features from Roman sarcophagi to various scenes of the Gates of Paradise—the *Entry into Jerusalem* and the *Cain and Abel,* for example—produced an inadvertent communion with the great ages of Greek art, a relation often taken for granted in the work of Renaissance artists. The artists of Roman sarcophagi were Greek eclectics, and the motifs which Ghiberti and others borrowed without more than artistic selectivity were often verbatim excerpts from Greek works going back

to the generation after Pheidias. Ghiberti, and painters such as Benozzo Gozzoli and Domenico Ghirlandaio, loved the billowy motion of maenad draperies.[20] The swirling celestial cloaks of Zeus or Nox on the Column of Trajan also caught their fancies. Zeus appears as God the Father on frequent occasions. In general in the Gates of Paradise, Ghiberti turned from the historical reliefs and calmer figures of his earlier period to the agitated figures of Pergamene or Neo-Attic derivative art. When prototypes were not agitated, he occasionally agitated them in his interpretations.

Ghiberti's art became homogenous as he moved into this later phase because his image of antiquity was total. Sarcophagi varied considerably in style and composition, and he was all the greater for his ability to weld a cohesive style out of fragmentary antiquity. Part of this unified approach to antiquity stems from the classical unity which Greek workmen fused into Roman sarcophagi; nonetheless, Ghiberti created a new concept of beauty out of antiquity and his own immediate heritage. He was one of the first Renaissance artists to appreciate antiquity as a cleansed and improved edition of nature.

DONATELLO

Donatello (1386–1466) moves on from the level of classical perception achieved by Ghiberti.[21] The *David* with the head of Goliath, commissioned for Florence's cathedral in 1408, is an Italian Gothic statue which foreshadows the sculptor's great developments in naturalism.[22] *St. Mark* (1411) of Or San Michele reveals in pose, features, and costumes an understanding of Hellenistic sculpture, acquired partly from a journey to Rome with Brunelleschi early in the new century.[23] Donatello's receptive personality fused antiquity with the many other images accumulated during a long and varied

life. He continually used major and minor ancient sources, and early Christian and medieval iconography and compositions. He showed a complex approach to the antique at a time when excerpts and selectivity, or a developed degree of these, might be expected.

In the years immediately after 1430, Donatello carved the Cavalcanti *Annunciation* in Santa Croce, Florence (figure 29).[24] The technique of very high relief in an aedicula or elaborate architectural niche revives the designs of Attic grave-reliefs of the late fifth and fourth centuries B.C. Hegeso and her servant-girl, in the famous grave-relief that lay beneath the Athenian soil in Donatello's time, are drawn together in an almost tondolike spiritual interrelation. Donatello reverses this concept of unity. His Virgin and Angel came together in an inverse manner, the former rising from her chair as though to leave and turning back to listen to the latter. The enframing niche is covered with imaginative but orthodox Greco-Roman details and displays a richly soffited background, almost suggesting the portals of a temple. The two heads are the surviving heads of the Three Graces, then in Rome and now in the Piccolomini Library in Siena, a Roman copy of a lost Hellenistic composition.* In Donatello's *Annunciation,* the draperies of the Virgin and the Angel blend antiquity, the late Gothic, and the sculptor's own restless naturalism.

The bronze *Virgin and Child* of Donatello's next commission, the high altar of Sant'Antonio in Padua, can be singled out for its recondite classicism presented by means of an ancient Byzantine, hieratic pose (figure 30).[26] The Virgin's head is that of Agorakritos' Mother of the Gods (Cybele) in Athens, a work much reproduced in varying sizes in Hellenistic and Roman times. The Child is held in front of her, a pose both suggesting medieval paintings and mosaics and allowing Donatello to convey the notion of arrested motion as the Child is raised in benediction. The sphinx arm-supports may be a duplication of Cybele's lion, or Donatello may have seen the Greek fourth-century coins of Aphrodisias which show Aphrodite seated in just such a fashion.[27] The whole concept of the statue is also reminiscent of those fifth-century Etruscan cineraria in the form of a woman seated holding a child on her lap between sphinxes (figure 31). Since these were made in northern Etruria (Clusium and vicinity) and exist in Florence, they were not beyond Donatello's range of vision. The large expressive hands holding the Christ Child are especially like those so powerfully portrayed in the Etruscan cinerary urns. The Christ Child is a Hellenistic infant, a conscious contrast to the vertical classicism of the Madonna and her throne. In Donatello's bronze, the drapery is also a contrast, consciously Gothic, to the Pheidian face.

The key monuments of Donatello's final years were the pulpits at San Lorenzo, left to be completed by pupils on the master's death in 1466.[28] "Not only the over-all structure, but individual details throughout the narrative scenes reflect that careful study of ancient monuments which had been such a potent force in Donatello's art from the beginning; now it is making its contribution to the expressive vocabulary of his latest style."[29] The concern with religious expression in these late works with scenes of the Passion and of the Martyrdom of St. Lawrence produced a combination of Tuscan Romanesque, Trecento, and antique elements, traditional pulpits and classical enframement (the

* The group in Rome was considered remarkable in its time. A version of the statue in the Louvre preserves all three heads, with slightly more elaborate hairdress; other replicas of the Hellenistic composition have always been known on sarcophagi and in Greco-Roman decorative reliefs.[25]

frieze of putti above the principal scenes) being part of Donatello's complex Christian, and pagan, symbolism.

It has been stated that in Donatello's Late Style, "the rational and humanistic qualities of the early Renaissance, to the formulation of which he had himself made such a prodigious contribution, had been overshadowed by an anxious concern with religious expression." Nevertheless, classical details fill the pulpits.[30] In *Christ before Pilate and Caiphas,* the judgment scene at the left is based on the Aurelian *Clementia Augusti* of the Arch of Constantine, or on one of the sarcophagi with illustrations of the life of a high official. The enframement, two arcuated porticoes with spiraled columns, comes from an early imperial architectural terracotta or Campana plaque of the type with Nilotic scenes.[31] The coffered arches have a history in Renaissance painting, being a prominent feature of the *Trinity* by Masaccio; such types of antique vaulting were very much in the minds of architects experimenting in the Quattrocento.

I. Lavin suggests an ingenious and plausible connection between the nude riders on saddled horses in very low relief in the upper part of the *Lamentation* and the horsemen of the Parthenon frieze (figure 32). These riders may have been done by the hand of an apprentice. Donatello was personally acquainted with Ciriaco d'Ancona who made drawings of the Parthenon.[32] Otherwise, a Roman relief with two riders in a very close approximation of the Parthenon style was known in Rome until 1516, when it disappeared to the Duke of Medinaceli's collection in Spain (figure 33).[33] This relief is more likely to have served as Donatello's model, for Ciriaco was not capable of such accurate transcription of Pheidian style. None of the copies of his notebooks portrays any grasp of stylistic differences in the sculpture sketched; everything is overlaid with a fussy medievalism, and Donatello could hardly have recreated the Pheidian style without an inspiring source.

Other less startling and less speculative relations demonstrate Donatello's reliance on the usual sarcophagi. The kneeling figures of the *Entombment* may depend on those of the Fall of Phaeton sarcophagus in the Uffizi, a relief known at least since the second half of the fifteenth century.[34] In the remaining scenes of the pulpits, especially the *Ascension,* the grouping of the Apostles shows strong dependence on Antonine or Severan crowd scenes, specifically on the groups of suppliants of the Column of Marcus Aurelius and various groups of figures on the Arch of Septimius Severus.[35] The arch was then much more visible, and less mutilated. The principal reliefs were nearly at ground level, owing to the filling in of the Forum or Campo Vaccino. The community of emotion between this major aspect of Severan art and Donatello's Late Style is interesting; he seemed to derive much artistic satisfaction from ancient art in its technically masterful, thoroughly Roman, transitional phase before the late antique.

In the *Marys at the Tomb,* Christ's sepulcher is a classical strigilated sarcophagus. A strigilar sarcophagus had been used earlier, notably in the Trecento. The *Descent into Limbo,* pendent to the scene of the *Ascension,* combines Byzantine centralization of composition with faces (on the left) which are those of Trajanic Dacians or even the expressive barbarians on the Column of Marcus Aurelius. In the *Resurrection,* the center of the side containing the *Descent* and the *Ascension,* the treatment of Christ in profile at the left end seems to have originated in the figure of an old man leaning on a staff, with leg raised, on a sarcophagus illustrating the Death of Meleager, probably the much drawn example of distinguished pedigree now in the Villa Tor-

Ionia-Albani in Rome.[36] (The same group of sarcophagi is said to have produced the wailing, hair-tearing women in Donatello's Lamentation scenes.) The figure of Christ may also be likened to that of the captive barbarian on a second-century sarcophagus with scenes of imperatorial conquest, now in the Belvedere of the Vatican. These figures demonstrate the variety of the sculptor's sources, for the groups on any one of several *conclamatio* (or deathbed scene) sarcophagi could have produced the same result.[37]

The columns of Trajan and Marcus Aurelius also provide organization of figures and dramatic vocabulary for the *Ascension* and the *Pentecost*. The Tuscan Trecento furnishes the semicircle of kneeling figures in the latter without indication of environment or specific setting.[38] In the *Martyrdom of St. Lawrence,* extraneous to this Passion sequence because of the dedication of the church, Donatello's "gruesome" style is carried to extremes; a pinnacle of excerpted and absorbed antiquity has been reached: the little kneeling man fanning the flames with the bellows is a notion taken off the lids of Bacchic sarcophagi where satyrs stoke banquet furnaces. Examples of these unmistakable figures exist in Cinquecento and later drawings.[39]

Thus, although Donatello in his last years was moving away from a classical style, he continued to find inspiration in examples of the more expressive phases of ancient art, especially the Antonine and Severan baroque. Although critics speak of "crypto-antique" elements of the pulpits, noting elements of a "medieval revival," these monuments are saturated with a rich repertory of motifs from classical antiquity. Even in terms of Quattrocento humanism rather than Cinquecento scholarship, Donatello's choice of ancient sources is pedestrian. He uses little that would not have appealed to Nicolo Pisano, and departs no further from sarcophagi, architec-

tural reliefs, and Roman statuary as sources than does the Apulian master. What ranks Donatello among the immortals is the vivid force extracted from each class of ancient monument and made to live in personal creativity. The sole concern of his work is the part that antiquity played in realization of incisive genius.

Renaissance Painting

MASACCIO

Around 1425, Tommaso di Ser Giovanni di Mone (about 1401–1428), more familiar as Masaccio, painted *The Tribute Money* in the Florentine church of S. Maria del Carmine (figure 34). Masaccio is the first artist since late antiquity to master the meaning of volume, lighting, and atmospheric perspective in painting, and this fresco is his masterpiece.[40] It is also a masterpiece of absorbed classical style and of borrowings from specific ancient works of art integrated into a unified whole. Masaccio had ample opportunity to observe the early collections of ancient art in Florence, but the compositional basis of *The Tribute Money* is derived from close study of the fifth-century mosaics in S. Maria Maggiore, during a visit to Rome. These mosaics were the largest body of ancient painting in the Hellenistic-Antonine illusionistic style available to an artist of the early Quattrocento.

The Tribute Money employs the same devices of continuous narration found in the mosaics. St. Peter appears three times: Christ singles him out from the Twelve Apostles to collect the money from the mouth of the fish; this Peter does in the scene at the left rear; and at the right front he turns the money over to the publican (who thus also appears twice). This use of continuous narration recalls the double appearance of Abraham in the mosaic of the

Three Angels (also at San Vitale in Ravenna). Abraham directs Sarah in the kitchen and hands the loaves to the angels at an outdoor table. In *The Charge to the Apostles* of S. Maria Maggiore, Masaccio found the classical costumes expressed in broad masses of folds, the gestures of Christ and St. Peter, and the type of trees filling the background.[41] The debt to Giotto and a Trecento master such as Ambrogio Lorenzetti is evident in the porticoed, pavilioned building filling the right rear. But the most startling connection between *The Tribute Money* and the S. Maria Maggiore mosaics is in the face and expression of St. Peter, who is the same person in both, with full head of white hair and a bushy, round beard. In fairness to any tendencies to make overenthusiastic connections between Renaissance art and ancient sources, it should be noted that St. Peter of this general type turns up in Trecento painting, for example in the panel by Andrea Vanni of Siena (about 1332–1414) now in Boston.[42] But comparisons indicate that Masaccio went past medieval intermediaries directly to the late antique iconography of S. Maria Maggiore for his likeness of the Prince of the Apostles. In studying the mosaics the artist was not unaware of the early medieval bronze statue of Saint Peter in the Vatican Basilica which has always been a principal object of veneration.

The same antique model has been used for the head of the young St. John on Christ's immediate right and for the youthful Apostle seen over the publican's right shoulder. Both are marked by hair brushed forward and down at the sides and by low, sloping foreheads; they stand out radically from every other head in the group. The prototype is an ideal head of the fourth century B.C. The malformation of proportions is neither Greek, Roman, nor an invention of Masaccio. It is Etruscan, and Ma-saccio used an Etruscan terra-cotta head from a cinerary chest as his model. Countless parallels exist in Florence's Museo Archeologico and in other museums.[43] Since these cineraria are found in greatest numbers in Tuscany, examples were available in the city in Masaccio's time. The Apostle between Christ and the tax collector has the face of a Greco-Roman head of Socrates. The young Apostle directly behind St. Peter also has a classical face; his head has the heroic twist and generalized features of a Julio-Claudian portrait made in the Greek islands or western Asia Minor.[44]

Other borrowings are absorbed with no less ease in the few other works identified as from Masaccio's hand. There is the Hellenistic philosopher's pose used for the fashionable youth in the right foreground of the *Adoration of the Magi* in Berlin. The youth wears his cloak as the Lateran Sophocles wears his himation. Masaccio is to painting what Ghiberti, Brunelleschi, and Donatello are to sculpture, in that he led artistic interest in classical antiquity from the realm of the casual to that of the productively scientific.

PIERO DELLA FRANCESCA

There is a notable contrast between those artists who absorb a degree of antiquity and those who excerpt it in decorative fashion. In the category of painting infused with antiquity stand the monumental figures of Piero della Francesca (1410/20–1492).[45] In the full, direct simplicity of the *Baptism of Christ* in London a borrowing is evident in the figure of Christ in the center (figure 35). The figure is taken from an antique torso, one evidently missing its legs since the body is heavier and much more like a Polykleitan work than the legs which Piero has had to invent for the figure. The Roman copy in Boston of an athletic figure of the school of

Polykleitos illustrates the type (figure 36).[46] Christ's hands and arms pointing together in prayer conceal the fact that Piero has caught the Polykleitan twist of the body from right to left, a turning that is very visible in the Roman marble. The drapery provides the point of transition to the almost-spindly legs. The trio of angels at the left are studies in antique drapery. The one in the center of the trio has the pose and costume of some youthful charioteer, a type of Greco-Roman marble which can be seen in a number of old Italian collections from the Vatican to Venice. The world of revived classicism and the Medieval continuity of ancient Rome are contrasted at the right, behind John the Baptist, where Byzantine magistrates stand in conversation beyond the man pulling off his shirt.

The fragment of a fresco from Casa Graziani at Borgo San Sepolcro, now in the Gardner Museum in Boston, can be related to the *Baptism of Christ*. *Herakles* stands with his left hand on his hip and club in his lowered, extended right hand. The lion's skin is knotted around the neck and drawn into another knot at the groin.[47] Again the model is a Greco-Roman torso, to which a Renaissance head has been added. The ancient source is one of the mirror reversals of the Farnese Hercules, in which the left instead of the right hand held the apples of the Hesperides on the hip.[48] Mirror reversals of Greek statuary were not produced by the copyists until the age of Pasiteles (about 50 B.C.); they are met frequently in work produced under the Roman Empire.[49] Piero had access to some mutilated statue of this class. In *Herakles* he caught something of the elongated torso in slight *contrapposto* of the Lysippic original, and his handling of color and surfaces shows much of the marble quality of the Roman copy.

In the *Flagellation* in Urbino, a curious excerpting shines forth amid classical architectural perspective at the left and Renaissance perspective at the right.[50] The gilded "Pagan idol" on the column to which Christ is bound is an excellent transcription of a Greek fourth-century Hermes. The parallel to the bronze youth from Antikythera, in Athens, is almost startling.[51] When a Greek statue was needed, an artist working about 1460 could rise to new pinnacles of careful transcription. If the scene is an allegory of Constantinople's fall, as has been suggested, the "idol" recalls the old imperial capital with unexpected accuracy. The picture may commemorate one of the Councils held to deal with the Turkish conquests; the triad of intellectuals filling the scene in the right foreground remains unidentified, thus the full implications of the composition remain cloaked in speculation. The architectural detail is strikingly lucid and precise, from the Augustan moldings of the doorways to the minutely delineated composite capitals supporting the coffered ceiling. This wealth of classical detail is drawn with such delicacy as to have an almost Gothic air of lightness. What might have been no more than an essay in humanistic perspective becomes a delightfully subtle foil for the somewhat heavy, dignified, and richly robed humans crowding the picture plane, the trio of intellectuals at the right foreground.

The fresco cycles at Arezzo contain a few direct borrowings. The *Death of Adam* manifests a sarcophagus or decorative relief-like arrangement of figures.[52] A figure from a deathbed scene or a battle sarcophagus, like those borrowed by Donatello and the Trecento artists in Giotto's tradition, is seen in the center, with arms outstretched. The nude at the right, viewed from the back and leaning on a staff, seems to have been taken from an Endymion sarcophagus, from the herdsman on the short side or end, or

from a Hellenistic decorative relief of a resting philosopher, such as the bronze "Socrates and Aspasia" in Naples.[53] Similar figures occur in the background of paintings by Signorelli, in Renaissance bronzes, and in their ancient prototypes. A Greco-Roman bronze, perhaps one of the miniatures of the Farnese Hercules type, also may have been in Piero's mind when he planned this aspect of the composition. The chlamys-clad man behind Adam, as he sits near death, takes stance and costume from a statue of Hadrian widely viewed in Rome during the Renaissance. The startling concentration of nudity in this scene may be explained not only in the notion of great old age and creative rebirth in the demise of Adam but in the artist's belief that nudity best expressed antiquity. To an artist like Piero this meant classical antiquity.

As with many of his contemporaries, things in Piero's compositions that might be called "classical" are really handed down from the Middle Ages. Such is the case with poses of the figures in the *Resurrection* in Borgo San Sepolcro. The reclining figure of the sleeping soldier in the right foreground, however, looks like the Amazons and warriors scattered about in the lowest registers of Amazon or battle sarcophagi, or the inevitable Oceanus, placed beneath the moving figures and seen from the back, on Rape of Proserpina and similar sarcophagi.[54] The soldier in the left foreground also derives ultimately from Roman art, no doubt through the intermediary of Italian painting after Giotto. Seated, bent forward with his head in his hands, he is the barbarian found so often beneath trophies in Roman state relief, on sarcophagi, and on coins going back to the late Republic. The soldiers' armor has that touch of medievalism, amid calm and monumental composition of the figures, which marks the frescoes in Arezzo. A cuirass with its leather tabs (*pteryges*) and straps

can look Hellenistic in concept, but brightly colored socks and imaginative helmets based on those of late antiquity cast a spell of mystic power unthinkable in any work of Greek or Roman relief. It is only in going over this fresco detail by detail that the spectator becomes conscious of the SPQR, partly hidden, on the long red shield of the second soldier from the right. Finally, the landscape is an almost anticlassical contrast to Christ, the tomb, and the soldiers in its suggestion of the carpeted setting of an illuminated manuscript.

The most direct classical borrowings have been assigned to Piero's painted architecture. In his figures and many of his landscapes, however, soberly rich colors, simply draped poses, and noble, Hellenistic faces give his painting a classicism not dependent on mere borrowings or excerptings. Although the ancient statues and reliefs used in Piero's compositions differ little from those in the repertory of Quattrocento contemporaries, the resulting classicism is generally more Greek than Roman in spirit. Single figures and groups of several figures within a larger scene have the meditative dignity, the serene withdrawal of Attic grave reliefs in the late fifth century. Even the battle scenes at Arezzo exude a simple grandeur which gives them a spiritual union with the great military compositions of Greek fourth century and early Hellenistic painting. Piero's painting of drapery in vivid sculptural passages, set off by rational highlights and shadows, is a consistent theme of his individual brand of Pheidian classicism. The folds of his garments are always grand, never consciously affected even when they are anatomically inaccurate; while they have little to do with direct copying of Pheidian statues and reliefs, these folds would have been applauded by sculptors in the Pheidian circle. Without sacrificing his humanistic inquisitiveness, his

unaffected charm, and his almost mystic simplicity, Piero is an Olympian in the Athenian sense in an age when so many of his contemporaries were opening the doors of art on vistas in every progressive direction.

BOTTICELLI

Sandro Botticelli (1445–1510) was a compellingly individual artist in his approach to the basic Quattrocento problems of the human figure in action, of the telling of a good tale, and of the setting of these elements in natural or architectural landscape. At the same time he was the chief representative of a class of Quattrocento painters and sculptors who absorbed and exploited the bizarre delicacy, the well-ordered mannerisms of Neo-Attic art.[55] He has been termed an artist who painted in a system of critical intellect as opposed to the classical ideal of ancient models and motifs.[56] However much he seems to fuse classical disciplines with Gothic Christianity, however much he appears a painter of poetic formalism and controlled concepts, Botticelli cast the same aura of vague beauty and intangible perfection over the senses of his spectators that modern critics occasionally find in Neo-Attic paintings of the Pompeian Second Style. He was as much a classicist as the masters of repeated excerptings or the artists who painted as if they were turning Aurelian state and triumphal reliefs into monumental (two-dimensional) frescoes. Like that of Piero della Francesca, Botticelli's classicism rises above the principal stream in the line of Renaissance development, the secondhand classicism of the Roman second century.

Botticelli's most "classical" paintings are the *Primavera* (about 1478), the *Birth of Venus* (about 1485), the so-called *Lorenzo Tornabuoni and the Liberal Arts* (1486), the pendant known traditionally as *Giovanna degli Albizzi and the Cardinal Virtues* (1486) (figure 37), and the *Calumny of Apelles* (about 1494). In the *Tragedy of Lucretia* (after 1500), he could blend a "classical" relief and suggestions of the Arch of Constantine.

In the *Primavera,* to use the shortened name for the allegory, the arrangement of relief and trees is very much that of the Neo-Attic Eleusinian and Horae bases in the Villa Torlonia-Albani, represented in the drawn-out development in which they would have been sketched by a Quattrocento artist. Numerous drawings from 1500 on show these bases in this fashion. The putto or Eros overhead ("Blind Amor") is the most literally classical figure in all Botticelli's work; his ancient counterpart exists in Endymion sarcophagi and in a relief (fragment) walled up in the garden façade of the Villa Medici in Rome.[57] The tenets of Neo-Attic grace in Botticelli's work—delicate balancing of sculptural volume and calligraphic detail—are perfectly defined in the costuming of the Hora at the immediate right and the Three Graces at the left, a thoroughly independent group. Their pose and silhouettes are hallmarks of the artist's individuality.

Aside from the general inspiration of the composition, Venus herself and the figure at the right, again one of the Horae or nymphs, can be singled out as the most classical. The Venus is Botticelli's homage to a figure such as the Medici Venus in the Tribuna of the Uffizi, a work probably going back to a lost original by Skopas or Lysippos.[58] Her attendant is a late Quattrocento interpretation of a typical Neo-Attic Hora. So, too, in the Tornabuoni fresco of Giovanna and the Virtues, actually a scene of Venus-Humanitas introducing the bride to the Three Graces, reworkings and reversal of the late Hellenistic to Roman Hora or maenad compositions form the basis of the design (figure 38). Venus and the

Graces are free mirror images of the familiar Neo-Attic composition, Horae tripping along clutching their own and each other's draperies and tilting their heads back at angles which Botticelli found pleasing to his own style. Other than these general aspects of composition, the chief debt to the antique lies in the inspiration of linear, whirling drapery and the clear delineation of flattened silhouettes, aspects which emerge as measures of Botticelli's creative imagination in the *Primavera*. The little Eros in the right foreground has stepped off a second-century Attic sarcophagus; he has been thoroughly endowed with the artist's personality, however. In the pendant fresco, Lorenzo faces the Liberal Arts and is led to them by Venus as if he were a prince approaching a group of gods in a late antique manuscript.[59] Or, the Liberal Arts can be likened to a group of Apostles in a fifth-century apsidal mosaic, such as Sta. Pudenziana in Rome.[60]

It is very difficult to isolate classical details in the *Apelles*, the most openly antiquarian of Botticelli's surviving works. The figures in the niches suggest the statues of Or San Michele; they seem to be a consciously selected balance of classical, medieval, and Renaissance types. The reliefs on the bases are imbued with medieval Northern European mysticism. Bacchic motifs with Pans, sileni, and satyrs predominate; Nereids on sea beasts and Erotes in various scenes are also suggested. Everything is shrouded in a golden coloring of elongated, shadowy vagueness. Sarcophagi, some also Bacchic, and the reliefs of the Column of Marcus Aurelius have inspired the friezes on top. The over-all tone of the poses in the principal figures and groups is classical in the sense that a Roman military sarcophagus can show extremely Praxitelean passages in a scene otherwise worked out in terms of monumental Hellenistic painting.

MANTEGNA

The great antiquarian of the second half of the Quattrocento was the Northern Italian painter Andrea Mantegna (about 1431–1506).[61] He was a product of Venice, a city long oriented toward Greece and the classical world, and Padua, where the supposed discovery of Livy's bones in 1413 climaxed the intellectual antiquarianism of Francesco II and his circle. He undoubtedly met Donatello (since in 1443 the latter came to Padua for a decade) and therefore had access to the intellectual society in which that sculptor moved. He knew the early archaeologists who were collecting material which artists were to use in interpreting visually the literary climate produced by this conditioning.

The earliest and perhaps best-known among the Quattrocento investigators of ancient monuments and, in particular, of their inscriptions was Ciriaco d'Ancona (about 1391–about 1457). His travels through the dying Byzantine Empire were the most memorable aspects of an energetic, varied career. Mantegna had access to his work through Felice Feliciano of Verona, who carried on his collection of inscriptions. The physician Marcanova, whose manuscripts were prized almost as much as Cyriac's, was another close friend. The influence of these circles on Mantegna's work was profound and of long duration.[62]

Mantegna's painting is characterized by a broadly antiquarian style, a somewhat fussy one amid powerful physical forms. He uses freely the compositional techniques and organizational systems as well as the props of antiquity; strong perspectives and marblelike grisaille characterize his work. He represents the new humanism, not just a thorough mastery of a mass of ancient material. If anything, ancient architecture interests

him most; he is a painter many of whose great commissions were wall frescoes strongly related to architectural settings.

When Mantegna worked in the Ovetari Chapel of the Eremitani Church in Padua in the years after the middle of the century, he had the immediate model of Ansuino da Forlì's *Sermon of St. Christopher* before him. Ansuino introduced the motif of a Greek pulling an Amazon from her horse as a relief in the scene. The design, going back to the Bassae frieze, was taken from an Amazon sarcophagus, a lamp, or a Greco-Roman gem.[63] Few sculptures painted in Mantegna's work are so stridently classical, but Ansuino's excerpting was one more precedent for Mantegna's borrowings from antiquity.

The *Trial of St. James before Herod Agrippa* has been restudied of late in connection with excessive scholarly enthusiasm for attributing compositions and motifs in Mantegna to classical sources (figure 39).[64] There is no doubt that Mantegna, working far from the great centers of antique ruins, relied on eclectic and basically numismatic sources. Although he had access to a wide range of classical visual material, he was an artist of the Quattrocento, and it has been suggested that nothing should be classified as antique in immediate derivation that cannot be accounted for in other terms. Just as classical influences can be overstressed, so they can seem to be deëmphasized by speaking of the Byzantine and Early Christian conditioning of Mantegna's approach to his world of classical forms. He was thoroughly steeped in several forms of classicism, ancient and medieval.

The hagiographic theme of the works and passion of St. James Major was condensed from the *Legenda Aurea,* with bows to the Trecento cycle by Altichiero and Avanzo for the Chapel of St. Felix in the Santo.[65] The Petrarchian so-called Twelve Caesars murals (1367–1379) for the Sala Virorum Illustrium of the Palazzo della Ragione in Padua added a neighborhood ingredient of costume, based to a large extent on numismatic iconography.[66] This lingers on in the frequent use by Mantegna of medieval costume and armor, and Giottesque pavilionlike stage props. But it would be going too far to say that Mantegna disregarded the formal aspects of classical antiquarianism. Like other artists, his progressive development led him from an enthusiastic, almost naïve, antiquarianism to an understanding and partial rejection of antiquity, and finally to an overly professional classicism.

Sober classical space and architecture dominate the scene of the *Trial of St. James.* The Arch of Constantine in the background is one of the many Renaissance versions in which it is a free synthesis of all three surviving imperial arches in or near the Campo Vaccino: the Arch of Constantine, the Arch of Titus, and the Arch of Septimius Severus.[67] In Mantegna's trial scene, it is difficult to deny the influence of the Aurelian submission panel or allied aes reverses of the period from Trajan to Septimius Severus. The draperies are based on studies of ancient marbles, but the armor is that of Renaissance festive pageantry, a contemporary version of antiquarianism.[68]

In *St. James going to Execution,* the armor continues its half-correct, half-theatrical antiquarianism; Venice no doubt supplied the Turkish sword to the soldier marveling at St. James's piety. The arch through which the procession moves has a number of cleverly excerpted classical motifs integrated into its fussy sobriety. The side of an altar to Isis-Fortuna, with clypeus, bears (on the latter) the inscription: L VITRVVIVS CERDO ARCHITETVS, the signature on the Arco dei Gavi in Verona. (Mantegna may have thought the inscription referred to the famous Vitruvius Pollio.) The frieze below the lower attic

entablature is a storehouse of borrowings from antiquity: reclining sileni from a sarcophagus lid; a free version of the Rondanini sarcophagus with putti harvesting olives or grapes;[69] the front of a grave altar in the Uffizi;[70] and, at the extreme right, a section from a Bacchic centaur sarcophagus known from old drawings and now preserved only in a fragment in Sir John Soane's Museum in London.[71] In an earlier episode St. James uses a Greek or Italic oenochoe to baptize Hermogenes; another such vase appears among the crockery on the shelf under the small arch behind the scene.

Architecture and excerptings of sculpture dominate other frescoes by Mantegna and his contemporaries in the chapel. In the *Martyrdom of St. James,* antiquarianism centers on the formal, Renaissance organization of the composition and on minute treatment of ruins in the right middle ground and bottom of the hillside at the rear. The building at the right is a precise rendering of the cella of a Hellenistic temple, or of part of the Basilica Julia in the Roman Forum.[72] The complex of ruins at the foot of the fortified hill in the left background recalls the Arch of Drusus and the substructures of the Baths of Caracalla, with the little church of SS. Nereo e Acilleo at the right. Mantegna's feeling for antiquarian details in his ruins is so carefully thought out as to indicate knowledge of the best Quattrocento architectural drawings, not just the semi-phantasies of epigraphers and historians. He undoubtedly knew these Roman monuments from firsthand observation and from later study of his own notes made on the spot.

In the *Martyrdom of St. Christopher* and the pendent *Burial of St. Christopher,* amid an ordered mixture of Renaissance architecture and classical ruins, the structure in the rear center is made up of reminiscences of antiquities sketched in Rome. It is not difficult to pick out the sea monster and anthemion frieze in the Antiquarium of the Roman Forum and elsewhere, from the area of the Basilica Aemilia and the Juturna Fountain behind the Basilica Julia;[73] a pair of early imperial funerary reliefs with busts of the deceased;[74] and a recollection of the Tomb of the Baker outside the Porta Maggiore, in the seven holes surrounding the busts. Since these holes were designed by the architect of the early imperial tomb to suggest the baker's ovens, they are meaningless in Mantegna's painted architecture.[75]

An absorbing interest in the ancient world shines forth from the paintings and cartoons which span the remainder of Mantegna's career and which are singled out as landmarks of his classicism. The Louvre and Vienna St. Sebastians are veritable catalogues of ancient fragments. The triptych with the Madonna, eight saints, and sundry angels in San Zeno at Verona is a reversion to the excerptings of Ciriaco and Marcanova. The Hampton Court Cartoons are a Renaissance triumph based on a historical theme; the *Man of Sorrows* in Copenhagen absorbs the direct forms of an ancient statue; and the *Parnassus* in Paris takes the artist as far on the road to Botticelli's Neo-Attic style as he ever went.

Mantegna's treatment of ruins and borrowings of Greco-Roman figures seems to harmonize best in the *Triumph of Virtue over the Vices,* also in Paris. Many have preferred this to the pure antiquity of the grisailles near the end of his career. Of the grisailles the *Triumph of Scipio* in London is extraordinarily and eminently successful. The *Judith* scenes in the Chapel of S. Andrea at Mantua, executed by his pupils, are perhaps the just targets of the charges of overantiquarianism leveled at Mantegna. These examples of mythological and historical compositions dwell heavily on one side of Mantegna's

work; his Madonnas are another side of his pro-
duction, one in which classicism is more a matter
of form and costume. It is doubtful if the more
sophisticated classicism of the High Renaissance
in Venice (and even in Florence or Rome) would
have taken the form it did without the progres-
sive contributions made by Mantegna.

The *St. Sebastian* in Paris, carried out in al-
most grisaille tones, is a catalogue of precisely
arranged and drawn classical details. The saint
has a classically constructed torso, with a head
typical of Mantegna, Renaissance drapery about
the body, and Renaissance limbs. He stands
against a section of the Basilica Julia in the
Roman Forum; the foot of a marble statue of a
togate Roman lies at the left and a soffit block
beyond. A vista through the Arch of the Argen-
tarii at the left is matched by the Arch of Con-
stantine (with superstructure) in the right rear
and the ruins of the Library of Augustus to the
right. The landscape recalls the Italian hill
towns. The picture as a whole is a paraphrase of
a journey to and from Rome on the part of the
artist as well as a concentration of ruins visible
in the area of the Forum, based on San Gallo
sketchbooks or perhaps on personal remem-
brances. Inscriptions are even built into the cur-
tain walls of the ruins in the right center.[76] The
Vienna *St. Sebastian,* painted over a decade ear-
lier, contains a further collection of obtrusive
antiquarianism: a sarcophagus fragment with
reveling putti at the left, ancient heads and
feet, and the Basilica Julia with the Arch of
Septimius Severus as the Saint's column. The
work is signed in Greek: To Ergon tou Andreou,
The Work of Andrea.[77]

In the left and right wings of the triptych in San
Zeno at Verona, coin reverses, gems, sarcophagi,
and statues have provided the sources for the
circular medallions on the pillars or pilasters of
the hall in which the principals and the music-
making angels or Amorini appear. The recog-
nizable numismatic types include the Decursio
sestertii of Nero; the Victoria erecting a trophy
of Agathokles or Lucius Verus; and the Adventus
Augusti province series of Hadrian. The Nereid
on a triton tondo is based on a gem, or perhaps on
the detail of some stucco ceiling. In the central
panel there is less antiquarianism, as with all
Mantegna's portrayals of the Madonna. But
reversed-torch putti appear in the frieze above,
and there are tondi with Neo-Attic reliefs (a
horse-tamer and a Lapith battling a centaur).[78]
The large garlands, recalling those in the Ovetari
Chapel, are echoed in this frieze of Amorini
above the pilasters, a frieze made up of motifs
from Roman sarcophagi. The panels of the
predella are singularly devoid of antiquarian
tendencies, although the *Crucifixion* and the
Agony in the Garden treat the viewer to the hill-
town reconstructions of ancient Rome which
Mantegna loved to include.

A synthesis of the classical themes assembled
in the decorative details of the Ovetari Chapel
and the San Zeno altar came about in the frescoes
of the flat ceiling of the Camera degli Sposi in
Mantua. These frescoes, revolving around the
celebrated painted tondo balcony open to the
sky to show ladies of the court and putti looking
down, imitate bas-reliefs in their sober colors
and strong feeling for the depth and shading of
carving in marble. Rosettes, fillets, ogee base
moldings, and putti standing on acanthus clus-
ters fill out the borders or support the principal
designs. These principal designs consist of shield
or medallion busts of the Eight Caesars (Julius
through Otho), scenes of the deeds of Hercules,
and episodes of the Orpheus and Arion myths.
The completion of the room is celebrated by a
tablet in good Renaissance-Roman letters, hon-
oring Lodovico Gonzaga, his consort Barbara,
and, especially, their court painter Mantegna.

The three putti supporting the plaque and those flying to hold it at the sides come directly from several ancient reliefs known to the artist, including the Amorini flanking an elaborate throne "of Poseidon" before a colonnade of pilasters in San Vitale at Ravenna.[79] A Bacchic altar once in the church of San Zeno at Verona and later in the Museo Maffeiano has contributed further details.

In the mythological scenes, fitted in as triangular areas above the painted lunettes, the figures stand out in their neutral colors as reliefs against unusual backgrounds of little squares, designed to suggest the tesserae of mosaics. Roman state and funerary reliefs provided Mantegna's mythological iconography for the Hercules cycle and the Orpheus and Arion episodes. Expressions and proportions in the figures, however, are peculiar to his developed Quattrocento style, especially to his drawings and the resulting engravings. Unknown to Mantegna, a remarkable coincidence exists in that the fourth-century mosaics at Piazza Armerina contain the deeds of Hercules and the musicians Arion and Orpheus as principal mythological subjects.

The busts of the Caesars also have "mosaic" backgrounds. The tondo frames, surrounded by elaborate wreaths (the civic crowns of antiquity), imitate classical waterleaf molding to perfection, and the identifying inscriptions are in the best Trajanic lettering. The portraits of Tiberius, Nero, and Galba master the iconographic information supplied by the Roman imperial coins which the artist studied so carefully. Illustration of armor always allowed Mantegna to make elaborate mixtures from antiquity and contemporary manufacture in the Renaissance spirit of antiquity. The cuirasses of the Mantua Caesars are no exception, as careful observation of a Hadrianic bust (Julius Caesar) is set against something which only the Gonzagas could have worn (Caligula) or a breastplate which can only have stemmed from the artist's pen (Otho).

The Gonzaga family scenes on the side walls, with their echoes of classical details on the painted architecture between and behind the figures, have long been recognized as landmarks of monumental secular decoration in the age of new humanism. The ceiling has been praised for its daring perspective and for its success in converting a potentially dull piece of architecture into a room of boundless iconographic impact and vertical imagination. Mantegna deserves full credit for the way he applied his lessons from antiquity to a decorative program expressing carefully, thoughtfully, and not too blatantly the quintessence of Renaissance humanism. His uses of antiquity are as eclectic as always, but the borrowings are dominated throughout by the personalities of Lodovico Gonzaga, his large family, his court, and his hunting dogs. Mantegna's success as a Renaissance classicist lies in the fact that the room holds together as a unit in which the decorations play no more than their natural part.

Cartoons for the Triumph of Caesar

Mantegna's cartoons for the *Triumph of Caesar,* now in the Orangery at Hampton Court Palace, were one of the great essays of antiquity's survival in western European painting. The ground from which they sprang had been well cultivated by Marcanova who wrote treatises on the honors, triumphs, and military affairs of the ancient Romans. Mantegna's own collection of antiquities can be added to this. When he needed money during a plague, he was forced to sell his "favorite bust of Faustina." This is probably the bust which appears with city-tyche crown in the second part of the Hampton Court cartoons and which is Cybele in the *Triumph of Scipio.* In both cases the features are very like coin-portraits

of the younger Faustina. The possession of a bust, perhaps of an empress and certainly of a Cybele-Tyche, must have influenced Mantegna's choice of subjects. Although only an incidental detail in the *Triumph of Caesar,* it is the center of the *Triumph of Scipio.*[80]

The *Triumph of Caesar* is one of the least classically handled of Mantegna's classical subjects. The theme demands as much Romanization as the earlier Eremitani frescoes or the later *Triumph of Scipio* (figure 2). Although the subject conjures up a mixture of classical learning and Renaissance showmanship, the sum of the details weighs on the side of a Renaissance display rather than an archaeological revisualization of a Roman triumph. The forms of Livy's descriptions of Roman Republican triumphs are followed, but an almost medieval host of imaginative detail clutters the scenes, owing more to Marcanova or Quattrocento Venice than to classicism.[81] This is unlike the *Triumph of Scipio,* which follows not only classical coloring and organization but even the technique of viewing the composition from below, as if the viewer were looking at the frieze above the small arches on the Arch of Septimius Severus or at the attic of the Arch of Constantine.[82]

The nine large pictures of the *Triumph of Caesar* were painted to adorn a palace or theater wall in Mantua. Mantegna contemplated at least one additional part, for the scene of the scribes and soldiers following Caesar's cart is known only from a copper engraving after his drawing. The pictures were designed to be mounted as a series of scenes separated by pilasters, to give the effect of a procession moving in front of a loggia or colonnade. However elaborate the costumes and however fanciful the armor, trophies, candelabra, and other details, the form of a Roman triumph has been captured in admirable fashion.

In the first part or scene, trumpeteers, standard-bearers, and the legionaries carrying paintings of captured cities announce the procession. The scene quickly shifts to one in which the major booty is introduced (figure 40): a statue of a barbarian ruler on a cart, a model of a large building, siege machinery, a small shrine, and images of divinities are carried. The next two scenes display the spears, shields, helmets, cuirasses, and metal utensils taken during the campaigns. In the right half of the fourth scene, long trumpets and a bull led to sacrifice portend a new level of excitement.

The fifth scene is filled with elephants who bear mahouts and lighted candelabra on their backs. The tag end of the group with trumpets and another bull attended by a camillus and a *victimarius* link the elephants with what has gone before. In the sixth scene the elephants are followed by more metal vessels on a *ferculum* and more armor on long poles. This is probably Caesar's personal booty. Captives of all ages and sizes, court dwarfs and hangers-on, and Caesar's personal standard-bearers fill the two scenes immediately before the triumphator's cart, in the ninth part. Here the togate Caesar is enthroned on a curule chair, and a youth with artificial wings takes the part of Victoria, holding up a wreath behind him. The most absurdly Renaissance touch is provided by three delightful putti with olive branches, frolicking beneath the horses pulling Caesar's cart. Throughout the scenes, glimpses of sky, hilly landscape, and various buildings or ruins give an additional sense of unity and continuity.

In the First part Livy's descriptions of the triumphs of Scipio and the end of the Carthaginian Wars are used to illustrate the ancient Roman habit of showing paintings at a triumph. Small canvases with scenes of siege and battle are being carried by soldiers, amid the legionary standards. The armor sets the tone of the whole

series of cartoons, by being Roman only in flavor, not in any specific detail. The Second part contains the Faustina; it has been turned into a Tyche with the whole city wall and Castel Sant'Angelo on top of the head. The Castel Sant'Angelo motif is repeated as a building in the background, replete with the square base now known chiefly through the San Gallo drawings.[83] The captive standing on the cart at the left is taken from one of the Dacians on the Arch of Constantine. The siege machinery, as might be expected, is quite archaeologically correct, being modeled after that on the columns of Trajan and Marcus Aurelius.

The Third part combines, on the surface of a pelta-shaped shield, two unrelated scenes of Neo-Attic type, compositions which must have been considered exotic in the repertory of artists working in the last decades of the Quattrocento. An abduction scene is matched on the right by the now well-known group of the Tyrannicides, transformed into a pair of satyrs. Neo-Attic art preserved the Tyrannicides on marble thrones, on lamps, gems, and elsewhere.[84] On the *ferculum* at the right, the spectator's attention turns to a partial view of a Neo-Attic marble krater. There is a garland above and at least one figure below. Of the many metal vases shown throughout all the parts, none gives evidence of being directly copied from antiquity and none even has a classical shape.

Specific archaeological details can be picked out in the remaining six parts, and in the copper engraving after the projected tenth part. Throughout, the general feeling for friezelike composition and recessive planes of figures owes its inspiration to the Column of Trajan. The Fourth part contains a symphonic contrast of metallic vases, landscape, Roman ruins, humans with burdens, and a placid bull escorted by a camillus whose costume was designed in the Augustan age. The first penetrating observation of the contrasts of Roman state costume in Western European art is found in this camillus and in the older men with their precious but weighty charges. Mantegna practiced the exacting skill of illuminating manuscripts, and this precision shows in his choice of lettering for the slender banners beneath the trumpets transversing the rising landscape in this scene. The two cuirasses on poles in the Sixth part (The Corselet Bearers) are of Hellenistic rather than Roman type with simple, molded breastplates and short, rectangular rows of straps or *pteryges*. When a similar Greek cuirass appears in Titian's *Presentation of the Virgin* in Venice, the coincidence suggests that Greek sculpture brought from the East by Venetian collectors may have provided the source from which these cuirasses in Mantegna's painting ultimately derive. Renaissance artists generally copied the much more elaborate Roman imperial armor of the Antonine age, for cuirassed statues of this type were prevalent in Italy.

In the Eighth part, the general borrowing from state reliefs such as the Column of Trajan is narrowed to a Trajanic *Adlocutio* scene. A signifer or standard bearer, the grouping of standards, and the figure at the right, seen from the back, are all taken from one of the views of Trajan addressing the legions on his Column in Rome. In the Fifth and Seventh parts, the copper engravings and copies after preparatory drawings show the archaeological detail better. The bull led to sacrifice comes from the Mantua sarcophagus of a Roman official[85] and from the Aurelian triumphal relief, Marcus Aurelius before the Capitol, known in Rome throughout the Middle Ages. The host of Roman candelabra in the background have lost their detail and, consequently, much of their classical character in the various repaintings of later ages. Engrav-

ings and woodcuts have preserved all the rich detail of this ritual equipment. These candelabra have been recognized as misunderstandings of the fasces carried by the lictors in the background of the triumphator relief of the Arch of Titus, an error perpetuated as late as Giovannantonio Dosio in the middle of the following century. Mantegna embroidered the misunderstanding in his unique archaeological imaginativeness.

Can the left half of the procession of figures in the latter scene, the Seventh part, be based on one of the Medici slabs of the Ara Pacis Augustae, or the Ara Pietatis Augustae? Did Mantegna see these reliefs before the cartoon was finished, in 1492 or early 1493 at the latest? The tradition that the reliefs were not found until the first decade of the following century is not a firm one.[86] At any rate, the finished product is a more mature and monumental recording of a triumphal painting or procession than anything created heretofore in the cartoons—or in Renaissance painting in general.

Anyone viewing a procession such as Mantegna's *Triumph of Caesar* would naturally look toward the *carpentum* bearing the triumphator. Mantegna followed the canon of antiquity in saving this subject for the climax of his composition, his Ninth part. The scene is a veritable apotheosis of observations from scattered ancient works of art gathered within a Roman imperial framework enlivened by the artist's rich imagination and mystic love of detail. The frieze above the entablature filling the background shows understanding of a number of Roman imperial sources: the remains of the small procession on the Arch of Titus give a clue to what Mantegna might have drawn from the other side or the end blocks of this frieze in the late Quattrocento; the frieze of Domitian's *Aula Regia* on the Palatine included captives beneath trophies and

Victoriae slaying bulls. The plaque on the *carpentum* below Caesar is really a giant sardonyx cameo with three divinities enthroned (Tyche-Fortuna at the right).

There is a suggestion of greater accuracy in the armor of the legionary at the extreme left (correctly, the right) in the projected Tenth part, known only from a copper engraving.[87] He wears a plain cuirass, based on the figures on the columns of Trajan or Marcus Aurelius. In the Tenth part, the debt to Roman relief in overlapping planes is evident, and the architecture is one with the mood of the nine cartoons: as seen in the reversed engraving, a Marcanova version of Castel Sant'Angelo appears to the left of the Bramante palazzo (at the right).

The *Triumph of Caesar* has been repainted heavily since Mantegna carried out his program. La Guère went over the canvases completely in the late seventeenth century, and as recently as the 1920's Paul Nash repainted the first section (*The Picture Bearers*), under the direction of the critic Roger Fry. Critics, therefore, have to be careful not to underestimate the quaint, late Quattrocento quality which Mantegna originally imparted to a work so Roman in scope and spirit. The canvases were intended as decorations in a theater or open courtyard, and nowadays the viewer has to strain the imagination to see the sweep of color which gave the procession a lively warmth perfectly at home in Mantua of 1490 or Rome of 150 B.C.

High Renaissance qualities but few specific classical details are present in the large altarpieces and other religious pictures of Mantegna's last period. The *Man of Sorrows* in Copenhagen is an exception. The body, and the drapery without the arms and the cloth that falls down on the plinth at the left and right, are taken from the Villa Madama Zeus (figure 4).[88] The

sculptural quality of the ancient torso is evident, and the painting indicates Mantegna's wide acquaintance with various surviving sculptures in the round.

Two works in the Louvre, the *Parnassus* and the *Triumph of Virtue over the Vices*, make a spiritual pair. They were painted for Isabella d'Este's studio, a room in the Gonzaga palace at Mantua which the young princess made into a picture gallery and museum. In the former, Mantegna does not abandon his love of craggy landscape—his hill forts and bits of ruin. The motifs for the figures are quite Renaissance, almost like Botticelli, but in one or two cases details from Bacchic sarcophagi can be observed. The dancing Muses are Bacchic or, more precisely, Neo-Attic in rhythm. Their inspiration is contained in some marble relief such as the Borghese Dancers in the Louvre. The *Parnassus* shows a group of five maidens, perhaps Horae or Seasons, dancing with hands linked in front of a colonnade. The central figures could come from a coin or medallion reverse, one showing an Antonine Ares and Aphrodite.[89] The calligraphically rendered satyr at the upper left middle has much in common with Elpenor on the Attic red-figured pelike in Boston.[90] The only chance for connection could be through a lost Roman wall-painting copying older motifs. It is doubtful but not impossible that Mantegna ever saw a Greek vase, although the accessories in one of the Eremitani frescoes have spoken for this notion. Sculpture provides the usual prototypes for isolated figures: Vulcan in his forge at the left center is a classical torso; the Eros to the left of the top is the Niobid kneeling as he sinks to ground.[91] The sculptural quality of the figures is brought out not in grisaille but in warmer colors than Mantegna usually uses—reds and blues and greens.

In *Triumph of Virtue over the Vices*, the ruins are larger and unify the composition, which is also quite colorful. The running Athena at the left is taken from coin-reverses of the Severi.[92] A section of Bacchic centaur sarcophagus becomes the centaur in the water. A fleeing Niobid (restored) is also used in the center. The Eros at the right rear is known first from Endymion sarcophagi, where he leads Selene to the sleeping hunter. Justice with sword and balance takes his stance from that of the draped statue of Homer, once in the Arundel collection. This unique representation of the bard standing is known only from a drawing by Rubens.[93]

The *Triumph of Scipio* (figure 2) and other works are examples of Mantegna's painting in the stringently antiquarian style and tradition. The scenes of the welcome of Cybele to Rome by P. Cornelius Scipio and the miracles of Claudia Quinta, who testified to the power of the goddess, not only use friezelike composition and coloring (and perspective from the ground) but the Tomb of Scipio on the Via Appia,[94] Mantegna's bust of Faustina-Tyche-Cybele, groups from the Los Angeles sarcophagus (figure 1) or the small friezes of the Arch of Severus, and the heads of Severan barbarians to complete the classicism for which Mantegna strove. In the *Judith* scenes in S. Andrea at Mantua, the classical drapery of Judith is balanced by Turkish or Byzantine iconography for the attendants. Such harmony of selections—from antiquity and the contemporary Levant, through Venice—was Mantegna's habit.

The Renaissance Medallion

Nothing demonstrates the creative originality of the early Renaissance so much as the medallion. In their search for the art, history, and epigraphic testimonies of the classical world, the early humanists found ample material in the countless Greek and Roman medallions and

coins preserved in Medieval treasuries or unearthed in the exploration of ancient buildings and sites. Coins were among the first antiquities to be systematically collected. The portraiture, legends, and reverse types of the Roman imperial large bronze coins and medallions presented a challenge and a stimulus to artists of the early Quattrocento, but not until the Cinquecento did Roman bronzes become objects to be imitated in minute detail rather than general measures of one of the most expressive of the minor arts.

PISANELLO

One of the first to cast large medallions in bronze, the painter Antonio Pisano (called Pisanello), remains the greatest figure in this art. With antiquity as a guide, his creative imagination produced medallions unsurpassed in every appeal.

Pisanello (about 1395–1455) worked as a painter in the International Gothic style in succession to Gentile da Fabriano in Venice and in Rome. He chose to be remembered as a painter and signed his medallions in this way.[95] His first datable portrait medallion appeared in 1438; from then on he journeyed from Venice to Naples doing portrait medallions of the rulers at various courts. He eagerly embraced the science of perspective, and his inquiring mind emerges from a set of his drawings preserved in the Vallardi Codex in the Louvre.[96] Among these are studies of ancient statues and figures from sarcophagi. He was perhaps happiest and best at drawing animals, as his medallions as well as his paintings and drawings demonstrate. His drawing of a camel in the Royal Library at Windsor is unforgettable for its minute attention to detail and its sympathetic understanding of the ungainly beast.[97]

Direct classical quotations are rare in Pisanello's medallions. His obvious debt to antiquity lies in the use of a large flan, regular lettering, separation of inscriptions from humans, animals, and landscape, and imaginative grouping of elements in the field of the reverse. This adds up to emergence of a medallic art no longer related to the medieval concept of a coin-flan as a circulating seal, a vehicle for heraldry, religious devices, and standard inscriptions. One of the great links between Pisanello's medallions and those of the Roman Empire is a return to the use of a medallic flan for commemorative purposes. Events rather than abstract devices are recognized: the visit of the Byzantine Emperor John Palaeologus to the Council of Florence in 1439; the construction of an important building; the marriage of persons of high estate. The fact that Pisanello produced his cast medallions as works of art rather than units of currency harkens back to the two centuries from Trajan to Constantine (A.D. 100–300) when a flood of commemorative medallions elevated the output of the Rome mint to an artistic level seldom seen since the Greeks in the world of the fourth century B.C.

Two of Pisanello's medallions call for detailed examination. The medallion of Leonello d'Este was made for his marriage with Maria of Aragon in April 1444 (figure 41).[98] Portrait and lettering are admirably balanced on the obverse. In terms of classical organization, the reverse is to the medallion what Ghiberti's and Brunelleschi's trial-reliefs for the Baptistery doors were to monumental sculpture. Never was a design at once so well proportioned and appealingly conceived within the limits of a circle eighty millimeters in diameter. The center is held by a singing lion, his scroll of music held before him by a Cupid, for music played a prominent part at the wed-

ding. The Este eagle on a branch in the rocky landscape at the left rear is a further allusion to the patron. A square pillar in the background exhibits the date and supports a mast with a billowing sail, reference to the maritime and overseas imperial, commercial, and family connections of the bride. There is no specific detail from the antique. Lion, eagle, and Cupid would be perfectly at home on ancient medallions. Pisanello's great preoccupation in his reverses, seen to some extent here, was in perspective and foreshortening. This is perfectly in keeping with the antique, when the comparison is made with Antonine medallions of Hercules observed from the back or elaborate scenes of imperial sacrifice before divinities in a temple or shrine.

Pisanello made a medallion of Alfonso V, king of Aragon and Sicily, probably during a visit to Naples (1448–1449). It was reserved for the more precise classicism of later centuries to show the portrait on the obverse in Roman costume or armor. Like others in Quattrocento medallions, Alfonso appears in his contemporary civil robes. The reverse commemorates the king as VENATOR INTREPIDVS (and the medalist as a painter).[99] While two hounds pin back the ears of a large boar in full charge, the young Alfonso in the classical nude leaps on his back with a knife. The setting is framed by hills to the left and right in the background. The theme is borrowed from Meleager sarcophagi and from Hellenistic reliefs with hunting scenes. The treatment is Pisanello's, the isocephalic arrangement of the classical scene being rearranged to create four layers of recessive perspective. The later history of the medallion shows that Pisanello solved nearly all the problems afforded in the latitude of a circular flan up to ninety millimeters in diameter. Others offered new subjects and new ideas from antiquity, but few successors produced medal-

lions as appealing in style, design, and subject matter as those of the first Renaissance master.

MATTEO DE'PASTI

Pisanello's tradition was continued by his fellow Veronese, Matteo de'Pasti, who died in 1467 or 1468. He was versatile, producing excellent portraits and varied reverses. His elephant is a charming blend of classical idea and Renaissance concept. His ability to represent architecture within the limits of a medallic flan made him the successor of those Roman medalists who from Nero to Alexander Severus enriched their reverse dies with the temples, bridges, triumphal arches, stadia, and fora of the imperial capital. Matteo de'Pasti's views of the fortifications of Rimini on his medallions for Sigismondo Malatesta are particularly successful in this respect.[100] The fact that these designs are carried out in very high relief is no doubt due to Matteo's success as a modeler in wax. From his time onward medalists emulated the ancients by producing not only the medallions to be cast but by carrying out the preliminary studies in wax and wood.

ADRIANO FIORENTINO

Most of the contemporary currents of style found in major sculptures and paintings can be discovered in the work of Quattrocento medalists. The late Gothic elegance transformed by Agostino di Duccio and Botticelli into a kind of Renaissance Neo-Atticism made its way onto the flans of late Quattrocento medallions. The work of Adriano Fiorentino (who died in 1499), perhaps a pupil of Bertoldo, is an example.[101] Termed a clumsy and sometimes slipshod medalist, he was nevertheless the first to show portraits with Roman Republican faces and proportions. In his reverses he distinguishes the separation of

the figure and principal area of the field from the secondary lettering of the exergue. His reverse figures are in low relief, with classical drapery in the Neo-Attic manner. He modeled a successful reverse of the Muse Urania, based on Antonine and Severan coin types in which Providentia appears to be playing handball with the orb which is her attribute.[102]

GIOVANNI ZUAN BOLDÙ

The Paduan Giovanni Zuan Boldù, who died between 1473 and 1477, executed one of the great medallions of the third quarter of the fifteenth century (figure 42). The obverse is taken from an impression of an aureus of Septimius Severus and shows the young emperor Marcus Aurelius Antoninus, better known to posterity as Caracalla. His attractive youthful features have taken on something of the qualities of one of Desiderio's children. The reverse bears the date 1466 and the legend IO SON FINE (I am the end). The artist, nude, sits with his head in his hands, and the Genius of Death, in the form of a putto, sits nearby with a skull and a flame in his left hand.[103] The arrangement of the two figures in this very personal composition is like Hellenistic mythological or allegorical groups. The design is related to a marble medallion in the façade of the Certosa at Pavia, and the young man appears with another putto in a medallion of a monument now in the Museum at Brescia.

THE "MEDALIST OF THE ROMAN EMPERORS"

One of the first medalists to copy ancient medallions and coins in a curiously verbatim way is nameless. He worked in the last quarter of the century, probably in the neighborhood of Milan, and Sir George Hill has named him the "Medalist of the Roman Emperors." His medallions are large in scale, generally half again the size of those by Pisanello. Five of the medallions

attributed to him bear out his sobriquet; they commemorate Julius Caesar, Nero, Trajan, Hadrian, and Faustina the Elder, consort of Antoninus Pius.[104]

The medallion of the proto-emperor Julius Caesar is known only in one specimen, in the Museo Correr in Venice. The portrait on the obverse is represented as a half-figure bust, a method of presentation which the medalist favors in all his products. Julius Caesar wears a scale-mail cuirass, of the type found only on medallions of the period of Gallienus and in the half-length bust of Gordianus III in the Louvre. The reverse reflects the details of ancient coinage but is unrelated to any specific numismatic type of Julius Caesar. Caesar is shown on horseback charging to the right, over a panoply of arms and armor. The pose of horse and rider is taken from the reverses of Gallic gold reflecting the gold staters of Philip of Macedon or from some late South Italian or Carthaginian issue, for, being found in Italy in great numbers, South Italian and Sicilian Greek coin types were used by Quattrocento artists.[105]

In the medallion of Nero, the features are reproduced quite accurately from some ancient coin, and the half-figure bust is even found in antiquity on certain rare first brass or sestertii of that emperor (figure 43).[106] The inscription with COS VII PP never occurs. The reverse, inscribed NERO AVG on the exergue, centers on a large palm tree. Nero is seated to the right in a cuirass, on a curule. At the right, a nude man, rising from behind a large krater, points to the patera in Nero's outstretched hand. All this alludes to Nero as patron of the Isthmian and other games. The antiquarian who helped the medalist compose the reverse had in mind both the descriptions of Nero's patronages in Suetonius and the small aes of the emperor, with the krater and other symbols of victory at the games repre-

sented in detail.[107] Nero's first brass (A.D. 60–68), with the heavy face and long side whiskers, and the artistic program of commemorative reverses, is technically and stylistically among the finest of the whole Roman imperial series from Augustus to the end of the fourth century. This, coupled with the fascination which Nero as aristocrat, artist, degenerate, and antichrist always has exercised, made his coins the most obvious target for imitation by the anonymous, late Quattrocento medalist. His medallions measured up to the standards set for him by this particular period of antiquity.

Trajan also appears, with readily recognizable features, as a half-figure bust. The lengthy obverse inscription copies that standard for Trajan but ends with the curious PRIAVG, no doubt a misunderstanding or misreading of PP AVG. The portrait is the most successful as well as the most accurate of the series. The legend on the reverse, OPTIMO PRINCIPI AVG, is a variation of what appears on nearly every Trajanic coin. The letters SC continue the illusion of direct copying from an issue for the best of emperors, but the scene on the reverse has nothing to do with Trajan. It comes from sestertii struck in memory of the deified Vespasian by his sons Titus and Domitian.[108]

On this reverse, an elephant quadriga moves to the right, pulling a covered *carpentum* on which is a statue of the emperor. Curiously a part of the Renaissance, recalling the Mantegna cartoons at Hampton Court, is the fact that the mahouts are togate and serve as signifers. The medalist has observed that chariots and *carpenta* on ancient coins have statues and designs in relief on them. The Cupid dragging off a goat in the relief panels of this *carpentum* bearing Trajan's statue derives from a Bacchic relief partly lost and partly surviving in the Villa Borghese in Rome.[109] The Medusa head within

a festoon in another panel is a motif taken from Hadrianic and later sarcophagi.[110] A mixture of observations from the antique add up superficially to a greater feeling for antiquarian detail than previously encountered, and the total effect is worthy of the late Quattrocento.

The Hadrian, represented by a specimen in the National Gallery in Washington, D.C., is the least Roman of the series. Hadrian wears a wild, crested helmet of the late Quattrocento type, which hides most of the evidence that his portrait is accurately derived from the copious medallic production of his reign. The reverse bears the inscription MARS VIPTOR, no doubt a misunderstanding of the Augustan cult epithet MARS VLTOR. The SC graces the bottom of the field. Hadrian on horseback, wearing the same elaborate headgear shown on the obverse, gallops to the right, carrying a cloth standard (*vexillum*). This type has no exact parallel on ancient coins, although several reverses resemble it in a general way, including certain sestertii of Hadrian.[111]

The medallion of Faustina the Elder has not much more exact relation to the antique than the Hadrian, but the designs as a whole are more appealing to the aesthetic senses. Faustina's half-figure bust takes the suggestion of a portrait from coins struck for the empress in the years after her death, in A.D. 140. The inscription on the obverse garbles that found on the ancient DIVA FAVSTINA coins. On the reverse, Faustina is seated to the right, facing Antoninus Pius who wears a cuirass and is seated to the left. The Senatorial letters occupy the exergue. This medallion is no exception to the characteristics of large, wide areas in the field and well-formed Roman imperial letters common to the group.

This analysis has stressed the relation of the work of the "Medalist of the Roman Emperors" to Roman imperial prototypes. The results are about as productive of lists of similarities as if a

parallel catalogue in painting were to be compiled from Filippino Lippi's fresco cycle in the Caraffa Chapel, S. Maria sopra Minerva, in Rome (1488–1493). The medalist had all the mannerisms of late Quattrocento artists who were struggling to master antique styles but who had not yet perceived the forms and rhythm of classical compositions. Like Mantegna, the medalist saw something of style and much of detail, but he could neither absorb antiquity into his own style or bend his own style to that of a good period of antiquity.

<div style="text-align:center">CRISTOFORO DI GEREMIA</div>

The goldsmith Cristoforo di Geremia of Mantua was the most original and stimulating medalist working under the influence of Mantegna's vision of antiquity. From about 1456 on he was employed by the Gonzagas in his native city and in Rome. He restored the bronze statue of Marcus Aurelius on horseback near the Lateran in 1468. His death occurred in the winter of 1475 to 1476.[112] A medallion of exceptional merit was probably made on the occasion of Frederick III's visit to Rome in 1468 and commemorates the event under the guise of the Constantinian peace between church and state. A laureate, draped, and cuirassed bust of Constantine the Great is enframed by the inscription CAESAR IMPERATOR PONT PPP E SEMPER AVGVSTVS VIR. The portrait vaguely resembles that on coins of the emperor, and the inscription is taken from a late antique imperial formula. The reverse is inscribed CONCORDIA AVGG, with sc below the line of the exergue and the artist's signature on it. Constantine, laureate, wearing a toga, and grasping a caduceus in his left hand, extends his right to the Church, a veiled female holding a cornucopia. The letters PAX

are visible within the arms of the caduceus. The medallion is most successfully antique in style and intellect, the subject no doubt having been proposed by a Mantuan or Roman humanist. The reverse, the group of the emperor and Concordia that is, is one found with great frequency in Roman numismatics in the second and third centuries; the use of AVGG suggests a coin of the time of Balbinus and Pupienus (A.D. 238) might have been copied.[113] It is tempting to speculate whether the idea for the medal might not have arisen as a result of Cristoforo's work on the equestrian Marcus Aurelius in the same year. The bronze statue was thought in the Middle Ages to represent Constantine the Great extending the blessings of peace, and something of this notion certainly survived into the Quattrocento.[114] At least the medalist did not use the bearded features of Marcus Aurelius for those of Constantine, who had only a wispy beard or none at all; enough was known of numismatic and literary iconography to produce a more correct portrait.[115]

A medallion commemorating Alfonso V of Aragon and Naples shows the same feeling for ancient die design and Roman drapery found in the medallion honoring Constantine. Cristoforo executed this design in 1458, within a decade after Alfonso's death. The reverse portrays Alfonso cuirassed and holding orb and scepter. The inscription VICTOREM REGNI MARS ET BELLONA CORONAT names the two figures flanking him. Bellona's drapery is related to the grisaille draperies in Mantegna's work, or to the costuming in his *Triumph of Caesar*.

Between 1461 and 1465 Cristoforo was employed in Rome by Cardinal Lodovico Scarampi. He honored his patron with a medallion, the reverse of which reveals the medalist in a new and successful light. The theme is that of the Church

triumphant, ECCLESIA RESTITVTA and EXALTO in the exergue. The subject is treated as a Roman triumphal procession, moving to the left past a classical temple with an image visible between the columns. Style and details are exactly like those of third-century medallions, from Gordianus III through Valerianus (about A.D. 240–260).[116] Even the soldier, seen from the back, enframing the scene at the left is a detail handed from second-century monumental triumphal relief to third-century medallions and thus to the work of Cristoforo.[117] The crowded, restless quality of these later imperial medallions must have appealed to later Quattrocento artists, and a community of stylistic trends led the medalist of the latter day to his counterpart in a period of antiquity on the threshold of a major stylistic change.

BERTOLDO DI GIOVANNI

There is no better way of bringing medallic art back into the classical current of monumental sculpture and painting than to study the works of Bertoldo di Giovanni (about 1420–1491).[118] Bertoldo has been termed a classicist, and the knowledge of ancient art shown in his work indicates that he took full advantage of the contacts with Greek and Roman antiquities afforded by association with the Medici circle. As a man who designed and cast bronze medallions, he provides the link in one direction with the monumental sculpture of his master Donatello and in the other with the High Renaissance in the form of his pupil Michelangelo. His own sculpture is more than transitional, and it is unfortunate that additional examples of certain attribution have not been preserved or identified. Bertoldo finished Donatello's reliefs for the pulpit of San Lorenzo, and he is at least responsible for the casting if not the finished

designing of the *Entombment*. He also executed parts of the secondary frieze on this monument. In the last years of his life he was in charge of Lorenzo de'Medici's collection of antiquities at San Marco.

Bertoldo designed a bronze relief for the Medici with a battle scene. Now in the Bargello, it is based on a ruined, third-century battle sarcophagus in the Campo Santo at Pisa.[119] The relief is slightly less than half the size of the front of the sarcophagus. Bertoldo interprets the antique with a compactness of figures and a tightness of muscles made more apparent on account of the mutilated condition of the ancient relief. The center of the composition, where there is a large hole in the sarcophagus, is Bertoldo's own, but here as elsewhere he utilized the surviving clues of the supports or *puntelli* and the unbroken limbs, especially feet, left on the Roman relief. Other sarcophagus reliefs—for example a Fall of Phaeton sarcophagus of the type in the Medici collection, the sarcophagus spoken of in connection with the San Lorenzo *Entombment*—must have guided his handling of original details. One of these is the horse with his head turned frontally. The captives at the corners, mutilated but recognizable on the sarcophagus, have been completed on this evidence of supports and feet, in a manner perfectly in keeping with others in this class of imperial battle sarcophagi. The result, under Bertoldo's skillful interpretation, is a spirited composition in the antique manner. The relief seems filled with the latent power of the individual human form. It catches the Roman expression and gestures and has nothing of sentimental prettiness in its elegant finish.

Bertoldo's link with his work as a medalist comes in his bronze statuettes, two of which are well known, the *Apollo* or *Orpheus* in the Bar-

gello and the *Bellerophon* in Vienna. Inspiration for the former comes from a mutilated Roman bronze of Pan or a satyr dancing.[120] The wreathed head and the musical instruments are Bertoldo's addition to the familiar type of ancient body cloaked in an animal's skin and wearing high boots or sandals also suggesting the spoils of the Bacchic beasts, such as a panther or a goat.[121] The mixture of finished and unfinished surfaces gives the statuette the feeling of a corroded ancient bronze. The size of the head shows the Renaissance desire to add a new humanism to a shattered survival of antiquity. The proportions, of course, immediately betray the way in which Bertoldo created his work from the evidence of antiquity.

The *Bellerophon and Pegasus* is "one of the most beautiful small bronzes that has ever been produced."[122] Much appreciated, it has given birth to a host of copies and reinterpretations in all sizes and media in all ages down to the present. The best-known copies are Guillaume Coustou's *Chevaux de Marly* (1740–1745), now at the entrance to the Champs-Elysées in Paris. The bronze groups donated to the city of Washington by the Italian government after the Second World War present versions of the design also influenced by the Etruscan terracottas of Tarquinia.

In Bertoldo's bronze the dominant prototype is the Dioscuri of Monte Cavallo, but Hellenistic reliefs of the Palazzo Spada type and the horses reminiscent of the Parthenon frieze in the background of Donatello's San Lorenzo pulpit reliefs have been well observed. Bertoldo's group achieves the perfect synthesis of the antique and the Quattrocento. Nothing is awkward. No detail is too lovingly dwelt upon. Bellerophon is unmistakably a late Quattrocento figure, and Pegasus is worthy of Greek friezes or the best in Etruscan terracottas. In technical accomplishment as well as in treatment of subject, a work such as this unites the innovations of Donatello and the optimum in antiquity.

The most memorable medallion of this master among metalworkers combines contemporary political history with classical excerpts and general Romanization of composition (figure 44). It commemorates Mohammed II, Sultan of Turkey, and was made, after a medallion or a painted portrait by Bellini, when Lorenzo and the Sultan were in close contact. The medallion may have been commissioned by Lorenzo as a return present for the one by Bellini.[123] The obverse shows the titles of the Sultan, surrounding his familiar bust in turban, furs, and a crescented necklace. The reverse is a complex allegory of Mohammed's triumphs over GRETIE, TRAPESVNTY (the last Byzantine kingdom), and ASIE. Mars Victor conducts a triumphal cart, on which a man in barbarian costume (the Sultan) holds up a statuette of Bonus Eventus and leads the three nude female personifications with Tyche-crowns by a cord. The cart is enriched in the usual fashion, after ancient coins. The signature is in the exergue, where the whole composition is enframed by Oceanus and Tellus reclining with their classical attributes. The cart and the scene on it is the invention of a late Quattrocento humanist, but the enframing geographical personifications point up the fact that Bertoldo worked with the image of a Roman imperial third-century medallion in front of him.[124]

If a shift to the High Renaissance in medallic style, other than in the details already illustrated, can be defined, it is in greater simplicity—whether figures are large or small, or even whether there are many of them in a reverse. The new medallions are either larger or smaller in size; intermediate sizes, corresponding to the

later thaler or crown, disappear. The larger medallions become more Roman in secondary details, the forms of the letters, use of an exergue, and the border of dots dividing the field from the rim of the flan. The smaller medallions blend in with the heraldic and generally retro-gressive tendencies of the late medieval Renaissance coins. These heraldic and ṛgressive tendencies, brought about by the ṭtional conservatism of coin types, place them stylistically in the realm of late Gothic art.

The Age of Raphael and Michelangelo

THE shift from the Quattrocento to the High Renaissance in terms of classicism in art saw the achievement of aims toward which artists from Masaccio to Mantegna had moved. The High Renaissance was as marked a development of the arts in the year 1500 as was Neoclassicism in the year 1790. Yet, unlike other periods, the High Renaissance and its integration of ancient models could not be explained by the rediscovery of certain antiquities, the doctrines of a single historian, or the sudden advent of new political forms. It produced and was part of a new synthesis of form and content, based on classical ideals; it could absorb antiquity into itself without the conflicts of excerpting and of medieval mannerisms, or the problem of limited access to antiquities.[1] The High Renaissance was nourished in Rome, where great collections were being formed and where yields of the sketch-pad, as well as the spade were greatest.

The homogeneity of styles and the preciseness of perspective and balance in High Renaissance compositions, so far as antiquarianism was concerned, were the result of a near elimination of excerpting or quoting from ancient works of art in contemporary creations of nonclassical style. During the High Renaissance classicism moved in a stylistic direction which harmonized with antiquity. Raphael's style was to come very close to classical practice as well as spirit; the *Galatea* of the Farnesina or the decorations of the Loggie in the Vatican were the first of a series of decorative wall-paintings, extending to the nineteenth century, which would not seem out of place in a Romano-Campanian villa.[2] To a greater and more consistent degree than had the late Quattrocento artists, Raphael and his circle looked past the fluttering draperies of Neo-Attic reliefs and classicizing frescoes to the Greek art of the fifth century B.C. Michelangelo, on the other hand, moving toward styles which were to replace the High Renaissance with Mannerism, gravitated to the Flavian and Antonine baroque sculptures which preserved the grandiose, dramatic ideas of the schools of Pergamon and Rhodes in the Hellenistic period.

By 1500, the study of antiquity had grown almost beyond the grasp of one energetic, intelligent man in one lifetime.[3] Pirro Ligorio was perhaps the only archaeologist of the century who was simultaneously an architect, artist, epigrapher, historian, and topographer.[4] In general, the Cinquecento saw artistic discipline after the antique separating itself from archaeological, numismatic, literary, and historical activity. Classicism was becoming too large a

subject. Its sciences were becoming too complex for even the Renaissance man. Organization of the classical disciplines, however, made the work of artistic exploration easier.

Leonardo da Vinci

To begin with Leonardo da Vinci (1452–1519) in a chapter largely devoted to Raphael and Michelangelo should not be considered misleading. It has been said frequently that Leonardo was a man of the sixteenth century, in spite of the fact his life was lived largely in the Quattrocento. Classical antiquity had surprisingly little direct influence on his work, if his paintings and drawings are classified in terms of catalogued borrowings; however, there is no question of his place as the scientist who led art out of the late Quattrocento and into the High Renaissance. As a scientist, Leonardo wrestled with classic problems untouched since antiquity, and such must be considered at this point.[5]

Many elements in Leonardo's approach to classical antiquity are those of the Quattrocento; his choice of religious subjects, in the tradition of Verrocchio and partly dictated by commissions, precluded strong demonstration of the antique style, at least until 1503 and 1504 in Florence when he conceived the *Battle of Anghiari*. Leonardo was not a man to employ excerpts or to fill his paintings with direct translations of ancient sculptures. The scientific orientation of his painting meant that each problem had to be solved, and copying was not in keeping with this scientific application. Leonardo's powerful, individual style, seen in so many of his Madonnas and in portraits of women, owed more to the developments of artists in Florence in the period 1440 to 1475 than to any overt reinterpretation of antiquity. He achieved his own classic style, with its persuasive imprint, without strong resort to antiquarianism. Although equally interested in scientific inquiry, Leonardo and Mantegna, as near contemporaries, stand at opposite extremes of the late Quattrocento approach to antiquity.

In the *Battle of Anghiari* Leonardo was influenced by Bertoldo di Giovanni's bronze relief of a battle between Romans and barbarians, now in the Bargello. This, in turn, was based on the Antonine battle sarcophagus in the Campo Santo at Pisa. The passion and violence of Leonardo's subject expressed neither the delicate, sometimes timid, classicism of the Quattrocento nor the cold, restrained Neoclassicism of Winckelmann and Thorvaldsen. The *Battle of Anghiari* was thought by its author to express the impact of events not long past in terms of the great battle-pieces described by Pliny and echoed in Antonine Roman funerary sculpture. Rubens' copy of a section of Leonardo's lost work shows that the central part of a Fall of Phaeton sarcophagus, such as the examples now in the Uffizi and the Louvre, served as a further model for the grouping of men and horses.[6] The drama of Apollo's panic-stricken steeds and Phaeton's falling body, expressed in Antonine baroque terms, became Leonardo's expression of the struggle of cavalrymen for the standard.

Problems worked out by Leonardo in his notebooks were often solved with the aid of illustrations from ancient minor arts, a tradition well grounded in the Quattrocento. There are numerous studies for the *Equestrian Statue of Gian Giacomo Trivulzio*, French general in Milan (1511) (figure 45). The drawings show a type of rearing steed for which not only the Regisole, a bronze equestrian statue of Septimius Severus at Pavia until the French Revolution,[7] but also classical reliefs, gems, and coin-reverses of Vespasian, Domitian, or Trajan[8] were bases for his solution of the relation of rider to horse (figure

46). The fallen warrior beneath the horse's hooves can also be compared to the Cinquecento interpretations of Myron's discobolus as a fallen gladiator (figure 9). The Roman imperial coins as well as reliefs in the schema of the Mausoleum frieze may have suggested the Cinquecento studies of discobolus torsos while they were helping to shape Leonardo's designs. The influences of the High Renaissance, and especially of Michelangelo, were manifest in the elaborate high pedestal which he designed for the Trivulzio monument.

In 1504, Leonardo did a design of *Neptune in his Chariot* for his learned Florentine friend Antonio Segni. Two preparatory studies are preserved in the Royal Library at Windsor (figure 47).[9] The designs consist of a brilliant swirl in light and heavy lines of sea god with trident raised, hippocamps, and dolphins frolicking below. The ultimate influence of the Pergamene school, of the Zeus on the Great Altar of Eumenes, was transformed by Leonardo into a decorative composition of singular power. Direct influence were Nereid sarcophagi and, particularly, a curved frieze from Hadrian's Villa at Tivoli (figure 48). This frieze, known since the early Cinquecento, is scattered about Italy and Western Europe, a pertinent section being in the part of the Villa d'Este at Tivoli laid out by Ligorio.[10]

Attention has been drawn to the influence of Leonardo's Neptune on sculpture and painting in the next two centuries. Raphael's *Galatea* (figure 52), Ammanati's Neptune fountain in the Piazza della Signoria, and Bernini's Trevi fountain in Rome have been cited as expansions of the same theme.[11] Other examples are scattered through Cinquecento and later minor arts. They seem far, but not too far, removed from the baroque decorations of Hadrianic and Antonine villas.

Raphael

With a short but prolific career, Raphael (1483–1520) became known as the sublime painter of the High Renaissance.[12] He developed the most in his own style by understanding and exploiting the best of art with which he came in contact in the age in which he worked. This included not only the art of his contemporaries but also Greek and Roman sculpture, painting, and architecture. The ease with which Raphael assimilated influences applied to classical antiquity. At all times his style can be characterized as gentle and graceful, and at most times his figures, both in line and modeling, are in close communion with the spirit and proportions of antiquity. His *Three Graces* at Chantilly and several of the popular *Madonna and Child* groups demonstrate this. The period of ancient art which most suited his temperament was the fourth century B.C., the age and tradition of Praxiteles. Somehow, his genius instinctively singled out and exploited those surviving sculptures which reflected the softened (but not insipid) classicism of the period before the Pergamene baroque. In Raphael's time important ancient paintings were coming to light in the ruins of the imperial palaces. Many turned up in the rooms of Nero's Golden House, where the Laocoön was discovered in 1506.[13] The mythological scenes in these frescoes were often Augustan or Julio-Claudian reflections of fourth-century painting,[14] and from these Campanian decorative works Raphael could also extract the late high classical ideal.[15]

Raphael's taste for ancient art was kindled in his youth in the Library of the Palazzo Ducale at Urbino. The architecture of Luciano Laurana and the studies of Duke Federigo da Montefeltro had been based on a healthy understanding of the antique, whether the late Roman architec-

ture at Spalato and Aquileia or the military tactics of Livy and Caesar. From the latter, Francesco di Giorgio planned siege-engines and was generally inspired to draw extensively after ancient sarcophagi and reliefs.[16] Raphael's progress from the enlightened court at Urbino to Florence and ultimately to Rome was marked at every turn by contact with ancient monuments and with those interested in their interpretation.

Raphael led his High Renaissance contemporaries in an ability to adapt ancient designs to contemporary life, to the originality of his compositions. For the Apollo of his *Parnassus,* he chose Orpheus with the lyre from an early Christian sarcophagus, of a type surviving in many examples in various collections, changing the lyre to the fiddle "whose notes, with their wider range, could be wafted with effect among the groups surrounding the god."[17] For the Muses beside Apollo the airy freedom of the Delphic mountain has been combined with reminiscences of the Vatican Ariadne and the reliefs of the Achilles on Skyros sarcophagus in the Louvre. The preliminary drawing in Oxford confirms that Melpomene, third to the right of Apollo, comes from the flying Victoria in the upper section of the large Trajanic state relief now in the Louvre. This relief, found in many pieces some of which are now lost, shows a scene of examination of a victim's entrails (*extispicium*).[18] The Madama Zeus was also used in the *Parnassus,* notably for the figure of the philosopher seated in the right foreground. And Raphael no doubt invented the designs, carried out in drawings and grisaille frescoes by his assistants (notably Gianfrancesco Penni), for the two subjects below the *Parnassus* in the Stanza della Segnatura: *Alexander Committing to Safety the Writings of Homer* and *Augustus Saving the Aeneid.* In both scenes the composition comes from the much-used sarcophagus with

scenes of the career of an Antonine general, then in the Atrium of Old St. Peter's and now in Los Angeles.

Certain other famous antiquities, such as the Belvedere Torso, appear over and over again in Raphael's work. In the *Council of the Gods* of the Farnesina frescoes, the whole friezelike composition set on cigar-smoke clouds depends on Roman sarcophagi (figure 49). The Olympus, reclining in the foreground, is the Belvedere Torso (figure 77), shown from the same angle that Heemskerck sketched it lying in the Belvedere. Raphael also employed it for the relaxed but powerful back of his Hercules, achieving the effect later produced when the torso was installed in the Vatican. He has restored the arms and the club in such a fashion as to give the hero a resemblance to Rodin's *Thinker.* His contribution to the problem of how the legs were placed is to show the right crossed over the left. The Belvedere Torso has influenced the anatomy of all the older male divinities at the meeting. Among the younger men, Apollo, seated between Bacchus and Mars, owes his hair to the Belvedere Apollo (figure 114), or to the head known as the Giustiniani Apollo, and his body to some Roman emperor in heroic guise. A torso, which Heemskerck recorded in the court and garden of the Casa Galli (figure 53), was used by Raphael for Hermes in the fresco of *Hermes and Psyche,* and also for the messenger god in the left-hand group of the *Council of the Gods.*[19] The women, Hebe, Venus, Diana, Juno, and Minerva, have the physiques of Michelangelo's ladies, overlaid with Renaissance courtliness and grace. A divinity out of place in this pantheon is the two-faced Janus, whose older self watches the decision of Jupiter while his youthful personality shares Hebe's kylix with Hermes. Janus is copied from an imperial coin of Hadrian.

In the *Wedding Feast of the Gods,* the torso used for Hermes becomes Apollo as leader of the Muses, seen from the back and with the marked divisions of the back of the torso also stressed in the fresco. Hercules is again the Belvedere Torso, sitting on his lionskin with club behind him (figure 50). The *Wedding Feast* contains an excerpting worthy of the Quattrocento in the figure of the Amorino carrying a bowcase or flagon between the group of the Muses and Vulcan. Here he is surely bringing something in the way of refreshments to the party, but he comes directly from Neo-Attic candelabrum bases where he is one of several Amorini carrying the arms of Mars. The table about which the gods congregate is a triumph of Renaissance imagery, with animal heads and paw-footed legs and with the Gorgoneia and pelta-shaped scrollwork between.

The variety of Raphael's borrowings from antiquity is the more startling because they are so thoroughly absorbed into his compositions. The Romano-Egyptian sphinx once in the courtyard of the Casa Galli (figure 53) turns up in the *Council of the Gods*; this brief, distorted glimpse of the Egyptian past stretching back beyond the art of Greece and Rome was one of a series of such creatures set in the Iseum and Sarapeum of the Campus Martius, where they were found in the Renaissance.[20] Hebe's graceful form in the *Wedding Feast* is adapted from a Hellenistic or Roman relief in Mantua, the much sketched *letto di Policrate,* acquired by Raphael's pupil Giulio Romano for the Duke of Ferrara.[21] One of the Three Graces in the same painting is an Aphrodite of the Medici type, perhaps the statue now in New York, as can be seen by means of a drawing at Windsor and a view of the New York Venus in the album of drawings by Pierre Jacques.[22] Poseidon and Amphitrite, embracing each other at the far side of the table, echo

the motif of the red *terra sigillata* (or Arretine) bowl observed by the artist-biographer Vasari in his grandfather's house and which came as a gift into the possession of the Medici family. It is one of the earliest "Greek" vases mentioned in Renaissance literature.[23]

All strains of the antique cross and recross in Raphael's work. From his early studies with Perugino and from the influence of Ghirlandaio in Florence he absorbed something of the Quattrocento Neo-Atticism, associated with Agostino di Duccio and Botticelli. This is exemplified by the two ladies at the extreme left center of the monumental *Healing of the Lame Man,* in the series of cartoons for the Sistine tapestries. From the Neo-Attic to the Pergamene heroic it is quite a jump in ancient art, but the superimposition of his own softness and controlled calm makes this no difficult matter for Raphael in the persuasively absorbing influences of his own style.

St. Catherine in London leans on her wheel in an attitude taken from the Muse in a drawing in the Duke of Devonshire's collection at Chatsworth (figure 51); her attitude thus comes from an ancient representation of the Muse Euterpe. Her pose and costuming, the high-girt chiton and the himation wrapped loosely around the waist and over the left shoulder, descend from an Athena or Demeter in the Pergamene tradition. A number of Roman copies (figure 89) as well as figures on sarcophagi preserve the type. It is likely that Raphael took it from the sarcophagus with Muses and philosophers, long in the gardens of the Villa Mattei and now in the Museo delle Terme in Rome.[24] The classic massiveness of St. Catherine's Hellenistic hair, flesh, and drapery is silhouetted in sharp contrast to the landscapes on either side of her.

The Pheidian-Pergamene marble Dioscuri (or Horse-Tamers) of Monte Cavallo impressed Raphael. He used the right-hand Dioscurus, seen

from the back, for the executioner of the *Judgment of Solomon* in the Stanza della Segnatura.[25] This work presents a section of Roman relief in High Renaissance terms against a background imitative of monumental mosaic. Solomon, enthroned at the right, wears the radiate crown of late antiquity, and his pose on the imperatorial suggestum is that of the bronze St. Peter in the Vatican, the gesture of benediction turned into one of surprise. Decorative demands have simplified the spatial props around the sculptural figures, and this has brought the scene as close to the mood of a monumental Roman imperial mosaic or fresco as any comparable secondary work of the High Renaissance. The two horses of Monte Cavallo appear as the hippocamp amid the figures at the left in the *Triumph of Galatea*, a work not only antique in flavor but in specific details of derivation. Since both the Dioscuri and their horses were based on the sculptures of the Parthenon pediments, Raphael was reaching a degree of Greek High Classicism unusual in Cinquecento Rome.

In the *Galatea*, the only work in the Farnesina entirely Raphael's, the influence of Nereid sarcophagi is not unexpected, considering the marine setting of the theme (figure 52). Galatea is a composite of a Nereid and waterborn Aphrodite of Capua, the motif which passes through the Victory of Brescia to become the writing Victoriae on the columns of Trajan and Marcus Aurelius. The group of a Nereid seen from the rear on the back of a Triton just beyond Galatea is particularly Roman in flavor and detail. Raphael's desire to show all the figures as completely as the composition permits, despite the fact that they are swimming, leads to the same effects of walking on the water found in ancient frescoes. Another detail, antique in spirit, is the Amorino who holds a bundle of arrows behind the little cloud at the upper left, while his symmetrically arranged companions fire away at Galatea from above. The horizontal layers and levels of powerful dark and light figures, the swirling draperies, the flying Cupids, and the interplay of humans and animals harmonize with ancient sculpture and with what glimpses remain of Hellenistic painting.

The *Judgment of Paris*, one of Raphael's great compositions, known to posterity only from Marcantonio's engraving, was taken almost directly from a Severan sarcophagus now walled up in the garden façade of the Villa Medici (figure 7). From Marcantonio one part of the composition passed to Giorgione and ultimately to Manet, who probably little realized his *Déjeuner sur l'Herbe* derived from a Roman sarcophagus (figure 8).[26] Such is also the case with Courbet's *Reclining Nude* in Boston, based on a Roman Nereid[27] and likewise taken from a sarcophagus relief (figure 93).

In each of Raphael's multifigured compositions and in several of his single saints there are sometimes one or two, sometimes many, instances of reliance on antiquity. Besides the usual sources, statuary and sarcophagi, and besides the paintings coming to light in the ruins of Roman palaces, early Christian mosaics influenced Raphael, as they had Melozzo da Forlì and Perugino before him.* The strong forms and rhythms, the shimmering break-up of colors, the survivals of Roman second-century (Antonine) pictorialism in the fifth-century mosaics of the nave of Santa Maria Maggiore fascinated him.[28] The highlighted youth showing the way in Raphael's *Disputa* is the striding figure in the

* In his *Assumption of the Virgin* and his Cambio frescoes, Perugino attempted to recover the spatial form and the compositional rules of early Christian art. This attempt was partly an unconscious realization of what the schema of late antique mosaic did for the isolated figures, strong outlines, and Neo-Attic draperies at which he excelled.

Charge to the Apostles of Santa Maria Maggiore.[29] The principal group of the *Heliodorus* is like the chief motif of the *Battle of Joshua* mosaic;[30] this cavalry combat, as a composition, traces back through Antonine battle sarcophagi to the Great Trajanic Frieze and ultimately to Hellenistic paintings or to the battle scenes of Philoxenus of Eretria,[31] reflected in the *Alexander and Darius* mosaic from Pompeii. The river-god motif found in mosaics and sarcophagus reliefs serves for the collapsing figure of the rapacious treasurer or for *Ananias* smitten by the judgment of God.

A further example of Raphael's ability to extract the most out of ancient sources in a single, simple but dramatic composition is the *Vision of Ezekiel* in the Palazzo Pitti in Florence. The Madama Zeus (figures 4, 5) is the source for God the Father.[32] The bull bellowing to the Lord as a symbol of St. Luke is taken from the Capitoline Mithras relief, now in the Louvre, from the group of Mithras Tauroktonos which Marten van Heemskerck sketched in the courtyard of the Casa Santacroce about 1535, or from one of the two statues of Nike Tauroktonos, located in the Casa Sassi in Raphael's time and now in the British Museum.[33] Raphael's winged bull even has his head thrown back and his forelegs doubled up beneath him, in the manner of a bull about to be sacrificed.

In spite of the several changes in his style, at no point in his mature period was Raphael far from ancient works of art as inspiration. Aside from ancient paintings and mosaics, he relied most on Roman copies of works by Praxiteles (leaning Dionysos-Eros, Lycian Apollo, Hermes), Euphranor (Cook Apollo),[34] Leochares (Apollo Belvedere), Skopas (Aphrodite, Muses), and other artists of the fourth century and the early Hellenistic period. He liked their technically facile, softened, and sometimes slightly emo-

tional classicism. From the vast range of sarcophagi he preferred examples with Hellenistic decorative motifs: the Conservatori season sarcophagus,[35] or sarcophagus lids with Amorini driving animals.[36] But he could use classicizing works of greater dramatic impact, such as Pheidias' Dioscuri of Monte Cavallo, Apollonius' Belvedere Torso, or the Villa Medici Judgment of Paris sarcophagus, with its Severan recollections of a monumental Hellenistic mythological painting. After Fra Giacondo's death, in August 1515, Raphael was appointed Conservator of Roman Antiquities by Leo X; he was supposed to prevent the destruction of ancient buildings and fragments, but he was practical rather than romantic or sentimental about antiquities. On his death he was buried in Hadrian's Pantheon in a Roman late-first-century sarcophagus not without interest for its rare presentation of the bucrania-and-garland motif.[37]

In the sense that he is indebted to it, Raphael integrates the antique as well as any artist before his time—or after, until the time of the Carracci and Poussin. He dominates antiquity, without the display of the rugged (sometimes even ragged) power of Michelangelo's sculpture. He became the first of many great artists to use selected figures and motifs in easier fashion in his paintings, after having first developed them in drawings. He can be archaeologically "correct" or he can be "free" in his interpretations when necessary. Even in the best of the late Quattrocento, in Botticelli or Mantegna, creations grounded in classical antiquity manifest either a scientific working of certain antique styles into a very personal art or a strained desire to comprehend the antique spirit by use of antique forms. Leonardo was too interested in the facts of nature to bend to antiquity and too independent to absorb antiquity to decorative uses. In Michelangelo's sculpture and painting an-

tiquity was bent to the demands of a spirit and a style too great for the age in which it developed. Mannerist artists saw Raphael's and Michelangelo's uses of the antique and wrongly thought that they had gone far beyond the former and could understand only the forms, not the contents, of the latter. Amid so many other impressions, Raphael not only comprehends the breadth of ancient art surviving in his time but reaches out to make its spirit his own.

Michelangelo

The practical introduction of Michelangelo (1475–1564) to the antique, like so many Quattrocento artists, came through the Antonine baroque.[38] An ability to infuse power into a dramatic composition manifests itself in his earliest work, the *Battle of the Centaurs* (1492), where he adheres to the imaginatively altered prototype of an Antonine sarcophagus. The relief, now in the Casa Buonarroti, was executed in Lorenzo de'Medici's humanist circle under the eye of Bertoldo, who had produced his bronze battle scene reflecting the inspiration of the sarcophagus in Pisa. Michelangelo catches the rough anatomy of men and the intimation of horses struggling in high relief, while Bertoldo dwelt on the polish and finished detail in well-preserved examples of these sarcophagi. Bertoldo's bronze makes the position of every soldier and every horse explicit.

Michelangelo's rough indefiniteness is such that the sex of the humans is open to debate and the equine part of the "centaurs" is indiscernible. At this early age he picks up the optics of three-plane perspective in Roman sarcophagi of about A.D. 180 to 280, and uses the tricks of elongation and superimposition of violent figures, found in Pergamene painting and Antonine sculpture. He sees the best in classicism, and yet his figures, especially at the lower left, have the sweep of Hellenistic bronzes. The era of specific, excerpted observation is just past for many older artists, and the young Michelangelo adheres to this tradition by placing the features of Socrates (at the left, holding a rock) into the composition drawn from second-century (Antonine) sarcophagi. The overt sense of the marble from which the relief is carved has been most stressed in the work as a whole; where heads and limbs do not break the frame of the composition they are set off by a trench of chiseled furrows.

Early third-century Roman and Gothic tendencies mix in the figures of the tomb of S. Domenico in Bologna. The *Kneeling Angel* (1494–1495) is the most Quattrocento of the three. An Antonine head of Hermes or Apollo with full, matted, seemingly wreathed hair kneels in a classical Renaissance pose, with the heavy drapery of Masaccio or the Or San Michele sculptures. The figure begins to show the powerful body and suggested (but unpolished) forms of Michelangelo's great periods. The whole sculpture, however, is still almost timid and bound by tradition. *S. Petronio,* holding up the church, is the most Gothic, in pose, iconography, and drapery, but from the heavy, rumpled, unarticulated robes a head in the late Antonine or Severan manner emerges. The particular prototype was taken by Michelangelo from a wreathed garden herm now in the Villa Medici in Rome.* The pendent *S. Proculo* is "Gothic" too, but with a force which looks back into the art of Gaul in late antiquity. The saint is almost a Gallic Good Shepherd, with a head too compressed, too broad for the classical ideal. The face wears the look of uncertain youth—Michelangelo's youth.

Michelangelo constantly gravitates to the late

* The incised eyes and drilled-out beard of S. Petronio bear the same relation to later Roman sculpture found in the work of Bernini's father at the close of Mannerism.

antique—to sculpture from the Antonine period through the age of Gallienus (253–268)—whether in copies or originals. This tendency is evident in his works at the end of the Quattrocento. After 1500, the range of his borrowings broadens, but favorites such as the Apollo Belvedere, the Belvedere Torso, and the Laocoön group are used in many different ways. The *Bacchus* (1496–1497) is an unclassical Antinoüs, the marble statue known as the Antinoüs Farnese in Naples providing the neo-Polykleitan cast and proportions of the body (figure 53). The little Pan or satyr boy nibbling grapes behind the left leg is based on a figure in one of the late Hellenistic groups showing Pan teaching Daphnis to play the flutes. Such a group was also in the Farnese collection and is now in Naples.[39] The *Bacchus* was mistaken by Raphael and others for an ancient statue, notwithstanding its Renaissance flavor; the thin face on a thick neck, the developed muscle of the right arm, and the large feet have no antique parallels in the school of Polykleitos. These elements lead directly to aspects of the *David* which relate to Hellenistic rather than Polykleitan sculpture. Michelangelo's ability to handle his chisel in the manner of a Roman copyist is exhibited with success in the *Bacchus*. The techniques of late copies are particularly noteworthy in the drillwork of the panther or boar mask held in the left hand and falling over the support on which the satyr boy sits.

Another work mistaken for an antique was the *Sleeping Cupid* which Michelangelo carved in 1495, just after returning to Florence from Bologna. The statue passed from the ducal collection at Mantua to that of Charles I in London, and appears to have perished in the fire at Whitehall Palace in 1698. Condivi relates that Cardinal Raffaello Riario bought the Cupid in Rome as an antiquity; discovering the deception, he re-

turned it to the dealer and recovered his money. Vasari criticized the Cardinal for not recognizing that a contemporary work which could pass as ancient had merit. An ancient sleeping Cupid, gift from Ferdinand I of Naples to Lorenzo de'Medici and placed in the Medici gardens in 1488, seems to have provided Michelangelo with his model. It is possibly the sleeping Cupid now in the Uffizi, one of several about which records of provenience are imprecise.[40] From this statue and what is known of Michelangelo's style at this time, his *Sleeping Cupid* can be identified among other sleeping Cupids on a page of drawings of the statuary sent from Mantua to Charles I.[41]

The *Pietà* (1498–1499) in St. Peter's shows the proto-Mannerism of Michelangelo and manifests his later style in technical terms of Roman third-century sarcophagi.* In the closed eyes, the highly polished flesh, the drilled hair, and thin (drilled and incised) beard, the head of Christ approaches the grotesque qualities of the barbarians on the Ludovisi battle sarcophagus of the middle of the third century.[42] The elongation of limbs is also a part of this sarcophagus (not excavated until 1620) and other, similar reliefs known in Michelangelo's time.[43]

In religious votives of the High Renaissance, Michelangelo's individuality requires no lavish reliance on the antique. The *Madonna of Bruges*, produced in 1501 or slightly later is a good illustration (figure 54). Here, however, the high polish and deep cutting of third-century Roman sculpture is also present. The head of the Christ Child would do nicely as a Hellenistic Cupid. The Christ Child's pose and expression are taken verbatim from a Hellenistic Eros seated on a rock, with his hands on his left knee which is

* The early Mannerists were much impressed by the features of Christ and the draperies surrounding Mary. Christ contributes a strong measure of form to the central figure of Rosso's *Dead Christ with Angels* (figure 64).

drawn up under him (figure 55). Michelangelo found this motif perfectly suited to his conception of the Christ Child protected by the rich folds of Mary's robe, and the antique origins of the design are in no way readily recognized.

On the other hand, in the marble tondo known as *The Virgin of Bartolommeo Pitti* (1504–1505), the head of the Virgin is Michelangelo's personal version of a fourth-century Ariadne.[44] For the nude figures in the background of the painted tondo known as the *Doni Madonna* (1503–1504), Greek sculpture of the Praxitelean period has provided the qualitative and stylistic inspiration (figure 56). The nude in the center of the right-hand group has the crossed legs and contrasted pose of a Praxitelean to Lysippic faun or satyr. In the left-hand group, the nude on the right is a young Apollo who slays Niobids.[45] The little John the Baptist, who looks up at the central group from behind the wooden railing, is also Praxitelean. He is a satyr-boy, with sheepskin and pedum setting off the rustic expression in face and curly hair.

Before Michelangelo undertook *David* (1501–1504), he studied colossal Roman copies of Pergamene or Hellenistic statues. The *David* originally had the high polish characteristic of Roman second- and third-century reflections of Greek prototypes. For the treatment of surfaces in heroic size, for the drilling of the large eyes and the massive bunching of hair, the direct prototype was the Dioscuri of Monte Cavallo. So, too, the Michelangelesque treatment of the lower limbs and large feet, producing a seemingly canted body, is taken from colossal statues of Herakles which reflect a Pergamene original. Examples include the Herakles and Telephos in the Louvre, the Giustiniani Herakles in the Metropolitan Museum, and the colossal Herakles at Wilton House. The last statue carries the connection even more closely, for the feet, legs,

and other details were said to have been restored by Michelangelo.[46]

To speak of classicism in the *Sistine Ceiling* (1508–1512) is to speak of the continually recurring forms of the most powerful and dramatic periods of ancient sculpture: the Pergamene (colossal divinities; Gaul groups), the Flavian (the great river gods), and the Antonine-Severan (Farnese Hercules; statues in Naples). The massive features of standing Herculeses, seated Zeuses, the Belvedere Torso, and reclining Father Tibers, seen from all angles, occur over and over again. Other elements are raised to the titanic scale demanded by the artist. Playful Hellenistic satyrs or fauns, such as the group of the youth astride a dolphin (now in the Villa Borghese), are given stature far beyond their original purposes; they become the ignudi around the framed scenes of the ceiling's center. The arrangements of the *Creation of Man* and the *Expulsion from Paradise* suggest that Michelangelo studied the scenes of a composition like that of the Julio-Claudian glass jug in the British Museum, known as the Portland Vase. He may have studied the vase itself, for its history before 1600 is very uncertain, and it may have been known earlier than the late Cinquecento date traditionally given for its discovery.[47]

The relations between Michelangelo's two scenes and groups on the Portland Vase are not easily defined. They exist by intuition. "Peleus" touching the arm of "Thetis" gives the design for Adam's creation. The angel of the Expulsion is the Amor above Thetis and her snake. In the Expulsion the tree remains very much the same, but the snake is much larger, partly human in form, and coiled around the tree. And, in the mirror reversal of an engraving or counterproof of a drawing, "Poseidon" needs little adjustment to become Eve's accomplice.

Michelangelo's Adam is a reversal of the

"Theseus" from the east pediment of the Parthenon. Ciriaco d'Ancona's sketches have been suggested as the source of relation between Michelangelo's Adam and the Pheidian Theseus.[48] Other statuary in this schema was available in Rome around 1500. A powerful Greek original, now lost, was at Mantua in Isabella d'Este's collection and is known from a drawing of Charles I's sculptures at Whitehall. It was probably in Rome between 1500 and 1527.[49] If these connections are too tenuous, even Adam's posture at the Creation might perhaps be linked with the Portland Vase rather than with sculptures deriving from the Parthenon.

The gigantic conception of the nude in the *Noah, Flood,* and *Creation* scenes is rivaled only by certain Antonine to Constantinian mosaics, such as the "gladiators" in the Lateran from the Baths of Caracalla or the giants and hunters in the hemicycles of the early-fourth-century imperial villa at Piazza Armerina.[50] One or two of the youths flanking the principal scenes of the Sistine Ceiling can be traced to eye-catching statues in the Pergamene or Hellenistic rococo style. The youth at the left above the Erythraea is a mirror reversal of the Hellenistic satyr riding a dolphin. The Renaissance tondi of the Palazzo Medici-Riccardi in Florence, enlarged copies of Greco-Roman cameo and intaglio gems, have also supplied several of the poses used in these ignudi, giving Michelangelo's figures a High Renaissance flavor one intellectual step removed from the antique.[51] Only where architecture is involved is overt classicism tolerated in the Sistine Ceiling—the putti flanking the Prophets and Sibyls, or the silhouetting and placing of figures in the lunettes. Michelangelo's human touch evidences itself in the little Hellenistic boy who supports the plaque under *Daniel* and in those integrated in the architecture flanking the figures of *Zechariah* and the *Persian Sibyl.*

Tomb of Pope Julius II

Various antiquarian features can be picked out from the figures for the *Tomb of Pope Julius II.* In the aesthetic sense, however, these great sculptures transcend any efforts at analysis for classical components. The head of the Sleeping Captive or Dying Slave in Paris is a "dying Alexander-Helios" of the type in the Uffizi or in Boston, or seen in less exaggerated fashion in the complete statue of Alexander at Wilton House. The arm rests above the head, almost like a well-developed Praxitelean Apollo, the Apollo Lykeios. To set off the delicate hands and polished limbs a support of very canine form rises up behind, as if the Alexander-like captive was falling back in death upon the patient form of some Hellenistic mastiff.

The Heroic Captive (Rebellious Slave) of the Louvre is "Pasquino" or, to be more accurate, the Pergamene Menelaus reversed and altered, through the medium of a terra-cotta sculptor's study (*bozzetto*) (figure 57). To see this, it is necessary only to blank out the face and cover up the lower extremities from the knees. Certain additions and alterations to the muscular structure have been made under the influence of the Laocoön, and the head derives much from the Helios long known as the Dying Alexander. Of the *Moses,* it has perhaps never been said that the peculiar superimposition of terribilità on power is transmitted through face and especially eyes. These distinctions of physiognomy belong in the series of colossal Greco-Roman creations after Hellenistic types, the River Gods and the Dioscuri of Monte Cavallo.

In the *Victory and Vanquished,* now in the Palazzo Vecchio in Florence, the head of the Vanquished is Pheidian or early Praxitelean in style and proportions (figure 58). Some Zeus or Sardanapalus underlies the creation in this face

of middle-aged brutality pressed down upon his Roman cuirass by heroic youth. Specifically, the head can be compared to the Pheidian Zeus from Mylasa (Caria) in Boston[52] or to some Neo-Attic Bacchus. This head can also be placed alongside that of the Farnese Hercules, a work much admired by Michelangelo. The torso of Victory depends on the "Pasquino" group, although this cannot be sensed at first glance because of the cloak drawn over the back. The clay model in the Casa Buonarroti, thought to be an early study for it, shows this dependence on the "Pasquino" group more directly. The proportions of Victory's head reach back to the Bacchus of 1496–1497. Mannerism will take up these small, thin heads on elongated necks, but it is really the *contrapposto* of the figures that makes Michelangelo's style and later that of Mannerism stand out.

The face and turn of the chest and left shoulder of the *Bearded Slave* in the Accademia are those of Laocoön in the group of the priest and his two sons. Michelangelo uses this motif again and again, and so do his followers, especially the Mannerists. In the *Walking Slave,* the motif is reversed. Models in clay and wax for the "Giants" from the Tomb of Pope Julius show how Michelangelo's ideas started from Hellenistic sculpture: the satyr with the footclappers (Casa Buonarroti), the post-Lysippic Apoxyomenos (same location), and the hanging Marsyas (British Museum sketch).

Finally, *Rachel* (Contemplative Life) of 1542, one of the last figures for the ill-starred tomb, emerges in the profile of her head as one of the Medici Niobids. The absorption of a specific ancient type into an ecstatic figure in unnatural pose and swathed in drapery looks ahead to the relation between ancient and contemporary sculpture found in the Baroque expression of the Italian Seicento. As if to weigh her down in thought, the pendent *Leah* (Active Life) is based on a draped female in high-girt peplos with long overfold. Such figures go back, through Roman copies such as the colossal Ceres or Agorakritan Nemesis of the Vatican,[53] to the Pheidian originals, cult-statues produced in Attica in the time of the Parthenon.

In the secondary enrichment of his architecture and the settings for his sculpture, Michelangelo practiced great imagination within the classical tradition. This is traditional in view of how much variety an artist in Medieval and later Italy could find for inspiration in ancient architectural ornament. The reliefs inside the niche of the Moses on the Julius monument (about 1514) are Roman Imperial in style. This is especially true of the relief with branch-bearing Tritons. They support an inscription plate, a common classical motif of decoration, above which is a foliate fillet and torches left and right. In the heads of the Tritons, Michelangelo has captured the pseudo-Pheidian style of the early imperial, Neo-Attic classical prototype, a prototype most likely found in the carved detail of cinerary urns of the Julio-Claudian period.

Michelangelo's decorative enrichment in his monumental architecture combines a moving, flexible imagination, daring of experiment, with a keen observation of the bizarre in ancient ornament. In his architectural decoration, as in the subordinate details of his freestanding statues, masks intrigued Michelangelo. He used them with exhaustive inventiveness on every imaginable occasion: on the frame of the Doni Madonna, on Giuliano de'Medici's cuirass (itself an unantique synthesis of Roman cuirasses), on the capitals of the Medici Chapel (1524), on the friezes in the Chapel (1534), and in the frieze of the Palazzo Farnese. As bizarre, as unclassical, as some of these masks may seem, the archaistic

friezes of the early Roman Empire provided the prototypes.

The classical dependence of the *Brutus* (1537 or later) on a bust of Caracalla of the type in Naples is obvious, although the finishing of the togate bust in this fashion is attributed to Tiberio Calcagni, an associate of Michelangelo after 1556.[54] It is difficult to add anything further than what has been said in general terms in the cases of the Medici Chapel (1524–1534) and the *Last Judgment* in the Sistine Chapel. The reclining figures of the former exploit every High Renaissance possibility inherent in the classical river-god types, figures of which Michelangelo was extremely fond. *Night's* connection with the *Leda* of Michelangelo's own painting and an ancient motif, lost in relief but surviving in the minor arts and in sixteenth-century drawings, has been demonstrated by writers in the last century.[55] The seated, cuirassed Giuliano is a return to the powerful physique of the Belvedere torso.

In the *Last Judgment* the isolation of monumental Hellenistic forms in the ceiling is continued in exaggerated form thirty years later. *Anna* stands forth as Niobe and her youngest daughter, and the head of Christ is a powerful reworking of the head of Apollo from the statue in the Vatican Belvedere. The Belvedere Torso and Hellenistic philosopher heads are still there, as in the ceiling, but it is almost an injustice to the composition to single them out in the titanic interplay of struggling figures. High Renaissance classicism has passed over into something artists other than Michelangelo can only treat as Mannerism.

Michelangelo's styles vis-à-vis antiquity seem to pass through the cycle of development discussed in connection with Ghiberti and made very obvious in the development of Mantegna's styles. The youthful period was one of great interest in investigating the antique. The dependence on ancient art is also explained by the fact that it was one of the chief models for a sculptor in 1490. Early commissions to restore ancient marbles increased the relationship. Very quickly and for a long middle period, Michelangelo was able to and chose to subordinate antiquity to his own developed styles. He absorbed in these styles the elements of antiquity, and antiquity came out as an unconscious ingredient. In his later years, Michelangelo returned to or increased the proportion of more conscious borrowings from antiquity. He was experimenting with several styles, and direct connection with ancient art, however, was never more than a limited or controlled manifestation of these experiments.

Mannerism and the Organization of Classical Antiquity

By the time of Michelangelo's death it seems that artists in Rome, Florence, Venice, and elsewhere must have found and used all that classical antiquity could offer to contemporary painting and sculpture. This was not so; although there was less borrowing from the antique, the process took on new forms, often difficult to recognize. The Mannerists—to use the term favored by critics in recent years—had so much to borrow from Leonardo, Raphael, and Michelangelo that they needed less contact with antique sources.[1] For example, Rosso, in Michelangelo's own lifetime, could mix casual observation of an antiquity with penetrating study of the human figure in the Sistine Ceiling. To these he added careful scrutiny of the master's drawings and finished sculptures.

Three factors made Mannerism a series of styles as much in need of classical nourishment as those of the High Renaissance. First, Mannerism grew out of the High Renaissance which was thoroughly grounded in antiquity. This reliance on antiquity forced at least an occasional trip to the sources exploited by the older generations and to the new contributions of the spade from the ruins of Rome and the surrounding villas. Second, excavations and chance finds in the decades after the sack of Rome (1527) were bringing countless new antiquities to light which

the artists could not afford to ignore. Third, archaeology as a separate science was on the verge of birth. As Giorgio Vasari was beginning the study of the history of art, others were collecting and publishing known antiquities. Artists had their attention drawn to monuments perhaps long known but little publicized.

The Mannerists did not turn to heretofore unexploited monuments. Much the same sculpture and all the same sculptural types were studied: Praxitelean statues, Neo-Attic reliefs, Antonine and Severan sarcophagi, and certain striking gems. The Column of Trajan provided an accurate source for Roman triumphal friezes and decorative panoplies of weapons. There was a tendency to subordinate borrowings of compositions in favor of isolated figures and, especially, isolated poses. A single sarcophagus could provide several exaggerated figures amid otherwise very classical myths or decorative scenes (figure 59). The elongated tension of a struggling Greek warrior could be excerpted from an Amazon sarcophagus; the pathos of an old nurse could come from the same Death of Meleager sarcophagus in which Raphael found the classic containment for an *Entombment*; or the Nereid riding a triton or sea beast in the complex decorative composition of a Nereid sarcophagus could be taken out of context and transformed into

Aphrodite or an allegorical figure in wall decoration. In short, the ancient world could provide material for the most abstracted, most exotic design which Mannerist decoration could invent within the framework of a classic rationality taken over from the High Renaissance. Ancient artists had often reached the same degree of calligraphic abstraction of classical nature and proportions which Mannerists sought as their expression of a new objectivity.[2]

Mannerist Classicism and Giulio Romano

Giulio Romano (1499–1546) is the logical artist with whom to begin a study of the period. Born in the shadow of the Roman Campidoglio, he fused the art of both Raphael and Michelangelo into his decorative style, a process made easy by the fact that the former was swayed toward Michelangelo's powerful style in his last years. He was left a great legacy of Raphael's designs and ideas as well as immediate command of his very active atelier. Though in disfavor with critics a generation ago, current taste values Giulio Romano. His work in the Vatican chambers known as the Stanze is no longer passed by in "pious horror," and his rich, cycloramic approach to monumental frescoes is especially suited to the combination of sensuousness and scholarship in the twentieth-century approach to art.[3]

If a group of monuments which influenced the development of this native Roman artist, independent of the classical sources learned from Raphael, were singled out, it would be Trajanic, Hadrianic, and Antonine historical reliefs. Giulio's work under Raphael and later his own grand historical frescoes in Rome and Mantua drew him again and again to the "network of linear rhythms," the dramatic placement of victor and vanquished, the details of costume and ritual, and even the architectural backgrounds of the narrative reliefs of Roman columns and arches within a few minutes walk of his birthplace. Giulio was conscious of different periods in Roman sculpture and architecture and he could use material contrasts of epoch—the Colosseum and Old St. Peter's—to good purpose in the backgrounds of his paintings. The High Renaissance had made figures more classical in form and compositions more Greco-Roman in arrangement. Giulio and artists of his age imparted greater accuracy to archaeological details. Mantegna's Roman legionaries wear the cloaks and armor cast off from some Renaissance festival; Giulio's heroes and imperatorial martyrs are cuirassed in the most correct Antonine fashion, his legionaries carry the correct arms, his captives are Germans from the Column of Marcus Aurelius or Parthians from the Arch of Septimius Severus. In these and many other details Cinquecento painting was still far from the archaeological, historical, and epigraphic accuracy of Ingres' *Martyrdom of St. Symphorian* (1834) in Autun Cathedral, but never again would the ancient or Early Christian world appear derived from a Gothic fairy tale. Styles and ideas of color or proportion changed, but seriousness of approach to the visual forms of antiquity as well as the absorption of antique designs never departed from the new plateau of accuracy.

To catalogue all the borrowings from antiquity in Giulio Romano would be a major work, but those mentioned here give some notion of the subject. The frescoes of the Vatican Stanze merit consideration. In this work Giulio Romano, a pupil of Raphael, becomes Giulio Romano, an independent creative force. The *Vision of Constantine* depends most explicitly on the Column of Trajan, for the Adlocutio scene at the left

74

and especially for the grouping of the figures on the podium (figure 60). The Aurelian *Adlocutio* and *Reception of Prisoners* on the Arch of Constantine have also been important determinants in this composition, executed by Raffaellino del Colle from a cartoon by Giulio Romano. The face and armor of the general behind Constantine are accurate, feeling transcriptions of a late Antonine or Severan statue. And Constantine himself could have stepped right out of the reverse of a Roman medallion of the third century. If any painting of the Cinquecento could be cited as the epitome of massive dependence on the antique, it would be this fresco. The grandest surviving Roman triumphal reliefs have been made the comprehensive basis of a sweeping summation of imperial Christianity. The planning and execution of a panorama of Roman imperium in which antiquity's strengths of composition were put to unprecedented uses were great achievements in the visual and intellectual history of the later Renaissance.

Authentic antiquarian details crowd the background of the *Vision of Constantine*: the Vatican pyramid, a tomb like that of Caius Cestius outside the Porta San Sebastiano; a restored version of Hadrian's tomb; the Pons Aelius, taken from Hadrianic or Antonine medallions; and the mausoleum of Augustus, as it looked in the Cinquecento in the distance on the opposite or city bank. The Aurelian column and ruins are faintly traceable beyond, behind the flood of divine light from the cross. And yet, this is not a pictorial reconstruction of one event such as might be made in our own time for the *National Geographic Magazine*. The pages or squires with the plumed helmets to the left of Constantine's podium and the court dwarf with the large helmet in the right foreground are products of High Renaissance decoration, as is the rhythmic pattern of animation in the legionaries who run

or have run from the right to join the emperor in his vision and proclamation of policy.

Several Roman battle motifs are mixed to produce the *Battle of Constantine (Mulvian Bridge)*. The thoroughly formal presentation of the subject depends on that of a Roman battle or hunting sarcophagus, several examples of which were well known by 1520. A general debt to the battle scenes of the Great Trajanic frieze in the Arch of Constantine and on the Column of Marcus Aurelius, roughly contemporary with the sarcophagi, is evident. The grouping of the central horses, rumps out, piled up in various planes, can be traced to the group of sarcophagi which present the Fall of Phaeton in this dramatic fashion. Amazon and other battle sarcophagi contribute many details of the struggle: the elongated infantryman about to be crushed by the horse's hooves in the left foreground, the man falling from the large white horse in the center, and the group beneath Constantine's charger. The group of horsemen attacking in the middle ground at the extreme left is taken from the left end of the Los Angeles sarcophagus of a Roman official (figure 1).

In total effect, Giulio Romano's *Battle of Constantine* is High Renaissance Christianity's answer to the *Alexander and Darius* of Philoxenos of Eretria, preserved through the mosaic in Naples. Philoxenos' late-fourth-century composition stands at the head of a long development in Hellenistic and Roman battle painting. In reflecting Roman examples of this tradition, Giulio's composition becomes the culmination of a creative process started in Alexander's lifetime and traceable through works now known only from abbreviated copies or pale reflections. Alexander, symbol of Hellenism, opposes the oriental potentate Darius. Constantine, conquering under the sign of the cross, sends the pagan Maxentius to a watery grave. In celebrating this

Christian triumph in terms of Greco-Roman classicism, Giulio's Papal patrons were adding artistic luster to the glories of the Church while pointing to Constantine as triumphator over the forces of despotism and darkness. The parallel is no less meaningful despite the fact the Alexander mosaic was unknown in the sixteenth century. The tradition continued in the seventeenth century, in the classical battle-pieces of Pietro da Cortona and Charles Lebrun.[4]

In the *Baptism of Constantine,* carried out by Gianfrancesco Penni from a cartoon by Giulio Romano, sophisticated excerpting provides the statuary on the columns at the left and right. The Pasitelean Aphrodite, of the type known as the Marbury Hall "Electra," appears both in direct transcription and in reversal.[5] The work survives in a number of replicas, including the group now with the Farnese marbles in Naples, and any one of these could have been used by Raphael's pupils. The clinging drapery combined with vigorous, angular stance made the type very appealing to the early Mannerist tendencies in Giulio Romano's decorative work.

Several classical borrowings of a nonmilitary nature are observed in the *Fire in the Borgo,* which might have been studied to equal advantage in the chapter on Raphael. The Aeneas and Anchises motif is prominent in the left foreground, with the Hellenistic Old Market Woman as Creusa trailing behind. Anchises has a head of the Pythagoras type, an East Greek philosopher replete with the turban to be borrowed in Giulio's own time by the Ottoman Turks, so recently the conquerors of Constantinople. As early as 1518 the notion of turning Raphael's drawings for this group into a "Flight of Aeneas" was carried out in chiaroscuro woodcut by Ugo da Carpi. The Quattrocento persistence of Neo-Attic poses and drapery manifests itself in the muscular woman with a pitcher on her head,

moving at the extreme right and in certain details of "Creusa's" pose and costume. Another "maenad" or "Hora," seen from the back, has become the woman with a little child in the empty area between the panic in the foreground and the Pope's appearance in the rear. The maenad on the right front corner of sarcophagi with the Indian Triumph of Dionysos, such as the splendidly preserved example in Baltimore, provided the prototype. The dominant figure of the scene is no doubt the nude who lets himself down from the wall behind Ascanius. Like certain figures in the *Battle of Constantine,* he can be linked to late Antonine and Severan "mannerist" battle sarcophagi, scenes of struggles between Greeks and Gauls or Romans and barbarians.

The costumes in the *Battle of Ostia* are taken from the Column of Marcus Aurelius, a correct notion since Antonine armor survived long into the early Middle Ages. The idea of representing a scene of supplication and the actions of the captors and of the unfortunate prisoners brought before the Pope are based on the two imperial columns. All the details are there: the soldiers in chain mail binding the barbarians, forcing them to kneel, and dragging them by the hair.

The climax of Giulio's career in the fifteen years from 1526 centers in the decorations of the Palazzo del Te and, to a lesser extent, the rooms of the Palazzo Ducale, both in Mantua. The whole series of frescoes are strikingly classical in the Roman sense. The models for the lost frescoes of the garden façade of the former are the "Dacians" from the Arch of Constantine, the seated "Dacian" in the Palazzo Altieri, and the Victoriae from the spandrels of the several triumphal arches in and near the Roman Forum. These subjects were very popular in the repertory of Cinquecento sketchbooks. The frescoes in the Sala delle Metamorfosi of the Palazzo del

Te demonstrate that, when Giulio presents a variety of mythological subjects in a series of uniform panels, he takes Roman sarcophagi, especially Bacchic sarcophagi and their lids, as models.

Sarcophagi and Greco-Roman decorative reliefs have provided inspiration in whole and in part for scenes in the Sala delle Metamorfosi, such as the *Contest of Apollo and Marsyas, Orpheus before Pluto and Proserpina,* and *Judgment of Paris,* forerunners of Baroque frescoed interiors. In these works and in the many mythological compositions to follow, Giulio was influenced by his collaboration with Raphael in the Farnesina frescoes. Baroque ceiling decorations are further foretold in the full movement away from the Quattrocento patchwork view of antiquity. Giulio's mural decorations take on the broad unities of Roman sarcophagi, and their relations to Hellenistic painting through these second- and third-century sarcophagi are projected without resort to combinations of isolated recordings. The spirit of his compositions often penetrates back beyond the Roman imperial models to the sweeping nobility of creations by ancient painters and sculptors of Greco-Roman antiquity. This marks a stage of supreme success in a civilization, such as the Italian Cinquecento, bent on extracting the best in its classical heritage, as that heritage was understood. The choice and presentation of myths owe much more to ancient sculpture than to the culling of Ovid implied in the titles given the rooms in both Mantuan palaces. This serves as a reminder of how rapidly, from Quattrocento on, mythological sarcophagi and reliefs were correctly identified by the humanists.

In one of the cycloramic scenes on the end of the ceiling of the Sala di Troia of the Palazzo Ducale, the *Battle around the Body of Patroclus* (1538–1539), Giulio Romano's grandest style

can be connected with a specific antiquity (figure 61). Pupils carried out the work in this series of scenes from the combats in the *Iliad,* and the brilliant designs of the master have been turned to pedestrian decoration under the hands of his assistants, in this instance, Fermo da Caravaggio. The ancient prototype for this scene is quite literally the section of an Antonine frieze with a battle scene involving Romans and Gauls. Giulio Romano probably brought this from Rome to Mantua in 1524, and it is still there. The Roman frieze includes a central group of a bearded warrior rescuing the body of a fallen comrade. The Antonine baroque sculptor, as might be suspected, copied the Pergamene group of Menelaus with the body of Patroclus for his two figures, and it is more than this coincidence that Giulio took this frieze with its central group for his version of the myth. Giulio Romano's style found its antique counterpart in Pergamene or Antonine baroque sculpture and painting, and he, like the Roman sculptor of the relief, gravitated most naturally to the ultimate model of a group created in Pergamon around 200 to 150 B.C. The link is subjective rather than antiquarian, for until the nineteenth century the copies of the Pergamene Menelaus and Patroclus known in the Renaissance were thought to represent Ajax with the body of Achilles. The whole process is one of the many examples of an artist finding his spiritual and technical niche in Greek art through the intermediary of a Roman derivation in a style which he had already made his own.[6]

Generally throughout the Palazzo del Te and the Palazzo Ducale the closest dependence on the antique is in single panels without the great force of gigantic perspective so often marked in Giulio's late work. An excellent example is the *Triumph of Vespasian and Titus* (1537), painted for the Gabinetto dei Cesari of the Palazzo

Ducale and now in the Louvre (figure 62). The majesty of the triumph, passing through the Arch of Titus at the right, is expressed in the sculptural dignity of Raphael's High Renaissance style. The colors are more sober than is usual in Giulio's repertory, which is grounded on the feeling that, however expressive, painting is basically a departure from the bas-reliefs of the Romans. The sculptural qualities of the scene are enhanced by the fact that the passageway relief of the Arch of Titus, visible behind part of the seven-branched candlestick, repeats with slight variation the scenes of the whole composition. And the constant fascination of Cinquecento artists with Nereid sarcophagi has supplied the relief on the front of the chariot in which the two emperors stand. The profiles of Vespasian and Titus are faithful to High Renaissance studies of Roman coins, but a coin of the short-lived emperor Didius Julianus (A.D. 193) has supplied the face of the bearded man beyond the horses, and the three Roman cuirasses in the scene come either from the Column of Marcus Aurelius or from Antonine and later statues. All falls neatly together, however, with clouds, mountains, and the ruined aqueduct between Medieval castles projecting our vision around the path of triumph. The Victory flying down from the upper left completes the sense of balance with the arch at the right, both serving to hold everything in close relation to a major monument of Roman historical carving such as the two panels on the Arch of Titus.

The stucco relief of the *Rape of Proserpina* in the Sala delle Aquile of the Palazzo del Te is seen, through the preparatory study in the École des Beaux-Arts, as a reversal of a Roman sarcophagus showing this scene. The greatest development out of and sublimation of antique forms, or away from direct dependence on the antique, comes in ceiling panels, such as the series form-ing the Sala di Psiche. Even here, Penni's work from Giulio's designs contains echoes of familiar Roman sarcophagi. The barbarian couple in the *Clementia* scene on the Los Angeles sarcophagus with scenes from the life of a Roman general (figure 1) becomes *Psyche and her Father at the Oracle*. The gestures and general costume are the same. The figure below Psyche, behind the steps, is very much an echo, in position and concept, of the barbarian child in the Clementia scene of the relief.[7]

Certain series, such as the Loggia della Grotta, are more classical than others. The much-imitated stucco processions in the Sala degli Stucchi are based on the friezes of the Column of Trajan and the Column of Marcus Aurelius. The preliminary versions in the Louvre and elsewhere bear out the correctness with which the scenes were copied as they wind around the columns. Legionaries, signifers, barbarians on horse and foot, female prisoners with baggage and children, wagon trains, exotic animals, and a seated Writing Victoria appear.

Parmigianino and Bronzino

Francesco Mazzuoli (1503–1540), called Parmigianino, represents a much fuller development away from Raphael and toward Mannerism. Yet, he was born only four years after, and died six years earlier than, Giulio Romano. Parmigianino worked in Rome from 1524 to 1527, enjoying short-lived prosperity and leaving just after the sack of the city. The key in his stylistic relation to antiquity lies in a casual approach to classical art, which, nonetheless, emerges as a consistently strong degree of Mannerist classicism. His Roman studies of the antique seem to have been "quite superficial," although drawings from antique models exist for this period in his development. Throughout his brief career,

more reminiscences of antique statuary turn up in his drawings than in his paintings.[8]

One of these drawings is a study, in the Uffizi, of the head of the older son from the Laocoön group (figure 63). He is seen in two views, in profile to the left. Parmigianino used these full wash views on several occasions, in one instance as the model for a minor figure in his etching of the *Entombment*. Obviously he liked the curly-headed, open-mouthed elder son because, while the whole Laocoön group expresses in Greco-Roman sculpture what Mannerism sought in Cinquecento painting, this particular figure is the most expressively Mannerist of the group. It makes a much stronger impression than the younger son, who fails to escape from the snaky coils.

Other artists reacted to this same head. Some reactions are almost breathtaking in their twentieth-century immediacy. For his *Dead Christ with Angels,* in Boston, Giovanni Battista Rosso used a mirror image of the torso of Laocoön for Christ and the head of the elder son twice, in left and right profile, for the flanking angels (figure 64). The effect is that of a new, Christian, Laocoön, in a series of Mannerist profiles at varying degrees from the picture plane. The intermediate stage between the Laocoön and Rosso's *Christ* was provided by Michelangelo's study for a *Pietà* (about 1519), in the Louvre.[9] Rosso reversed Michelangelo's drawing to create his own version of the *Dead Christ*. The High Renaissance exploitation of balance and clarity provided the Mannerists with a complex relation of basic designs and motifs reused and reversed, reduplicated and revised in the work of the great masters. A single antique source, like the Laocoön or the Belvedere Torso, reappeared again and again.

Parmigianino's experience with ancient art and the temper of the decades in which he worked gave him a taste for a somewhat classical, but still far from archaeologically exact, appearance of costume. This appears in his mythological subjects and in his few saintly legends which take place in a classical setting. Rather than an understanding of classical art, this has been termed "only an acquiescence in the current mode." In general, the artist experienced a casual response to tangible antiquity. Parmigianino's unclassical disposition, however, was genuinely responsive to content and atmosphere of antique mythology. He felt the effect of the literary heritage of antiquity, as distinguished from its visual survivals.

These diverse contacts with the classical tradition often resulted in a type of religious painting which, while not classical in form, was imbued with more classicism than Christian feeling. This is true of the *Madonna della Rosa* (1528–1530), now in Dresden. Legend has it that, until it was given to Pope Clement in Bologna in 1530, the painting was entitled "Venus and Cupid"; it then became a Madonna and Child. Qualities of surface beauty and sensual feeling are evident. The pose of the arms of the Madonna echoes a Venus of the Cnidian, Capitoline, or Medici type, an unfunctional and irrelevant imitation of the attitude of an antique. In this detail the painting is related to Bronzino's *Madonna and Child (Holy Family)* in the Pitti (figure 65), painted about 1550 on his return from Rome and certainly influenced by the *Madonna della Rosa*.[10]

Both artists clothe the Madonna in a nearly transparent chiton set off by a more opaque robe or himation, indicating a respect for the physical beauty and proportions of the classical model. In choosing this clothing Parmigianino gravitates repeatedly to works of the post-Pheidian period in Attic art. He chooses these details from Greco-Roman statues or Neo-Attic reliefs

based on the sculptures of Alkamenes, Agora-kritos, or Kallimachos. The Mannerist eye went quite naturally to the mannerist contrasts of form and drapery in the Venus Genetrix and related types. The matronly type, known in a number of copies and called the Livia Laterane from the chief replica, occurs constantly as a Madonna. The distinguishing detail is the ample chiton which forms a loose over-fold beneath the breasts. The original preserves the high-classical forms of a Pheidian Demeter, softened by an elaboration of stance and a loosening of dra-peries.

Classical architecture is all but eliminated in the Mannerist projections of the human form. The dominance of the distorted human in Man-nerist painting not only subordinates architec-ture but often gives buildings an unnatural humanity of their own. In Parmigianino's *Ma-donna with St. Zachary, the Magdalen, and the Infant St. John,* painted in Bologna about 1530 and now in the Uffizi, the Column of Trajan (or Marcus Aurelius), without the statue on top, and the Arch of Constantine appear as vistas in the right rear (figure 66). They are no doubt no more than the usual classical stock in trade, but it is interesting to see them as indications of the artist's Mannerist outlook on antiquity. Where the Dacians should be on the entablatures of the arch, he places a statue of Mars Ultor (taken from the colossal marble known in Rome since 1500, the Massimi Mars Ultor now in the Museo Capitolino). Where Constantine's titles are re-corded in Latin, there are faint traces of a mean-ingless *Greek* inscription. Both column and arch have that indefinite unreality which later in the century became a stamp of Flemish Manner-ist landscape.

Like the *Madonna della Rosa,* the Madonna of Parmigianino's *Holy Family with St. Zachary* is a version of the Cnidian Venus, in hair and

face as well as in body. Parmigianino surpasses Bronzino, his younger contemporary, in greater feeling for the classical form of drapery. It is perhaps for this reason that critics speak of the international, or at least timeless, character of Parmigianino's Mannerist style. His works are suspended in an elegant time and space that could only have been created at the end of the High Renaissance. The influences of classical antiquity in their creation are very evident.

An anonymous chiaroscuro woodcut after a composition by Parmigianino, *The Martyrdom of Saints Peter and Paul,* records the artist's con-tribution to the long line of Roman imperial *adlocutio* or *supplicatio* scenes. Despite the anti-quarian paraphernalia, the setting is dominated by figures that are explosive in gesture and in contrast of active and static qualities, or quali-ties of arrested motion. The excitement of the scene makes thoughts about classical antiquity difficult, a characteristic giving this aspect of Parmigianino's work a spiritual link with the High Baroque. Other compositions associated with Parmigianino and known from chiaroscuro woodcuts illustrate the development and round out the breadth of his style. One of these is a reclining river god in Michelangelo's style turned into a figure of *Saturn.* The design, with putto helping to hold up the hourglass balanced in Saturn's right hand, is derived from the re-clining seasons and amorini on the lids of Roman sarcophagi.

Bronzino

Agnolo Bronzino (1503–1572) has been men-tioned in connection with his *Holy Family,* containing a Madonna who emerges as a languid transformation of the Cnidia. In face and hair Bronzino catches the mechanical preciseness and hardness of the Medici or Vatican Cnidia,

turning it into something suited to the polished lucidity of Mannerism. This painting also contains a Joseph, who is, line for line, curl for curl, a Roman portrait of the Severan period. While Bronzino displays in his Mannerism less of the consistent feeling for classical costume manifested by Parmigianino, he falls back to a much greater degree on the Quattrocento habit of excerpting classical poses in his multifigured compositions. Because he takes the poses rather than the specific figures out of ancient art, he is a product of the High Renaissance with its latitude of experiment with the Greco-Roman past.[11]

Bronzino's *Nativity* (1535–1540), in Budapest, can be termed Quattrocento in feeling. Joseph, seated at the left, is taken from one of the two Muses perched in corresponding positions on a rock, statues long in the Vatican. The shepherd kneeling at the right front could be the satyr who stokes the furnace on one of the class of sarcophagus lids showing satyrs imitating philosophers at a symposium. The angel running in from the left is derived from the running Victoria on Roman coins of the Severan period (about 190–240) or from a comparable triumphal relief fragment in marble. Leonardo's gestures have had a marked effect on the other angels. The arms of one are folded in a stereotype of adoration, and the angel in the right rear holds up a branch in that gesture of pointing so familiar in Leonardo.

In *Portrait of a Man* (1532–1540), in Berlin, the type of classical marble most appealing to the painter appears as an accessory, poised on a Renaissance plinth on the circular table in the background. This painting shows how well Bronzino could draw an ancient sculpture when he chose to be accurate. Although the statuette is headless and has lost the left arm and much of the legs, it is clearly Aphrodite gathering her drapery around her lower limbs, with the right hand in the *pudique* gesture which Parmigianino and Bronzino adapt so successfully to their Madonnas. The gesture, elegant in the sculpture, has been carefully carried out by the artist.

The two versions of *Venus, Cupid, and Jealousy* abound in motifs and designs derived from classical sources. In the painting in Budapest (1545–1546), Cupid is a Mannerist version of a Praxitelean Eros. Venus slides into a form of Mannerist languor and elongation of figure which has its basis in the principal figures on Nereid sarcophagi. This occurs in a more exaggerated way in the painting in London (about 1546) where the right arm of Venus reaches up in the same way which Nereids caress hippocamps on the Antonine and Severan sarcophagi of this class. The sculptural organization of the figures in several degrees of surface plane and in three levels of heads (counting the masks at the bottom) is the effect secured by looking at a section, say a third or a quarter, of a sarcophagus panel from a very short distance and at eye level with the middle of the relief. Mannerist drawings of sarcophagi show this, for they exhibit for the first time in postclassical study of the antique a desire to project details of the relief to the surface of the picture plane in a drawing of large, almost cartoon, scale.

In *Christ in Limbo* (1552) in the Museo di Santa Croce, Eve is a combination of the Cnidia and a reversal of the torso of Aphrodite shown in the *Portrait of a Man*. The strongly classical woman in the foreground, pulling a man from limbo, is almost a female Pasquino. She is some Amazon, perhaps Penthesilea from the Pergamene group known in a few replicas, or else one of the women of the pendant Artemis and Iphigenia group now in the Ny Carlsberg Glyptotek in Copenhagen.[12] The particular refinements of drapery seen in the figure of Eve are

taken from a Pasitelean work such as the Electra of the Orestes and Electra group in Naples, a Neo-Attic eclectic statue which has come down from the first century B.C. in a number of free-standing versions. The Pasquino, viewed from the back, appears again, supplying the torso of the man in the left foreground, pointing inward toward Christ. Christ striding in sculptural isolation across the central plane of the crowded composition suggests that Bronzino sketched from a fragmentary replica of Myron's discobolus (figure 9). In Bronzino's day such a torso in the Cesi garden next to the Vatican was described by the critic Ulisse Aldrovandi. Christ has emerged as a mirror reversal of the ancient marble. In this painting Bronzino is extremely torso-conscious, to state it mildly, and the sculptural effect is so overwhelming that it gives a feeling of opening the door to an antiquarium or storehouse of Greco-Roman fragments. Those who have looked behind the gates across the lower arches of the Theater of Marcellus in Rome or through the grille at the Tower of the Winds in Athens will immediately sense this aspect of Bronzino's antiquarianism.

For a Mannerist, Bronzino is very classical in his careful, sober approach to details of antiquity. He paints classical profiles constantly and handles classical form superbly. He must have spent much time drawing after the antique, and, even in his most mannered religious and mythological paintings, does not conceal this training.

The Cinquecento Medalists

CAVINO

The High Renaissance medalist also perpetuated and disseminated the classical ideal for his fellow artists. The greatest classicist of the Cinquecento medalists was Giovanni Cavino,

known as the "Paduan." He was a contemporary of Benevenuto Cellini, having been born at Padua in 1499 or 1500 and dying there in 1570. Padua, with its long classical tradition, was the center of his output. Though he produced many medals of distinguished Paduan jurists and professors at the University, Cavino is best known for his "Paduans," imitations of Roman sestertii and aes.[13]

In choosing his ancient prototypes, Cavino had the help of Alessandro Bassiano, who left a manuscript on the "Lives of the Twelve Caesars." Cavino favored medals of the first twelve Caesars, inventing types where none existed. His reverses have a Roman second-century flavor, and the hair styles of his portraits of all periods resemble those affected by the Antonine emperors. His medallions are further examples of the concordance between Cinquecento and Antonine "baroque" classicism. One hundred and twenty-two of Cavino's dies are still preserved in Paris, and his ancient coins can still be studied from these. They are too Mannerist to be confused with their ancient prototypes, and they have a noticeably homogeneous style. They are too round, too regular in lettering and surface details, too broad, and too thin to be taken for ancient. The setting of the design in a border of regular dots is a telltale feature. They were, however, very popular and remain so today, spreading the science of ancient numismatics and compositions after ancient (Roman imperial) coins in many new quarters. Giovanni Cavino's son continued to use the dies his father had cut, many of which were in circulation in the seventeenth and eighteenth centuries.

Several of Cavino's masterpieces attempt to create portrait bronzes for rulers (such as the Roman emperor Otho) who never struck such coins. A fascinating fabrication is the bronze medallion or coin of sestertius size honor-

ing Artemisia of Halicarnassus, who lived about 350 B.C. (figure 67). Her bust on the obverse (amid the inscription "Artemisia Queen" in Greek) recalls coin portraits of the Ptolemaic queens or possibly commemorative aes struck for the two Faustinas, consorts of Antoninus Pius and Marcus Aurelius in the second century A.D. A veiled female head also appears on coins of nearby Cos minted before 300 B.C. Although the style is quite different from Cavino's medallion and the subject is probably Demeter, to the sixteenth-century antiquarian the head easily could have been taken for that of the famous Carian queen. As the Greek inscription indicates, the reverse presents Cavino's attempt to reconstruct the Mausoleum, using the descriptions provided by Pliny the Elder and Vitruvius. Considering that this Wonder of the Ancient World was not rediscovered until Sir Charles Newton's expedition in 1856, the medalist has done a very creditable job. Although the decoration of the base resembles Renaissance reconstructions of Hadrian's tomb beside the Tiber, the colonnade with statuary and the stepped pyramid surmounted by the quadriga give the structure as a whole a plausibility beyond that usually found in Renaissance revisualizations from classical literary sources. As a work of Cinquecento art, this "Paduan" of Queen Artemisia and her contribution to history and the arts conveys the flavor of a Roman imperial medallion with an originality which confirms Cavino's reputation as a medalist above the level of a mere skilled imitator.

While Cavino was concerned with imitations of important Roman medallions and sestertii, other medalists were using the High Renaissance style and the trend toward greater antiquarian accuracy in casting and striking to fashion contemporary masterpieces. Much of Cavino's success in imitating ancient coins came from the fact that he struck rather than cast these imitations. Casting still remained the technique used by creative medalists who also produced bronzes of larger scale. Casting techniques improved, and it was often difficult to tell a carefully cast medallion from one which had been struck. Generally speaking, medallions of the size of those instituted by Pisanello and his successors, and larger pieces, were cast, for presses were as yet incapable of stamping out dies of these sizes.

LEONE LEONI, GIACOMO DA TREZZO, AND POMPEO LEONI

A triumvirate of medalists created a number of aesthetically and historically noteworthy medallions in the second half of the sixteenth century: Leone Leoni (1509–1590), Giacomo Nizolla da Trezzo (1515/20–1587), and Pompeo Leoni (1535–1610). The work of Leone Leoni is often difficult to distinguish from that of Da Trezzo, and Pompeo was the son of Leone Leoni. All were versatile artists who made their fame working for the Austrian and Spanish Hapsburgs. Pompeo Leoni worked a considerable time in Spain, where Da Trezzo also found commissions after jobs in Milan and in the imperial service in the Netherlands.[14]

Leone Leoni was the greatest; the others to a certain extent continued the High Renaissance and Mannerist medallic styles he set. Superlative portraits, complex and understandable reverses, careful lettering, and the use of Roman imperial details characterize his medallions, which were struck in silver and bronze. Leone Leoni was born at Arezzo, and worked from 1537 to 1540 at the papal mint where he caused Cellini's imprisonment. In 1540 he was condemned to the galleys for participating in a murder, but the Genoese admiral Andrea Doria procured his release. From 1542 until his death, although nominally engraver to the Milanese mint, he

traveled to the Hapsburg courts on a number of occasions.

Leoni's best series of medallions are those of the Hapsburg family, carried out in 1548 and 1551. They are strongly classical, in the powerful spirit of Leoni's close friend Michelangelo, and they take the best of Michelangelo's distortions and dramatizations of the human form at a time when his followers had begun to turn these forms into Mannerism.[15] The symptoms of Mannerism show in these medallions, but the drawing and modeling are well controlled. They do not move counter to the containment demanded by the medium and its size. His medallion of Charles V commemorates the victory of Mühlberg in 1547. The imperial portrait in contemporary armor on the obverse is matched by a reverse showing Jupiter thundering against the giants, who pile Ossa on Pelion in their efforts to reach Olympus, DISCITE IVSTITIAM MONITI, Learn Justice Ye Admonished Ones. This reverse is the medallic counterpart of Michelangelo's Sistine *Last Judgment* in its piling up of powerful forms, the gods clustered around Jupiter in the upper level, bodies hurling through the central area, and dead giants enframing the bottom curve of the tondo. The reverse is an almost indecipherable mass of struggling figures, male and female, nude and nearly so.

The medallion of Maximilian, King of Bohemia, has as its reverse Mercury, QVO ME FATA VOCANT, Whither the Fates May Call Me. Mercury, the prototype of Giovanni Bologna's celebrated figure, flies to the left, with right hand raised in Leonardo's gesture of pointing. His left hand holds the caduceus, and his cloak floats behind him as he speeds over the cloudy landscape. The composition stands midway between the elegant Mannerism of Bologna's bronze and the Roman classicism of Raphael's frescoed Mercury in a pendentive of the Farnesina. The Isabella in the series presents Leoni's contribution to the long succession of Renaissance medallions representing the Three Graces on the reverse. They shower riches on a group of Cupids or putti, and are Cinquecento versions of the late Hellenistic group best known from the Roman marble replica in the Piccolomini Library in Siena. The companion piece of Ferdinand I is medallic classicism's interpretation of reclining nudes of Michelangelo and Rosso. The Medici Chapel figures, Rosso's Danae, or the Sistine ignudi come to mind. To the right a river god reclines in reeds, with an overturned urn at his right elbow, holding a paddle in his raised left hand. The colossal Roman figures on the Capitol, in the Vatican, and the Louvre provide the monumental prototypes, but the rearrangement of Michelangelo's more balanced poses and its compression in a small, circular area is a tribute to Leone Leoni's genius.

His medallion of Pietro Aretino (1492–1557), executed about 1542, uses a reverse symbolic of Aretino's position as an often unloved literatus, VERITAS ODIVM PARIT, Truth Begets Hatred. Truth, seated and nude, is crowned by Victory, while a Pan (Hatred) crouches before her. Truth points down at Pan and looks up at Jupiter in the clouds. The Victory is derived from Roman second-century bronze coins where such a figure appears alone running or walking to the left. Truth on her seat of rocks is partly in the style of Michelangelo and partly after a Roman copy of a Hellenistic group. There are several variations of the theme of Pan and Aphrodite rendered in marble by sculptors from 200 to 50 B.C. and surviving in Roman copies. Leoni has found one or more of these suitable for his grouping of Hatred and Truth.

Leone Leoni executed a medallion of Pope

Paul III, Farnese (1534–1549). This piece is dated 1538. Roma with Wolf and Twins, and the seated Tiber below, are taken directly from imperial bronzes. The group of Roma occurs only on coins of Vespasian and Titus in the late first century; Father Tiber is found more frequently on coins of Hadrian and his successor Antoninus Pius about the middle of the second century.

A medallion commemorating Gianello della Torre, engineer of Charles V, who died in 1583 at Toledo, is variously attributed to Leone Leoni and Da Trezzo. The obverse of the specimen illustrated here is taken from Leone Leoni's medallion of Philip II in the series of 1547. The fountain of the sciences, as designed for the Della Torre medallion and combined with the older obverse in this piece, fills the reverse, VIRTVS NVNQ[VAM] DEFICIT, Virtue Has Never Failed (figure 68). A Caryatid of the type from Herodes Atticus' temple in the Campana off the Via Appia or those in the Canopus of Hadrian's villa at Tivoli pours water from an urn on her head toward figures in the style of Michelangelo at either side. One stoops to draw water from the pool around her. The old man from the Meleager sarcophagi, a figure much exploited in the Quattrocento, completes the scene, as the one who reaches his cup toward the stream at the right. Mannerism, a statement of its advance in medallic art, is evident in the fussy drapery over the monumental, High-Renaissance figures of the men, old and young, around the fountain. The Caryatid, a Roman second-century copy of the fifth-century examples on the Erechtheum in Athens, has undergone this important stylistic change at the hands of the medalist.

Pompeo Leoni is represented by a medallion of Ercole II d'Este, fourth Duke of Ferrara (1554)· The obverse bust is encompassed in a richer display of fur and armor than hitherto en-countered. It is the parallel of Leoni's freestanding busts in bronze and marble. The female on the reverse has undergone a Mannerist projection to the surface of the picture plane and is surrounded by the legend SVPERANDA OMNIS FORTVNA, All Prevailing Fortune. She is chained by her left foot to a boulder in a rocky landscape. On this stony area appear a vase and a celestial globe. This concept of Fortuna is hardly an example of the antique. It is a foretaste of the allegories in marble to be initiated by Bernini and continued by his Baroque followers, in the following century.

Venetian Classicism:
Titian and Tintoretto

TITIAN

Titian (about 1490–1576) was constantly and actively introducing a classical element in his painting.[16] As suited a great artist of the period after 1500, he was consciously reshaping, not necessarily copying faithfully, classical models. The freedom with which Titian employed ancient art increased with the years. His borrowings are his own and show little concern for historical criticism or archaeological correctness. He was not interested in ancient art as an example of naturalism, but, like his contemporaries, he was receptive to the formal qualities of ancient painting and sculpture. He transformed the human image of antiquity into the High Renaissance "grand manner," and had an eye for the expressiveness of ancient prototypes in terms of gesture and movement. (He used Pergamene Gauls and late Hellenistic satyrs, and on one occasion even hung a cast upside down to endow it with more proto-Baroque qualities than it already possessed!) Naturally he transformed ancient motifs and used classical forms in connotations entirely foreign to their original

purpose. (For example, in the *Europa*, the Pergamene Gaul falling on his back becomes Europa on the back of the bull.) After 1560 he abandoned the use of ancient models and relied on summaries of his older experiences, that is, on the designs which he had evolved from ancient art and elsewhere. His "natural shapes begin to dissolve in dimmer lights and sharper contrasts, the violence of emotional expression growing in proportion with the power of formal integration." "He mostly revived in his own work one aspect of ancient art to which he was supremely sensitive: its inherent expressionism."

An important, major characteristic of the antique sources used by Titian while working in Venice is the number of instances in which the antique composition is reversed. This suggests that he worked from engravings, not from firsthand sketches of the actual monument. The aesthetic problems or discrepancies of reversal were of no concern to artists and antiquarians before the disciplines of the eighteenth century.* Titian, using ancient statues and reliefs for his own subjective purposes, was little concerned whether he was copying the ancient work of art directly or in mirror reversal.

Titian's borrowings from the antique can be divided into five principal periods of his work, from about 1505 to 1560. The first period covers the years from about 1505 to 1511. The style of classical monuments was easily grasped and well understood in the finished paintings. Ancient prototypes are rendered in a general way and perhaps from several sources. "Ancient" monuments are freely made up. The base on which St. Peter sits in the *Votive of Jacopo Pesaro* (about 1505), in the Antwerp Museum, is a relief in the ancient manner and includes scenes taken from a sarcophagus with Bacchic reliefs. Titian was another expert at painting in the style of the antique without making verbatim copies. The absorption of ancient statuary into his figures is the main concern, but when, as here, he chose to include an ancient marble as furniture his inventiveness was unparalleled. On the other hand, he needed an imperial statue for the background of *St. Anthony Healing a New-Born Child* (1511), in the Scuola del Santo at Padua. For his Caesar he copied the cuirassed Agrippa or Nero Drusus from the Julio-Claudian commemorative relief in San Vitale at Ravenna. The figure is lifted neatly out of context, and the other Julio-Claudians in high relief either side of this figure are ignored.[17]

In the second period (about 1512–1520), the prototypes are single figures and motifs taken from sarcophagi, rather than single statues. In *Sacred and Profane Love* (about 1516), Profane Love has been recognized as a Nereid transferred from her sea beast on a sarcophagus to the well. Nereids were very attractive to artists of the Cinquecento; their elongated figures and complex and sometimes mannered poses exercised considerable appeal, and they are used again and again, in the most unlikely places. The relief on the front of the well is a free excerpting of figures from an Endymion sarcophagus on the left and from a Bacchic sarcophagus with Pans chastising each other on the right. A fluted phiale of purely classical design is poised on the rim above. The same Nereid used for Profane Love appears again in a surviving fragment of a lost fresco of the Fondaco dei Tedeschi, underlying the fact that artists were continually going back to their copybooks. The potentials of con-

* The plates of Bartoli-Bellori's *Admiranda* late in the seventeenth century demonstrate how little interest an artist or archaeologist could take in publishing the *direction* of a relief correctly. Bartoli must have seen the frieze of the Forum Transitorium nearly every day; yet he spread it over his plates in reversed form.

trasting poses in Medea sarcophagi attracted Titian. In the *Feast of Venus* (about 1518), he portrays the screaming Creusa in mirror reversal as a maenad, and the Christ Child in the finished version of the so-called *Madonna with the Cherries* (1515) is drawn from one of the children of Medea on the same sarcophagus.

The third period, from 1520 to 1528, is the period of maturity, of full development. Statuary now appears. About the time Rosso is using the Laocoön for *Dead Christ with Angels* (figure 64), the Laocoön (by way of a copy newly arrived in Venice) becomes the Rising Christ in a new altarpiece, the *Resurrection* in Brescia. Saint Sebastian at the right is fashioned after Michelangelo's Bound Slaves (figure 57), and, since the cuirassed St. Celsus in the left-hand panel recalls the face and gesture of Leonardo's St. John the Baptist, three great currents meet in one of Titian's works. Other artists at this time and in the centuries to follow look at the central figure of the Laocoön group, the old Trojan priest, and catch the faults of the figure and its traditional restoration (figure 63). Titian's Christ leaps through the sky as he holds aloft his white banner. This sense of sudden springing comes from the Laocoön, both from the mannered concept of what should be a titanic struggle and from the opened composition imparted by the misunderstood replacement of the raised and bent right arm. The years of Titian's work on the altarpiece in Brescia coincided with the years in which restoration of the Laocoön was being argued and tried in various media by the leading sculptors of Italy.

Other uses of ancient statues and reliefs at this time are varied and imaginative. *Bacchus and Ariadne* contains several. Orestes, portrayed in his fury on the group of Hadrianic or early Antonine sarcophagi showing the bloody revenge on Aegisthus and Clytemnestra, becomes the merry Bacchus leaping toward Ariadne from his lavish cart drawn by leopards. Ancient Bacchic reliefs supply other figures in the neo-Dionysiac scene. The Ariadne and the maenad behind Bacchus are taken from a fragment in Pisa; even the Silen entwined with snakes in the foreground is the Laocoön in reversal and seen from one side, the way he might have been studied more easily before the first restorations of the group. The old Silenus on his donkey in the right background is a standard figure on a certain class of Bacchic sarcophagi showing the triumphal procession of the god of wine and his consort.

In the *Entombment* (about 1516–1525), from Mantua and now in the Louvre, the ever-popular procession of Meleager's return provides the central group of the sad scene. The composition, in the correct direction when compared with the sarcophagi showing Meleager on his death-bed, is reversed when placed alongside the scenes of the procession. The scene naturally invites comparison with Raphael's *Deposition* (1507) in the Villa Borghese. When Raphael's composition is reversed, the two are very alike, Titian having eliminated two figures and closed in the landscape, as the change in subject from the Deposition to the Entombment would dictate. Raphael's group, with its sculptural, delineated figures, is an intermediary between the Roman sarcophagi and Titian's painting.

At this time Titian carried out a large altarpiece with the *Death of St. Peter Martyr*. The painting perished in a fire in 1867, and it is chiefly through engravings that its classical sources can be determined. Two statues figure prominently. The Pasquino, viewed from the back, is the murderer stooping over his victim, prostrate on the ground. In Titian's time a Hellenistic Cupid with water jug on his shoul-

ders, a fountain figure surviving in a number of replicas, received the lofty title "Cupid of Pheidias."* Titian drew this marble or, more likely, a cast of it in his possession. He then turned the figure into an angel in his painting, by substituting the martyr's palm for the water jug. The pen sketches for the painting in the Musée Wicar at Lille, show the steps in the transformation of the classical statue.

There was less borrowing in Titian's fourth period, about 1530 to 1545. Generally, this is a period of allegories and portraits. The Laocoön and an Orestes sarcophagus were used more than once where the inspiration they provided could be exploited. The dead soldier stripped of armor, in the foreground of the *Battle of Cadore* (1538), is the slain Aegisthus from one of this group of Orestes sarcophagi. The scene is known from the copy in Florence of the painting formerly in the Ducal Palace in Venice. The figure is reversed. Artistic adaptations—for a Biblical legend, for example—could be quite imaginative. The head of Laocoön is adopted for the face of St. Nicholas in a large altarpiece for the Frari, now in the Vatican. The antique model is also reversed, as is true in nearly every case considered so far.

An exception to the rule of reversal occurs in the *General Del Vasto Addressing his Soldiers* (about 1540), one of the few paintings in which Titian takes his composition from a Roman state or historical relief rather than from a statue or a sarcophagus. One of the Aurelian panels in the attic of the Arch of Constantine is the model. The scene of two Sarmatian prisoners led before Marcus Aurelius is easily transformed into the marquis, attended by a page. The

armored general is standing in classical pose of *adlocutio* and addressing the soldiers who form a semicircle around the estrade. As in the Roman relief, spears and standards fill the background. The total effect is one of stiffness almost alien to the creative freedom of which Titian was capable. No doubt, however, the classical scene in modern dress pleased his patron.

It was about this time (1537–1539) that Titian created his series of portraits of the canonical twelve Caesars for the Palazzo Ducale at Mantua, the last (Domitian) being painted by Giulio Romano. The set went to Charles I of England, thence to Spain in 1652, and is now known only from copies. The iconography from ancient busts and coins had been carefully worked out, so it was said, but the spirit is that of the portrait of General Del Vasto, since none of the Caesars wear costume more than remotely correct and at least two (Caligula and Claudius) are dressed in Cinquecento ceremonial armor.

In 1538 Titian painted a *Presentation of the Virgin at the Temple,* now in the Accademia in Venice (figure 69). At first glance this composition, handled with colorful clarity, seems to place more emphasis on the portraiture of these years and on four or five overt excerptings from antiquity than on general subordination to the habits of Roman imperial art. Such is not the case. The groups of Venetian notables at the left are balanced by a marble cuirassed torso in the right foreground. This exercise in observation from the antique looks like the Belvedere Torso (figure 77) in Greek imperial armor, but the cuirass type is too archaeologically correct to have been invented by Titian. Cuirassed statues of this type are found mostly in Greece, and in the Cinquecento, Venice had a higher proportion of antiquities from Hellas and the Aegean than any other Italian city.

The other bit of statuary in the painting is

* Titian's contemporary, Marten van Heemskerck, is best remembered among artists who recorded one replica prominently located as a fountain in a niche above a water trough in the garden of the Villa Cesi.18

partly visible in a niche just above the High Priest and the Virgin. Titian has caught quite clearly the contrast of heavy, zigzag, and transparent folds in an archaistic maiden or kore, a type of work produced for Roman patrons in the two centuries following 100 B.C. and existing in all major collections of ancient marbles. Prints and sketchbooks no doubt supplied the elongated pyramid of Caius Cestius in the left rear and the Palladian pronaos behind the rusticated stone staircase. The pyramid is handled in a manner reminiscent of such structures in the Quattrocento creations of Marcanova. The colonnade and staircase are put together from a side view of the Forum of Augustus, with the staircase derived from external vistas of the curtain wall. These parts of Titian's composition could also have found their inspiration in a similar recording of the Temple of Antoninus Pius and Faustina in the Roman Forum, before its internal transformation into an early Baroque church (1602).*

In addition to these obvious borrowings, the composition of the *Presentation* as a whole has the axis and grouping of a Roman imperial state relief, a tradition in Renaissance art which has been traced through various paintings from the *Tribute Money* of Masaccio. Statuesque figures and classical draperies abound, particularly where the women appear. The old woman seated with her basket of eggs to the right of the staircase could be a restoration from the seated figures in the West Pediment of the Parthenon; she might also be compared with a figure derived from these pediments—the statues of Cybele based on the Athenian cult-image by Agorakritos for instance. The lady receiving the group at the extreme left is the Italia or personified Alimenta

* Dupérac published, as plate four of his *Vestigi di Roma* in 1575, just the view of the building in the Roman Forum that Titian could have used, the rustication of the cella becoming the staircase of the Temple.

from a sestertius of Trajan or the *Anaglypha Traiani* in the Roman Forum, even to her long, girt Doric chiton. The various ways in which single figures or groups move toward the principals at the left and the use of the gestures are worthy of the complex, dramatic classicism of the Judgment of Paris sarcophagus in the Villa Medici. That relief was circulated far and wide in the High Renaissance in the work of Marcantonio Raimondi. Therefore, although Titian's *Presentation* might seem to belong in a class of Venetian High Renaissance paintings which have been little influenced by classical antiquity, the more the painting is analyzed the deeper appears its involvement with the Greco-Roman world. This is true of most of Titian's compositions. The undiminished antiquarianism of the Cinquecento and the subjective communion between the arts of ancient Rome and the Italian High Renaissance caused this involvement.

The fifth period, about 1545 to 1560, opened with Titian's visit to Rome in the winter of 1545–1546 which provided new stimuli. On his return the painter made great use of the classical sculptures of the Grimani collection in Venice. The small Gauls, copies of the second group dedicated by Attalus I at Pergamon and Athens about 200 B.C., were very popular. One of the Gauls falling on his back becomes, in reversal, *St. Lawrence,* tortured on the griddle, in the painting done about 1548 and now in the church of the Jesuits (figure 70). He also becomes *Tantalus* in the ceiling painting for Queen Maria of Hungary, known best from an engraving by G. Sanuto. In the engraving he is facing in the correct direction.

The same Gaul falling on his back appears as Europa on the bull in the *Rape of Europa* at the Gardner Museum (figure 71). This painting is made up entirely of borrowings from the antique. The Cupid on the dolphin at the lower

left is taken from a Renaissance fountain based on a Hellenistic model.* The Amor at the top is none other than the "Cupid of Phedias," painted from Titian's cast of the marble turned and suspended upside down (figure 72). The bull is one of those sea beasts found on Nereid sarcophagi. Although the principal figures have too much of Titian to be termed classical in a narrow sense, they reach a wholesome degree of exuberant Hellenism, of the type found in Pergamene painting and mosaics. Most Greco-Roman in this powerful rendering of myth is the landscape at the left and rear, where Europa's companions gesture helplessly on the shore. These passages, especially the mountains in the background, rival the spirit of the best ancient landscapes, the series with scenes from the *Odyssey* coming first to mind.

In *Perseus and Andromeda* (about 1555) of the Wallace Collection the suspended Andromeda is derived from the dying daughter of Niobe, held by her distraught nurse, on second- and third-century sarcophagi of the group showing the slaughter of the Niobids. Even Andromeda's face has assumed something of the Praxitelean, Cnidialike qualities found in the daughters of Niobe. They are well documented in the various Roman copies, chiefly those brought by the Medici from Rome to Florence. The Perseus develops Titian's interest in the foreshortened figure swooping down from overhead, and, if the overzealous could claim to see a dressed-up reversal of one of the Grimani Gauls in this figure, it would be time to say that the search for classical sources had overstepped itself. The similarity is due to the fact that an artist as gifted and imaginative as Titian could elaborate on a basic design in any number of ways. Nereids and nymphs with their combined feminine charm

* The actual fountain was acquired by Mrs. Gardner and is now in the garden at Fenway Court.

and dramatic poses continued to interest Titian. The conspicuous posture of Diana and certain of her companions in the Callisto stories (1599–1560) is developed from a Nereid on a sarcophagus. The attending nymph replaces the sea monster on which the figure rode in its original setting.

The Ara of the Grimani collection, with its reliefs of a nymph and a satyr in amorous poses, provided the compositions for the *Venus and Adonis* (1554) in Madrid and the related study in London (figure 73). The nymph and satyr are locked together, the former spinning backward as the satyr, partly kneeling on her draped bench, leans forward to kiss her (figure 74). Titian has subdued the eroticism of the scene and changed the posture of Adonis to that of a powerful young man setting off with his dogs to the hunt while Venus twists around, like the nymph, and tries to hold him in one last embrace. A sleeping Cupid, one of the conventional classical types, fills out the scene in the left rear. The group is also used by Veronese as inspiration for the central figures of one of his small canvases (*Venus and Jupiter*) in the Holmes Collection in Boston (figure 75).[19] Here the draped seat has become the draped lap of Jupiter, and Venus spins around on it as if to tease or spar with the father of the gods. The design stands out much more than in Titian because of the small height and great width of this painting, one evidently executed to be framed above a door. In both paintings the pose of Venus derives from that of the Grimani nymph. No doubt numerous other instances such as this of the popularity of the Ara Grimani can be found in Northern Italian art of the sixteenth to eighteenth century. The motif, almost unique in antiquity and challenging to the sixteenth century, easily fixed itself in the minds and on the canvases of painters.

Titian's sixth or final period has been considered one in which there were few new classical quotations but, rather, a summary of previous experiences. This period extends from about 1560 to 1576 and contains recollections of all of Titian's older periods. In the second treatment of the *Martyrdom of St. Lawrence* (1564–1567), in the Escorial, the same sources are interpreted in a later color style. The "Cupid of Pheidas" appears again, more than once, in the sky. The *St. Sebastian* (1560–1570), in Leningrad, is made up of the walking stance of the Apollo Belvedere and the upturned, suffering face of Laocoön's younger son. The design for the *Education of Cupid* (about 1565), in the Villa Borghese, reaches back through Michelangelo's tondo in Florence (figure 56) to the group on the Phaedra sarcophagi, probably the figures on the example prominent in Pisa since the time of Nicolo Pisano (figure 23). The clothing of Aphrodite (or Artemis) even reflects the Pheidian qualities of the Roman second- or third-century relief. Finally, perhaps because the eyes of the aged often prefer minute details, in several instances in this period cameos are used as compositional sources. This specialized type of borrowing is another, final index of Titian's imagination and his ability to use its versatile suggestions in his art.

TINTORETTO

Jacopo Tintoretto was the Venetian Cinquecento artist who incorporated classical forms in painting which was dramatic, expressive, and dependent on color. Born in 1518, his recorded work spans the period from 1545 to his death in 1594. He never manifests the classical tastes of Titian, and the classicism of the figures, which fill up the surfaces of his paintings, is almost lost due to the concentration on dramatic foreshortenings and recessive diagonals mapped out in contrasts of light, shadowed tones, and color.[20]

In 1545, Pietro Aretino, who had commissioned *Venus and Cupid* (retitled *Madonna della Rosa*) from Parmigianino, ordered a ceiling-painting, *Apollo and Marsyas,* from Tintoretto (figure 76). The painting is now in the Wadsworth Atheneum at Hartford. (A *Mercury and Argus* executed at the same time is now lost.) The composition included an Apollo reminiscent of Mantegna and a central, seated Muse whose pose and drapery are as Pheidian as the colossal seated Cybele in Boston or that drawn' by Giovannantonio Dosio in mid-sixteenth-century Rome (figure 77). In this early work, Tintoretto shows himself a student of the late Quattrocento and of the early Raphael by concentrating on the poetic qualities of the contest. Marsyas is as noble a youth as Apollo, and no less a product of the Northern Italian late Quattrocento as he sits with his long, hornlike flute. The elders in the right rear come directly from Titian's Venice, but there is also a strong reminiscence of Hellenistic classicism in the seated Muse in the right foreground, seen from the back.

From this date onward it is perhaps not pertinent to speak of overt borrowings in Tintoretto. They can be discerned only in certain foreshortened nude figures. Tintoretto is an artist of light and paint, "a modern artist clothed in the garb of Classic Art," and the difference between Titian's and his handling of a large composition is the difference between a great artist of the High Renaissance and a great decorator whose spirit was to descend into the nineteenth century through such masters of composition and contrasts as Caravaggio, Velazquez, Rembrandt, and Delacroix.

Tintoretto's *Visitation,* in Bologna, belongs to this period just following 1545. Elongated figures, sober classical drapery with touches of the richness of Mannerism, and stagelike classical

architecture in the rear characterize the work. The promise of things to come manifests itself in the *Raising of Lazarus* (about 1548) in Leipzig. The traditional Meleager composition is reversed and foreshortened from left to right to lead dramatically to the figure of Christ standing at the right. A typical river god or similar geographical personification lies in the foreground to enframe the composition. The idea stemmed from Roman sarcophagi where such figures both symbolized the locale of the action and directed the eye upward or inward toward the principal participants. Tintoretto makes full use of this trick of Antonine illusionism. Cinquecento and later topographical engravers employed it widely to lead the eye into their panoramas.

Borrowings from the antique continue but are increasingly hidden in the technical "tricks" of composition. In *St. Ursula and her Virgins* (about 1545) in the Venetian church of San Lazzaro dei Mendicanti, the angel with martyr's palms above is nothing but a draped Hellenistic fountain figure foreshortened on its side. This display, similar to that used by Titian in several of his works, must have derived from drawings which were copied and circulated in Cinquecento Venetian ateliers. Tintoretto bequeathed this type of art to his pupils, and the repertory of antiquities redrawn as figures in his large compositions passed ultimately into the paintings of Piazzetta and Tiepolo in the Venetian revival of the eighteenth century.

Tintoretto's *St. Mark Rescuing a Slave* (1548), in the Accademia, was the picture which made his reputation. In it his uses of depths, diagonals, and dramatic silhouetting are carried to new levels of refinement (figure 78). Nonetheless, there is a greater debt to ancient sculpture, particularly to sarcophagi, than appears at first glance. This relation can be noticed in the figure of a woman holding an infant; she is seen from

the back at the extreme left among the figures bunched at the left center. This debt is also evident in the figures seated in the right foreground. A maenad from a Bacchic sarcophagus, such as the famous example from the Della Valle collection and now at Blenheim Castle, has become the woman with the child, who leans up against the pillar at the left. The cuirassed soldier seated on the block is a variation of the old river-god motif from mythological sarcophagi.

The more deeply the works of Tintoretto are examined, the more it is evident that they possess the same wealth of classical borrowings found in Titian. In *Cain and Abel* (1550–1551) of the Accademia, Tintoretto uses the schema of the satyr and nymph on the Grimani altar in Venice, which Titian exploited with such successful frequency in his versions of *Venus and Adonis* in London and Madrid. The motif may well have been learned through the studies and drawings made by Tintoretto in Titian's studio in the years preceding 1545. When Tintoretto draws from the antique, he favors statues with Roman copyists' versions of rippling Hellenistic muscles. In a typical sketch, in the Louvre, he renders one of the reclining river gods (the Tigris or the Nile) on the Capitol, seen from the back. Tintoretto was seeking foreshortening and studies in diagonal design for the Old and New Testament compositions which were to make him famous. Antiquity provided the answer. Tintoretto secured the foreshortening he desired in terms of human perfection for his own art by viewing certain ancient statues and reliefs literally from a new, more dramatic angle. This is a heightening of Titian's characteristic interest in foreshortening and the ultimate development of Renaissance concern with perspective.

In the *Fall of Man,* finished just after the middle of the century and now in the Acca-

demia, Adam, observed from the back, is based partly on a figure from a sarcophagus and partly on one of Michelangelo's ignudi in the Sistine Ceiling. Eve, too, comes from a sarcophagus; she was originally a Nereid riding on a hippocamp. Tintoretto was no less aware than Titian and the Florentine Mannerists that the rhythmic, wavelike designs of Nereid sarcophagi offered unrivaled opportunity to artists interested in the combination of the nude form and interrelated action.

From the nature of the subject, mythological paintings should contain a higher proportion of direct classical borrowings, and Tintoretto's work at the height of his career is no exception. This use of borrowings is apparent in his *Vulcan, Venus, and Cupid* (with Mars under the bed), executed for the Gonzagas about 1550 and now in Munich. The sleeping Cupid in the background between Venus and Vulcan is reminiscent of the large group of ancient sleeping Cupids and the lost Cupid of Michelangelo.[21] Venus is a combination of two ancient statues surviving in more than one replica. The first is the so-called Trophos, a Muse or similar fourth-century figure, characterized by the gesture (seen in the painting) of the left arm pulling up the drapery above the left shoulder.[22] The second, the Capitoline group of Leda and the Swan, features Leda in a similar pose, protecting Zeus from the eyes of his jealous spouse.[23] Vulcan, as might be expected, is modeled after a Hellenistic sculptural type rich in muscular naturalism, the "Seneca in the Bath," also known as the Borghese Fisherman and now in the Louvre.[24] When, in the decade after 1550, Tintoretto painted a *Leda and the Swan,* now in the Uffizi, he represented her as a reclining nude, very like a Hellenistic Cupid on a rock and as much indebted to Titian as to any specific borrowing from the antique. In the *Allegory with Doge Girolamo Priuli,* receiving Sword and Scales from Justice (about 1560), in the Palazzo Ducale, the central scene conceals its classicism beneath Venetian color and design, but the grisaille panels above and below, and the enframing stucco decoration, show how really classical the pure decorators remained. This is true even when they are surrounded by the force of a great artist in a vital, new artistic tradition.

In the *Golden Calf* (about 1560), in the Madonna dell'Orto in Venice, the "calf" is, as might be expected in an antiquarian context, Myron's cow. Classically he could not be anything else. There were a number of copies of this famous lost statue preserved in Greco-Roman reliefs and marble statues surviving in the Renaissance.[25] Roman coins of the first century A.D. frequently show the beast.*

Tintoretto's *Nine Muses* (about 1565–1570), at Hampton Court, is an exercise in studies of the nude, with the influence of torsos and fragments more prominent than identifiable friezes or sarcophagus reliefs. In the great banquet scenes, such as the *Marriage at Cana* (1561), at Santa Maria della Salute in Venice, antiquity's influence on details is greater than might be discerned at first. From the second quarter of the sixteenth century onward, artists and antiquarian draftsmen produced those reconstructions of ancient daily life which culminated in the grandiose banquet scenes in the Ligorio drawings and in the *Museum Chartaceum* of Cassiano dal Pozzo and his Seicento circle. Details were sketched from funerary reliefs to show the deceased reclining at a banquet, and from Hellenistic reliefs to delineate interior details, such as

*Three-quarters of a century later Poussin was to draw on the same ancient source for the focal point of his painting in London, and Claude Lorraine placed Myron's cow on a classical cippus for his version of the subject, dated 1653 and until recently in the collection of the Duke of Westminster.

the series known as the "Visit of Dionysos to the House of the Poet." Greco-Roman votive and funerary reliefs showing the interiors of shops and workrooms, such as the relief in the Louvre of satyrs in the forge of Vulcan, were also employed. Tintoretto used such studies in preparing his *Marriage at Cana.*

In 1566, Tintoretto painted *Christ Before Pilate* in San Rocco. No one, after Mantegna's scenes in the Eremitani Church in Padua, had been capable of doing a judgment scene without strong dependence on the organization of the appropriate Aurelian panel on the Arch of Constantine, and Tintoretto was no exception. Christ stands like a Tanagra figurine, a contrast in classical simplicity to the architecture and struggling figures around him. The soldier in the left foreground is taken from one of the antique poses in the Aurelian panels of the Constantinian arch or of the Conservatori, perhaps through the medium of a drawing by Mantegna. Like Titian's *Europa,* the *Origins of the Milky Way* (painted after 1570) in London contains a number of classical sculptures seen from different angles. The familiar Cupid with the urn appears suspended at the right center. Jupiter or Mars flying down from the upper right and the eagle with *fulmen* at the right center are readily recognizable borrowings from classical antiquity. Juno possesses something of the Apollo Belvedere, passed through a number of sketches and turned into a female. This practice is encountered in the work of Michelangelo, Titian, and other artists who infused their painting with powerful or dramatic types after the antique, regardless of the difference between the sex of the original model and the ultimate product.

The *Origins of the Milky Way* has been attributed to Domenico Tintoretto, the artist's son who worked in his studio. Jacopo Tintoretto's atelier produced paintings under the master's close supervision and from his numerous drawings. What innovations from the antique are found in these works may be said to have been produced from his models.

Two last examples of Tintoretto's work represent the extremes of his handling of classicism in his later years. The first has a subject inviting work after the antique; the second can be classed with his series of Biblical scenes. The *Philosophers* (1571–1572) in the Libreria in Venice are powerful, classical compositions in classical settings. Contrasting with the figures, the painted grisailles above and below adhere to the principles of strict copying of antique reliefs in painting, developed and perfected by the secondary decorators working around the wall paintings of the masters of the High Renaissance. Although Tintoretto used his familiar diagonal composition in the *Last Supper* (about 1580) in San Stefano, he could not resist the enframing geographical personification at the right front—almost as much a hallmark as the inevitable Venetian dog on the steps at the left foreground. However many classical borrowings can be linked with Venetian artists of the Cinquecento, their art is still one of color, light, space, and staged setting, things which certain ancient paintings but not classical reliefs could teach them. Their relations to antiquity were on a consistently imaginative level. No such creative force in relation to the antique is found elsewhere in the late High Renaissance, a still-formative period of European art since 1400.

Baroque in Italy: Grandiose Exploitation of Antiquity

ALL FORMS of artistic expression derived from the antique would seem to have been thoroughly exploited by the last twenty years of the sixteenth century. On the contrary, these years offered new vistas of classicism in European art. New monuments were uncovered, and the science of archaeology, begun in a haphazard way in the age of Raphael, was accumulating an extensive bibliography. But monuments and statistics are never enough to propel artistic taste and the creative expression. Belief in the perfection and grandeur of Greece and Rome persisted undiminished. The genius of Pheidias or the grace of Apelles was thought to dwell in every sarcophagus front or fragment or bit of Campanian fresco. In many ways these were true premises.

The vision of antiquity in the art of the post-Mannerist renaissance (1580–1760) was admirably explained by Panofsky and Saxl thirty years ago: "The idea of antiquity developed into a dream of bliss and happiness; the classical past became a visionary harbor of refuge from every distress. A paradise lamented without having been possessed and longed for without being obtainable, it promised an ideal fulfillment to all unappeased desires. From this we can understand why, from the crisis of the Counter Reformation in the sixteenth century, when the classicism of the Carracci led the way out of Mannerism into the Baroque style, down to the crisis in our own days, which, among other phenomena, has given rise to the classicism of Picasso, almost every artistic and cultural crisis has been overcome by that recourse to antiquity which we know as Classicism."[1]

Patronage and Painting in the Early Seicento

Besides becoming concerned with other sciences in their work, after the middle of the sixteenth century artists and students of classical antiquity had to contend with the phenomenon of large-scale collecting. There had been older private collections, such as the Della Valle and the Cesi, but after 1550 small collections and single antiquities were concentrated in the hands of wealthy papal or mercantile families near the papal court. Mannerist architecture found classical and archaeological expression in Pirro Ligorio's Casino of Pius IV and in Annibale de'Lippi's Villa Medici on the Pincio (1590) where sarcophagi and other reliefs (many from the Della Valle collection) were let in walls to create an effect similar to that given by the hanging of the paintings in the Palazzo Pitti— a covering of wall surfaces in true expression of

horror vacui. From 1613 to 1615, Cardinal Scipione Borghese was building his villa on the Pincio. Vasanzio (Jan van Santen) covered its U-shaped front, the back, the sides, and the garden pavilions with niches, recesses, classical statuary, and reliefs. The Borghese Cardinal sought to outdo his older rivals not only in architectural splendor, but in the wealth of antiquities which he assembled to adorn the building.[2]

The practice, widespread by 1650, of inserting classical relief panels, sarcophagi and the like, in the façades, passageways, and porticoes of villas such as the Medici and the Borghese exerted considerable influence on the sculptural design between 1600 and 1750. Sculptors and architects worked together not only to set ancient and heavily restored reliefs into elaborate architectural settings but to create contemporary sculptures which could be similarly inserted. The result was some very classicizing reliefs even at the height of the Baroque period. One of the earliest original creations of this type was the strongly classical relief of *Christ Handing the Keys to St. Peter,* executed for St. Peter's by Paul V's principal sculptor, the Milanese Ambrogio Bonvicino (about 1552–1622). Algardi's *Leo and Attila* (1646–1653), also for St. Peter's, can be considered the high point in this process (figure 87). An early, post-Mannerist or proto-Baroque, landmark is the Aqua Felice (1587), by Domenico and Giovanni Fontana; this fountain combines Baroque monumentality of organization and setting with the grandeur of a Roman triumphal arch, ornamented with reliefs in the Mannerist "fragment style."

The name of Cardinal Scipione Borghese (who died in 1633 aged fifty-seven) suggests an era of great patronage. (The fact that works of architecture, sculptural commissions, painted decorations, and collecting of antiquities were associated with the same men could not fail to shape the degree of classicism of the artists who worked for them.) Cardinal Borghese not only collected major ancient marbles but was one of the earliest enthusiasts for ancient minor arts, especially Etruscan and Roman bronzes. His celebrated collection of ancient erotica forms the basis of the incomparable Vatican holdings in this type of classical art. Cardinal Barberini was a great collector of smaller antiquities, including bronzes, ivories, and terra-cotta statuettes.*

After Cardinal Scipione Borghese, the most distinguished patron of ancient art was Marchese Vincenzo Giustiniani (1564–1637). In the realm of contemporary art he encouraged both Caravaggio and the artists from Bologna. The Mannerist Cristoforo Roncalli (1552–1626), "a highly esteemed transitionalist," served as Giustiniani's artistic advisor at home and, in 1606, on travels through Italy and Europe. The great Giustiniani collection is now widely scattered, about thirty-five of the statues being in the United States.[4] In the seventeenth century the Giustiniani marbles were the ornament of a Giustiniani palazzo and two villas in Rome and many of the reliefs built into their architecture are still *in situ.* The most famous statue, the Hestia Giustiniani, is still in Rome, in the Villa Torlonia-Albani; the equally well known Athena or Minerva Giustiniani is an ornament of the Braccio Nuovo in the Vatican. In Vincenzo Giustiniani's day artists flocked to study and draw the marbles. The German scholar

* In the early seventeenth-century passion for small objects of antiquity in various media, the way was being paved for the researches of Cassiano dal Pozzo and the publications of Bartoli-Bellori, De la Chausse, and Montfaucon, the latter extending well into the eighteenth century. As a result, artists were looking more and more for inspiration to minor arts heretofore little exploited. Gems and coins were used constantly in the excerptings of Quattrocento artists, but Poussin's classical style cannot be understood without realizing he based his figures on minor bronzes as much as on life-sized marble statues.[3]

Sandrart published the collection in the sumptuous *Galleria Giustiniani* of 1631. Designs and engravings for these volumes were contributed by many of the leading Flemish, French, and Italian artists working in Rome at the time.

The brothers Asdrubale and Ciriaco Mattei also filled palaces and villas with ancient marbles, patronized artists such as Caravaggio, and encouraged studies of their collections. These were published in the same fashion as the Giustiniani holdings, but not until over a hundred years later. The three volumes of the *Monumenta Mattheiana* appeared in 1776 and 1779, just when the collections they glorified were beginning to be dispersed. The Mattei collection was particularly rich in decorative marbles, such as secondary funerary reliefs, architectural fragments, and cinerary urns.

Among the major artistic forces of the early seventeenth century, Caravaggio's place in art needs little comment. His development from late Mannerist stock poses instead of nature for designs and cartoons to an art based on nature, shadow, and emotion in no way conflicts with the return to High Renaissance classicism implicit in the paintings of the Carracci family and their successors. Caravaggio, therefore, although so important to his time, does not directly concern the tale told here.

ANNIBALE CARRACCI

Annibale Carracci (1555–1609) revived time-honored values in Italian art and revitalized the great tradition from Giotto to Masaccio to Raphael, of art's relation to antiquity through monumental fresco-painting and forthright classicism. He created a grand manner, "a dramatic style buttressed by a close study of nature, antiquity, Raphael, and Michelangelo," which charted "official" painting for the next century and a half.[5]

Annibale's great work on the vault of the Farnese Gallery between 1597 and 1605 consisted of mythological love scenes chosen from Ovid's *Metamorphoses*. A unity of *quadratura* framework, framed easel pictures (*quadri riportati*), and Herms and Atlantes to support the "ceiling" gave the perfect framework for a classicism worthy of Raphael's Farnesina *Cupid and Psyche* or the great lost works of Hellenistic antiquity, known only through Campanian copies. The center of the ceiling was dominated by the *Triumph of Bacchus and Ariadne* (figure 79). The arrangement of the principals is precisely that of the Woburn Abbey Bacchic sarcophagus, then on the Campidoglio in Rome, and its relations—the thiasos type, showing Bacchus, Ariadne, and their train of revelers, as opposed to the type showing the triumphal return from India. Drawings reveal Annibale's close study of Bacchic sarcophagi. The procession moves from left to right, with a satyr enframing the composition at the lower left and Tellus (and a seasonal putto) filling the corresponding corner in approved Roman imperial fashion. Bacchus sits in a truly Baroque cart, one carefully enriched with details (like goats in the vineyard) from ancient Bacchic iconography. His African lions are yoked for the occasion, and an infant faun guides them. Ariadne, one of Raphael's ladies, rides in a goat-propelled biga, with another playful faun as teamster. Satyrs, maenads, and the old Silenus on his donkey occupy the parts of the composition predestined by their canonical positions in the Roman imperial thiasos. Even the four putti overhead, carrying wine vessels, retain the spirit of a Roman frieze or painting in which the procession of the seasons symbolizes the constant joys of the principal scene.

While the train of revelers retains the character of classical relief and the individual figures

can be closely paralleled by classical types, the flowing, floating movement and the rich exuberance of expression and of action belongs to the Seicento, not to antiquity or the High Renaissance. This new alliance between naturalism and classical models is a forceful revival of antiquity, leading both to Poussin's pronounced classicism and the freedom of Rubens and the High Baroque. In keeping with the type and number of monuments to which he was exposed as an artist, Annibale represented this and other mythological scenes in ways closely related to Roman sarcophagi.

DOMENICHINO

In the years 1608 to 1610, the classical tendencies manifest in the Farnese ceiling were strengthened by the fresco cycles of the younger Bolognese artists. Domenichino (1581–1641) was among those younger painters who assisted Annibale and Agostino Carracci in the work of the Farnese Gallery. Among his masterpieces, the *Scourging of St. Andrew* (1608), in the Oratory of St. Andrew, S. Gregorio Magno in Rome, commissioned by Scipione Borghese, takes place in the closed architecture and parallel planes of Roman art. The size of the figures in the foreground violates Renaissance laws of perspective, something that can be paralleled in many Roman sarcophagi. The slain or falling figures in the lower foregrounds of Roman second- and third-century Amazon sarcophagi provide excellent examples in their reduced size and awkward distortion.

Following this commission, Domenichino worked for two years on scenes from the legend of Saint Nilus and Saint Bartholomew, in the Abbey at Grottaferrata near Rome. The masterpiece of this cycle is *The Building of the Abbey of Grottaferrata*. The excuse for the subject and its panoramic treatment is the miracle of St.

Nilus supporting a column about to topple on the workmen engaged in setting it up. Landscape, figures, and architecture are classically arranged in a sculptural sense. Secondary details, especially in the background at the left, are worthy of Roman frescoes. The archaeology of costumes (in the principal figures) and architecture is well handled. What is fascinating from the standpoint of Domenichino's training and environment is the scene in the right foreground. Two men are trundling off a pagan sarcophagus on rollers, as if taking it down the Alban mountain to Rome and the Borghese collections. The relief on the front is partly obscured by the workman with the crowbar, but the figures are Minerva standing at the right, a reclining personification in the center, and Ares or a warrior, bending forward at the left. The arrangement of these figures, carefully drawn in the Roman manner, suggests a mixture of scenes from a Rape of Proserpina and a Meleager or Orestes sarcophagus. The detail as a whole confirms other evidence that Domenichino studied and could draw Roman sarcophagi.[6]

An extreme form of classicism emerged in Domenichino's frescoes (1615–1617) in S. Luigi de'Francesci in Rome (figure 80). In these scenes from the life of St. Cecilia, the fresco showing *St. Cecilia before the Judge* is organized like a combination of the Aurelian reliefs in the Palazzo dei Conservatori (especially the detail of the attendant or camillus) and the sarcophagus on the Belvedere with scenes of barbarian submission to a Roman general. The head of the general has become that of the official judging the saint. The statue of Jove in the background is archaeologically accurate to the point of being taken from a black marble statue of Zeus or Asklepios such as the pair in the Museo Capitolino.[7] The scenes in the panel of the suggestum are based on Greco-Roman reliefs, such as the

votive to Jupiter Bronton in the garden of the Villa Doria-Pamphili on the Janiculum.[8] The closed depth, the large figures, and all the anti-quarianism of detail in the fresco as a whole not only make it the translation of a Roman state relief into early Baroque or proto-Baroque painting but emphasize the great debt to Raphael's cartoons as intermediaries between the Seicento and the antique.

GUIDO RENI

The energetic Borghese cardinal commissioned another landmark of this classicizing period from the Bolognese artist Guido Reni (1575–1642). In 1613 Reni painted the ceiling of the Casino dell'Aurora of the Palazzo Rospigliosi in Rome with *Aurora Leading Forth the Chariot of Apollo* (figure 81). The principal scene is a *quadri riportati* panel, but the enframement consists only of stuccos, with the surrounding area in white. Apollo in his chariot is sur-rounded by the dancing Horae, while Aurora hovers on clouds before him and drops flowers from her rosy fingers on the dark earth below. Wittkower characterizes the composition as the "statuesque ideal of bodily perfection and beauty by glowing, transparent light effects, welding figures adapted from classical and Renaissance art into a graceful and flowing con-ception." The composition has the horizontal organization of an Antonine or Severan sarcoph-agus. A Persephone, Medea, or Endymion sarcophagus gives parallels for the relation of figures and horses to the strong sense of motion in one direction, and the torch-bearing Eros flying above is drawn from one of these sarcoph-agi (figure 82). Aurora is partly drawn from the spandrels of a triumphal arch, and the Horae follow the poses of those on the Albani base and comparable Neo-Attic reliefs.[9] Even the use of clouds in cigar-smoke rolls has antique parallels,

including the clouds supporting the gods in Olympus on the much-drawn Judgment of Paris sarcophagus in the Villa Medici.

LANFRANCO AND GUERCINO

The frescoes of the dome of S. Andrea della Valle in Rome (1625–1628), by the painter Gio-vanni Lanfranco (1580–1647), from Parma, ended the predominance of classicism in the second decade of the Seicento. One of the artists who prepared drawings of the Giustiniani mar-bles, his pictorial manner and lighthearted grandeur, fused with color, was the antithesis of the design favored by Domenichino and Reni. These qualities are seen, in terms closer to the Carracci's Farnese ceiling, in the *Gods of Olym-pus* (unfortunately repainted) and the *Personi-fied Rivers* (1624, 1625), ceiling frescoes in the Villa Borghese on the Pincian.

Lanfranco's developments were paralleled by those of the powerful decorator Francesco Bar-bieri, nicknamed Guercino (1591–1666), who arrived in Rome in 1621. Guercino's *Aurora* (1621–1623) for the ceiling of the Casino Ludo-visi plunges through the sky as the boldly fore-shortened contrast to Guido Reni's fresco in the Casino Rospigliosi. *Day* and *Night* at either end provide symbols in the antique tradition of personified chronology for the moods evoked by the coming of dawn. Night holds up a cloak of the heavens, part of which takes the shape of Death's skull. The clouds follow the Roman canon, formed in painting in the Hellenistic period and brought in circulation through sculpture in the second century A.D. Thus, Guer-cino's tightly drawn clusters of clouds carry the same sense of a decisive groundline provided in the reverse designs of Roman imperial coins. These clouds are even more Roman in detail than those used by Guido Reni in his *Aurora*.

The principal composition is also dependent

on the shape of a Roman sarcophagus, the long, framed rectangle, but with the figures tilted so as to be seen from below. To a great degree this violent tilting came about as a result of the fact that in late Mannerist and early Baroque times (1590–1615) the great mythological sarcophagi were set high above the artists' heads, walled up in façades and courtyards. Compositions could be taken from these, but facial details in designs such as Guercino's ceiling came from the more-accessible Belvedere sarcophagus of a general receiving barbarian captives or the Aurelian panels in the Conservatori. Other sarcophagi and reliefs, which remained at ground level in their respective locations, provided further models for specific details.

Bernini and Classical Antiquity

The age of the High Baroque (about 1625–1675) is overshadowed by the deeds of Gianlorenzo Bernini (1598–1680), who refashioned Rome into a city of sweeping public squares, daring fountains, and emotional sculptures. His sculpture is much more personal, or unrestrained, than his architecture, and his painting is so impersonal as to be unidentifiable today. Bernini used classical sculptures as much as the works of Michelangelo, the Mannerist successors, and the Carracci as a basis for his own revolutionary concepts. The process of turning an antiquity into a creation of the High Baroque was achieved by Bernini through various stages of drawings.[10] Both versions of the *Angel Holding the Superscription,* for Ponte Sant'Angelo (1669), were based ultimately on the Vatican's Antinoüs and on a Praxitelean standing Eros. The preparatory drawings show that, under agitated folds, the bodies of these angels were taken from the coldly classical model, through alteration of proportions and a "process of ec-

static spiritualization began during an early stage of preparatory work."[11] It is a tribute to the strength of the model that both Bernini and Canova could look at the same ancient sculptures and produce works of such radically different classicism.

Like Michelangelo, Bernini was attracted more to Roman copies of works of the first and second Pergamene schools than to any other body of ancient art. He also drew heavily on the sculptures of the Hellenistic rococo which grew out of these. Bernini made no use of sarcophagi or Greco-Roman reliefs. The freestanding statue was the only vehicle worthy of the sculptor who gave form to the expressive, emotional, theatric demands of the fully developed Baroque. The nearest things to relief sculpture in Bernini's greatest works are statues such as the equestrian *Constantine* on the Scala Regia of the Vatican, in which the statue was set to be sensed in a single view and the artificial drapery and architecture behind make the background of the relief.

The freeing of Italian sculpture with classical connections from dependence on the antique relief was one of Bernini's most important secondary contributions to Italian art. Other Baroque and later artists, not to mention the Neoclassicists, returned to ancient reliefs as inspirations for their own works, but the reliance in so many ways on the same small group of Antonine and Severan mythological sarcophagi never reasserted itself. By 1760, the dawn of Neoclassicism, the Greek grave or cult relief was beginning to replace the Roman sarcophagus as the standard source. And Greek vases were just being discovered in numbers.

Bernini's father Pietro, a Florentine sculptor who worked in Naples and settled in Rome, found the joys of Antonine and later drillwork in a sculpture that represented the last breath of

Mannerism. Pietro advised his son Gianlorenzo (1598–1680) on his first monumental group for Cardinal Scipione Borghese, the *Aeneas and Anchises* (1618–1619). The group is the last work in which the father's contorted Mannerism and uses of the drill in the late Roman fashion are manifest. Antiquity supplies something to each figure. Aeneas' head is modeled on the "Carinus," an Antonine portrait of an unknown man with curly hair and slight beard in the Museo Capitolino;[12] his pose looks back to Michelangelo's almost Mannerist *Risen Christ* (1519–1520) in the Roman church of Santa Maria sopra Minerva. Anchises seems to suggest one of the barbarians from an Antonine battle sarcophagus; the Penates he grasps are two little Roman imperial cult statuettes, and the lionskin has been borrowed from some Roman Hercules. Ascanius, following closely behind, is a Hellenistic Cupid, or Boethos' boy without his goose.

Of the great works of the early series of statues executed for Cardinal Scipione, the *David* (1623) is based on the Borghese warrior and on one of the Gauls of the large Pergamene group (figure 83). From the chest to the thighs, the torso is powerfully conceived; it is bisected by the strap of the cloak as the young hero twists against the tension of his sling. These details find a striking parallel in the body of the Hellenistic, Pergamene Achilles, sword belt running from right shoulder to left side, as he turns to lower the body of the dying Amazon queen Penthesilea (figure 84). The unruly hair and straining face of Bernini's David are worked out as if he were a noble cousin of the famous Dying Gaul. A massing of Roman imperial armor serves as support for the figure.

The Apollo of *Apollo and Daphne* (1622–1625) (figure 85) is but another of the long line of sculptures directly dependent on the Apollo Belvedere (figure 114). The daring, painterly interpretation of the action at the moment of Daphne's transformation has few parallels in ancient art, save in vase painting. Her gracefully curving body has the mannered sweep of one of the Nereids embracing sea-bulls on the left and right fronts of certain Roman Nereid sarcophagi. This is seen more readily when a photograph of Bernini's group is tilted slightly to the right. Daphne's face has the asthmatic expression of a daughter of Niobe, heightened to Baroque terms. Details of sculptural technique are very classical in terms of Roman imperial work: the hair is somewhat drilled; the claw chisel has been used to define the bark of the tree trunk; and the limbs are smoothed and brought to a high polish.

The *Santa Bibiana* (1624–1626) was the first of Bernini's long output of religious statues in which sculpture is brought fully into the service of emotional and ecstatic devotion. Compared to his series for the Borghese cardinal, this statue shows how rapidly he traveled past the barriers of visible antiquity to a relation in which sculpture spelled the message of the Italian Baroque within the framework of Hellenistic classicism. Sculpture reached out in directions unimagined since the late Hellenistic phases of literary and theatrical emotion. The many possibilities of drapery, based generally on the antique, were exploited to support the mental attitude and sustain the spiritual concept of the figure. This relation to emotion carried sculpture far beyond the purely artistic tour de force of Mannerism. The basis of Santa Bibiana is a Hellenistic statue of a Muse at a column, such as is found in the plates of Sandrart's *Galleria Giustiniana*. The column determined the immediate choice of prototype, for, like Christ, the saint was scourged while bound to a columnar shaft. The high-girt chiton and ample himation wrapped around front, under the left arm and over the column were perfect vehicles for Bernini's Baroque ex-

pressiveness, as in less telling fashion Pergamene and other Hellenistic artists had exploited them in statues of women.

Although wearing a Hellenistic leather cuirass, *Longinus* (1629–1638) presents a contrast of Polykleitan body and dramatically conceived drapery. The head, modeled after that of the Borghese Centaur in Paris or one of its counterparts, is thus derived from the emotional phase of late Pergamene art. The swirl of the flaps or *pteryges* at the shoulders, as well as the military boots, enhance the Baroque qualities of pose and drapery. The helmet at the feet is a classical touch taken from a Roman copy of a statue of Ares or a cuirassed statue such as the Roman proconsul Celsus from Ephesus.[13] Like the Angels of Ponte Sant'Angelo, Longinus represented the Baroque ultimate in a departure from the antique and from life through a rapid succession of numerous sketches and clay models; twenty-two preliminary studies have been documented. (In the *bozzetto* in the Fogg Art Museum the classical form of the body is apparent before the drapery was given its final shape (figure 86).) The result in the finished statue in St. Peter's is that, however many classical sources can be enumerated for details, the Longinus is only comprehensible in the instant grasp of ecstatic and physical magnitude so characteristic of Baroque sculpture and architecture.

In two works of the middle and late 1630's Bernini demonstrated how far he could and would bring his own styles in line with the currents of classicism directing the output of his only important rivals, Algardi and Duquesnoy. Sober arrangement of massive drapery and an attitude of classical *contrapposto* mark the statue of *Countess Matilda* (1634–1637) atop her coffin in St. Peter's. These characteristics are made more dramatic in the central Christ in very high relief of the *Pasce Oves Meas* (1633–1646) inside the portico above the central door of the basilica. Here the *contrapposto* is reversed, the curve of Christ's body leading into the landscape and emphasizing the gesture of the right hand pointing down to the sheep. Matilda, holding the papal tiara and keys and standing poised to defend the Holy See, is Bernini's transformation of a Julio-Claudian statue of a divinity or empress. The diadem and classicizing face suggest Livia, Augustus' wife, in the guise of Juno or Ceres. The statue can be compared with the Julio-Claudian princess as Ceres, in the Pantheon at Stourhead (Wiltshire),[14] and a number of parallels known and unknown in Bernini's time. The *Pasce Oves Meas* is the Christian version of the large Hellenistic reliefs in the Lateran and the Palazzo Spada.[15] The central figures of Christ and St. Peter, Bernini's immediate contribution to his own general design, have the late Hellenistic quality of looking like statues in a landscaped setting. They tell the whole story; the rest of the relief, including the sheep, seems almost superficial.

Bernini's middle period (1640–1655), like the 1630's, saw changes, revisions, and new adventures in what classical antiquity could offer his concepts of classic beauty. In *Constantine* (1654–1668) the new type of Baroque equestrian monument reached back to antiquity through the landmark of the Raphael-Giulio Romano fresco in the Sala di Constantino of the Vatican. The Roman armor beneath the cloak is appropriately Constantinian, being taken from the Lateran or the Capitoline statues of that emperor; the radiate crown came to Giulio Romano and thence to Bernini from Antoniniani or gold medallions of Constantine, where the imperial features, seen in crisp profile, are plainly labeled. Bernini used literary as well as numismatic aids for the imperial portrait. His drawings show a "portrait-study" of Constantine's features, based on the

description in Nicephorus' thirteenth-century *Historia Ecclesiastica*. The relevant passage describes Constantine as having the aquiline nose evident in his coins and a thin beard. Both of these are transposed to the equestrian statue. The ultimate source for Constantine's charger lies in the horse of the late Roman lion attacking a horse group in the Conservatori gardens. Here, however, Bernini was again reaching back to antiquity through the Cinquecento, for this group supposedly was restored under the direction of Michelangelo. A horse of similar proportions and expression was utilized about the same time by Bernini for the ill-starred equestrian monument of Louis XIV (1669–1677), which so displeased the king that he had Girardon convert it into a garden ornament.

The classical basis for the angels of Bernini's late period has given indication of how far and yet how near the Greco-Roman source can stand in relation to the High Baroque. A mixture of transformed classicism and directly evident borrowing also characterizes the *Habakkuk* (1655–1661) and the pendant *Daniel* (1655–1657) in the Chigi Chapel of S. Maria del Popolo. In the former, the prophet's head is the type of the marble bust identified as the short-lived emperor Pertinax (A.D. 193) and now in the British Museum; the body is Bernini's compact version of his later style with strong, polished muscles in contrast to dramatic drapery; and the angel recalls the Borghese Boy with Goose earlier used for Ascanius in the *Aeneas and Anchises*.[16] The grouping and setting on a rockwork base come from another Borghese antiquity, the group of Aphrodite and Eros seated looking at each other, still in the villa on the Pincian.[17] Farfetched though it may seem, the Laocoön was the point of departure for the *Daniel*. The development can be followed from a copy of that figure through a number of preparatory drawings to

the final realization in marble. The anatomy of the old Trojan priest with his showy muscles and veined skin occurs over and over again in Baroque sculpture, in the work of lesser masters as well as that of Bernini.

Bernini explored antiquity as thoroughly as any artist. His chisel and drill on figures, on their supports, and on their bases show minute knowledge of the best Greek originals and, especially, Roman copies available in Seicento Rome. Bernini reached his conclusions—drawn from a limited range of works—and he used and reused them without evidence of intellectual sterility or repetitiousness. The collections of his first patron, Cardinal Borghese, provided him with nearly all the ancient sculpture he needed for a lifetime supply of models.

In addition, he and his contemporaries, such as Algardi, restored ancient marbles. The sensitive German critic of ancient sculpture, Adolf Michaelis, thought that Bernini's restoration of a headless and armless *togatus* now at Holkham Hall was one of the most successful restorations he had ever encountered.[18] Bernini's success in this endeavor can be assessed from the cushion of the Borghese Hermaphrodite now in the Louvre, from the extremities of the Barberini Faun (known through Maffei's engraving and Bouchardon's marble copy), and from the head of Eros and the right foot of Ares in the Ludovisi group now in the Museo Nazionale Romano. Others in the seventeenth century also were responsible for restorations of important ancient sculpture. Algardi's completion of the Herakles and the Hydra in the Museo Capitolino, the statue studied by Bernini at the outset of his career for the Pluto of his *Pluto and Proserpina*, was proven the peer of the missing part by its subsequent discovery and placement alongside the restoration.[19] In technical understanding of the best of antiquity, as in all else, Bernini rose

above his contemporaries in the Seicento as Michelangelo had in the previous century.

Pietro da Cortona, Sacchi, and High Baroque Classicism

The most archaeologically inclined seventeenth-century painter was Pietro Berrettini, called Pietro da Cortona (1596–1669). He came to Rome in 1612 or 1613, and studied Raphael and the antique with great devotion. His early commissions were in the enlightened circle of the Sacchetti household, and he became a lifelong worker for Cardinal Francesco Barberini. Cortona was also employed by Cassiano dal Pozzo to copy antiquities; evidence of his abilities in this is provided by the sketchbook preserved in Toronto.[20]

In the three frescoes of Santa Bibiana in Rome, carried out between 1624 and 1626, Cortona raised religious painting of a historical nature to a new level. The masterpiece is *Santa Bibiana's Refusal to Sacrifice to the Pagan God.* The scene has been compared with Domenichino's St. Cecilia frescoes of a decade earlier. In Cortona's fresco, the careful classicism of Domenichino's work is supplanted by figures of greater volume, tactile values, and breadth of life. Domenichino's composition betrays its connection with Roman sarcophagi and historical reliefs in the friezelike isolation of the figures. Although Cortona employs diagonal surges into depth and dramatic focus, the points of origin in Roman imperial antiquity are similar. Cortona's figures, as well as the accessories like the sacrificial tripod and statue of Jupiter in the background, faithfully follow the ancient models used with such care by Domenichino. The Capitoline Asklepios is the cult statue, and the camillus and equipment of sacrifice are taken from the Aurelian panel in the Palazzo dei Conservatori. Costumes of the saints and priestesses are also composed after the antique.

In altering the currents of classicism in the work of the Carracci and Domenichino to meet the High Baroque's taste for drama in complex forms, Cortona worked hard to extract all that antiquity might reveal in the manner of dramatic composition and interaction of figures. He drew all the reliefs of the Column of Trajan no less than three times. Other artists had drawn parts of them but usually had contented themselves with sketches of the *adlocutio* and departure (*profectio*) scenes just above the rectangular base, about the only scenes that can be drawn accurately without the aid of scaffolding.*

Cortona's work at this time began to move farther from classical simplicity toward a more dramatic, colorful, complex (in composition), and sensual (in handling of figures) painting. The influence of Giulio Romano, Polidoro da Caravaggio, and the great historical or mythological battle-pieces of the Cinquecento manifests itself in his *Battle of Arbela,* painted for the Sacchetti in the middle 1630's and now in the Capitoline Gallery. In Giulio's *Battle of Constantine (Mulvian Bridge),* the unconscious subjective and compositional connections with the Alexander mosaic and Philoxenos of Eretria were reached through Roman state and sarcophagus reliefs. The identity of subject makes these connections even more apparent in Cortona's *Battle of Arbela.* The scene is a heroic paraphrase of the few lines in Arrian describing this part of the battle at Gaugamela, seventy-five miles from Arbela. Baroque antiquarian correct-

* A sketchbook by Cortona in Toronto was inspired by an erudite approach to antiquity, and certain complex subjects such as the armor and weapons in relief on the base of the Column of Trajan continually fascinated him. Among the artists of the previous century, he was particularly interested in the engravings and frescoes of Polidoro da Caravaggio, one of the most classical of the Mannerist decorators.[21]

ness in terms of Roman art of the centuries following A.D. 100 is observed in costumes and weapons. All the traditional tricks are present—as in Philoxenos, Leonardo, or Giulio Romano: the horse seen from the back; the falling horseman transfixed by a spear; figures crushed under hooves and armor; single combats amid the swirl; and lances or pikes filling the background. Alexander rides from the left, and, seeing him, the Great King (dressed like Maxentius) turns to flee in his chariot. This is a painting in the classical tradition, not in the traditions of Pheidias and Praxiteles but in the style of the early Hellenistic and the Antonine baroque.

Classicism in the sense of Greek introspection and unity of composition, represented by a few carefully delineated figures, was championed by Andrea Sacchi (1599–1661), whose masterpiece, the *Vision of St. Romuald* (about 1638), is in the Vatican Picture Gallery. Drama in this painting lies in an intense introspection of faces and attitudes. The white habits of Saint Romuald and his companions make them the Baroque counterparts of old men in Attic grave stelai. Trees and rocks hardly seem to exist, despite their size, in the face of the procession mounting heavenward at the upper left. Sacchi discovered his favorite long-bearded, bald old man with a large forehead in an unidentified Hellenistic philosopher whose portrait survives in several Roman copies and a number of Italian Seicento forgeries. He has been identified by some as Aristippos of Cyrene, either the father who was a young companion of Socrates or his grandson who taught that immediate pleasure was the only end of action.[22]

Cortona, originally the child of Seicento antiquarian tendencies, found himself in conflict with a wave of Greek, rather than Antonine Roman, classicism which surged over Italy. Greek grave reliefs had been collected in Venice, Verona, and Naples by this time. Sacchi's ideas —elaborated by the critic and biographer Giovanni Battista Passeri and promoted by the antiquarian Giovanni Bellori, both friends of Algardi, Poussin, and Duquesnoy—dominated Rome in the years after 1640. Cortona's theoretical position, made explicit in his work, said that painting should have many figures and be like an epic, with a main theme and many episodes. Sacchi likened painting to an Elizabethan tragedy, stressing few figures and simplicity and unity of what was basic. Like Cortona, he had disciplined himself by drawing after the antique, and what is known of his efforts indicates an unusually understanding, accurate, and no less talented hand.

As the Seicento advanced, the breach between the painters who epitomized the Baroque (and later the Rococo) and the painters of the strictly defined classicism of Sacchi and Poussin widened. Poussin's influence led the French Academy to turn a vital classical creed into a pedantic doctrine of classical forms and classic emotions in the service of monumental decoration. Sacchi's position passed to his pupil Carlo Maratta, who handed the doctrine of contained classicism to the eighteenth century, and, through a host of artists whose works merit greater recognition, ultimately to Anton Raphael Mengs, the leading early Neoclassic painter, and "the real father of Neo-Classicism and passionate enemy to all things Baroque."[23]

Cortona has been recognized as the ancestor of the hedonistic trend which led to the French and Italian Rococo, although his compositions have a nobility of subject, purpose, and execution unthinkable in any Rococo. As a decorator of rooms, especially ceilings, he showed how to make a rich classical mythology subservient to an elaborate decoration—thus anticipating the Rococo. In these ceiling decorations he produced

groups and passages so classical in any sense as to win him admirers even from the adherents of Sacchi and Poussin. This abrupt mixing of the rational and the dramatic is not new to the history of classicism. The intervention of the Greek fifth-century style in the midst of the dramatic baroque is as old as the Altar of Zeus at Pergamon. It was a basic feature of the art of sarcophagus carvers in the Antonine and Severan periods, the art which exerted so much influence in the three centuries following 1400.

The frescoes which gave full range to Cortona's talents were those of the Palazzo Pitti (1637–1647)—the *Four Ages* and the rooms of the planets Venus, Jupiter, Mars, Apollo, and Saturn. The wealth of decoration in this astromythological chart of the deeds of Cosimo I includes stuccos and friezelike panels between. The classicism of the painting is heightened, unlike many later Baroque church ceilings, by the inviolability of the frames and many details in connection with them, such as the trophies in the Sala di Marte, derived directly from antiquity. A decade earlier Cortona had painted his *Rape of the Sabine Women* (1627–1629), one of a series of large pictures executed for the Sacchetti family and now in the Museo Capitolino. The drama of this historical-mythological subject is set on an elaborately contrived antique stage. Armor and costume follow the artist's usual desire for accuracy. The loosely painted, carefully staged groups of figures are a transformation of Domenichino's earlier frieze-type composition which, however, maintains a sense of sculpture in the round. The total effect is of light but purposeful narration, devoid of great moral weight. The Capitoline Zeus-Asklepios appears again, as Poseidon at the upper left. The signifer at the left enframes the composition in a technique taken from the Trajanic relief in the Arch of Constantine. This signifer discharges one of the artist's multifold debts to his early studies of historical reliefs.

Classicizing Sculptors in the High Baroque:

ALGARDI

The sculptor Alessandro Algardi (1595–1654), has already been mentioned as a member of the classicizing circle of the 1640's. He came to Rome in 1625 from Bologna by way of Mantua, and began his career in the capital as a restorer of antiques for the Cardinal Lodovico Ludovisi. His *Mary Magdalene* in stucco for the Capella Bandini in S. Silvestro al Quirinale (about 1628) has a Niobid face and a body carried out in a classical style halfway between Bernini's *Bibiana* and Duquesnoy's *Susanna*.

From 1634 to 1644, Algardi worked on the *Tomb of Leo XI* in St. Peter's. Leo XI was Pope for four weeks in 1605. His great triumph, however, came when he was Cardinal Legate to the French court. He arranged Henry IV's treaty of peace with Spain, and the event is represented in relief on his tomb. The Athena-Roma on the left and the lady rejecting wealth are classical types overlaid with Bernini's theatrical drapery. The classicism is emphasized by the use of white marble, but, although this tomb has been called the "true monument of High Baroque classicism," its work must not be confused with the Neoclassicism of Canova. Algardi is to Canova what Sacchi is to Mengs; this implies that the development of art is still far from the systematic classicism of the eighteenth century.

Algardi's largest and justly celebrated work is the relief of the *Meeting of Leo and Attila* (1646–1653), executed in partial collaboration with Domenico Guidi (figure 87). This relief became the new standard for a popular type of

Baroque relief in which spatial organization, division into zones, and mastery of dramatic illusionism can be traced back through the reliefs of Donatello and Ghiberti to the Aurelian panels in the Conservatori or to the designs of the Antonine and Severan imperial medallions. The subject, the miraculous salvation of the Church and the city from barbarian onslaught in A.D. 452, owed a debt to the fresco after Raphael in the Vatican and, from the standpoint of history, linked the Christian Middle Ages with the end of the ancient world. The faces are a mixture of types known from the age of Michelangelo and from antiquity. The officer crouching in the left foreground, behind the Pope, is a Roman of the early Antonine period. The man with the two prelates in the background is the artistic descendant of Michelangelo's Risen Christ. In the group around Attila at the lower right, the heads of his soldiers come from Aurelian and Severan historical relief. The little page with Attila's helmet and bow is a study in Quattrocento elegance. Attila, by contrast, wears late Roman armor and has a face derived from the Hellenistic Centaurs, the same face used by Bernini for his Longinus.

The success of the relief in presenting a scene of Roman imperial complexity at a level of dramatic excitement is due to the fact that Algardi knew the limits of high classicism and compromised with the trends of Bernini's grand manner. Algardi drew his ancient models from the grandest manner of classical relief—the Antonine historical scenes—rather than from the sarcophagi favored by the Carracci. This selectivity is further evidence of an artist's finding his own stylistic leanings in a specific class of antiquity related to the works being produced. Algardi's "Baroque classicism," like that of Pietro da Cortona, needed the great optic contrasts and spatial organization in relief of

the imperial state monuments. *Leo and Attila* was the imperial triumphal relief of Counter-Reformation Rome.

DUQUESNOY

Francesco Duquesnoy (1594–1643), a member of the circle of Poussin and Sacchi, apparently was one of the artists who worked for Cassiano dal Pozzo's *Museum Chartaceum*; over sixty of his drawings appear to survive in the *Museum Chartaceum* volumes at Windsor Castle. He was a great sculptor but never a popular one because he refused to bend his classicism to the High Baroque tastes and techniques set by Bernini. In 1627 and 1628 Bernini used his services on the sculptural decoration of the great bronze baldachin over the tomb of St. Peter. The baldachin, the most Baroque of early Baroque monuments, was copied directly from the late-antique twisted columns moved to new St. Peter's from the altar of the Constantinian basilica.[24] This stresses the fact that much of what is subconsciously taken as original in Baroque sculpture, and painting, can be traced to some facet of ancient art, in most cases sculpture. Duquesnoy was one of several artists whose reputations were established in this partly realized, partly unconscious homage to antiquity, an antiquity as much that of Early Christian Rome as of Hellenistic Greece.

Duquesnoy's two great works in marble, the *St. Andrew* in the transept of St. Peter's and the *St. Susanna* in the choir of S. Maria di Loreto, were carried out in the decade from 1629 to 1640. *Susanna* (1629–1633), who once held her martyr's palm in the right hand, makes "a timid gesture towards the altar, while her face is turned in the direction of the congregation" (figure 88). (The figure now stands in the wrong niche.) Duquesnoy worked for years on the model, and the antiquarian-collector-biographer Bellori be-

lieved that it was "impossible to achieve a more perfect synthesis of the study of nature and the idea of antiquity" than this statue. A similar *contrapposto* can be seen in the drawings of draped statues in the *Museum Chartaceum* of Dal Pozzo, and this "canon of the modern draped figure of a saint" presents a convincing understanding of the antique. Susanna's eyes are unincised, a contrast to Bernini's *Bibiana* with pupils expressed in direction and degree of emotion. Duquesnoy's statue catches the heavy repose of Greek bronzes, marbles, and terracottas of 400 to 300 B.C., but the "sweet," tilted, and almost upturned head and the lines of the silhouette are reminders that the statue is a creation of the High Baroque, nothing more. She has the face of the Cnidian Aphrodite, so popular in Mannerist paintings, and a classical body, based principally on the Cesi Juno in the Museo Capitolino. This statue of a goddess in the Pergamene tradition, perhaps Demeter, was much studied by artists from 1500 on, because of the contrasts of heavily and delicately modeled drapery and because of its rather dramatic pose, with head turned and arm akimbo. A draped statue restored as a Muse, such as the Urania now in Naples, or a comparable statue in the Museo Capitolino,[25] served as the Greco-Roman prototype, in addition to the Cesi Juno (figure 89).*

St. Andrew embracing his diagonal cross, displays a body taken in an almost academic way from standing Jupiter types and head from Domenichino's *St. Jerome* (at his last Communion). This type of head goes beyond the Baroque and back to antiquity, to the suppliant barbarians of the Aurelian reliefs or the old pedagogue of the Niobid sarcophagi and lesser reliefs in their tradition. The body is that of a standing Zeus of the Dresden type or some Roman emperor, like Claudius, as Zeus. To this Duquesnoy has succeeded in adding a feeling of Baroque expansiveness. This is conveyed not only by the outstretched arms and the diagonal cross but by the way in which the body is tilted as the viewer eyes it from below. The strong diagonals of the hips and legs increase the Baroque note, while counterbalancing the cross.

The connection between a copyist's academic Zeus of A.D. 50 to 200 and a work such as *St. Andrew* was reënforced by the work of the restorers, among whom were Duquesnoy and Algardi. For example, in S. Agnese in Piazza Navona, the Pamphili church of the High Baroque, there is a statue of *St. Sebastian* leaning forward from the waist in the agony of his ordeal of arrows. The statue, as Baroque as any original creation, consists of a Greco-Roman statue of Zeus or an imperator as Zeus, seated and clad in a himation about the lower limbs. To this, Paolo Campi added the head to transform it into a standing St. Sebastian, good evidence of the anatomical leeway between the majesty of antiquity and the emotion of the Italian Baroque.[26]

Maratta Reconciles Baroque Classicism and Emotion

The two trends in Baroque art, classical and emotional, were reconciled in the grand frescoes, in the conventional canvases, and in the preliminary studies of Carlo Maratta (or Maratti) (1625–1713). It was Maratta who created the celebrated Roma Barberini out of a Constantinian fresco probably representing Venus Felix, Roma's truly pagan counterpart as patroness of the ancient city. He drew extensively after an-

* The line of artistic development leads from the sculpture of Duquesnoy to the Italian classical Rococo typified by such works as Filippo della Valle's *Temperance* and the figures of the Trevi Fountain.

cient statues and reliefs, and at least seven of these drawings have been identified in the Royal Library at Windsor. Their subjects include the head known as the Caetani Aphrodite (no. 4108), the Capitoline bust of Homer (4112), a section of the decorative frieze from the Forum Traiani (4269), the maenad dragging a wild boar from the "Marriage of Peleus and Thetis" sarcophagus (figure 90) in the Villa Torlonia-Albani (4381), and a cuirassed torso of a Roman emperor, now with the Farnese marbles in Naples and restored as a statue of Lucius Verus (4387). The drawings exhibit the highest degree of skilled accuracy. If any Baroque flavor has been imparted to the subjects, it is no more than such Greco-Roman carvings normally reflect, whether copies after Greek works of the fourth century B.C. and Hellenistic period or new, Roman expressions of older Greek ideas. In these studies Maratta exhibits a love of simple lines for flesh and anatomical contour, in contrast to the sculptural shading and complex detail of draperies. These drawings seem far removed from the idea of the artist which is formed from his finished works, but his long life and obvious talents offered ample opportunity to absorb antiquity into the services of his grand style in major works of large scale.

Maratta's mixture of classical faces and draperies and of rich color and almost-glib allegories became the grand court style of Louis XIV's Europe. Through him the classicizing currents of the Baroque passed to the eighteenth century as a force stronger than the plainly historical drama of Cortona, Gaulli, and their successors.[27] He made a strong impression on his contemporaries, and the volatile Bellori felt that he was the artist fitted to uphold the classical concept of painting as a sum of beautiful parts rather than an unpremeditated or dogmatic understanding of beauty. Maratta was considered to have "re-established a feeling for the dignity of the human figure seen in great, simple, plastic forms and rendered with a sincerity and moral conviction without parallel at this moment."[28] However distorted in practice by the peculiarities of the late Baroque, this is what classicism in any age has held as an elevating purpose. Maratta's work was of such significance because he reached out for these ideals at a time when they were difficult to achieve.

The *Virgin and Child with Saint Francis and Saint James* (1687), in S. Maria di Montesanto in Rome, is typical of Maratta's grand style combined with classical details. For instance, St. James is figured in the Writing Victory pose of the statue in the Brescia Museum or the two reliefs on the two imperial columns. He is turned in the composition to extract the utmost in Baroque animation from the already-complex figure. Such poses and postures were used to fullest advantage in sculpture on a large scale in the various statues carved for the nave of the Lateran early in the following century.

Nicolas Poussin

The great classicist in Seicento art worked in the heart of Baroque classical Rome but stood apart from the currents and crosscurrents of his age. It is more than the fact that Nicolas Poussin (1593/94–1665) was a Frenchman (after all, Duquesnoy was a Fleming); it is the uncompromisingly individual quality of everything he created that gives Poussin a place apart from the painters and sculptors of the Baroque century. Yet Poussin belonged "not to the French school, but to that of Rome or the Mediterranean," and his introduction to classical circles in Rome of the Barberini Pope was not much different from that of the several Bolognese artists.[29]

It is easy to see but difficult to explain just

what makes Poussin such a success as a painter in the "classical" manner. Painting in the classical style was no automatic formula for immortality, as the works of Poussin's pupil Lebrun testify. Poussin's paintings rejoice in a continual relation with the world of ancient Greece and Rome. They are never dull, for borrowings from antiquity are varied in dozens of ways and mixed with careful appraisal of painters from Raphael to Guido Reni. Figures, architecture, and landscape maintain a consistently personal, consistently even feeling for Hellenistic and Roman art. Nothing "classical" in Poussin's compositions jars the senses as overtly eclectic or artificially introduced. Backgrounds respond to the atmosphere of rational classicism by seeming eternally natural, never stage props.

The universality of Poussin's relation with antiquity makes the ancient world more at home in his art than in the work of perhaps any other painter. He must have spent endless hours looking at ancient architecture, sculpture, and painting, and at the drawings collected by patrons such as Dal Pozzo. List after list of borrowings could be compiled. Certain Roman copies of Greek fifth- and fourth-century draped figures of goddesses, Muses, and commemorative statues are used several times. Nymphs, satyrs, and river gods from Roman sarcophagi turn up by the dozens. The architecture of ancient Rome, of Tivoli, or of Praeneste rises strongly or dimly amid the Alban Hills and the lowlands of the Tiber. The ancient architecture is always refreshingly clean-cut and rational, the perfect restoration of the ideal Roman *tempietto*; the later architecture is often familiar without being out of place or academic. Orpheus and Eurydice can act out their drama in front of the Torre Milizie and Castel Sant'Angelo. Eleazer and Rebecca meet happily in a setting that is half taken from a Roman sarcophagus and is half the view of a grand Renaissance palace. The obelisks, pyramids, and pylons of Greco-Egyptian Rome fascinated Poussin. To him as to the Romans they often represented ages beyond the classical past, ages when the Old Testament was as alive as his precise imagination made it in his paintings.

Imagination pitched on a rational key must have been greatly admired by Greek and Roman artists. This quality characterizes Poussin's painting. Within a strongly Greco-Roman framework, perception, imagination, and technical genius led him to create an art unlike anything else in any age. Like Raphael at his best, Poussin is a great classicist because he understood that the material survivals of imperial Rome could be drawn upon continuously and inexhaustibly in personal ways. In his painting they served a creativity identified with no precisely defined age or school of painting.

Poussin worked in Paris from 1612 to 1624; drawings in the late Mannerist style, illustrating Ovid's *Metamorphoses,* are the only works of this period attributed to him with certainty. In 1625 and 1626 he painted two Old Testament battle scenes in Rome: the *Victory of Moses* (or the *Victory of Joshua over the Amalekites*), now in the Hermitage; and the *Victory of Joshua over the Amorites,* now in Moscow. The influences of Antonine and Severan Amazon and battle sarcophagi, and of engravings after Giulio Romano and Polidoro, are evident. Poussin remembered the latter from his Paris days and no doubt renewed acquaintance with the engravings and with the actual sculptures in Rome. Each painting is a veritable encyclopedia of Greco-Roman motifs, borrowed directly or through the intermediary of older painters. Some borrowings, of course, are reversed, since Poussin had trained himself from engravings as well as marbles and casts. This is true of the Old Peda-

gogue from the Niobid groups, seen from the back in the left foreground of the first picture. In the second composition the Dioscurus of Monte Cavallo is easy to spot in the left foreground, and the soldier bending over a falling adversary at the right is the discobolus torso much sketched in sixteenth- and seventeenth-century Rome. The over-all impression is that the two battle pieces are still the work of a late Mannerist. In spite of the sound and fury, "the composition is constructed in terms of high relief, without any real space in which the figures can exist and move." This is quite different from Poussin's mature work.

Poussin did not achieve quick success, although his style improved rapidly. His *Triumph of David,* at Dulwich, started late in the decade and worked on for many years, has the processional dignity and spatial organization of a Flavian or Trajanic triumphal relief, such as those on the Column of Trajan or the arch at Beneventum. The influence of Domenichino is evident in the sober Roman architecture of the background, a glimpse of the Hadrianeum in Rome with its high podium brought to life by the crowds thronging between the columns. Archaeological awareness is pointed up by the places where the blocks of the podium show medieval gouging for metal clamps and by the upended cornice with dentils in the left foreground.

In 1628 and 1629 Poussin painted the *Inspiration of the Poet,* now in the Louvre, a composition based on a Hellenistic or Greco-Roman relief now known only from drawings made around 1600. For the pose of the Muse Calliope, the ancient model is copied with a directness unusual at this period and speaks strongly of Poussin's lifelong connection with ancient designs and details. The choice and handling of color recall the diversified, controlled warmth of the Venetian Veronese. Much question exists as to the identity of the poet being crowned with double laurels by the Eros flying behind Apollo. Virgil has been suggested with good reason; he was much read and admired in Seicento Rome. Two laurels are used (the *Iliad* and the *Odyssey*), and pose and costume of the poet resembled the Arundel Homer, also suggesting that the recipient of these honors may be the great Greek epic poet, represented in his youth.

At the end of the 1620's Poussin abandoned efforts to secure big commissions from major patrons. His connection with Dal Pozzo and the scholarly circle developed. He produced relatively small paintings. He chose his themes from ancient mythology and from Tasso; religious subjects were scarcely touched. The *Arcadian Shepherds* at Chatsworth and the pendent *Midas Washing in the Pactolus* are typical of these paintings. In the former, the angle of vision in the composition is dominated by the river god reclining in the foreground and seen from the back, as on numerous mythological sarcophagi. Otherwise, there is much beautiful painting and, save for the post-Pheidian costume of the female, little specific borrowing from antiquity in this document of Seicento classicism.

In the realm of ancient history, the *Death of Germanicus,* in Minneapolis, painted about 1626 for the Cardinal Barberini, takes its grouping around the prince's deathbed directly from Roman *conclamatio* sarcophagi, a relation made evident in the drawing for the painting at Chantilly. On the other hand, the Roman commander (Titus) on horseback amidst the besiegers in the *Capture of Jerusalem* (after 1630), in Vienna, is an anticipation of Bernini's marble equestrian *Constantine.* The Titus also reaches back to Raphael and Giulio Romano, to the High Renaissance in its ability to clothe the chief figure of a complex scene in noble, rational, and

therefore dramatic isolation. Roman military costumes and equipment are painfully "correct" in terms of Dal Pozzo's studies of the columns of Trajan and Marcus Aurelius, and the reliefs on the Arch of Constantine. Few of Poussin's paintings present such a verbatim record of Roman ruins as the side view of the Temple of Antoninus Pius and Faustina in the background.

Poussin treated religious themes in the elegiac spirit of melancholy and moodful evocation. Antiquity of a type used again and again by painters enters here. The Dead Christ in the Munich *Entombment* or *Lamentation* is identical with the young hunter in the *Death of Adonis* at Caen.[30] The *Death of Adonis* portrays Venus pouring nectar into the blood of the dead hunter to create the symbol of his resurrection each spring. Poussin may have planned this painting and the Munich *Entombment* to be pendent expressions of pagan and Christian resurrection.

Another change in Poussin's choice of compositions and in their style took place about 1633. For his paintings of 1633 to 1637, he selected subjects with a good pageant or story in contrast to poetical and mythological themes. Paintings with subjects in this category include: the *Crossing of the Red Sea,* the *Rape of the Sabines,* and the *Saving of Pyrrhus.* The Great Bacchanals, notably those painted for Cardinal Richelieu, are famous. In the *Worship of the Golden Calf,* in London's National Gallery, the colorful depth and dissolved surfaces of Titian are replaced by the influences of Roman sculpture and of the late Raphael and his successor Giulio Romano. The quality of "freezing" figures into single planes shows Poussin's increased study of ancient sculpture in relief. The dancing figures can be traced from Roman reliefs through paintings by Mantegna, Giulio Romano, and Taddeo Zuccaro to Poussin's new style. The

mother and two children in the foreground go back to Raphael's *Mass of Bolsena.* The kneeling figures at the extreme right, particularly the old man, are taken from the Antonine reliefs of suppliant barbarians before the emperor, especially the early Antonine relief with a restored head of Lucius Verus in the Torlonia collection. The old man has been reversed. The "calf," as in Tintoretto's painting of the same subject, is based on one of the many surviving replicas of Myron's cow.

This combined debt to Raphael and to antiquity was intensified in the *Kingdom of Flora* in Dresden, now recognized as a forerunner of Poussin's new style and dated 1630 or 1631. The sarcophagus in the Villa Medici with scenes of the Judgment of Paris (figure 7), that much-sketched and much-used group of compositions, has inspired the sky and background. This motif of Apollo driving his chariot through the zodiacal circle and across the sky occurs throughout Poussin's career: *Diana and Endymion* (about 1630) in Detroit; and the drawing for the *Infant Bacchus Entrusted to the Nymphs* (1657), in the Fogg Museum. The radiant sun god in his quadriga was omitted in the finished painting. In the right foreground of the *Flora,* figures are taken from Nereid sarcophagi. The interlocking relations between the mythological figures recall Raphael's best: Echo and Narcissus form a closed oval in the foreground; Ajax, committing suicide, balances Flora; and Clytie follows Apollo with her eyes. Adonis and, especially, Hyacinth are Praxitelean statues seen from different angles. The composition is one of the strongest statements of sculptural form in an extremely intellectual series of relations in Poussin's early work.

The highly organized transmission of designs from ancient reliefs and paintings through artists of the late Quattrocento, High Renaissance, and

Mannerist periods is a characteristic of Baroque compositions of classical type. With its origin in the ancient world, it extended in Greco-Roman times beyond the mere borrowing of Greek fifth- and fourth-century motifs and styles on Hadrianic and later sarcophagi. It reached further than the world of Neo-Attic reliefs. Roman decorative and minor arts—terra-cotta plaques, relief vases, gems, medallions and coins—developed the perpetuation of compositions to an elaborate science. Roman imperial coin designers even kept files of older compositions and used them as points of reference in creating new reverse designs, from the period of Augustus to the age of Diocletian (about 30 B.C.–A.D. 300). The collections of drawings and engravings formed by Seicento historians of art—the Dal Pozzo albums being the oft-cited example—served artists of Poussin's age in this scientific fashion in their reuse of older designs and motifs, suggestions going back ultimately to Greek and Roman art.

In 1640 Poussin journeyed to Paris. Bernini, Poussin, and Puget, three of the greatest artists of the High Baroque, were failures at the French court. This was an indication of the artistic mediocrity of Paris officialdom rather than any reflection on the mid-career work of the artists. In the decade following his return to Rome in 1642, Poussin produced those paintings most highly regarded by his contemporaries, those now considered among the purest embodiments of French classicism. Rational calm prevailed, and the debt to classical types in sculpture was evident. This is best seen in the new version of the *Arcadian Shepherds,* now in the Louvre. The poetry of the earlier painting has given way to a philosophic interpretation in which the discovery of the inscription is suspended in time and space in the manner in which, in an Attic grave stele of about 400 B.C., action turns inward to

contemplation. The subjects of this new decade also included dramatic and personal interpretations of the Bible and illustrations of Stoic mythology or history (Coriolanus, Scipio, Diogenes, and Phocion).

In the second series of the Seven Sacraments done at this time *The Eucharist* (1647), in Lord Ellesmere's collection, may be singled out as representative of how the dramatic—the departure of Judas—and the mystic—Christ's impending Passion—could be portrayed against an archaeological background that does not overwhelm the mood or message. The simple setting is severely symmetrical, with plain Doric pilasters behind and Roman tripod-basins in foreground and rear at the right. Dal Pozzo's researches into the dining habits of the Romans and the large drawings prepared to illustrate Roman banquets have been studied carefully. The Apostles dine in Roman costume and recline correctly on couches around the table, details which Dal Pozzo and Poussin corroborated from Roman tombstones and sarcophagi. The curtain suspended behind is a device used in such scenes on Roman sarcophagi to suggest an indoor setting, and Poussin has even hung a Roman bronze candelabrum (from Bellori's collection) above the supper table. Although extremely classical and Roman, the scene is equally Christian, for Poussin and his learned friends were well aware that the early Church dwelled in a Roman world and that in many respects early Christian art was as Roman as the reliefs on the Arch of Constantine.

Between 1648 and 1650 Poussin painted the *Achilles on Skyros,* lost for many years but now in Boston (figure 91). The painting proves that the artist could produce a sober version of a myth represented dramatically in ancient literature and art. An even more motionless version of the discovery of Achilles by Odysseus and

Diomedes among the daughters of Lycomedes was painted in 1656, Poussin's last period. This painting, until recently known only from prints, is now in the Virginia Museum of Fine Arts. The Boston version shows the discovery of Achilles, as he eagerly forgets his female costume to unsheathe a sword, with an atmosphere of subdued surprise and classical emphasis on gesture. Here Poussin demonstrates his subjective communion with the colors of ancient costume and with the textures of chitons and himations. Grecian heads are used as models for the three daughters of Lycomedes, but by way of contrast Achilles has been arrayed in a wig of the Capitoline Aphrodite type, replete with Hellenistic topknot! Odysseus wears the turban of a peddler from the Ottoman East, and in this splendid example of tight, controlled painting Diomedes' Antonine head of the Lucius Verus type stands out against the Jovian Grove at the left and the sober architecture at the right.

The *Finding of Moses* (1651), at Bellasis House in Surrey, includes several classical figures copied from drawings or minor antiquities available through Cassiano dal Pozzo. The Hera Chiaramonti, a bronze now in Vienna, appears as a veiled figure at the left rear. The heavy, Pheidian drapery of this Roman copy appealed to Poussin. The relief in the Louvre known as the *Nova Nupta* (the groom undressing the bride on their wedding night), or one of the *Washing of the Child* scenes from a sarcophagus with episodes from the life of a general, is used at the right foot of the composition. Draperies flutter among the figures on the left, a technique used in Greco-Roman reliefs to express excitement. The river god amid the rocks and palm trees of the upper background gives a contrasting note of complete serenity.

Poussin's manner of working reveals how dependent he must have been on small ancient bronzes and the terracottas then known. He first made a rough sketch of a projected design. Then he modeled small wax figures, dressed them with linen draperies, and put them on a minature, peep-show stage. He used controlled lighting and a painted back cloth for the landscape. He next went through stages of making more sketches and more puppets, moving ultimately to a set of bigger models with cloth drapery. He never painted from life, and this could only lead to the proportions of his figures being based on ancient statues. It was certainly fortunate for Poussin's antiquarian style that the hoards of Tanagra figurines from Greece and Asia Minor had not yet been discovered. The terracottas he knew had little of their prettiness or distortion of proportions.

The years from 1653 until his death in 1665 saw an intensification of the puritanical simplicity and severity of composition in Poussin's style. Picturesque ornament was eliminated, and archaeology increased in importance, if such were possible. Egyptology as understood, or misunderstood, in the Seicento played a greater part in his work. The Egyptian architecture and scenes in the background of the *Rest on the Flight into Egypt* (about 1657), in Leningrad, have been taken from the Palestrina or Barberini mosaic, a work which impressed both Poussin and Cassiano dal Pozzo.[31] The mosaic had already given Poussin the idea for the large building in the left rear of the *Finding of Moses,* another painting with an Egyptian setting. Egyptian and classical details in his late paintings are taken from Romano-Egyptian bronzes, one of the few other sources available to a would-be Egyptologist in Seicento Rome.

In the *Holy Family* (1655), in Leningrad, a painting with almost life-sized figures, the group of the washing of the child from the Los Angeles or the Uffizi daily life sarcophagi is used again,

as it had been a few years earlier in the *Finding of Moses*. The Madonna's costume is Hellenistic, like the Arcadia of the Herakles-Telephos fresco from Herculaneum, both in scale and in bold, sculptural handling of undergarment and massive cloak. Going back nearly a decade in Poussin's career, the *Holy Family on the Steps* (of 1648), in Washington, demonstrates how the five figures of the Holy Family could be rearranged, using the same classical relationships in a seemingly novel composition. In this painting the tilting of the view is similar to effects achieved by Baroque decorators of palazzo walls and recalls the inspiration they found in viewing Roman sarcophagi set over their heads in the façades of late Mannerist villas. Curiously enough, in an early wash study for the painting (Morgan Library) Poussin's sculptural shading brings out his debt to ancient reliefs without tilting the figures and architecture and with a further variant in disposing the figures.[32]

Poussin's last work, the unfinished *Apollo and Daphne* in the Louvre (1665), moved from clarity of subject to emphasis on the wilder nature behind (figure 92). The composition, filled with standing and reclining female forms, seems to have been a poetic summation of the unfortunate loves of the sun god. In the center background, before a herd of cattle, a mastiff of the Vatican-Uffizi type contemplates another scene of tragedy, probably the death of Hyacinth. The actions of Eros drawing back his bow, Apollo, and Hermes at the left seem hardly to affect the reclining daughters of the river god Ladon, certainly not their carefully sculptural postures. Nereid motifs are widely used, and their classic poses mark antiquity's domination of Poussin's painting to a degree filled with material recognition and spiritual understanding in all ages.*

* One of these Nereids links the painting with a work of exactly two centuries later, Courbet's *Reclining Nude*

Sculpture in France

PUGET

Pierre Puget (1620–1694) projects the powerful forms of the Pergamene Baroque into the sculpture of seventeenth-century France.[33] His Pergamene and Trajanic style was arrived at through the same unconscious selectivity among ancient originals and copies so characteristic of many artists. Puget himself was unaware that his style was molded by Pergamene art; such an analysis in classical terms was impossible before the discoveries at Pergamon in the 1880's. He was blunt and outspoken, factors which contributed to his never becoming a successful court sculptor. His sudden, short-lived success in the 1680's was due to the brief favor in which the Italian Baroque found itself in France.

Puget was born in Marseilles. He spent the years 1640 to 1643 in Rome and in Florence, working under Pietro da Cortona on the rooms in the Palazzo Pitti. In the years before 1656 he divided his time between Marseilles and Toulon, designing warship decorations and executing paintings for local churches. The nature of the former made them apt to be extremely baroque, gilded sea creatures as figureheads and Atlantids supporting the poop-deck.†

In 1656, Puget carved the *Portals of the Hôtel de Ville at Toulon*, with herms or terminal figures flanking the doors. The herm on the left is modeled on the Dying Alexander (or Helios) in the Uffizi.[34] The torso is taken from that of a seated Zeus or an imperatorial figure as Zeus. Just at this time the Zeus of the Villa

in Boston (figure 93). In Courbet's creation the figure is a mirror reversal of the nymph almost in the center of the foreground, just in front of Eros.

† A volume or two could be written on the classical influences in post-Renaissance ship ornament. The Swedish warship *Vasa* recovered from Stockholm harbor provides a major monument for the Baroque.

Madama was taken apart and the head and torso of this seated colossus remade as a terminal figure for the gardens at Versailles (figures 5, 6). The effect was precisely what Puget succeeded in creating in his herms, Pergamene power combined with Baroque richness. The herm on the right has the head of the Silenus with the infant Dionysos, a Lysippan work known from many replicas and variants. The anguish of these figures is not the supercharged drama of Bernini's religious and decorative works. It is the restrained power of antiquity combined with the deep passion of Michelangelo's slaves. Cortona had used such struggling Atlantids in the painted corners supporting the entablatures in the Palazzo Barberini.

Puget's two greatest works, the *Milo of Croton* and the large relief *Alexander and Diogenes,* both in the Louvre, occupied much of the last two decades of his career. The *Milo,* considered in the middle eighteenth century to rank with the noblest works of antiquity, was a synthesis of the Pergamene or the Antonine Pergamene Farnese Hercules and the late Pergamene Laocoön. The proportions, veins, and muscles are those of the former statue. The lion was taken from the Conservatori group of a lion tearing at a horse, a prominent Roman antiquity possibly restored by Michelangelo.[35] Bernini used the horse from this group in his two equestrian compositions. The naturalism of *Milo's* tree trunk combined impressions of Bernini's *Apollo and Daphne* with careful scrutiny of the supports so beloved of ancient copyists and seen in so many adaptations of Greek originals. Milo's face is that of an agonized Caracalla. Baroque sculptors and painters seemed to have found satisfaction in a limited repertory of antique facial types, learned when sketching Greek and Roman portraits in their youth and used continually throughout their careers. Puget's favorites were

the Cinquecento portraits of Nero (of the type showing him as a bloated Hellenistic ruler) and the late portraits of Caracalla (bearded and with head turned to imitate Alexander the Great).

Alexander and Diogenes, like Algardi's *Leo and Attila,* is a relief worthy of the imperial triumphal monuments of the Trajanic period (figure 94). The Flavian to Trajanic drilling sets off the Roman imperial faces. Alexander on his mighty steed Bucephalus has the cruel, sensuous head of Caracalla as he was portrayed on the eve of his infamous reign, and the bloated Neronian type is all too evident in the man restraining the philosopher's dog. The Caracalla type is repeated, as foil for the Macedonian conqueror, in the soldier athwart the cynic's barrel, and the Roman god Mars Ultor has provided the model for the helmeted horseman immediately behind Alexander. The armor in the background is based on that of the Praetorian Guard in the Mattei-Borghese Flavian or Trajanic state relief now in the Louvre. This Roman imperial relief shows several Praetorians in full armor, the secondary details of helmets and cuirasses being treated in detail. A detailed but very baroque view of Rome in the manner of Hellenistic reliefs, the Column of Trajan, or Campanian paintings appears behind the walls and banners of the area surrounding the principals. The creation by Puget, in drama as well as in details, is unmistakably a product of the seventeenth-century Baroque. Diogenes is another reworking of Domenichino's painting of St. Jerome at his last Communion.

Working within a limited range of physically powerful religious, mythological, and historical subjects, Puget maintained a consistent stylistic relation to a certain phase of antiquity, the Pergamene baroque. His connection with the overwhelming and dynamic in sculpture was made easier and more durable by the sad fact that he

was not a popular artist. The great patrons did not find his temperament or his work congenial, and the demands on his genius were not such as to distort or weaken his style by turning him into an impresario. As such, as a great impresario, there was room only for Bernini in the arts of the High Baroque, and only Bernini constantly evolved styles unaffected by the scale on which he worked.

GIRARDON

While Puget expressed a form of classicism grounded in Bernini's Pergamene Baroque, François Girardon (1627/28–1715) symbolizes the conflict between academic classicism and the High Baroque which occurred in the court sculpture of Louis XIV.[36] Louis made it evident that Bernini's unadulterated Baroque, or any French provincial version of it, was not in favor at Versailles and the Louvre. The artistic dictatorship of Colbert and Lebrun required a subservience to classicism as expressed in the Greco-Roman sculpture surviving in Rome about 1650, but at the same time it required a decorative grandeur which could only be served by fusing this classicism with methods and techniques achieved by Bernini, Algardi, Duquesnoy, and others. Girardon's northern French background, his lack of close experience with art in Italy, and his willingness to work within the official framework gave his natural ability the equipment to meet these demands with success. He enjoyed particularly close relations with the bronze-casting firm of Keller; this allowed him access to casts of ancient works and copies of contemporary masterpieces from Italy. He worked in a milieu where these, particularly the former, were being reproduced in bronze for the royal gardens and parks. It was a small step from making casts and copies to the creation of new sculptures which

were based on iconography and style of the antiques and their Italian successors.

After working as a painter and sculptor in his native Troyes, Girardon spent the years 1648 to 1650 traveling to Italy. He met Poussin, and his early training as a descendant of the School of Fontainebleau no doubt led to his admiration of the Cinquecento classicism of Giovanni Bologna and the Baroque classicism of Duquesnoy. He emerges, therefore, as a sculptor naturally inclined to mix direct copying from the antique with excursions into a form of Baroque art which recalled the technical virtuosity of Bologna and the styles of Bernini at a time when the High Baroque was being developed. Caught up in the grandeur of Louis XIV's tastes, he absorbed the theatrical aspects of the High Baroque, the restless repose of Bernini's portraits, and the fabricated emotion of his funerary monuments. Girardon lacked the uncompromising consistency of Poussin and Puget, but with a temperament like theirs he too would have failed as a court artist and remained a second-rate provincial decorator.

Girardon came to Paris the year after his return from Rome; it was not until 1666, however, that he received the commission which made him famous, the marble group *Apollon servi par les nymphes* for La Grotte de Thétys in the gardens at Versailles (figure 95). Apollo and three of the nymphs were by Girardon; the remaining three were the work of Thomas Regnaudin. Like so many artists of his time, Girardon was destined to divide his time between decorative and funerary commissions. He carved either a group for the center of a fountain or a complex marble ensemble for a cathedral. His least rewarding sculptures must have been those for the rooftops of Versailles and the Louvre. Those from which he could derive a maximum of satisfaction were undoubtedly portraits of impor-

tant persons: Louis XIV, Boileau, Pierre Mignard, and Colbert.

Girardon restored antiquities, an employment which forced upon him an historical appreciation of the arts, keeping him in close touch with the technical as well as the aesthetic details of ancient sculpture. From the lists preserved it is evident that he restored not only Roman copies in the royal collections but Renaissance and later works which reached France from Italy or which were executed by artists such as those forming the Mannerist School of Fontainebleau. He designed new bronze drapery for the series of Cinquecento heads of emperors in the Salles de la Guerre and de la Paix at Versailles. The chief attractions of the royal collection of marbles, the Diana of Versailles and the Venus of Arles, received their present form at the hands of Girardon. It was his decision to place the apple in the hand of the Venus, thus settling the question whether the beautiful Arlesian was to be considered the goddess of love or the goddess of the chase.

Girardon also had an extensive collection of ancient sculptures. In addition he acquired reduced versions in bronze of ancient marbles and bronzes, and replicas of sculpture from Michelangelo's age to his own time. A few years before his death, thirteen large engravings appeared showing his sculptures in an imaginary gallery. These sculptures were sources of reference for his own works. His best original was the porphyry head of Alexander the Great from Richelieu's collection, a masterpiece which passed into the royal collections in the eighteenth century. The restorations with which it is seen in the Louvre were Girardon's work and won him considerable fame.

The classical works which inspired Girardon's own creations were mostly statues in the tradition of the fourth century B.C. He favored Greek

works of the period of the Apollo Belvedere (figure 114) and the Capitoline Venus (figure 19), or copies of Hellenistic works in this style, such as the sleeping Hermaphrodite which he used for one of the figures on his lead relief, *Le bain des nymphes*. The derivations of the Apollo group are obvious (figure 95): the nymphs serving Apollo are variants of Greco-Roman fountain nymphs with seashells or draped females such as the secondary figures of the group known as the Farnese Bull. She at the extreme right has the Capitoline Venus' head, and the nymph washing Apollo's right foot is the well-known Aphrodite of Doedalsas, crouching at her bath, an early Hellenistic variant on the Capitoline and Medici Venuses which has survived in numerous Roman copies. At first glance the group might seem laughable, but lacking religious or political pretensions, it is a stirring success as a decorative recollection of the life of the gods, carried out in terms of Roman copies and their combinations of Greek fourth-century to Hellenistic prototypes. This is one of the first monumental, freestanding sculptural interpretations of classical antiquity without a lofty purpose or major message. Like Titian's mythological paintings, it was designed as a document of courtly pleasures.

Girardon's *Carrying Off of Proserpina* is a classical variation to a theme familiar from Bologna's and Bernini's groups. The circular pedestal is one of the sculptor's few borrowings from sarcophagi, from a Proserpina and, perhaps, a Medea sarcophagus, partly through the intermediary of a contemporary painting. His surviving pair of large marble vases for Versailles, *Triomphe de Venus* and *Triomphe de Thétys*, also blend motifs from ancient sarcophagi and large vases or urns with the artist's special understanding of just how Baroque these works ought to be to suit the royal taste. Girardon's work

of a triumphal nature, such as *La victoire de la France sur l'Espagne,* goes straight back to the Roman tradition of the Capitoline Trofei di Mario. His *Mars and Hercules* for the top of the façade at Versailles, a work subsequently damaged and now restored, places two of the familiar Roman river gods amid the arms and armor at the base of the late Flavian trophies on the balustrade of the Capitol.[37]

Girardon died the same day as his great royal patron. His fortune was made and his work formed by a king who tried to transplant the glories of Trajanic, Hadrianic, and Antonine Rome to the valley of the Seine. The image of French royal splendor in the age of Louis XIV is due largely to the success of Girardon in implementing the material aspects of this dream.

Rococo, Ancient and Modern

ITALY was the chief source of the classicism underlying much of European art after the late Middle Ages. Italian artists or artists absorbed into the Italian schools developed this classicism. This is not meant to belittle the history of art in other nations, but although classicism did shape the course of non-Italian artists in the centuries under review, from 1100 to 1700 the story of antiquity's survival has been almost entirely a chapter in the history of Italian art. The importance of French art in the age of Louis XIV, however, has received more than passing mention.

The eighteenth century presents a picture of Italian art brought through a full range of creative forms. The rationality of the Renaissance had given way to Michelangelo's power and Mannerism's perversions; Bernini's Baroque carried an emotional classicism beyond anything common to antiquity. After 1700 the initiative of creation was handed on to non-Italians in sculpture and, to a great extent, in painting, until Antonio Canova emerged to give Italian sculpture its last half century as one of the primary expressions of European art in the post-Renaissance period. Italian eighteenth century painting is enjoying the deserved acclaim of current fashion, but no amount of research or enthusiasm can raise artists, other than Tiepolo, to the level of the Italians who went before or the French who followed.

Italian Classicism in Northern Europe and Travelers in Classical Lands

The saga of voyagers from northern Europe and to the Aegean from all parts of Europe is the story of what these trips contributed to the spread and development of classicism in Western European art. Since the eighteenth century was the great century of archaeologically profitable travel to Turkish lands, it was at this point that external forces altered the current of artistic inspiration that had flowed solely from Italy. The flow of Greek originals, mainly sculptured reliefs, from Greece, the islands, and Asia Minor began when the Venetian General Morosini and his German artillery blew up the Parthenon in 1687. British agents of Lord Arundel were scouring the eastern Mediterranean for ancient marbles in the generation before the middle of the century. The rising tide of imports westward, however, made its effect on artists about the time the discoveries of Pompeii and Herculaneum brought revelations in understanding of Greek and Roman minor and domestic arts.

The classical landscape or semifictitious ruins of Giovanni Paolo Panini (1691–1765) and his

followers were the result of architectural voyages from 1700 on, of increased travel to admire Roman ruins, of the antiquarian landscapes of Claude and Poussin, and of Seicento developments in stage design and decoration.[1] It was rare to find architecture and sculptured reliefs mixed in seventeenth-century classical landscapes. Artists included ruined buildings in natural settings, or used ancient statuary and reliefs as bases for their own compositional creations. When sculptured reliefs appeared, they usually contributed to the story of the painting, the miracle of a saint or a Roman martyrdom. Architecture was published in one type of books; statuary and reliefs appeared in other compilations or sets of engravings. Panini made a great contribution to the classical taste and decorative senses of eighteenth-century Europe by bringing the statuary, reliefs, and sarcophagi out of the palaces, museums, and parks and into the romance of ruins.

Panini's work falls into four categories: views of contemporary fetes and of areas of Rome as they were in his lifetime; paintings of ancient buildings in Rome as they were in his own days; ancient (and later) buildings represented as rearranged ruins, with ancient sculpture and modern people placed about to set the mood; and composite, encyclopedic glimpses of ancient or modern buildings portrayed in a single painting like pictures in a gallery. Examples of the latter are the scenes of ancient Rome in the Metropolitan Museum and the Louvre, and the views of modern Rome in Paris and Boston. He had the artist's predilection for a limited number of classical sculptures and reliefs, which he used over and over again in a variety of settings. The Farnese Hercules, the Farnese Flora, the Belvedere Torso, the Borghese Warrior, the Silenus with the Infant Dionysos, the Medici and Borghese vases, and the Aurelian reliefs in the Conservatori were the best-known ancient marbles of Panini's age; and their appearance amid recognizable ruins could not fail to evoke classical memories in the minds of Northern European purchasers of these decorative paintings (figure 96). A typical example of Panini's discipline crowds more ancient monuments into a coherent composition than seems possible without showing them as framed pictures on a wall. From left to right the buildings are: the column of Trajan, the temple of Saturn (restored), the arch of Constantine, the round temple by the Tiber, the pyramid of Cestius, the arch of Janus, Colosseum, temple of Castor, and basilica of Maxentius—all in the heart of Rome within a few minutes walk of each other. The sculptures are: a reclining river god in the Villa Torlonia-Albani, the Lycian Apollo, the principal slab of the Ahenobarbus base, a lion of Egyptian style in the Vatican, the sarcophagus of Constantia, the Belvedere torso, the Borghese krater, and an imperial scene of sacrifice (in mirror reversal because it was taken from an engraving). All of these were in Roman collections in the artist's time, although the scene of sacrifice went to Florence with the Medici antiquities, and the Ahenobarbus relief of Poseidon and Amphitrite migrated to Munich and the Borghese vase to Paris in the Neoclassic dissemination of Rome's treasures.

In his evocation of the Greco-Roman past, Panini is not so much a great artist using classical antiquity as an artist who kept the taste for classicism at an intelligible level in a period when Italian art was most concerned with allegorical and theological decoration. At this time, French painting was (with the exception of Panini's follower, Hubert Robert) in the grip of the Rococo, and British art meant portraiture, some landscape (preferably with horses), and little else.

Giovanni Batista Piranesi (1720–1778) blended Panini's stimulus of the classical senses with the new level of archaeological science reached in the Seicento by combining romance and learning in his books of engravings.[2] He profited most from his ability to extract the maximum in grandeur from the most prosaic ruin. He also benefited from the century-old process of codifying classical antiquity, which started with the *Museum Chartaceum* of Cassiano dal Pozzo and culminated in the repertories of Bartoli, De la Chausse, Montfaucon, and the Comte de Caylus. As a practicing architect, he not only drew ruins well but added a draftsman's intuition to his theories of topography. As a dealer in and a restorer of ancient marbles, he could make the meanest cinerarium or the most prosaic marble candelabrum take on the qualities of a great work of Greco-Roman art in his plates. He was not above illustrating and selling a forgery, as several of the urns in Sir John Soane's Museum testify.[3] Piranesi's drawings of interiors, of chimney-pieces, and of mantels paved the way for the archaeologically exciting and correct decorative classicism of the Adam brothers. Through this family of Scottish architects and contractors he provided employment for countless second-rate Italian decorators in England, and through them several generations of English and Irish gentry were stimulated to the pursuit of classical works of art, ancient marbles, or modern paintings and sculptures. Piranesi motivated countless journeys to classical lands. He also encouraged the foundation of what later became England's leading learned societies (the Society of Dilettanti, for instance). In yet another sense he paved the way for the advent of Neoclassicism.

Although the work of Panini and Piranesi acted as a bridge between Baroque and Neoclassic classicism in Italy, the Rococo in France was the important development in art between 1700 and 1760. Long defined as a reaction to the dramatic pretentiousness and religious dedication of the Italian Seicento, the Rococo's concern with colorfully fragile decoration, pastoral poetry in art, sculpture on minute rather than colossal scales, and trivial instead of significant subjects gave its works a character as readily identifiable as the works of Bernini, Algardi, or Puget in the previous century. The Rococo was consistently and intimately concerned with classical art, and in Greek and Roman art its artists found the works which inspired what they were trying to express.

The connection between Greek art and rococo tendencies began long before the eighteenth-century Rococo was conceived. It began, in fact, as early as 150 B.C. From 250 to 150 B.C. the dominant movement in Hellenistic art was the so-called school of Pergamon. Through a series of political circumstances, there arose in Asia Minor a city-state to which artists flocked for commissions at the behest of the ruling Attalid dynasty. The Attalids had recently saved, or thought they had saved, the Greek world from catastrophic invasion on the part of marauding Gauls moving out of Asia toward Europe. The defeat of these Gauls called for heroic commemorations in painting and sculpture, works as emotional and dramatic as the deeds that had inspired them. Thus, the groups of fighting Pergamenes and Gauls, Greeks and Amazons, Greeks and Persians, and the Gods and Giants of the great altar of Eumenes II were created. The Romans admired Pergamene art, and copies of its masterpieces abounded. Copies of these baroque sculptures were around Rome and Florence in the Seicento, and it was more than an accident that Bernini and his contemporaries turned to them for suggestions.

After about 150 B.C. a reaction to Pergamene

art set in throughout the Hellenistic world.* Instead of producing heroic works illustrating epic and contemporary themes, artists turned to the decorative and the precious in art. A child playing with a goose or a satyr reeling unsteadily, smiles of pleasure past and future on his face, replaced Pheidian cult-statues or Artemis saving Iphigenia. The vast Hellenistic world was filled with people of different races, many living in urban slums. Artists of the Hellenistic rococo sought out people of non-Greek type or of low estate as subjects. An old market woman with her basket of chickens or a farmer driving his cows to market was deemed as suitable a subject for the new art as an excerpt from the Trojan Wars had been for the old. In mythological works, the triviality of the Dionysiac thiasos was preferred to the significance of the deeds of heroes.

The Hellenistic rococo was the climax of an innate tendency in Greek art to represent the domestic as well as the divine. This tendency is first seen in monumental Greek art in Attic grave steles of the fifth century B.C., that of Hegeso serving as a good example. The style continued long after the implications of its art as a reaction to Pergamene pretension had passed away. The rococo merged with other Hellenistic currents, and in the Augustan to Antonine ages of the Roman Empire its expressions and their copies were still being created alongside archaistic (figure 11), Neo-Attic (figure 38), and even the Pergamene paintings and sculptures against which the Hellenistic rococo had originally reacted.

When the French Rococo looked to classical antiquity, the model on which it fastened was the Hellenistic rococo, created to satisfy a re-action similar to that experienced by French artists in the period after 1710. The works of E. Bouchardon (1698–1762), E.-M. Falconet (1716–1791), and J. B. Pigalle (1714–1785) in sculpture offer many examples.[5] However, if a single piece of sculpture were singled out as most typical of the links between the French Rococo and its ancient counterpart, it would be Clodion's *Nymph and Satyr,* a Sèvres porcelain in New York (figure 98). Claude Michel, called Clodion (1738–1814), worked in the last years of Louis XV and under Louis XVI, and even modified his style radically enough to become a monumental Neoclassicist under Napoleon. His nymph and satyr are Rococo counterparts of the ancient groups of the *Satyr Pursuing the Nymph* (or *Hermaphrodite*) (figure 97); the only difference is that the nymph or Hermaphrodite is half-trying to escape from the satyr's clutches, while the French Rococo nymph cloaks her desires with no such pretense.

French Rococo Sculpture

EDMÉ BOUCHARDON

Bouchardon's fame began during nearly a decade spent in Rome (from 1723), where among other activities he produced copies of ancient marbles. One of the statues he copied was the Barberini Faun (as rococo a translation of Pergamene baroque as could be found in such large size). He is perhaps best remembered for his *Fontaine de la rue de Grenelle* (1739–1746) in Paris. The reliefs of this monument, featuring putti as the seasons, are related to this lighter side of antiquity and have ancient parallels in sarcophagi, altars, bases, and the Pompeian Third Style painted friezes of the House of the Vettii in the city buried by the eruption of Vesuvius. Bouchardon's other great contribution to France's unconscious revival of the Hellenistic

* In an important book written over fifty years ago, Wilhelm Klein called this reaction the Hellenistic rococo, having in mind the art which dominated France in the eighteenth century.[4]

rococo is a statue known as *Cupid fashioning his bow from the club of Hercules* (1747–1750) (figure 99). As he bends and half smiles, this nearly adolescent Eros is the counterpart to Lysippos' statue of Eros with a bow, surviving in a great many replicas. The theme is related, for the subject of the ancient marble has been identified as Eros *unbending the bow of Herakles,* another variation on the theme of force disarmed by love.[6]

ÉTIENNE-MAURICE FALCONET

Although he never visited Rome, Falconet brought the world of Hellenistic Greece into his charming, disarming creations. From 1757 to 1766 he was Director of Sculpture at the Sèvres Porcelain Manufactory, something which brought his treatment of the French Rococo statuette very much in rapport with Hellenistic terracottas and small marble groups. His marble *Hebe* (1759) in the Ceramic Museum of Sèvres, is a perfect illustration of this. In his essay of 1761, *Réflexions sur la sculpture,* he went so far as to state that he thought the warmth and softness of the human body to have been better rendered by his own contemporaries than by the ancients. Unaware of many Tanagra and other Greek terracottas discovered mainly in the nineteenth century, he was reacting against the lifeless Roman copies then adorning Versailles and the Louvre. He might have felt differently had he had an opportunity to wander among the palaces and galleries of Rome, or to see the surviving examples of Roman wall painting in Central Italy.

Falconet's Academy piece of 1754, *Milo of Croton,* in the Louvre, invited comparison with Puget's more famous group of the previous century; the contrast between the two is the difference between Bernini's powerful Baroque and the more pretentious of the French Rococo mythological groups. *La Musique* (1752), in the Louvre, sums up all the tripping grace, airy drapery (when included), and trivial charm of Falconet's Aphrodites, nymphs, bathers, and other female creatures. *L'Amour menaçant* (1757), in the Louvre, seated and with the right index finger at the lips, brings new life to the Hellenistic rococo type of the Eros seated on a rock (figure 100). In antiquity and in the eighteenth century this Eros (figure 55) could be changed to a child by removing the wings and to a fisherboy or peasant child by substitution of costume and appropriate attributes for the feathery wings. In addition, the emphasis on the gesture of the finger to the lips makes Falconet's statue a new version of the Alexandrian Hellenistic types of the infant Harpocrates, the Egyptian child Horus who became a Greco-Roman embodiment of esoteric divinity in child form.

JEAN-BAPTISTE PIGALLE

Pigalle, Falconet's rival, in 1736 went to Rome for three years (at his own expense) and nearly starved. His *Mercury (Fastening his Sandals)* (about 1740) is the counterpart of a group of Hermeses, the best-known of which is the seated youth in bronze from Herculaneum and in the Museo Nazionale in Naples. Pigalle's terracotta in New York (figure 101) and the finished marble in Paris breathe lightness of expression, grace of motion, and perfection of surface. The ancient type was created in the workshop of Lysippos, about 300 B.C., and was much diffused in the Hellenistic rococo in small marble and bronze sculptures. Pigalle's Mercury dwells not so much on the erotic aspect of the Rococo as on its strength in small-scale sculpture. The god's body has the anatomical tension of the Lysippic school; the additional tightness of a contorted pose and a gaze fixed sideways at some event or object stir our speculation. All this, the manu-

factured containment and the directed gaze expressed in a pyramidal figure, was begun in the early Hellenistic period of Greek art and seems so natural that it is hard to comprehend as a direct borrowing from antiquity.

Pigalle's children looking at birds who have flown out of their little cages are, line for line, the child with the fox-goose, the smallest variety of that bird. Countless copies of this Hellenistic group of a child squeezing a miniature goose under its hand have survived.[7] The original was created about 150 B.C. The charm and personality of both works make them basic illustrations of the movements in which they were produced. Pigalle's classically Rococo *Love and Friendship* (1758), made for Madame de Pompadour and now in the Louvre, demonstrates a difference more apparent than real between the Hellenistic rococo and the French Rococo. This difference lies in the fact that the titles given by the ancients to the charming creations of the former period are not known. The appeal is partly in the half-serious allegory or the trifling moral, and this is lacking in the works surviving from antiquity.

Those works which parallel one aspect of the antique in theme and composition have been singled out for comparison. These three sculptors, particularly Pigalle, were as versatile as their Hellenistic counterparts would seem if more information about their careers had survived. Pigalle's decorative trivia and his mythological lightheartedness can command too much attention. On the other hand, he created religious statuary in a style best termed Late Baroque; he was commissioned to do royal monuments; his fame rests as much as all else on two tombs of great nobles of the realm; and he was responsible for large garden kraters worthy of those extracted by Piranesi from Hadrian's Tiburtine Villa and elaborately restored in ar-

bitrary fashion. Because of their training, all three sculptors could—and did—produce the competent portrait busts which critics of the present consider one of the glories of their age. Two aspects of method brought these sculptors in the closest communion with the antique—the rococo manifestation of Hellenism dwelt upon here. Like the masters of the fourth century and Hellenistic worlds, they made finished models in clay and terra cotta; and, like the sculptors of the age when Rome commanded Greece's patronage, they encouraged production of a successful composition in several media and in various sizes.

The French Rococo was a short-lived affair. It started in the early part of the eighteenth century, a decade before the death of Louis XIV. Like surviving painting of the Pompeian third and fourth styles, it was primarily a movement of interior decoration. The Italian Baroque had belonged to grand chambers and great city squares; the French Rococo was more at home in the palace bedchamber or rustic retreat. The Rococo, in France at least, began to die with the advent of Neoclassicism from the Campanian cities via the academies of Naples and Rome (about 1740 and 1750). In Germany and Austria the style continued with vigor almost into the nineteenth century.

Painting in the French Rococo

In France the two generations following 1710 are too short a period to discuss and define the Rococo style in painting, as well as in sculpture.[8] The Rococo in painting is best known and often referred to in terms of its most prolific painter, François Boucher, who was very active until his death in 1770. His sometime pupil Jean Honoré Fragonard, although out of fashion at his death in 1806, was not born until 1732. Their pre-

cursor, Antoine Watteau, fits best into the "High Rococo" because he died most prematurely of tuberculosis in 1721. It took some years for the Neoclassic movement to eliminate the Rococo, which was really killed by the French Revolution. The two existed side by side for many years. Rococo art did not lend itself to history painting, and the line between Poussin's subdued Baroque and David's warm Neoclassicism was alway thin in this the most respectable branch of painting. The Rococo was just free enough and just specific enough in its use of classical mythology for ceiling painting, but it was really at home in wall-canvases or easel-paintings, and pastels were perfect answer to its lightness of subject and technique and its qualities of ephemeral fashion arrested. Greuze could fail before the Academy in 1769 with his *Septimius Severus Reproaching Caracalla* and still mint money as a painter of trivially moral themes.

WATTEAU AND BOUCHER

Every tradition of the role of classical sculpture in art seemed to be negated by the painting of the Rococo. Watteau developed his colors, landscape, sky, soft textures, and fleshy (if not plump) figures in a personal form of *Rubénisme* concocted from drawings after Rubens' *Marie de'Medici* series and other large canvases, from studies of Veronese's rich scenes, and from a passing acquaintance with the genre and still-life painting of the Low Countries where he was born. This development can be seen by placing a reversal of Watteau's *Nude Female Torso* in the Louvre beside Rubens' *Venus and Adonis* in New York. Boucher used models only in his youth and painted directly on the canvas with a minimum of literary research and recourse to sketches. Both he and Fragonard measured much of their success in terms of pastoral

and boudoir scenes often termed "charmingly indelicate" to avoid using the term pornographic. When sculpture was the recognized model for a figure or a group, or even when sculpture appeared in a garden scene (such as in Fragonard's *The Swing,* in the Wallace Collection, or *A Game of Hot Cockles,* in Washington), the statue or relief was usually the work of a contemporary such as Bouchardon, Falconet, or Pigalle rather than an ancient marble.

These painters produced a positive view of classicism in a phase of art which was a reaction to the grand decorative styles of organized art at the court of Louis XIV. In the Quattrocento, in the age of the Mannerists, and even in the large paintings of the early Baroque, sculpture is used as the classical fountainhead. Such classical sources cannot be employed in dealing with Rococo painting. When Rococo painting is placed alongside what ancient painting survives from the later Campanian styles, they often turn out to be related. The same relations were encountered in French Rococo sculpture and the statues and reliefs of the Hellenistic world from 150 to 50 B.C. The ancient theater exerted great influence on the decorative frescoes of the third and fourth Pompeian styles. Watteau studied under Gillot, a painter of theater scenes, and worked closely with the performing arts. In landscape, specifically in Watteau's drawing (*The*) *Cottages Among Trees,* in the Musée Bonnat at Bayonne, the delicacy and whimsy in hiding little buildings in leafy trees recall painted friezes such as the early imperial *Yellow Frieze* from Livia's Villa at Prima Porta.

Finally, the Rococo interest in Chinoiserie matches the Roman Rococo's preoccupation with exotic details from Egyptian and Nilotic life. Boucher's *An Audience of the Emperor of China,* in the Besançon Museum, is Chinese in costumes, headdresses, umbrellas, primitive weapons, and

evidences of ritual. The courtesans surrounding the emperor have slanted eyes, but in all other respects they are Boucher's shepherdesses. The ambassadors' presents in the right foreground include a late Roman Republican cinerary urn, an Italic or Etruscan pyxis, an Etruscan cista, and three sets of South Italian Greek black-glazed cups and dishes. The incense-burner is a Greek cauldron mounted on a Roman tripod, such as appears in Domenichino's *St. Cecilia before the Judge* (figure 80) or Cortona's *Santa Bibiana's Refusal to Sacrifice to the Pagan God.* This supposedly Chinese utensil is thus derived ultimately from the Aurelian relief of the Sacrifice of Marcus Aurelius before the Capitol, in the Palazzo dei Conservatori. The background is no less charmingly un-Chinese. Louis XIV's canopied bed is flanked by two baldachins based on Bernini's creation for the high altar of St. Peter's! This, at least, is no artistic distortion of a Christian symbol into items of decorative furniture at the Chinese emperor's court, for Bernini had been ordered to make a reduced version of his baldachin to cover Urban VIII's bed at Castel Gandolfo.

Boucher was as accurate in his Chinoiserie as the Romans were in their details of Egyptian life. The Barberini mosaic mixes architecture, costumes, armor, and landscape from all over the Mediterranean in a number of ages in its attempt to give an Egyptian setting. The Pompeian frescoes of the ritual of Isis priests show just the synthesis of Greek and Egyptian elements which, it can be imagined, went on in the Egyptian rites at the Iseum and the Sarapeum in Rome's Campus Martius. The French Rococo and the decorators of the Roman house under the Farnesina sought a common goal: a decoration devoid of content, interested far more in the stimulation than the accuracy of forms for this decoration. Greek and Roman mythology were popular in both ages, but Egyptian motifs or Chinoiserie provided the exotic outlet.

In the treatment of ruins in landscape the French Rococo could be as trivial as Panini was serious or Piranesi was dramatic. Boucher's *Pastoral Scene* in the Louvre is typical (figure 102). The well-dressed shepherd and his two charming companions are looking after their fleecy charges in a landscape that uses a Baroque curtain of trees and foliage drawn back at the left to reveal a Roman town and aqueduct in the right rear. The foliage at the left serves as a background for an herb-covered urn on a Roman cippus or statue base. Both a rockwork relief and a water-god (or Pan) mask in coral or foliage look out from the leaves and falling water beyond. The scene on the face of the relief is equally in tune with the lighthearted Dionysiac flavor of the pasture. A Cupid is mounted on a goat which is being dragged by another Cupid and pushed by two helpers, one of whom tumbles in a playful attempt to unseat his playmate. The relief is as Rococo as the whole scene, and Bouchardon, Falconet, or Pigalle, can be imagined carving it for a noble garden. The Cupids' goat is echoed by the real beast and the two sheep in the right foreground. The Campanian decorators were also interested in ruins, and the lighthearted little temples, colonnades, garden gates, and fountains in their frescoes provide a similar setting for the classical ancestors of Boucher's courtly rustics.

It might almost seem that there was no direct recourse to ancient sculpture in the French Rococo. Examples exist to qualify this, but it is not always clear how conscious or how direct the borrowings were. Watteau's *A Lady at her Toilet,* in the Wallace Collection, is surprisingly sculptural (figure 103). The lady lifts her nightgown over her head and into her lap in a gesture just like that of the crouching Aphrodite at-

tributed to the school of Rhodes in the Hellenistic rococo (figure 104). Watteau's lady is clearly outlined and rendered in the round, a contrast to the couch and curtains surrounding her. Obviously several drawings from Rubens and perhaps directly from the antique have gone into developing the figure.

Like Watteau, Boucher produced paintings in which a relation to Hellenistic rococo statuary can be imagined, if not proved, by means of the same processes (not on Boucher's part) by which Bernini's most Baroque creations have been traced to the antique. In the *Bath of Diana* in the Louvre (figure 105), the goddess of the chase can be compared in pose and modeling to the Hellenistic *Invitation to the Dance* (figure 106). In this group, a satyr playing castanets and foot-clappers invites a nymph to remove her sandal, rise from her rockwork seat, and join him in the dance. The original figures were probably in bronze, but several marble Roman copies of the satyr and one or two of the nymph survive. Boucher has based his scene of Diana disrobing for the bath after a successful day with bow and quiver on a nymph in just such a pose and of identical proportions. In the artist's very similar *Toilet of Venus* (1751) in New York, the central goddess is much like the Diana seen in reverse. The facile Boucher, like the French Rococo in general, could get along with the same females, shepherds, and putti in settings differing little from each other. The Hellenistic rococo had done the equivalent thing, in painting as well as sculpture, with nymphs, satyrs, Erotes, and the like.

Boucher's *Triumph of Venus* (1748) in the Stockholm National Museum blends his usual boudoir and couch scenes with the possibilities afforded by the mythological mixture of powerful male and fish forms in the tritons, all amid the tossing sea. A Nereid reclines in the same langorous pose given Venus in the artist's *Mars and Venus Surprised by Vulcan*. Another Nereid (to the left of Venus) falls back on a dolphin in a pose recalling Boucher's drawing of a *Nude Girl Asleep*, in the Besançon Museum. This part of the design goes back through the seventeenth century to Mannerist mythological compositions such as Rosso's drawing after Michelangelo of *Leda and the Swan*. But the composition as a whole is the French Rococo's contribution to the Renaissance and later history of treating the subjects, themes, compositions, and motifs offered by Roman Nereid sarcophagi. Boucher combines the originality of his age with skillful selection of classical sources. Doves and a Cupid sport about the principal male figure, the triton pouring water from a large shell; he has his place on the more rococo of Nereid sarcophagi, such as the example in the Lateran. The positions and actions of the tritons, the friezelike disposition of the figures, and the sculptural forms record a debt to Roman monuments which was probably incurred through the medium of Venetian and Flemish color and love of warm mythological richness.

FRAGONARD

Fragonard's strong obligation to his Roman adventures is manifested in a form of art related to literary vignettes. Two of his etchings, *Satyrs Playing*, are in the Bibliothèque Nationale in Paris. The first, a gemlike oval in a forest setting, shows two Pans lifting up a happily ensnared nymph in their interlocked wrists. The composition is a tribute to Fragonard's mischievous spirit. It is a parody of a sarcophagus relief, now partly lost, but then in the Mattei collections in Rome and published in the *Monumenta Mattheiana*, the sumptuous eighteenth-century catalogue of the marbles in that collection. The subject was probably the birth of Aphrodite,

carried triumphant from the foam.[9] The second etching presents the short side or end of a Bacchic sarcophagus in a rustic setting replete with Bacchic situla and thrysus. A nymph with an Isiac sistrum capers along amid a family of Pans. (The scene is perhaps the outcome of the encounter in the previous etching.) The relief could be from a Bacchic sarcophagus, but it is really the perfect expression of what Fragonard thought ought to be on a relief of this class. His lighthearted synthesis of antique and Rococo is admirable.

In the prolific years 1767 to 1771 Fragonard produced a painting, *Les amants heureux ou L'instant désiré,* showing two lovers embracing on a richly covered couch. Two versions of the subject are extant. The lady's nude back is toward the viewer, and the youth leans over from the other side of the bed. The design and the poses, perhaps unknown to Fragonard, have a classical source in one of the scenes on the Ara Grimani in Venice (figure 74). Titian exploited the ancient relief of a satyr embracing a maenad for *Venus and Adonis* (figure 73). Fragonard undoubtedly derived his treatment of the theme from an engraving after Titian. The ancient work is very much a creation of the Hellenistic rococo, and Fragonard's young couple have caught more of the frolicsome abandon of the original than Titian could put into his rather noble, if not pretentious, composition.

Fragonard had proven his ability to do palatable history paintings in the grand tradition. His first dated work (1752), is *Jéroboam sacrifiant aux idoles,* in the École des Beaux Arts, and in 1765 his name was made with *Le Grand-Prêtre Corésus se sacrifie pour sauver Callirhoé.* The finished canvas was purchased by Louis XV for the Gobelins tapestry works and is now in the Louvre (figure 107). Fragonard had painted a preliminary version, now in Angers, the previous year. All three compositions (the two of Corésus differ radically) are in the best High Baroque tradition. *Jéroboam* prays to Myron's cow amid colonnades and swirling drapery worthy of Bernini; he even looks like Domenichino's proverbial St. Jerome. The final version of *Corésus* (with its two oil sketches) employs every dramatic trick: figures and clouds in the sky, columns rising through the scene, masses of drapery, and figures recoiling from the most theatrical suicide. During his years in Rome, Fragonard learned his lessons from Cortona, the Bolognese and the Aurelian reliefs. Fortunately he chose not to continue this aspect of his career.

Twenty years later, about 1783, he painted a pair of scenes which suggest the story of Cupid and Psyche, *Le Sacrifice de la Rose* and *L'Invocation à l'Amour.* The scenes in both paintings and the finished studies for them are set in those evocations of natural, classical (in the rustic sense), and almost romantic parkland which make the French Rococo recognized as a method of expression without parallel in European art. The altar in *Le Sacrifice de la Rose* is based on a circular cinerarium long in the Museo Capitolino. It is the classically sculptural figure of the swooning maiden beside Cupid that arrests attention, however. She wears diaphanous drapery around and beneath a Praxitelean or Hellenistic body. These combinations are prime characteristics of Neo-Atticism or the school of Pasiteles, and in fact she is nothing more than an animated version of some late Hellenistic Aphrodite or of the Marbury Hall Electra type.[10] The pendent scene presents a lady in supplication before a statue of Cupid, seated on a high circular base (figure 108).[11] The lady could come directly off a Greek mirrorcase or could be the screaming Creusa from the Medea sarcophagus used by Titian for a maenad in the *Feast of Venus.* Her god is the Praxitelean Eros, seated

and given a few Rococo overtones; the resulting interpretation of Eros or Cupid is strangely, but probably accidentally, like those decorative bronzes being found at Pompeii and Herculaneum at this time. The style, if not the subjects, of these two paintings makes it hard to realize that Fragonard was doomed to such a lingering artistic demise. They are almost on the threshold of the new Neoclassicism. They return to the best of the dramatic spirit of his early historical paintings yet suggest that Fragonard could have surrendered to the triumphant Neoclassicism had he been young enough to wish to try.

GRAVELOT

Hubert François Bourguignon, called Gravelot, was born in 1699 and died in 1773, his active career as a minor master spanning the French Rococo in its broadest sense. He is remembered as an illustrator of books, an artist who carried Watteau's influence beyond mid-century and across the Channel to England.

About 1768 he produced fifty drawings to illustrate the complete works of Voltaire, published in Geneva between 1768 and 1774. Roughly two years later Gravelot sketched *Orpheus Playing to the Animals,* now in the Philadelphia Museum of Art, as the frontispiece of *L'Art poétique* in the British edition of Horace's *Opera,* a drawing which may be considered the touchstone of his Rococo classicism (figure 109).[12] Orpheus, head tilted back in a jaunty manner reminiscent of Watteau, sits on a mossy bank in a forest of large trees. Birds fly past or perch on the branches above, and a squirrel (?) peeks from his nest in the tree on the left. The animals are the proper mixture of domestic and exotic: horse, cow, and stag mingling happily with lions, wolf, fox, turtle, and even an elephant at the far left rear. A snake

glides from the lower left toward the inspired musician, and it may be supposed that the animal partially visible at the extreme right is a camel.

The obviously classical subject has a number of prototypes among ancient paintings, mosaics, and reliefs. A marble tondo relief, once in the Mattei collection in Rome and now lost, provides a good comparison. Gravelot's drawing gives every indication that he was thinking of an ancient marble when he designed the scene. The handling of the eagle, the squirrel, and the trees of the background is very much that of Hellenistic reliefs. The Mattei relief was published in the third volume of the *Monumenta Mattheiana,* which did not appear until 1779.[13] It is useless to speculate whether Gravelot knew the relief through engravings, a plaster cast, or firsthand observation. At least the relief can be cited as comparative illustration of how the French Rococo warmed and lightened the most classical of rustic or rural scenes. Seventeenth-century drawings of the Mattei relief were in circulation, and it is not inconceivable that Gravelot saw them. Two such studies came to England with the Dal Pozzo-Albani volumes purchased by George III—more than eight years before Gravelot made his drawing.[14] Of these, an unfinished drawing belongs in the early seventeenth century,[15] and a highly finished, colored sketch was carried out about 1640.[16] The latter may be compared with Gravelot's composition (figure 110).

In this careful drawing after the Mattei marble tondo, Orpheus sits in right profile, in a half-draped, classically constructed pose worthy of a Pheidian cult statue. Beyond this striking difference, only the dramatic quality of the animals' reactions to music separates the ancient relief from Gravelot's eighteenth-century drawing. In the Greco-Roman relief, probably made between 50 B.C. and A.D. 140, birds sit and some

animals graze, but the wolf and the ass sing while the lion and the bear sleep. These small differences introduced by the artist mark the contrast between a Rococo work and its ancient parallels. Gravelot shows animals drawn to a center of joyous music; this is, to say the least, the spirit of an Orpheus scene. The Greco-Roman relief is too bound up in its academic traditions, although this may be unfair to a work judged only through the graphic arts of a much later age. The joyous simplicity of a classical composition constructed with much imagination makes Gravelot's design such a success in terms of the classical basis of the French Rococo.

The Impact of the French Rococo

Classicism in the French Rococo was more involved in a stratified social, literary, and artistic mood than any creative movement since the early Quattrocento. The French Rococo answered the demands of the king and a limited group surrounding him for a court art. That this art spread throughout Europe was no indication of a mass movement but a reminder that eighteenth-century Europe consisted of a thousand petty courts all looking to Versailles for fashions of patronage. The patronage was mostly secular; for the first time since Late Antiquity, art in the service of the Church counts for little.

The situation was similar to that which occurred in the Hellenistic world from 200 to 50 B.C., the world which produced the less rigidly circumscribed rococo of classical antiquity. In Greece of 100 B.C. and in Europe of 1750 royal and noble autocrats commanded a decorative art which was unpretentious, lighthearted, and technically facile and at the same time traditional in reliance on the importance of classical mythology, the ideal human figure, and rational arrangement of composition and secondary enrichment. However much the French Rococo may seem a creature of Versailles and contemporary court taste, its painting and sculpture never lose a carefully defined relation to classical antiquity.

The French Rococo might seem at first glance to have been devoid of science with respect to the antique. This was far from true. Great works in archaeology were accomplished; the Comte de Caylus toiled on his catalogues amid the more extravagant of court activities. Louis XV was no fool, and the efforts of Madame de Pompadour were but one manifestation of the general intellectual milieu. Versailles had its well maintained antiquarian collections. Neoclassic taste and the resulting art could not have swept France with such thoroughness without the way having been amply illuminated by the intellectual and antiquarian climate of the Rococo.[17]

CHAPTER VIII

Neoclassicism and the French Empire

THE artistic movement known as Neoclassicism, which gripped Europe from 1760 to 1820, began for a group of reasons once defined with utmost simplicity and now told in increasingly complex terms.[1] Pompeii and Herculaneum were rediscovered and excavated. Stuart and Revett published their *Antiquities of Athens* (1762) and built structures comparable to the Propylaea and the little temple by the Ilissos in English parklands. Winckelmann's *History of Art Among the Ancients* (1764) gave literate substance to the notion of quality in ancient art. The French Rococo had run its course as a reaction to the Italo-French Baroque, and the artistic extravagances of the French court were associated with increasingly intolerable political beliefs and practices. Writers made these beliefs and practices seem inconsistent with the ideals of antiquity. When the new humanism of the American, French, and Italian revolutions burst upon Europe, the classic purity, simplicity, and spiritual containment of Greek art were associated with the historical (democratic) virtues of the Roman Republic and sometimes of the early ages of Greece.*

* Revolutionary rioters did destroy classical antiquities, but the prime example, the "Regisole" of Pavia, was a bronze equestrian statue of Septimius Severus and the very symbol of imperial autocracy.

Neoclassicism and Ancient Art

Greek art and Roman Republican ideals emerged from the French Rococo as an artistic unity. Hegeso, the post-Pheidian seated, draped lady of the Attic grave stele, became Brutus' wife in David's painting; threefold Aristonautes, the striding warior of the Skopasian stele in Athens, took the oath of the Horatii in another of his compositions. Praxitelean Erotes became Homeric heroes under the brush of Ingres. Roman versions of the Pheidian Zeus gave pose and costume (or lack of same) to the founder of the American republic as chiseled by Horatio Greenough. The urge to fill Wren's St. Paul's with monuments to the heroes fallen in the Napoleonic wars and the form taken by these marble groups manifested this intensely literate art. None of this would have been possible without the wide knowledge of antiquity possessed by the average artist of the decades after 1760. A Canova, a David, or an Ingres was not trained in a few short years from the study of a welter of new publications on antiquity. The way had been prepared not only by Panini and Piranesi but by the encyclopedic antiquarian Montfaucon, the excavator Bianchini, and the collector-scholar Caylus. The physical dissemination of Greek and Roman art in the eighteenth

century also played a major part in the development of Neoclassic art.

Neoclassicism and Archaeology

The first excavations at Herculaneum took place in 1711. From 1733 on, both Herculaneum and Pompeii were dug with vigor; but it was not until three decades later that their influence was felt in the circles of painters and sculptors—not the least reasons being the zeal with which the Neapolitan Bourbons guarded the finds, and the consequent, inevitable delay in publication of the antiquities.

What was the nature of the material discovered? The most important series of finds were the Campanian frescoes on the walls of public buildings and lavish villas. These paintings were often early imperial copies of masterpieces of fourth-century or Hellenistic art. The ancient wall-paintings known in Rome since the late Quattrocento had been exploited and published and were in no physical condition to offer fresh inspiration to artists. These paintings in the city and the villas or tombs of the immediate countryside were now badly faded and damaged. The vistas of figures, decoration, and architectural enframement offered in the new finds in the Naples area were immeasurable. Joseph Marie Vien (1716–1809), disciple of Winckelmann and intimate of Caylus, began by painting the *Marchande d'Amours,* now at Fontainebleau, directly after an ancient fresco. The scene of a woman selling a basket of Erotes is sentimental enough in the French Rococo sense to bridge the transition to Neoclassicism. From this point it was an easy departure to canvases in which the Campanian designs were less obvious.

The glimpses of ancient costuming and ancient household decoration provided in the Campanian frescoes were matched by the wealth of minor works of art and utensils found in the excavations near Naples. Of these, bronzes formed the most interesting group of newly discovered antiquities with domestic connections. Thanks to Pompeii and Herculaneum, it was possible for David's *Socrates* to die in the presence of a Hellenistic candelabrum (figure 10) or for Ingres' *Stratonice* to lie amid correctly represented ancient furnishings (figure 125). The masses of ancient candelabra, vessels, pots, instruments, and braziers gave Neoclassic critics a feeling of being in communion with a world of antiquity never reached in the Villa Borghese or Museo Pio-Clementino marbles whose lifelessness and poor restoration has not aided their appeal.

The domestic pottery, wine-jars, and the like, many found in the contexts in which they had been used, added a breadth of the personal and the utilitarian which not even the bronzes could convey. Although pottery had been discovered in the previous three centuries, it was usually in funerary rather than domestic circumstances. With these new discoveries, eighteenth-century antiquarians and artists could literally furnish the kitchen or the wine-cellar of a Roman house. The temptation offered contemporary artists—often at the behest of patrons steeped in antiquity—to paint minutely detailed classical interiors was overwhelming.

In the realm of art, rather than decoration or functional objects, portraiture received stimuli of a new sort in the bronze busts and statues of quality, often with inlaid eyes, brought from the ruins of the two cities on the Bay of Naples. These gave new breadth and new life to many of the marbles in Rome, Florence, and elsewhere. Some bore inscriptions to poets, playwrights, or philosophers, enlarging the list of identifications among the nameless marble copies of lost Greek portraits.

The antiquities of the Neoclassic repertory which generally had not been available to artists before 1760 were the Greek black- and red-figured painted vases. A small group of vases was known to Dal Pozzo's circle in Rome and Bologna in the first half of the seventeenth century, but only isolated vases had appeared in publications before the age of Winckelmann. The great discoveries and the great collections were products of the Neoclassic period of amateur exploration and acquisition, and the urge for publication ensured that these newly appreciated vases were rapidly made available to Blake, Flaxman, Ingres, and others who sensed their importance.

Greek vases revealed a heretofore unsuspected form of Greek painting. Artists no longer had to depend on Antonine and Severan sarcophagi and certain related Campanian paintings for ancient representations of Greek myths. The truly classic, truly refined and contained Greek art had been discovered, and artists hastened to reap this refreshing harvest. Greek vases, expressions of an art controlled by incised lines and fired glaze, have severe limitations of course. The transformation of a highly calligraphic figure into the multicolored (though very restrained) classicism of, say, Ingres was not always successful. The designs were eminently successful in the lesser media, however; in Portobello china they are superb. With the advent of Delacroix and Romanticism, Greek vases lost their relation to contemporary art, one which they are beginning to recover in the classical world of Picasso and the modern expressionists.

Neoclassic art was based on a wider range of scientific understanding and classical monuments than had been available previously. The dangers of academicism lurked everywhere, and many artists, especially sculptors, whose names are now scarcely remembered, practiced a Neoclassicism hardly above the level of the churchyard stone-cutter. On the other hand, clockmakers produced some masterpieces in gilt bronze which have never been equaled. The combination of classical figures and modern machinery came together with singular success in these particular products.

Neoclassic Sculpture: Canova and Thorvaldsen

Antonio Canova (1757–1822) symbolizes the greatest in Neoclassic sculpture. His career was a long one, crowned with success at every turn; his production was enormous; his work was universally admired. He amassed wealth and was made Marchese d'Ischia by the Pope for his part in restoring works of art looted by Napoleon to Rome.*

On the second day of his first visit to Rome in 1779, Canova is reputed to have said that, although it was essential to study ancient statues, it was futile to copy them. Too many of his countrymen were employed as copyists in ateliers such as that of Cavaceppi, while creative commissions went to foreign artists resident in Rome and Florence. In 1794, when an American collector offered any price for copies of the Apollo Belvedere and the Venus dei Medici, Canova refused to channel his talents in this fashion. This act enhanced his position as spokesman for the originality of Neoclassicism.[3]

In his earliest works, Canova demonstrates a lifelong ability to absorb every aspect of the Roman copy after older Greek statues into his stylistic and technical repertory. The late Rococo *Dedalus and Icarus* (1779) begins to lean to the art of Pasiteles, specifically the ephebe after Stephanos in the Villa Torlonia-Albani. Icarus

* Canova's vast output is best understood by a visit to the *bozzetti* and casts in the museum of his native village, Possagno near Treviso.[2]

has borrowed the ephebe's head (and hairdress), slender body, and soft anatomy. The (headless) *Apollo Crowning Himself* (1781) adopts the atmosphere of a Roman second-century A.D. copy after a severe-style athletic figure of about 450 B.C. (figure 111), including the support (a cloak draped over a tree trunk). A copy of such a figure in the Institute of Arts in Detroit (figure 112) makes a telling comparison with the *Apollo*,[4] which is a reversal of the *Apollo* (1761) by A. R. Mengs in the Parnassus Ceiling of the Villa Torlonia-Albani. The relation of Canova's sculpture and Mengs' painting is one of the many coincidental relations between Roman copies and their mirror reversals. In his creation Canova has tried to combine the harshness of the Roman copy with his own natural talent for modeling. Body and limbs are mechanical; the cloak conveys the impression of academic drapery carved with the running drill rather than modeled from clay in its first stage of execution. Only in the bark of the tree trunk has Canova given way to an innate ability to sketch nature rather than copy classicism. Even the circular plinth is what would be expected in a Roman copy made in the ages of Hadrian or the Antonines.

The group of *Theseus and the Minotaur* (1781–1782) borrows the iconographic type of Hercules Invictus from the statuette shown on the Arch of Constantine and on Antonine medallions. Hercules Invictus is also known from several small marbles, such as the group in Liverpool.[5] Theseus sits on the slain Minotaur, with his club held vertically in his left hand. The style, especially that of the head of Theseus, is post-Praxitelean, and the ensemble presents the Neoclassic interpretation of the group of copies of a statue generally identified as Dionysos (seated) with the lion. The best of these, although with head restored, was known in Rome from Renaissance times and is now in the University Museum at Philadelphia.[6]

In his early sculpture of a religious and allegorical nature Canova shows his natural freedom and his inheritance of the Italian late Rococo style. These characteristics are embodied in the statue of *Clement XIV* (1783), the central figure for Canova's first major commission. On the other hand, the head of *Temperanza* for the monument to this pope, in Santi Apostoli in Rome, is taken directly from the Cnidian Aphrodite. A slight change in expression, a greater tilt of the head, and a roughening of the hair give the work just that touch of freshness, of originality which kept Canova far above the copyist level of his many mediocre contemporaries, while allowing him to draw directly on the antique.

Canova's *Amorino* of 1787, best studied in the headless model at Possagno, has the copyists' tree-trunk support enriched with the love-god's large bow. His model was the Eros of Centocelle or the Praxitelean Eros known chiefly from the copy found under Napoleon III on the Palatine and now in the Louvre.[7] This *Amorino*, like Bouchardon's Cupid, is the adolescent Eros who, from size and muscular development, is almost interchangeable with the youthful Apollos of Praxiteles and his school, such as the popular type termed the Apollo Sauroktonos by modern critics, after Pliny the Elder's precise description in his *Natural History*. In fact, in 1797 Canova made his fourth version of this *Amorino* which became an Apollo by virtue of a serpent coiled around the tree-trunk support.

Canova's children at this period come out of the Rococo-classical heritage of Pigalle and Houdon. His *Head of a Putto*, probably made between 1787 and 1789, owes its inspiration to busts of Caracalla as a child. Comparisons with coins permit these portraits to be dated around 198, the year Septimius Severus made his son

co-emperor. These likenesses of the young Cara-calla had caught the attention of several artists in centuries past, notably the Quattrocento medalist Giovanni Boldù (figure 42). In his study, Canova has captured the late Antonine, Severan method of rendering the pupils by a central incision and a large surrounding circle.[8]

In one instance among these portrayals of children, a *Testa di Bambino* (Bassi, no. 21), said to be a study from nature, Canova produces a free, rather florid version of a Quattrocento bust in the style of the famous tomb-sculptors of the fifteenth century, Rossellino, Desiderio, or even Mino da Fiesole. Canova is a learned adaptor in a learned period. His success at working in different styles is reminiscent of the forger Dossena in our own century. Had Canova chosen to be a forger of ancient or Renaissance sculptures, no doubt he would have been a highly successful one.

The first *bozzetto* for the funerary monument of Clement XIII in St. Peter's (1787–1792) is nothing but a large, circular cinerarium with divinities in relief, flanking the closed portals above which appears the inscription-plate. Piranesi had devoted years to restoring, drawing, and selling just such secondary plunder from Julio-Claudian and Flavian columbaria. They can be counted by the dozens in English country houses, in Roman palaces, and in obscure corners of the Vatican Museum. As the principal component, in a scale many sizes vaster than the original, the marble cinerarium may be considered an unfortunate choice for a Papal tomb. The figure of the Pope would have been placed on top of this sepulchral urn, a further note of unreality in borrowing from the antique. The monument to the Rezzonico Pope, as actually carried out, established a standard type of Neo-classic tomb: the recumbent lions, the heavily draped female symbolic of Religion, the mourn-ing reversed-torch Thanatos, and the rectangular urn with pedimented lid. The Thanatos or Funerary Genius is nothing more than another of the adolescent Erotes or a heavily topknotted Hellenistic Apollo in the tradition of Praxiteles. The Apollo Egremont at Petworth House provides an apt parallel.[9]

Canova created a new vocabulary for the monumental papal tomb. He was the first of his age to produce a funerary ensemble not dependent on the Baroque idiom created by Bernini over a century earlier. This break with the past greatly enhanced his reputation. In his *Monument to Maria Christina of Austria* (1798–1805), in a Viennese church (Augustinerkirche), Canova hit a superlative of classical refinement (the costumes of the females) and a low point of archaeological correctness in the use of the pseudo-Seneca for the head of old "Father Time" at the extreme left. In this tomb the iconographic paraphernalia are arranged with a new burst of imagination. Among Canova's many gifts was his ability to move correctly classical figures through lifelike settings. His mourners and personifications walk up marble stylobates or enter pyramidal tombs with equal grace and sentiment.

The lions which adorn these tombs combine Hellenistic dignity and naturalism with Italian imagination and sympathy in handling animal form. The dogs of the Sala degli Animali of the Vatican provided a model for a *Seated Dog*. The dog could either exist alone or as the support for an appropriate group.

Canova's mythological and historical reliefs can be considered curiosities rather than great works of art. In the statue, the group, or the tomb the eclecticism of his age seems much better absorbed and integrated in a natural way. This eclecticism was thoroughly absorbed, and greatly dignified, in the Neoclassic portrait. Among the unusual examples of Canova's output, an im-

portant group of reliefs belongs in the years 1787 to 1790. The *Death of Priam* in this series is a study in Neo-Attic emotion. The pyramidal composition is dominated by Neoptolemos, with dagger raised to strike at the old man standing on the lowest step of the three-stepped podium. Hecuba swoons at the left, and the remaining area around the principals is filled with Trojan women in striking attitudes of anger, anguish, grief, and fear. When Neoclassic artists break away from the restraint imagined in Greek art, they often swing to exaggerated extremes in animating their classically constructed figures. In this relief, Canova's Trojan women anticipate the emotional flavor imparted to Winckelmann's classicism in the paintings of Fuseli or the drawings of Blake.

Briseis Given to Heralds is based on Attic multifigured grave reliefs. The composition is derived from the group of figures posed in various gestures of farewell on Attic marble funerary vases. Achilles, raising his arm in grief at the left, is a free mirror reversal of the Apollo Belvedere. The figure in this relief anticipates the *Perseus* (1799–1801) (figure 113), which reverses the precise pose back to match the stance of the Belvedere Apollo (figure 114). Canova, through an almost mechanical process worthy of Neo-Attic copyists, could extract the most value from one successful Greek motif without appearing overtly eclectic or repetitious. He could use an ancient design in one work and reuse the design in mirror reversal in another.

From the standpoint of antiquarian correctness, Canova's *Death of Socrates* and *Socrates Consoling his Family* are less jarring than David's painting of the former. There are no Roman arches in the background. The portraits of attendant disciples and friends are derived from a successful, if unchronological, mixture of Greek philosopher and Roman Republican types. The costumes are adapted from Greco-Roman reliefs. Architectural terracottas of the early imperial period, "Campana plaques," with classicizing scenes and the set of mythological reliefs in the Palazzo Spada supply most of the details. In both scenes the emotions are overplayed, if only because Canova has tried to make them too naturalistic within the classical framework. The ancients, even in their more unrestrained moments, used a limited number of stock gestures, such as the woman with arms outstretched in grief or the figure seated chin in hand as a sign of meditative mourning. At its best, Neoclassic sculpture exceeds its purpose of creative antiquarianism by trying to make a scene such as *Socrates Consoling his Family* too actual or naturalistic rather than meaningfully symbolic. At its worst, Canova's imitators turned on the faucets of sentiment in carving their commissioned tomb reliefs or gravestones. These emotional excesses of second-rate Neoclassic stonecutters have characterized Italian funerary art right down to the present day.

The two other reliefs in the Socrates series (1790–1792) draw on Roman sarcophagi and historical or state reliefs, monuments much used from 1400 to 1650, for their classicism. That Canova could execute four reliefs in a series based on four different types of ancient marbles was only one measure of his genius as a borrower and as an artist. In *Criton Closing the Eyes of Socrates,* a work in the tradition of the others, both the arrangement of the figures (to the left and to the right of the dead philosopher) and the gestures are taken from *conclamatio* sarcophagi, those popular classical scenes of the mourning for the deceased on his deathbed or bier. The two examples of *conclamatio* sarcophagi in the Lateran Museum or the one in the Lateran Hospital since the Cinquecento furnished models close at hand. Drawings made in

the sixteenth or seventeenth centuries also may have served as intermediate studies, for the relief in the Lateran Hospital was once in better condition. Other reliefs of this class were drawn in earlier centuries and lost by Canova's lifetime.

Canova paid considerable attention to these secondary documents of Greek and Roman art. The walls of his studio in Rome are still covered with the fragments—many provocative and important—which he assembled for enjoyment and study. The most latitude for original, creative action or narration in the Socrates series is provided by the relief of the *Apologia of Socrates Before the Judges*. This contains elements derived from the Borghese historical relief, now in the Louvre, showing an *extispicium* or sacrifice of a bull before the temple of Jupiter Capitolinus, in the presence of the emperor Trajan.[10] The gestures are no less exaggerated than in the earlier reliefs, and Socrates in isolation before the judges' podium is a more dramatic figure than customary in Neoclassic art.

Canova combined and recombined motifs successfully. He was not only a Neoclassicist but also a Neo-Pasitelean in his ability to put Greek art of varying periods together seemingly to create new works. In *Venus and Adonis* (1793–1795), an Apollo of the type of the Cook statue in the Ashmolean Museum identified with the fourth-century sculptor Euphranor[11] is joined with one of Canova's *Three Graces*. The Graces are animated, half-draped versions of the Capitoline Venus. Canova reuses the type constantly, varying the pose only slightly. The effect of the *pasticcio* is improved by the presence of Adonis' dog behind the couple. This dog is the same beast for which Canova found models in the papal collections of classical canines.

Eclectic creations of this type could and did produce low points in taste, even in an artist as gifted as Canova. One of these was the funerary stele to the memory of *Angelo Emo* (1792–1795). The Venetian admiral's draped bust is carved in the Renaissance style and mounted on a shaft with prows. A marble Nike at the left, betraying its derivation from a terra-cotta model, and the Thanatos at the right are studies in Hellenistic motifs of flight. The crouching "Nike," recording the deeds of the hero, demonstrates the great variety of classical hair styles used by Canova in his work. Her topknot is derived both from Hellenistic terracottas and from the Victoriae on Antonine and Severan imperial coins. Antiquarian horizons were broadening at an astonishingly rapid rate; the great era of discovery of Greek terracottas of Tanagra type did not dawn until the middle of the nineteenth century, but the influence of the trickle of these figurines westward from Greece and Turkey in the years after 1750 was felt in the styles of a number of Canova's monumental marbles. Canova planned his marbles from terra-cotta or clay *bozzetti,* and he would naturally have been drawn to ancient works in similar media in the first stages of his creative process.

A sculptor as versatile as Canova could use the same ancient model studied by a great artist of different temperament, in this case Bernini, and create a work of striking originality, in no way influenced by the Baroque creations of his predecessor. Canova's head of the *Penitent Magdalene* (1796), a study carried out in several replicas, demonstrates this range of vision. It is based on the dying or dead wife of the Gaul in the Ludovisi group of the *Gaul Slaying his Wife.* Surprisingly enough, the Gaul's wife belongs among the more classical of the Pergamene baroque heads. Like the dead Amazon from the second Attalid group or a number of heads on the Altar of Zeus, the model was drawn from

Attic art of the Pheidian period, and something of Pheidian grandeur ennobles the pathos of Canova's Magdalene.

For the *Hebe* of 1796, Canova again used a Hellenistic terracotta, one of the flying Nikai carried out on scales up to two feet high and deemed so popular by Hellenistic Greeks as offerings or memorials in tombs (figure 115). He combined inspiration from these sources with free rendering of a marble statue in the Uffizi, itself a Hellenistic version of a terra-cotta statuette interpreted in monumental scale (figure 116). Canova's first marble was such a success that, as in other instances, he executed several later versions or replicas of the same statue. The terra-cotta-like quality of the work recalls the French Rococo, but the classical proportions and fullness of form beneath drapery reminiscent of the Nike of Paeonius at Olympia are Neoclassic. The head is taken in free fashion from the post-Pheidian Sappho type, a head of Aphrodite which may have belonged to a seated, draped statue created in Athens around 425 B.C.[12] The Hellenistic Greeks, however, had already adopted the type for terracottas and given it the touch of prettiness perpetuated by Canova's *Hebe*.

Amor and Psyche (1797), a standing group, is in the tradition of Pasitelean academic, artificial works. There were a number of Hellenistic prototypes in all materials and on all scales, showing Eros and Psyche represented at different ages. The marble group from Asia Minor in the Louvre may provide an illustration, but Canova has chosen his Amor and Psyche from his own repertory of creations after the antique. Psyche is his Hebe in relaxed pose; Amor is a wingless version of the Thanatos found on the steps of the tomb of Maria Christina in Vienna, a monumental commission carried out at this time. The ancient counterpart can be found in a Pasi-

telean *pasticcio* such as the Ildefonso group in Madrid.[13]

Canova's painting was by far the most unfortunate of his artistic ventures. It is nothing more than sculptured relief in tones rather than in planes. The models are partly Campanian and partly drawn from the decorative stuccos found in tombs outside Rome's walls and in the vaults of Hadrian's villa below the Alban Hills. He seemed hypnotized by Pompeian paintings of the class of the *Marchande d'Amours*, and he painted groups of Aphrodite, divinities, nymphs, and Erotes over and over again. Some are almost amusing; most hover near or just on the good side of a saccharine sentimentality. It is difficult to find anything good to say about these paintings, but even in this medium something of Canova's Venetian aura, if not his imagination, shines through the frosty Neoclassicism (figure 117). His female faces invariably repeat the type created for Venus from a Roman Nereid by Lorenzo Lotto in *The Triumph of Chastity*, in the Palazzo Rospigliosi. It is to his credit to say that Canova did look on occasion at the best of Venice, at Titian's *Venus from Urbino*, to create his notions of Venus in repose, but, somehow, he always managed to inflate the goddess of love's body with that rubbery quality found in poor Pompeian figure painting.

The *Perseus with the Head of Medusa* (1799–1801) depended on the Apollo Belvedere for political as well as aesthetic reasons, since it served as a reminder to the Romans that Napoleon had carried their cherished antique off to Paris to grace his new museum. The Medusa, based on the Rondinini head, completes the note of eclecticism. The statue is now enshrined with the Apollo, the Hermes Belvedere, and the Laocoön in the Cortile of the Belvedere—papal recognition of Winckelmann's doctrine that con-

temporary artists could surpass the ancients by emulating them.

The two pugilists, *Creugante* and *Damosseno* (1795–1802), presently flanking the Perseus are unfortunate heirs of the Pergamene tradition. The former has a head developed from one of the Dioscuri of Monte Cavallo, a final instance of many centuries of inspiration and derivation. The latter pugilist is no less than Caracalla boxing; Damosseno is at best worthy of a poor imitator of Puget, if such could have existed. One of the faults of the figures may lie in their presentation. They are always photographed separately and are wrongly, meaninglessly placed. The positions of the tree-trunk supports show that Canova intended the combatants to be seen together, Creugante at the right side of Damosseno, in the manner of the Tyrannicides of Kritios and Nesiotes in Naples. These statues had been grouped together in the eighteenth century and were thought of as gladiators, before later generations of scientific archaeologists, particularly von Brunn and Furtwängler, divined their identification and their place in the history of Greek art.[14] In his Creugante, Canova was also influenced by the fourth-century head wrongly restored on the body of Aristogeiton in Naples. He failed to comprehend the Greek Transitional qualities of the head of Harmodius, and turned to Caracalla for his Damosseno. He also rejected Harmodius' body modeled in the severe, preclassical style and based Damosseno's heavier frame on the ever-popular Belvedere torso.

Aside from the preliminary studies in perishable materials, the highly personal, often uncharacteristic, *bozzetti*, Canova's artistic personality and its relation to classical antiquity are best summed up in one of his lesser funerary monuments. The grave stele of *Giovanni Volpato* dated 1807 was set up in the Santi Apostoli in Rome (figure 118). Volpato was an engraver, sometime art dealer, and adviser on antiquities to Pope Clement XIV. A number of marbles found in his own excavations passed to English country houses, such as Ince Blundell Hall near Liverpool. Canova derived much antiquarian scholarship from his friendship with Volpato and through him saw new discoveries of the spade before they were whisked off for renovation by the famous restorer and sometime forger Cavaceppi or others who practiced these trades. The inscription on the columnar pedestal of Volpato's bust in the relief records Canova's personal devotion to the deceased; and a Grecian figure labeled *Amicitia* sits bowed in grief before Volpato's wreathed bust.

The monument to Volpato sums up the Neoclassic sculptor's desire to fuse his knowledge of classical Greek art with the art of the Roman world. The pedimented form of the stele copies Greco-Roman tombstones conceived in the tradition of Attic grave stelai. The seated *Amicitia* is a Praxitelean Muse fraught with Italianate emotion. Volpato himself looks down on her with that combination of ideal nobility and verism in which the late Republic portrayed Cicero, Agrippa, and even Julius Caesar. The taste of the ensemble is questionable (perhaps because modern judgments have been conditioned by ten thousand vulgar imitations in Italian cemeteries from Canova's time to the present). In the hundreds of surviving Attic grave reliefs no Greek sculptor portrayed a female wiping away floods of tears with the edge of her himation. The only females permitted such displays of weeping in Attic sculpture were the Sirens serving as crowning statues or reliefs of grave monuments.

Four works of the final decades are easily traced through their antique sources. Canova made no attempt to hide his sources, and one of

the self-advertised strengths of his work, or at least one of the reasons for his popularity, was that his patrons and contemporaries could see without too much difficulty the ancient proto-types behind the modern creations. The *Pala-mede* (1803–1805) is a standing discobolus based on the statues in the Vatican, the Louvre, and at Duncombe Park, attributed to Naukydes of Argos. Canova had somewhat softened the struc-ture of the post-Polykleitan body, giving it much of the flavor of the Pasitelean athletes or youths by Stephanos, so popular in his repertory of athletic and mythological figures.

The seated *Letizia Bonaparte* (1805) was an intelligent use of the Agrippina type, one em-ployed for portraits in antiquity from the Julio-Claudian period to the time of Helena, mother of Constantine the Great (figure 119). Napoleon's mother has been given the features of an An-tonine empress. Any resemblance to Saint Helena and any political implications were coincidental, for the identification of the statues in the Museo Capitolino and the Galleria degli Uffizi as Con-stantine's mother was made only a few years ago. The type of the body used for these portraits has been identified with an Aphrodite of the post-Pheidian circle in Athens, perhaps Alka-menes' statue known as the Aphrodite in the Gardens (figure 120). The head postulated for this Aphrodite is one of the type chosen by Canova for his Hebe. The matronly majesty of the seated, richly draped figure, like one of the Parthenon Fates to which it was related in school and style, appealed to Canova, Thor-valdsen, and their circles.

Canova's most important official commission was the statue of *Napoleon* (1811). After Water-loo the Duke of Wellington carried off the large marble version of this statue from Paris to his London mansion, Apsley House, where it stands crammed into the entrance hall at the foot of the main staircase. The smaller and more satisfying bronze version is in the courtyard of the Palazzo di Brera at Milan. The statue in Milan has a strong portrait, which does not hide Napoleon's individual traits behind Augustan classicism. The body, the walking pose, and the support with sword and swordbelt are taken from Roman eclectic work of the Hadrianic period. The torso with its fleshy chest and severe hips is the same mixture of late Transitional and Polykleitan statues distorted by Hadrianic copyists for heroic statues of that emperor or for statues of his favorite Antinoüs under the guise of various divinities. The total effect is impressive indeed. Murat had ordered an equestrian statue (never finished) of Napoleon for Naples. This gave Canova added impetus to study the imperial features, and the major outcome was to be the standing statue for a monument in Paris, the statue never really set up and subsequently taken to England as a trophy of Waterloo. Napoleon was not completely pleased at being portrayed as a neo-Antinoüs, clutching the Greco-Roman bronze Victory of Cassel in his right hand. It is easy to ridicule such work, but given the pervad-ing Romanism of Napoleonic official art, the statue had its place at the pinnacle of such re-creations of Roman imperial antiquity.*

The *Paris* (1813–1816) presents an unhappy use of supports in a statue based on the Lans-downe Paris. The post-Polykleitan "Narcissus," a Greek fourth-century work known in a number of copies, and the many leaning Fauns of the type immortalized by Nathaniel Hawthorne and attributed to Praxiteles have also exerted their influence in this sculpture. The subject of *Theseus Vanquishing a Centaur* (1817–1819; be-gun about 1805) may have been suggested by the

* It was much more suited to its subject than Horatio Greenough's little-appreciated marble portrayal of George Washington as a Roman emperor in the heroic pose (and Pheidian drapery) of Jupiter Capitolinus.

violent combats of the newly discovered Bassae frieze. It was also influenced in composition and technique of perspective by the metopes of the Parthenon. The hero is shown in Neo-Attic contortion, like Niobids in relief. The anguished Centaur is one of the Hellenistic rococo Louvre–Capitoline creatures. Canova also studied a dead horse for the Centaur, but nature has added little to Greek art.

Canova's constant attempt to emulate in his finished marbles the mechanical copyists of ancient Rome was one of the less successful aspects of his total style as a sculptor. In fairness to an imaginative, versatile Neoclassic artist, it must be stated again that a desire to show classical sources has dictated the selection of works discussed. Canova's portraits deserve fuller treatment, as creations of genius as well as reinterpretations of antiquity. He was a prolific sculptor, whose work within its limits was on a consistently high level. His self-portrait (1812), in the Temple at Possagno, owes an obvious debt to the Menander-Virgil portraits, a connection best seen in the herm in Boston. Historians of art will perhaps always remain divided as to whether the subject of this group of portraits is Greek or Roman. So, too, Canova's work is sometimes worthy of the generation after Praxiteles and sometimes belongs among the Greco-Roman copyists of the Augustan age and later. Many of these copyists were very imaginative in their interpretation of older works, and imagination was one of Canova's strongest characteristics. The secret of his genius lay in his ability to rival the ancient sculptors whose work he knew. In terms of modern knowledge the Greco-Roman repertory appears limited and stifled by the generally mediocre quality of surviving copies. Canova culled the best he could from the material at hand, and his use of Greco-Roman marbles reflects continual thought and practice. This was

the most Neoclassicism could demand of its greatest sculptor.

THORVALDSEN

The other Titan of the Neoclassic age, the Danish sculptor Bertel Thorvaldsen (1770–1884), was the man on whom Canova's mantle fell; those observations on sources and approach to antiquity made for Canova apply to him also. Although Thorvaldsen lived on into the period which rejected the all-embracing Greco-Romanism of the Napoleonic era in favor of romantic naturalism, he seems to have accepted the situation with considerable grace, and he certainly did not die without honor in his own land. Like Canova, Thorvaldsen can be best appreciated and understood by a visit to the "personal museum," material for which he presented his native city of Copenhagen, in 1837.[15]

Thorvaldsen is, if possible, more classical than Canova. He is a more direct imitator of the antique. His statues include a greater proportion of direct copies from Greco-Roman works. His relief showing the *Procession of Alexander the Great* (*Triumphal Entry into Babylon*) with Persians, an elephant, and Greeks in various heroic and Bacchic attire (1812) is soberly classical and purified of any Rococo tendencies, but it is almost a parody in its mingling of antiquarian observations, costume, and paraphernalia. *Jason* (1802) needs no introduction as the Doryphoros. His portrayals of Hermes, Ganymede, Shepherd Boys, Cupid and Psyche, and the Three Graces, to pick among many, come directly from Pasitelean works in the tradition of Praxiteles' Palermo-Dresden satyr or his Apollo Sauroktonos. His work is often not Rococo but almost Victorian in its emphasis on slight, sweet youthfulness rather than virility.

Even Thorvaldsen's equestrian statue of *Prince Jozef Poniatowski,* modeled in 1827 and

set up in Warsaw, is a devitalized Marcus Aurelius. When the Polish poet Odyniec informed him that Poles felt the statue bore little resemblance to the Prince, the sculptor made the classic confession of a Neoclassic portraitist: "What you allow in portrait painting, is inadmissible in sculpture, because a work of sculpture is a monument, and just as the purpose of a monument cannot consist only in recreating the actual event, thus a statue can achieve this and without reproducing the features."[16] When in 1818 the *Princess Bariatinska* became the Lesser Lady from Herculaneum, enveloped in a mass of drapery and with her right index finger poised against her chin, the process of identifying a contemporary person with a document of archaeology (rather than classical beauty) had gone too far!*

Neoclassic Painting: David

The greatest of the Neoclassic painters, Jacques Louis David (1748–1825), was a distant relative of Boucher, the epitome of the French Rococo.[17] He was placed as a student under Joseph Marie Vien in 1765, won the Prix de Rome in 1774, and went there with Vien in the following year. Six profitable years were spent as a creative student of antiquity, of Poussin, and of Italian Seicento artists. David's return to France led to intensive artistic and political activities as a supporter of the French Revolution and thence as a follower of Napoleon. As Napoleon's star rose, so did David's. He became the First Empire's foremost court painter, producing a succession of grand mythological compositions and

scenes of contemporary history. After Waterloo and the Bourbon Restoration, David betook himself to Switzerland and later died in exile in Brussels.

As a stylist David moved rapidly from Boucher's Rococo to a mixture of Vien's Pompeian antiquarianism and Cortona's historical painting and thence to the almost-romantic Neoclassicism which characterized his career. At first his color was controlled by the strong chiaroscuro of Caravaggio. The so-called Venetian color and light in his otherwise rigidly drawn paintings is really the color-scheme of Romano-Campanian frescoes, which he had ample opportunity to study in the company of their great interpreter, Vien. In *Death of Socrates* (1787) he hit the perfect combination of a series of colors arranged in the manner of Poussin but in the heightened tones of the antique (figure 10). These colors somewhat relieve the temptation for the eye to dwell too fondly on the accuracy of the portraits, the details of costume, the Etruscan *bucchero* cup containing the hemlock, the emblem of Athena and its Greek inscription, or even the two signatures on the blocks of marble.

Portraits are a vigorous aspect of David's career. Some, such as *Mme. Recamier* (1800), are obviously related to the antique because the subject reclines in Empire costume on pseudo-antique furniture and the vertical of the composition is provided by the tall Pompeian bronze candelabrum at the left. His *Pius VII and Cardinal Caprara* of 1805, related to the pertinent part of the *Coronation of (Sacre de) Napoléon*, is more typical of the power of personality and dignity of characterization infused in his sitters, whatever their sex, costume, or station in society. David's ability to produce decisive portraits and scholarly Neoclassic mythological tableaux at the same time made him a true measure of the degree in which Neoclassicism was steeped in the

* Canova was imaginative in his creations, but the premises of Neoclassicism left no room for other great demonstrations of originality in sculpture. Thorvaldsen (and Flaxman) came closest after Canova to making Neoclassic sculpture the living art it was foredestined never to become.

Greco-Roman tradition. Had Canova and David lived in the age of Augustus, both would have been great artists. David's abilities as a penetrating and colorful portraitist would have made him the greater. Had he lived in the Augustan age, however, none of his paintings would have survived, save perhaps in pedestrian reflections in the minor arts. Like other ancient painters, David would have been remembered solely in the pages of writers such as Pliny the Elder, but Canova would have lived on as a great artist if only because a fair number of his monumental marbles would have survived in originals or in copies. This analogy can easily be applied to Apelles and Praxiteles.

In 1771, David painted *Combat de Minerve contre Mars secouru par Vénus,* now in the Louvre (figure 121). This scene of divine combat from Book Five of the *Iliad* is treated in the idiom of Rococo historical painting. Venus, reclining with Cupid on a cloud immediately above the battle scene, betrays stylistic links with the mythological and boudoir scenes of Boucher. Minerva in her plumed helmet, flapping aegis, and fussy drapery is overdramatized in a way which recalls Rococo ceilings and Flemish painting in the tradition of Rubens. "Mars" on the ground is a dramatic mixture of a reclining river god and a Baroque St. Paul at his conversion. The remainder of the scene is filled with the paraphernalia of war in the tradition of Rubens—a heavy curtain at the upper right, smoke rising to the clouds, and helmeted forms, spears, and struggling horses dimly seen in the background.

David's successful Academy (Prix de Rome) piece of 1774 was titled (in its brief form) *Erasistrate découvrant la cause de la maladie d'Antiochus.* This painting displays less of the Rococo and more of historical painting, as instituted by Cortona. Fragonard, who was not much older

than David, produced works of a similar nature in order to gain the stature to enable him to paint what he wanted and what was financially profitable. One is tempted to compare David's *Erasistrate* with Ingres' painting of a similar subject seventy-five years later in order to see the beginning and the end of French Neoclassicism. David's figures are absorbed in Baroque drapery, and the background beyond the usual heavy curtain and columns is filled with architecture suggestive of a well-organized Piranesi dream of the Arch of Constantine. The painting shows accuracy of antiquarian details but not the identifiable precision of *Paris and Helen,* painted fourteen years later. The elimination of the Baroque curtain leading up beyond half-concealed columns of gigantic proportions demonstrates one of the advances of Neoclassic composition. The beginnings of stricter Neoclassicism are seen in the white chiton and himation and sharply delineated outline of the figure of the unfortunate stepmother Stratonice, standing at the foot of Antiochus' elaborate sickbed.

In the historical painting he brought back to Paris as testimony of six active years in Rome, the new Neoclassicism emerges as a total composition. Its subject, *Bélisaire demandant l'aumône est reconnu par un de ses soldats* (1781), presents a new treatment of a theme which Panini used in the eighteenth century as an excuse to place figures in ruins. The Arch of Constantine soaring out of the composition at the right is the remains of the Baroque convention. The landscape depends on Poussin. Belisarius is a cross between Laocoön and the Baroque St. Jerome. Otherwise the figures are reduced to the child holding out the blind old warrior's helmet, the Roman matron giving alms, and the soldier throwing out his arms in the Caravagesque gesture of surprise at the left. This is eighteenth-century historical painting, but it is

not cluttered with empty pretensions as the two previous works nor as obviously eclectic as some of the artist's later Neoclassicism. The figures have the calmness, the volume, and the archaeological correctness to make them a happy departure from the artificial emotional effects seen in David's earlier paintings of this type. They have not yet been reduced to the Praxitelean nudity which he thought so necessary in later creations.

The *Serment des Horaces* (1784) translates the advances made in the *Belisarius* into a great composition as well as a masterfully told story (figure 122). The sources for this particular beginning to the combat of the Horatii and the Curiatii have been traced to the contemporary theater rather than to classical literature.[18] The setting is stagelike and obviously dramatic. The old Horatius, balanced on one side by his three determined sons and on the other by the weeping women of his household, is the actor in the rising action of a drama. The sorrowing Camilla (or Horatia), presumably the lady at the extreme right, foretells a tragedy more complex than merely the deaths of all but one of the six combatants. When compared to the several preparatory sketches, the final painting is considerably simplified in figures and attendant detail. The grim, brooding qualities of the tragic principals gain strength from the shadowed depth of late Roman architecture framing the background. The Roman cinerary urns in the right rear carry appropriate inscriptions to the gods and the ancestral shades. A marble group of the Lupa Romana (She-Wolf and Twins Romulus and Remus), with a wreath on the animal's neck, can be dimly discerned beyond the last brick arch. Even the architecture is archaeological in terms of the third or fourth centuries from which it is drawn. Late Roman brickwork is carefully imitated, and ruin (or impending doom) is inherent

in the irregular areas of plaster which conceal parts of this construction. Neoclassic designers of stage scenery could have reached new plateaus of antiquarianism with masters such as David for their guides.

David's next excursion into the deeds of early Rome is a historical piece pregnant with contemporary political implications. *Les licteurs rapportant à Brutus les corps de ses fils* (1789) spells out the fact that the turning point from eighteenth-century romanticism to full-blown Neoclassicism has been passed (figure 123). The archaeological preciseness of detail makes the eclecticism of figures all the more obvious. The Roma Barberini, that fragment of fresco discovered in the middle Seicento beneath the Lateran and restored as Dea Roma by Carlo Maratta, is the cult-image silhouetted at the left. Brutus pondering darkly in the foreground is the Vatican "Posidippus" half-rising from his philosopher's throne; the distraught wife and younger offspring are Niobe and her daughter or daughters, represented in statuesque naturalism. The right side of the painting, with the curtain pinned across the background, the high-backed chairs, and the mourning nurse at the extreme right, is taken from one or more of the *conclamatio* sarcophagi. The simple, direct, understandable emotion of these sarcophagi made them much used for interior scenes of a dramatic nature in all ages since the Quattrocento. The totality of composition, perhaps from the warmth as well as the statuesque delineation of the figures, produces a Romanism more convincing than the frozen scenes of Ingres, in which the former quality is eliminated and the latter is distilled through overapplication of the benefits to be derived from drawings after engravings of Greek vases. A recurrent weakness in David's paintings of this type is the preoccupation with the accuracy and detail of ancient furniture; the

props are made to seem as important as the figures.

As time advanced, David's work assumed more of the repertory of formal, classical poses in the outlined nude which are the essence of Neoclassicism. The drawing for the overwhelmingly successful *Les Sabines arrêtant le combat entre les Romains et les Sabins* (1799) hardly differs from the finished composition. In this overcrowded scene, Praxitelean forms as interpreted in the marble sculptures of Canova serve David's style, in addition to direct reminiscences of antiquity apparent in the poses and proportions of the males. The youth in Phrygian cap, leading a horse at the extreme right, is even the Paris of Canova rather than a figure from the antique. Hersilia, Romulus' wife, the woman parting the warriors in the center, is an Electra or a Niobid, and the Old Market Woman or the nurse from a Niobid sarcophagus kneels and bares her breast below the shield of Romulus as he stands frozen in combat with the Sabine leader, Titus Tatius. Romulus is, at best, the Ares Borghese sprung to action. It is hard to believe that ladies of fashion, actors, and young artists were the models for these figures. Classical in these details, the scene as a whole has more of the sensation of a battle-piece by the Neapolitan romantic Salvator Rosa (1615–1673), and the concentration on the figures in the foreground is achieved at the expense of too many spears in the background. David published a booklet about the painting, a text mainly devoted to justifying his ideas that Greek and Roman Republican heroes should be presented in the heroic, dignified nude.

One thing that sets the Neoclassicism of David above that of Ingres is that he creates his Neoclassicism from all types of Greek and Greco-Roman sculpture—not just from the insipid phase of Praxiteles treated in the formal terms of Greek vase-painting. It was said in David's time that he borrowed the general design for the *Sabine Women* from a Roman medallion engraved in Montfaucon; the so-called medallion is a "Paduan" or a Cinquecento creation after the antique.[19] In many ways the crowded yet orderly designs of David's painting are a Neoclassic translation of a frieze by Giulio Romano or a fresco by Polidoro da Caravaggio. The dominant balance of the three principals in the center is one of many illustrations of Neoclassicism's return to the geometrically harmonious compositions of the High Renaissance.

At a period when David was working on the grand, official commissions for Napoleon and on private portraits he continued to paint mythological scenes. One of the worst of these, *Sapho et Phaon* (1809), now in Leningrad, is devoid of the political or moralistic significance of the paintings discussed heretofore. The scene is based on the unreliable Hellenistic tale of Sappho's ill-fated love for a youth named Phaon, the "Shining One." Eros steals Sappho's lyre as she swoons back in her lover's arms, her poems fluttering to the floor. Phaon, arrayed as a young Endymion or Adonis, is an animated Praxitelean or Lysippic satyr. Greek furniture, Roman temple architecture, and Pompeian candelabra fill the open spaces in the background. Neoclassic artists—and David is no exception—were at a loss as how to treat facial expressions, other than those of extreme emotion or anguish. (After all, very few Greek statues or Campanian paintings stress this.) Phaon looks irrelevantly impersonal; Sappho, moonstruck and foolish; and Eros, playfully asinine. The mating doves on the window ledge are the final absurdity. Old engravings reveal that the central composition is borrowed directly from the groups of the woman dying in childbirth in Attic funerary art.[20] At this time the design was forged as a decorative relief suggesting a mirror-case, in ivory. Neoclassic paint-

ers and sculptors, by the definition of their art, could not or chose not to be inventive. Wherever possible a design was sought in antiquity.

Léonidas aux Thermopyles (1814) was a return to contemporary political thinking cloaked in classical history. Although David began working on this subject fifteen years earlier, Napoleon's last stand could be likened to the rearguard sacrifices of the Spartans against the Persians. As with the *Sabine Women,* and the *"Corona-tion" of Napoleon,* the scene is too crowded with people—portraits or pseudo-portraits. An unreal classicist, David went from one extreme to the other—single-figured portraits and three-figured mythological scenes, or a veritable deluge of pseudo-Greek forms. Leonidas is the Ares Borghese, one of David's favorite antiquities; the god's face has been framed in a rich, Mediterranean beard. His pose may be derived from a cameo published in Winckelmann's *Monumenti Inediti*; and there is a visible iconographic relation to the group of Augustan or later gems and glass pastes showing Diomedes crouching with the Palladium. One of these gems was also widely known from the inclusion of its design in the Renaissance tondi of the Medici-Riccardi palace in Florence. Two nudes from Antonine Amazon sarcophagi leap toward the rocks in the right foreground, and the group climbing the path at the right is an excerpt from a Roman relief in the Louvre. A version of the famous inscription "Stranger, go tell the Lacedaemonians that we lie here having obeyed their commands" is being carved in garbled Greek by a youth climbing the rocks at the left rear and using his sword-hilt for the purpose.

David's compositions drawn from classical mythology and ancient history could develop no further stylistically and technically, save for a certain calligraphic hardness of forms already inherent in the *Sapho* and *Léonidas,* but these paintings are studied for their success or failure in terms of how they tell the story. After Napoleon's fall, David painted some of his most incisive portraits.

Ingres

Ingres' approach to classicism is characterized by narrow limits of stylistic change and constant repetition of certain subjects.[21] He repeated identical motifs, often simplifying or elaborating and often reversing them. Jean-Auguste-Dominique Ingres was born at Montauban in 1780 and died in Paris in 1867, long after the movement he stood for so uncompromisingly had spent itself. His ideas were molded in Toulouse from 1791 to 1797, when he joined David's atelier and felt the current of admiration of antiquity in that artist's circle. Perhaps more than any other artist before or since, Ingres' antiquity was influenced through the medium of publications. He took much from the rich archaeological volumes of his age: the seven volumes of Caylus' *Le recueil d'antiquités* (1752), Winckelmann's *Monumenti inediti* (1767 and 1768); the twelve volumes of the *Antiquités d'Herculaneum* (1780 on); and d'Hancarville and Tishbein's publications of the Hamilton collections of Greek painted vases. David had had access to all these works, and in 1783 to 1784 he had been the companion of Sir William Hamilton in Italy, where he studied the vases and other objects which influenced his work and that of his pupils.

In Paris, Ingres read avidly and had the sculptor Lorenzo Bartolini as his companion in David's studio. Bartolini's tracings of John Flaxman's *Iliad, Odyssey,* and *Tragedies of Aeschylus,* which appeared in French editions in 1803, made a profound impression on Ingres. In the same year he earned a pittance illustrating the *Musée Napoléon.* Tradition identifies Ingres as

the author of a discobolus, but none of these drawings are signed. He painted his lifelong friend Bartolini at least twice—with a Greco-Roman head of Sarapis figuring as an adjunct to the composition, a detail recalling the antiquarian portraits of Bronzino or Titian.

A borrower, Ingres displayed limited imaginative powers and great artistic gifts. He "dreamed up" nothing, being even less creative than David. In the painting which won him the Prix de Rome in 1801, *The Ambassadors of Agamemnon before Achilles,* the borrowings are obvious: the Vatican Ganymede for Patroclus and the Vatican Phocion for Odysseus. They almost obliterate the great amount of thought put into the scene, the "pertinent details" based on copious notes made by Ingres from the *Iliad. Venus Wounded by Diomedes* is simply a reversal of a Hamilton vase published in Tishbein's opus. The original scene showed Artemis, mounting her chariot, and Apollo. Ingres' armor is very Greek, not Roman, in this his next major historical painting. The details of the cuirass recall red-figure vase painting of the period of the Altamura Painter (about 465 B.C.). Even the shield with the emblem of a snake upon it is a detail prevalent on vases of the generation after the Persian wars.

Antique sources are even less concealed in *Thetis before Zeus* (1811). The extraordinary grace of Thetis derives ultimately from Nereids, through Flaxman's drawings. The cameo, the Naples gigantomachy, becomes the relief on the base of the throne through the intermediary of Winckelmann or James Tassie, whose casts of ancient and modern engraved gems circulated throughout Europe after 1791. A current of admiration for Raphael also runs throughout Ingres' work. Single figures from the Cinquecento master abound, and the Montauban Cathedral's *Vow of Louis XIII* (1824) is Ingres'

modernization of Raphael's *Transfiguration,* one of the three most-admired paintings in eighteenth- and early nineteenth-century Rome. The Montauban Madonna and Child mix elements from the Alba and Sistine Madonnas. In *Thetis before Zeus,* the withdrawn *gravitas* of Zeus is taken from the center of *The Vision of Ezekiel* in Florence. From this painting the notion of divinity has been traced directly to the colossal Villa Madama Zeus.

In the version of *Virgil Reading the Aeneid* in Brussels (1819), only Augustus, Livia, and Marcellus' mother Octavia are present (figure 124). As Virgil reaches his famous passage "Tu Marcellus eris," Octavia swoons across the lap of cold, haughty Livia into the arm of Augustus, seated in profile in the heroic nude. Augustus has been copied from some seated statue of heroic aspect, such as the Tiberius of the Vatican.[22] When a competent Neoclassicist makes a mistake in his standards of antiquarian accuracy, he slips badly. Ingres' Livia is the "Agrippina" of the Capitol and elsewhere, so far as the pose, drapery, and chair are concerned, but her head is a portrait of Trajan's wife Plotina, replete with elaborate, late-Trajanic, early-Hadrianic coiffure. In juxtaposition with Augustus the sensation is appalling. Ancient heads in Naples, the Museo Capitolino, and elsewhere provided the prototype. Octavia, whose features have only lately been identified, is a French girl of the post-Napoleonic period wrapped in a classical bedsheet, almost Victorian in her sentiment. Ingres looks ahead as well as backward, and *Christ Among the Doctors* (1862) lies somewhere between a Pre-Raphaelite creation and the worst of the late-nineteenth-century French academic paintings. Even here, archaeology is not far away for Christ lectures between the late Roman or Constantinian twisted columns from Old St. Peter's.

David and Ingres turn the clock back to Mantegna by their excerptings and their introduction of specific antiquities in generally "antique" compositions. In David's *Paris and Helen* and the *Stratonice* (or *The Sickness of Antiochus*) of Ingres (1840) books and catalogues of objects have been systematically culled to give specific background for the antique atmosphere.[23] In the *Stratonice* of Ingres, a subject which had been treated by David near the outset of his career, historical accuracy and correct dramatic atmosphere of the tensions among the Macedonian Hellenistic Successors are provided by the dynastic dedication to Alexander the Great on the pillar of his cult-statue in the center rear (figure 125). A cameo in Naples again becomes a decorative adjunct. The reverse of the giant sardonyx known as the Tazza Farnese, the side with the Gorgon's head, has been transformed into the shield hanging over Antiochus' bed. Two Campanian frescoes also in Naples, the infant Herakles strangling the snakes and Achilles among the daughters of Lycomedes, have been amalgamated into a mural on the wall behind the statue of Alexander. The unfortunate Queen Stratonice, diademed and wrapped in her white himation, leaps out at the beholder as a classical statue culled from the pages of Visconti or the forerunners of Clarac's *Musée de sculpture*. The statue is one of the pudicitia type, best studied from a version in the Vatican and from a variant in the Ashmolean Museum at Oxford. These Hellenistic funerary figures, wrapped in their ample cloaks and with hand under chin in pensive gesture, are most appropriate for the young wife of Seleucus I of Syria. Neapolitan sources, the frescoes found at Pompeii, may have even exerted their influence, for Stratonice is also like Briseis in the scene of Achilles surrendering Briseis to Agamemnon.

Empire architecture, furniture, costume, and decorative arts were conscious instruments of an imperial antiquarianism. The gathering of ancient objects into the details of Neoclassic painting, therefore, was the ultimate in expression in terms of the way in which the Napoleonic era chose to be remembered. That Ingres survived to be honored by the third Napoleon was a justice to the persistence of his ideas, despite the fact that Neoclassicism had long since outlived itself. When Ingres died Impressionism was being born and the story of modern art had begun.

Pistrucci, Master of Neoclassic Medalists

The Neoclassic phase of European art is the last period in which the medalist and gem-engraver ranked as a major rather than a secondary artist. Thanks to the esteem in which the age held close study of ancient coins and gems as documents of the art and history of antiquity, his position was higher than at any time since the sixteenth century. These documents were collected with no less relish in the century and a half from the death of Leone Leoni to the age of Canova, but the expansive drama of Baroque art lent itself in nearly impossible fashion to gems and medals in which theatrical grandeur rather than classical orderliness was compressed into the limits of a small, circular flan. The direct relations with antiquity were exploited in a rather unoriginal and unsympathetic fashion in the seventeenth century, the bizarre aspects of ancient armor, drapery, hair styles, and compositional groupings catching the engravers' eyes as they created designs for the courts and cathedrals of Europe.

The Neoclassic feeling for the medallic arts of antiquity reached its full development in the generation which followed the return to Greco-

Roman classicism in painting and sculpture. Winckelmann's circle gave new focus to the study of ancient gems and gem-engraving in the antique manner. Neoclassic engravers arrived at such a high level of absorption in antiquity as to be capable of producing gems still classified as ancient in the world's major collections. For economic reasons, governments and their mints are always a generation behind the arts in changing coin designs. The Greco-Roman symbolism with which Napoleon vested his Empire gave Europe the impetus of patronage and fashion in coin and gem design; this continued well into the Victorian era. It was never really displaced in the world's coinages down to the end of the First World War and the new designs brought about by elimination of monarchies and abandonment of the gold standard.[24]

The impact of Neoclassicism on medallic design is best demonstrated by the die-engraving of Benedetto Pistrucci, the Canova of his craft. His lifetime, 1784 to 1855, coincides with the Golden Age of Neoclassic gems and medals. In 1956 the centenary of his death occasioned a great exhibition in the Palazzo Braschi in Rome and an opportunity to reappraise his work. His products have never been out of favor and his importance never lost sight of by the historians of medallic art.[25]

Pistrucci, born in Rome of good family, is first heard of as a restorer of antiquities. As an apprentice engraver of cameos, at the age of fourteen (1798) he is said to have reworked the large sardonyx, now in Leningrad, showing Constantine the Great in ceremonial cuirass crowned by a female standing near him. This lady, of Hellenistic city-Tyche type, is either Roma, the personification of Res Publica or, most likely, the Tyche of his new city of Constantinopolis. Pistrucci's chief contribution seems to have been to point up the face under the

mistaken notion that the emperor represented was Augustus and not Constantinus Magnus as Novus Augustus.[26] The other tale of his youthful talents parallels that of Michelangelo and his *Sleeping Cupid*: Pistrucci's arrival in London immediately after Waterloo attracted attention when he recognized a gem, prized by Richard Payne Knight, as being not an ancient stone but his own product sold to the great antiquarian as an antiquity. To prove his point, he made several more versions of this allegedly ancient, broken cameo bust of Flora.

Pistrucci settled in England, where he achieved fame not only for his designs for coins of George III and George IV but for portrait cameos of the principal figures in British public life from 1815 on. He also produced mythological cameos of the type made familiar by Canova's monumental reliefs and their cheap imitations. His masterpieces, other than portraits, are closely related to his coin-dies and cameos, and include the medallic *Saint George and the Dragon* (figure 128), the *Waterloo Medal* (figure 126), and the *Medal for the Acquisition of the Parthenon Marbles* (figure 127). Pistrucci's mythological studies suffer from the Neoclassic desire to lard pedantic compositions with painterly figures of sculptural quality. He borrows in canonically correct fashion from Roman copies of fourth-century and later statues, mixing these figures with passages from Pompeian frescoed decorations and Roman mythological sarcophagi. These are the faults of Canova's marbled classicism, weaknesses exaggerated by spiritual emptiness and near-sentimentality in many works of Thorvaldsen. Pistrucci handles this in admirable fashion in his chosen media.

St. George and the Dragon embodies the best of Domitian's aes reverses of the emperor on horseback and the contained excitement of the Parthenon horsemen. The parallel of Leonardo

da Vinci's numismatic borrowings for the Tre-vulzio monument in Milan comes to mind in the use of an imperial bronze of the late first century A.D. The equestrian types derived from the Parthenon frieze have a long history in Western painting and sculpture among artists with an eye for quality. Greco-Roman deriva-tives of the Parthenon frieze inspired the horse-men in the background of Donatello's pulpit-reliefs in San Lorenzo. The persistence of Pistru-cci's design as the reverse for British gold and silver down to the present day is due not only to a commercial reluctance to change die de-signs but to the successful relation of horse and rider in violent action to mythological monster and plinthlike groundline within the constric-tions of the medallic tondo. The power of his work is seen most immediately in his *bozzetti*, in his medallic studies in wax and clay. Pistrucci not only designed with imagination but exe-cuted his designs with a detailed precision com-bining quality and beauty.

The monumental *Waterloo Medal* is nearly the size of a dinner plate. Greek in mood and models, it is Roman (of the spirit of the Prima Porta Augustus' cuirass) in its mustering of al-legorical details to illustrate historical reality. The obverse is dominated by the jugate busts of the sovereigns of the Allied Powers, the conque-rors in fact and sympathy; the reverse centers on the classic goddess Victoria (in the scheme of a well-known Roman Republican coin reverse and gem design) guiding Wellington and Blücher, the Waterloo victors, as Roman warriors mounted and riding in the design of horsemen in the Parthenon frieze. Around this reverse Pistrucci has placed a forceful rendering of the quadrigate Jove (top) hurling thunderbolts at a host of Pergamene giants, whom he topples into Hades. This motif recalls Leone Leoni's medal-lic reverse for the Hapsburg court, carried out nearly a quarter of a millenium previously. A host of eclectic details can be seen in the outside area of the obverse. Several of these are as Cano-vesque in origin as they are directly based on antiquity (the seated Justitia or Pax, recalling Agrippina or St. Helena, at the left, and the three Furies below a Herculean restoration of the Belvedere torso at the right). The medal as a whole presents an overwhelming congrega-tion of mythological groups, but clearly defined neutral areas and grandeur of conception pull the obverse and reverse designs together to achieve the most ambitious *tour de force* of Neo-classic medallic art.

Pistrucci's *Medal for the Acquisition of the Parthenon Marbles* (1816) is the apogee of Neo-classic art in the service of history and classical archaeology. Although never executed, the medal survives in an unfinished wax study. On the obverse a bust of George IV (Prince Regent) dominates a view of the east façade of the Par-thenon, with the reclining river god Ilissos (from the west pediment) amid the rocks and fragments of the foreground. The view of the building as it was before Lord Elgin's opera-tions is a sculptural revisualization of Stuart and Revett's publications and other drawings made on the site. The reverse of Pistrucci's medallion is a veritable symphony of trophies from the Parthenon, with reclining Dionysos (seen from the back) in the center. A handleless hydria at the left center and a headless statue of the Kritios-boy period, objects undoubtedly from Greece or Athens but not from the building itself, are introduced to give the central design the unity of a Neoclassic funerary monument. The obverse of Pistrucci's medal is bold and novel, but the reverse suffers from overcrowd-ing and the disparate scale of sections of the frieze (above) and groups from the pediments (below).

Pistrucci also executed large bronze and marble portrait busts and submitted a *bozzetto* in the contest to design the Nelson monument (1839). He shared with great predecessors like Leonardo and Leone Leoni a proud, difficult temperament which caused many of his works to reach only the preliminary designs. In his youth he brawled with his fellow apprentices and was once badly wounded. His portrait of the fat, aging, unbalanced George III, for the British coinage of 1818, was widely criticized for its naturalism, and Pistrucci felt the uproar a lifelong blow to his creative pride. His total production makes him the equal of the titans of his age and places him among the great designers of any period. The art of gem and die engraving as the preserve of great individuals, both artists and patrons, died with this Neoclassic Dioscurides.

Conclusion

CLASSICISM means something different to each. Defined in terms of Greek and Roman art, the word implies a series of interlocking cycles of development, revival, decay or fatigue, and survival. Defined in terms of European art from 1200 to 1800, the idea is extremely broad and constantly changing. Granted that no single study can be conclusive or all inclusive, I have stressed certain ideas of antiquity's survival in the visual arts.

The body of ancient art in the centuries of humanistic reawakening and development kept pace with progressive ideas of intellect. Certain antiquities in Rome remained accessible and popular. The ravages of time and neglect were more than balanced by the continuing flow of new discoveries.

From about 1550 on, the collector and scientific archaeologist made the artist's choice of ancient models easier by organizing the field of study, through installation, classification, and recording or publication.

Artists saw in ancient art what they wanted to see. Through various processes, including the study of antiquity, each artist evolved a mature style which he renewed or modified by recourse to those documents of the classical past which fitted his means of achieving artistic development.

In ages when classicism or classical borrowings seemed at a minimum, owing to the hegemony of a particular style, the strong classical foundation of other periods can be found chiefly by knowing how the artist moved away from the ancient model.

The reasons ancient art was a point of reference were complex and differing. The medieval mind saw ancient art from a variety of symbolic points of view; gifted medieval artists recognized the quality, not the message or meaning, in selecting surviving sculptures. Later periods faced classicism for many more doctrinaire or romantic but no less practical purposes.

Postclassical art has been related to the world of ancient Greece and Rome through rules and reasons inherent in the background and production of a succession of major painters, sculptors, and medalists. European art from the twelfth to the twentieth centuries can be divided into seven principal periods. For the purposes of the history of art, ancient civilization can be said to have ceased with the fall of Rome in 476. The strength of the classical world remained such that for the next seven hundred years architecture, sculpture, and painting in both East and West had ancient art as an unconscious source of reference.

In France and Italy in the twelfth and thirteenth centuries individual artists, who emerge as forceful if frequently anonymous personalities, initiated a series of conscious returns to ancient art. Nicolo Pisano, who came from Southern Italy to create a school of sculpture in Tuscany, was the foremost individual example. Sculptors and painters of the thirteenth and fourteenth centuries relied on those remains of

monumental antiquity which were above ground or discovered by chance. Excavation belonged to the enquiring humanism of the Quattrocento. In the two preceding centuries the great body of available antiquity, whether architectural decoration or reliefs such as sarcophagi, was of the Roman imperial period from the late first century to the time of Constantine the Great. Aside from chance Roman copies, little of Greek art was known, and even Roman art of the late Republic and early Empire had been swept beneath the vast building programs of the later Empire. Accidental influences, such as occasional Etruscan works of art, however, have always given an interesting complexity to the classical sources used by late medieval artists.

The Italian Renaissance brought no less a revolution to the type of ancient art used by painters and sculptors than it did to the creations of these artists. The revolution was more than mere application of the rule that artists saw in antiquity what their scientific leanings conditioned them to see. The building boom throughout Quattrocento Italy brought to light many ancient masterpieces—from good Roman copies of Greek statues, to Greco-Roman frescoes, to small bronzes, gems, and coins. Quattrocento artists applied themselves to understanding and incorporating these discoveries. Masters of excerpted borrowings, such as Mantegna, went through stages of comprehension of antiquity. They emerged with considerable elimination of blatant borrowings without substituting an engraver's record of ancient monuments. Artists such as Ghiberti, Donatello, and Botticelli found elements of antiquity for their sculptures and paintings, without sacrificing the clarity, individuality, and mastery of style which characterizes the genius of the great Renaissance artists.

The High Renaissance, age of Leonardo, Raphael, and Michelangelo, was a brief two generations following 1490. During this period for certain men of Florence and Rome the scientific, the gigantic, and the sublime of Italian Renaissance art came together in a classic rationality matched only by the great centuries of Hellenistic Greek art from 350 to 150 B.C. In generating the brilliant, unfinished suggestions of his brush and pen, Leonardo often explored the byways of antiquity, minor reliefs and coins. Raphael knew mythology very well in an era when visual antiquity was beginning to be collected and codified. His multitude of borrowings was outweighed by the poetic antiquity of his mythological frescoes (Farnesina), historical painting (Vatican), and religious themes.

Michelangelo's heroic art discovered worthy sources in the Roman copies of the Gauls, giants, demigods, and Homeric leaders of the schools of Pergamon. His search for a phase of antiquity worthy of his titanic impulses found fitting inspiration in the Pergamene, Flavian, and Antonine baroque phases of Greco-Roman painting and sculpture. In his earliest reliefs, carved in Florence, Michelangelo singled out as models the types of Antonine friezes echoing the powerful Hellenistic epic and mythological paintings which, remarkably enough, came closest to his later work in the Sistine Chapel.

Mannerism grew out of incomplete comprehension of Michelangelo. Giulio Romano and the mature Mannerists, such as Rosso, Bronzino, and Parmigianino, leaned toward the High Renaissance masters before they reached toward antique sources. Giulio Romano was somewhat of a connoisseur of the Roman antiquities in which he grew up (near the Campo Vaccino or site of the Roman Forum). They, particularly the state reliefs of the Roman tri-

umphal arches, appear over and over again in his compositions. The elements of reaction to the Antonine baroque which paralleled Mannerist reaction to Michelangelo were found in certain classes of sarcophagi, mosaics, and frescoes. Bronzino and Parmigianino, probably unconsciously and certainly through the sketchbooks of their day, fell in with the elongation and optical distortions of this phase of Greco-Roman art and used them in their paintings.

The great Venetians, Titian and Tintoretto, painted in a city which depended on imported antiquities, plaster casts, and graphic media as contacts with the classical past. They exploited them with exceptional imagination. Titian could make one motif (for example, the Cupid of Pheidias) useful in several ways on different occasions throughout his long career. As Venetians, both artists had opportunities to study Greek (as opposed to Greco-Roman) works of art brought from Greece and the Levant. Echoes of this art, usually denied artists in Renaissance Rome, turn up in their paintings. Otherwise, they draw on the orthodox sources and on the sculptures brought from Rome with the Grimani collection.

The decades from 1590 to 1610 mark a transition from the end of two centuries of artistic marvels to the beginning of art in the midst of scientific archaeology. The phase of collecting and patronage which began in Rome outshone in capital outlay the efforts of the Quattrocento and the sixteenth century. This patronage extended not only to architects, sculptors, and painters but to archaeologists such as Cassiano dal Pozzo and antiquarians such as Pietro Sante Bartoli and Giovanni Pietro Bellori. The art which had recourse to this newly collected, this newly codified, antiquity was the Italian Baroque.

The name of Bernini shines forth as the soul and symbol of the Italian Baroque. In this century, the Seicento, the story spreads from Italy to France. The great French classicist Nicolas Poussin carries on his private practice of painting in Rome. Pierre Puget, a Baroque sculptor whose art is worthy of Flavian Rome, finds his only success in the south of France. At Versailles in the reign of Louis XIV, François Girardon tries to carve out a Roman imperial idiom for the architecture of the grand monarch. In painting this idiom was codified by Charles Lebrun in a manner which reached Hellenistic antiquity through a frozen rendering of the grand decorations of Raphael and Giulio Romano.

Bernini and Pietro da Cortona are opposites in their approach to antiquity, but both attained High Baroque comprehensiveness and passionate drama from Greek and Roman statues and reliefs. Bernini's early statues for Cardinal Scipione Borghese begin his habit of taking one specific ancient statue and working its individuality into a High Baroque creation far removed from the ancient marble. The Apollo Belvedere is too evident in *Apollo and Daphne,* but later the Capitoline Eros after Lysippos is unthinkable as the basis for the *Angel Holding the Superscription* of Ponte Sant'Angelo. Bernini's approach to antiquity could be scholarly as well as emotionally perceptive, as his researches on the physiognomy of Constantine the Great exemplify.

Because of his need to earn a living when first in Rome, Pietro da Cortona experienced an intimate, scientific contact with ancient sculpture. What is known of his early efforts indicates he gravitated toward Roman narrative relief. The fact that much of his painting was complex Hellenistic grandeur in High Baroque terms stems from such feats as drawing the reliefs of the

Column of Trajan over and over again. In the course of these archaeological activities Pietro gave his painting a style which is the most classical in the Roman imperial sense of any artist of his century.

Poussin, whose classicism is the complete understanding of perceptive personal communion with a small bronze of quality, a Neo-Attic relief or an Alexandrian landscape mosaic, stood at another extreme. Of all the seventeenth-century painters, he profited most from the small, secondary antiquities collected by the Borghese, the Barberini, and lesser individuals. Poussin applied his great rational intellect to adapting his own work to the ordered view of antiquity presented by Cassiano dal Pozzo's *Museum Chartaceum*. His inquiries into ancient rites and the manner in which he built up compositions from wax and cloth models on miniature stages did not destroy the poetry and haunting beauty of his canvases. The success of Poussin's classicism is the total impression conveyed by his works rather than the sums of parts derived from antiquity.

In the eighteenth century the scene shifts from Italy to France, although northern Europeans still receive their indoctrination in classical antiquity from Italians. In this century the principal Italian antiquarian artists were Panini and Piranesi. On the other hand, Montfaucon and Caylus, the archaeological compilers whose work affects the period before the Neoclassic, were French. The area of greatest archaeological discovery also shifts—from Rome to Pompeii and Herculaneum. The revelations of the buried cities are revelations of Greek and Roman domestic art, from Campanian wall frescoes to minor objects in all materials, many found abandoned in their contexts of use. Although the impact of Pompeii and Herculaneum produced Neoclassicism after some delay in genera-

tion, the influences of the buried cities were far from unnoticed in the period of the French Rococo.

The French Rococo was a reaction to the Baroque which, created in Italy, had spread northward in the previous century. Its ancient parallel was the reaction of many scattered artists to the art of Pergamon. The Hellenistic rococo is not easy to define in terms of time and location, but the elements found in eighteenth-century France gripped the ancient world in the century after 160 B.C. The painters and sculptors of France in the half-century following 1720 were unaware of the Hellenistic rococo as an art historical phenomenon, but it is amazing how these artists selected its paintings and sculptures as their sources. In the sculptures of Bouchardon, Falconet, and Pigalle, themes and models (children, putti in seasonal occupations, nymphs, and Bacchic figures) were often taken verbatim from sculptures which critics now place in the Hellenistic rococo. The paintings of Watteau, Boucher, and Fragonard frequently paralleled the spirit and subjectivity of Campanian landscapes and, more often than is evident at first glance, incorporated Hellenistic rococo figures and motifs. The work of Gravelot in the graphic media demonstrates how complex direct links with antiquity become in an age when publications were frequent and varied, and the antiquities themselves were disappearing from Rome to the Italian provinces, northern Europe, and the British Isles.

The artistic and cultural movement known as Neoclassicism represents an orgy of subservience to Greco-Roman antiquity. Italy is the center in sculpture, and France maintains her newly found leadership in painting. Artists still visit Rome, but Romans such as the medalist and gem engraver Benedetto Pistrucci build their reputations abroad. Neoclassicism, an artistic

movement based on intellect and archaeological research, is the first of many phases of European art to have political implications of a social nature. In France, and to a certain degree Italy, it expressed the republicanism of the French Revolution. Napoleon used the iconography of Neoclassicism to portray the triumphal and domestic aspects of his Empire, giving this name to a period in European decorative art. Even the young American republic turned to Roman Neoclassicism for its symbols of power—the "American" eagle and the fasces, not to mention the architecture of its new capital on the Potomac and sundry statues of George Washington.

The best of the Neoclassic artists—Canova and Thorvaldsen in sculpture, David and Ingres in painting—drew on creative imagination to avoid the eclectic mediocrity encouraged by Neoclassicism. The art grew not only out of the archaeological revelations of Pompeii, Herculaneum, and the Etruscan tombs but out of the reclassification of "traditional" antiquities through the theories of Winckelmann. In the lifetime of Ingres the art of the Greek vase, as distilled into line engravings, made itself felt in monumental painting. The monotonous mediocrity so often evoked by Neoclassic work is based in many instances on modern knowledge that the ancient prototype was a mechanical copy with only a fraction of the true spirit of its earlier original. By contrast, on viewing the Parthenon sculptures, Canova was moved to remark on the inferiority of the Apollo Belvedere and to state that his art would have been very different had he seen these Pheidian originals at the beginning rather than the end of his career.

Neoclassicism cannot be dismissed on such a note of pessimism. Canova's models reveal an artistic personality nearly as passionate as Bernini's. His best portraits cannot hide under-standing of subject beneath the trimmings of classical pose and garb, features which, although frequently spoiled for the modern eye by mediocre repetition at the hands of stonecutters, confer timeless dignity on a sitter. Thorvaldsen showed less taste and more delicacy than Canova, qualities which made him less able to handle big mythological statues and better able to succeed in the realm of small, decorative reliefs. Both men were far above their imitators, and only a sculptor and draftsman such as John Flaxman in England has come to rank with them, on the level of intellectual contributions to Neoclassicism rather than by virtue of his monumental commissions.

David is the foremost political painter of Neoclassicism. His first work, in the late Rococo manner, showed little of his future promise, but four of his great Neoclassic compositions were finished before the French Revolution. Three of these treated themes from Roman history, preparing David for his role as an apostle of the revolution. When David joined Napoleon, his was the job of turning Neoclassic painting into a record of the present rather than of the mythological and moral past. As a result he commands attention less as an artist than as a great archivist.

Ingres carried the tradition of Neoclassicism's success with portraiture to the middle of the nineteenth century, contributing a searching eye and a brilliance of calligraphy to this art. In other respects, however, David's successor is spoken of as having outlived his age, practicing in a period when Romanticism and a return to landscape painting heralded the Impressionism of the second half of the century. The great artists from 1400 to 1800 could not have created Western civilization's contribution to culture without having explored classical art throughout their careers. Ingres was not the last artist

to learn antiquity from direct contact, from sketchbooks, and from publications, but he was one of the last to make this exploration a basis of his art.

Ancient art appealed to later ages for a variety of historical, intellectual, and emotional reasons. What came to light after 1400 was high in quality and rich in diversity of artistic expression. From the Renaissance on, artists returned to classical antiquity over and over again; it seemed a well-remembered home, a norm from which departures were readily measured adventures. Ancient history and classical literature were regarded as the foundations of intellect. The correlation between the visual and the written experience in ancient art strengthened its position as the source for artistic creativity. Even those artists who claimed to draw inspiration from nature alone expressed the world around them in classical terms.

The Napoleonic Wars and the Industrial Revolution changed much in European civilization. Only afterward could Western Europe contemplate painting and sculpture whose basis was not necessarily the art of ancient Greece and Rome. Classical art was centered on the human figure; Romanticism, Impressionism, and the twentieth-century movements have shown every degree of concern with subjects other than the human form. To be sure, classical antiquity has been exploited in the work of Rodin, Maillol, Picasso, and others, but their excursions into the Greek and Roman past have been striking exceptions rather than the universal rule.

The quality and value of ancient art has been debated incessantly since the Renaissance. If legions of painters, sculptors, and minor artists from 1400 on had not turned to Greek and Roman art, good and bad, with dedication and determination, the thoughts expressed in this book would be superfluous. Visions of Grecian divinity and Roman majesty have shaped Western art and literature ever since the last wave of barbarians rolled over the Western Roman Empire. Classicism's influence has been strong and obvious or weak and subtle, but for better or worse it has guided European art in successive centuries from the humanistic reawakening in Quattrocento Italy.

Periods and Phases of Ancient Art

*Certain terms appear frequently throughout this book. Some are chron-
ological in the historic sense; others have been made popular by historians
of art. The following outline has been prepared to avoid repetitious digres-
sions. (Needless to say, no dates are absolute.)*

GREEK ART

Archaic Period (development of monumental sculp-
ture), 620–490 B.C.

Period of Transition (so-called Severe Style), 490–
460 B.C.

Golden Age (of Athens in the time of the Parthenon,
Pericles, and Pheidias), 460–400 B.C.

Age of Praxiteles, Skopas, and Lysippos (Later High
Classical Period), 400–330 B.C.

Early Hellenistic Period (Alexander and the Succes-
sors), 300–250 B.C.

First School of Pergamon (in Western Asia Minor),
250–200 B.C.

Second Pergamene Age (Altar of Zeus), 200–150 B.C.

Hellenistic Rococo (Reaction to baroque art), 150–
50 B.C.

Greco-Roman Academicism and Eclectic Art (Age of
Pasiteles; Neo-Attic painting and sculpture; archa-
istic art), 50 B.C.–A.D. 50.

ITALIAN AND ROMAN ART

(most periods named for emperors and dynasties)

Etruscan Art in North Italy, 700–350 B.C.

Greek Art in Southern Italy and Sicily, 700–50 B.C.

Italo-Etruscan and Roman Republican Art, 350–
50 B.C.

Age of the Emperor Augustus (including Greco-
Roman classicistic art), 27 B.C.–A.D. 14.

Julio-Claudian Period (continuation of Augustan art),
A.D. 14–68.

Flavian Period (height of illusionism and pictorial-
ism), A.D. 69–98.

Trajanic Period (Empire's greatest extent reached),
A.D. 98–117.

Age of Hadrian (strong Greek revival), 117–138.

Antonine Period (return to Pergamene baroque),
138–192.

Severan Period (continuation of previous), 192–235.

Renaissance under Gallienus (Hellenistic revivals),
253–268.

Tetrarchy (rule of Diocletian and colleagues), 284–
312.

Constantinian Age (Christian Empire), 312–360.

Division of the Empire by Arcadius (East) and Hon-
orius (West), 395.

Fall of the Roman Empire in the Latin West, 476.

Artists, Antiquarians, and Archaeologists

AGOSTINO di Duccio (1418–about 1490)

A Florentine sculptor and architect, Agostino is remembered for his work from 1447 to 1454 on the inner decorations of the Tempio Malatestiano at Rimini. He championed, probably unconsciously, the Neo-Attic style in Renaissance sculpture. His emphasis on silhouette and clinging, linear drapery recalls the maenads of Kallimachos, the Athenian sculptor of about 420 B.C.

Ulisse ALDROVANDI

A naturalist from Bologna, Aldrovandi wrote an itinerary of the principal collections of ancient sculpture in Rome, in 1550. Titled *Delle Statue di Roma*, it was published in 1556, 1558, and 1562 as a supplement to Lucio Mauro's *Antichità di Roma*. As a descriptive companion to what Renaissance artists recorded in their sketchbooks, Aldrovandi's work is perhaps the most important, certainly the most comprehensive, early guide of its kind.

ALTICHIERO da Zevio (about 1320–about 1385)

The principal works of this Veronese painter were frescoes in Verona and Padua. He was the chief artist of the frescoes in the Cappella S. Felice in Santo in the latter city. He also appears to have done secondary decoration in the Ovetari Chapel of the Eremitani Church, thus linking him in several ways with Mantegna.

ANSUINO da Forlì (Italian, fifteenth century)

Ansuino left his signature in the Eremitani at Padua, the scene of St. Christopher preaching. On the basis of style, the scenes of St. Christopher before the king and the saint healing a cripple are also attributed to this predecessor of Mantegna. Andrea del Castagno, Filippo Lippi, and Donatello are said to have influenced his style.

APELLES (about 370–310 B.C.)

An Ionian from Kolophon and Ephesus, Apelles became the leading painter of the fourth century. He enjoyed the patronage of Philip of Macedon and of Alexander the Great. Only descriptions of his great works, *Calumny* and *Aphrodite Rising from the Sea,* have been preserved, but these references were enough to insure his fame in the Renaissance. His portraits were as celebrated as his mythological subjects. All agree he was a master of composition, coloring, and chiaroscuro.

Amico ASPERTINI (about 1475–1552)

A Bolognese, Aspertini practiced the arts of painting, sculpture, and engraving. His early sixteenth-century sketchbooks (the Wolfegg Codex and the British Museum volumes) are basic sources for antiquities known to the High Renaissance. Aspertini was often careful to note *where* he sketched a given monument. His drawings after the antique have been edited, with full descriptions, by P. P. Bober, *Studies of the Warburg Institute,* vol. 21 (London, 1957).

Jacopo AVANZO

Paduan painter of the first half of the fourteenth century, Avanzo assisted ALTICHIERO in the Cappella S. Felice in Santo.

Francesco BARTOLI (about 1675–about 1730)

Engraver and antiquarian, Francesco was his father's assistant in many enterprises. His most important independent work lay in making copies in color of Roman wall paintings in the area of Rome.

Many archaeologists have been overzealous in condemning these watercolors because Bartoli took liberties with the original scenes.

Pietro Sante BARTOLI (about 1635–1700)

A native of Perugia, Bartoli came early to Rome where his career began as a pupil of Poussin. From painter he moved to his principal calling as merchant and engraver of antiquities. He published books on subjects ranging from the columns of Trajan and Marcus Aurelius to ancient tombs, ancient paintings, the illuminated manuscript known as the Vatican Virgil, and the principal Roman reliefs (historical panels and sarcophagi) in the vicinity of the capital. He was the forerunner in many respects of PIRANESI. The texts to his works were written by BELLORI, DE LA CHAUSSE, and other savants.

Lorenz BEGER (1653–1705)

His three-volume *Thesaurus Brandenburgicus Selectus,* published in 1696 and the years following, was the first major German archaeological catalogue. The Brandenburg collection, mainly that formed in Rome by BELLORI, was first in Berlin, but some antiquities soon migrated to Dresden, said to have been traded for a regiment of dragoons. His nephew (1663–1735) of the same name is remembered as an engraver.

Giovanni Pietro BELLORI (1615–1696)

Biographer of the artists of his time and basic source for the Baroque, Bellori found time to form a large collection of antiquities (much of it in Berlin and Dresden) and to write the texts to BARTOLI's books on ancient reliefs, iconography, and the contents of tombs around Rome.

Francesco BIANCHINI (1662–1729)

Bianchini was one of the first modern excavators, in that he tried to record what he found rather than merely plunder ancient sites. He dug the *Domus Flavia* (the Palace of Domitian) on the Palatine, and the results were published after his death, as *Del Palazzo de'Cesari* (Verona, 1738). He wrote extensively on astronomy and history.

BOETHOS

A sculptor from Chalcedon, Boethos worked in the second century B.C. Pliny attributes to him the group of a boy strangling a goose, copies of which exist in several collections. The group appealed greatly to Renaissance and later artists, and echoes of the composition and its style are found in sculpture from Verocchio to Bernini.

Giovanni BOLOGNA (1529–1608)

A Fleming by birth and early training, after Michelangelo's death Bologna became the most famous sculptor in Florence. He developed to its fullest the Mannerist principal of viewing sculpture from all angles, but he maintained close touch with Greco-Roman antiquity in his classical sense of proportions. The small bronzes from his workshop are often modeled closely on ancient sculpture.

Francesco BORROMINI (1599–1667)

Among those who created the Roman High Baroque, Borromini was the architect of neurotic imagination who designed buildings which challenged the Renaissance architectural concept of classical dependence on human proportions. Destined to work in the shadow of Bernini, he did build several extraordinary churches and redesigned the interior of the Lateran for the Holy Year of 1650. His twisting surfaces, broken façades, irrational entablatures, and curving interiors have a remarkable affinity with the phase of Eastern Roman architecture represented by the little "round" temple at Baalbek in Syria (about A.D. 250) and the rock-cut tomb-façades at Petra in Arabia. Borromini, of course, never saw these.

Pietro BRACCI (1700–1773)

Bracci, a pupil of Rusconi and one of the last Italian Baroque sculptors, worked on the Trevi Fountain in 1735, executed papal statues, and is remembered as a restorer. He inserted the very true-to-life heads of Constantine the Great in the Aurelian panels of the Arch of Constantine.

Filippo BRUNELLESCHI (1377–1446)

The great architect of the early Renaissance began his career as a metalworker. In 1401 he entered the competition for the second bronze door of the Baptistery in Florence. After 1402, Brunelleschi joined Donatello in an expedition to Rome to study sculpture, but he found his medium in architecture and the scientific theories involved. From 1417 to 1436 he built the cupola of the Cathedral in Florence and worked concurrently on other famous projects in the

city. Several of these were completed after his death, and others, such as the church of S. Lorenzo, have remained unfinished.

Heinrich von BRUNN (1822–1894)

An archaeologist and art historian in the present sense, Brunn wrote his *Geschichte der griechischen Künstler* in the 1850's (2nd edition, 1889). From 1888 to 1891 he started the photographic catalogues of ancient portraits and masterpieces of ancient sculpture still being published in Munich, where he was Professor of Archaeology. Brunn made many of the canonical discoveries of Greek masterpieces from the evidence of Roman copies, ancient writers, and minor works of art such as terracottas, vases, gems, and coins. For example, he identified the replicas of the two groups of Gauls and other combatants set up in Pergamon and Athens in the third century B.C. and thus paved the way for the rediscovery of the school of Pergamon.

Pietro Paolo CAMPI (about 1680–about 1740)

From Carrara where he learned the marble trade, Campi worked under Pierre II Legros at Monte Cassino. In Rome he executed one of the travertine statues on the colonnade of St. Peter's and sculptures in various Roman churches. His restoration of an ancient torso of a seated Zeus (or an emperor as Zeus) as St. Sebastian *standing* was highly praised. It is in S. Agnese in Piazza Navona.

Luigi CANINA (1795–1856)

Canina was partly a scientific archaeologist, partly an architect who made imaginative restorations in a precise hand, and perhaps the last "compiler" in the tradition from LIGORIO to MONTFAUCON and CAYLUS. His books on Rome, Tusculum, Ostia, and the Etruscan sites appeared in the decades after the Napoleonic Wars, when the disciples of WINCKEL-MANN made archaeology and the history of art modern sciences.

Polidoro (Caldara) da CARAVAGGIO (about 1496–about 1543)

Polidoro's decorative frescoes in a Mannerist antiquarian style made a great impression on his mid-Cinquecento contemporaries. His painted friezes, especially those on Roman palace walls, were sketched by artists interested in the antique, and several draw-ings after his work were incorporated in the *Museum Chartaceum* of Cassiano DAL POZZO. He began his career doing the secondary decorations of the Vatican *Stanze,* where he had good opportunity to work in an antiquarian style.

Bartolommeo CAVACEPPI (about 1716–1799)

Cavaceppi was the foremost and best restorer of ancient marbles in Rome during the "Golden Age of Classic Dilettantism." The Neoclassic collections of Italy, France, and especially England were populated with sculptures renovated in his studio. Much of his handiwork was published in a three-volume *Raccoltà* (1768–1772).

G. B. DE' CAVALIERI (DE CAVALLERIIS) (about 1525–1601)

A Northern Italian draftsman and engraver, De' Cavalieri worked in Rome from about 1550. In the following decades he published books on Roman ruins (see DOSIO), portraits of the Popes, portraits of the Holy Roman Emperors, and one hundred plates on ancient statues of the city of Rome. This last work went through a number of editions and was much copied in seventeenth-century Rome.

Comte DE CAYLUS (1692–1765)

Caylus was the leading French archaeologist of the period from MONTFAUCON to the French Revolution. He published a multivolume interpretive catalogue of his antiquities, mainly small bronzes, terracottas, and pottery. His knowledge of ancient daily life benefited from the discoveries at Pompeii and Herculaneum. An important part of his collection is in the Bibliothèque Nationale, Paris.

M. A. DE LA CHAUSSE (CAUSEUS) (about 1660–1720)

A Parisian by birth and a resident in Rome, De la Chausse published a learned and well-illustrated book on classical antiquities, *Romanum Museum,* which appeared in 1690. In this work he seems to hold the honor of being the first archaeologist to publish an ancient vase. He also published a book on gems, illustrated by P. S. BARTOLI, and a volume on ancient frescoes from the Rome area, principally the tombs of the Nasonii and the Palatine–Domus Aurea complex. He had as collaborators the two BARTOLI and Giovanni BELLORI.

CIRIACO d'Ancona (about 1391–about 1457)

A merchant, Ciriaco traveled throughout Greece and the Levant in the years before and after the fall of Constantinople. He filled diaries and sent letters back to his fellow humanists in Italy with notes on architecture, sketches of sculptures, and copies of inscriptions, many of which were subsequently destroyed under the Turks. He gives early and irreplaceable records of the Parthenon, the monument to Philopappos (in Athens), sculptures and inscriptions on Samothrace, and the giant Hadrianic temple at Cyzicus, destroyed during the very decades of Ciriaco's visits. His travels are sketched in convenient form in Chapter I of E. W. Bodnar, *Cyriacus of Ancona and Athens,* Collection Latomus, vol. XLIII (Brussels, 1960).

Giovanni COLI (1636–1681)

Born in Lucca, Coli came with his townsman Filippo GHERARDI to Rome; he worked there and in Venice under the influence of Pietro da Cortona. His great work, with GHERARDI, was the frescoed ceiling in the gallery of the Palazzo Colonna in Rome whose five principal scenes tell the history of Marcantonio Colonna and the naval victory over the Turks at Lepanto.

DIOSCURIDES

To the Renaissance, Dioscurides was undoubtedly the most celebrated ancient gem engraver. He was employed by the Emperor Augustus (27 B.C.–A.D. 14), and to his hand may be attributed the *Gemma Augustea,* with scenes of the glorification of the Augustan house, and perhaps the large sardonyx of Augustus and Roma, likewise in Vienna. At least ten stones survive bearing his signature, one often added to ancient and modern gems in the Neoclassic period.

Giovannantonio DOSIO (1533–1609)

A Florentine architect, sculptor, and antiquarian, who worked in Rome as well as in his native city, Dosio made splendid drawings of ancient monuments of all varieties. The Berlin Codex, the chief collection of these drawings, was produced in the years 1561 to 1565. Dosio also executed drawings for G. B. DE CAVALLERIIS'S publication in 1569 of the buildings of Rome.

FEDERIGO da Montefeltro (1422–1482)

The Duke of Urbino's military career fills several biographies. His profile is well known from Piero della Francesca's portrait in the Uffizi. He made Urbino a center of art, philosophy, and science. His gentle wife, the learned Battista Sforza, aided him in his humanistic undertakings.

Felice FELICIANO

A scientist, poet, and antiquarian from Verona, Feliciano taught at Padua and from 1452 until his death in 1467 held the chair of philosophy at Bologna. He made collections of ancient inscriptions, manuscripts of which are preserved in Bern (1460), Verona (1463), and Modena (1465). He wrote treatises on the honors, triumphs, and military affairs of the ancient Romans. Feliciano was a friend of Mantegna; in the company of other Northern Italian humanists, the two went on at least one outing in search of ancient inscriptions.

Antonio FILARETE (about 1400–1469)

Filarete's great work, the bronze doors of St. Peter's in Rome, occupied the Florentine sculptor and six assistants from 1433 to 1445. The scenes of the doors, the martyrdoms of Saints Peter and Paul together with important historical events, are classics in Early Renaissance excerpting of Greco-Roman motifs. They also show in splendid technical fashion partial absorption of the Roman historical style.

John FLAXMAN (1755–1826)

Flaxman is probably remembered more for his drawings illustrating the *Iliad* and the *Odyssey* than for his Neoclassic sculptures. These line drawings proclaimed him one of the first artists to appreciate the calligraphy of Greek vases. His work as a designer for the firm of Wedgwood has also won him lasting fame.

FRANCESCO di Giorgio (1439–1502)

This versatile Sienese was an architect, sculptor, painter, engineer, and scientific theoretician. From 1477 to 1482 he worked for FEDERIGO da Montefeltro in Urbino, mainly on buildings, fortifications, and bronze reliefs. A number of drawings after the antique, particularly of sarcophagi, have been attributed to him. For his architectural theories, see *ArtB,* 40 (1958), 257–261.

Adolf FURTWÄNGLER (1853–1907)

A giant among classical art historians in the generation following 1890, Furtwängler published the Olympia bronzes in that year, his *Masterpieces of Greek Sculpture* in 1895, a treatise on Roman copies in 1896, and the definitive work on classical gems in 1900. He wrote catalogues, investigated Aegina, and with the draftsman K. Reichhold published a lavish set of plates of the best in Greek vase painting. His contribution to the studies most pertinent to this book was to identify a number of lost originals by leading Greek masters from otherwise anonymous Roman copies, or fragments of same, in various collections throughout the world. To archaeology as a whole his monumental contribution lay in demonstrating how stylistic currents in the earliest periods of Greek art could be classified from the often-meager evidence of the spade.

Filippo GHERARDI (1643–1704)

Collaborator with COLI, Gherardi worked in Rome, Venice, and Lucca. The two men were largely responsible for bringing Roman High Baroque taste to Venice.

Gavin HAMILTON (1723–1798)

Like VASARI, the Scotsman Gavin Hamilton is remembered less as a painter than as a personality connected with the history of art. Hamilton spent most of his life in Rome where he painted portraits of British nobility and grand mythological subjects in the early Neoclassic manner. As an antiquarian, excavator, and art dealer, he achieved immortality by filling the country seats of England and Scotland with his discoveries and purchases. He did much to educate British gentry in the Neoclassic tastes of WINCKELMANN and Canova.

P. V. D'HANCARVILLE (1729–1805)

The nom de plume of one P. F. Hugues, who published the first collection of Greek vases formed by (Sir) William Hamilton. The four volumes, *Collection of Etruscan, Greek and Roman Antiquities from the Cabinet of the Honble Wm Hamilton,* appeared in 1766 and 1767. This was the first great work on Greek pottery, with large, colored drawings and diagrams of the shapes of the vases. Soon after, the British Museum received the collection and became the first public gallery to exhibit Greek vases, where artists came to study them. Hancarville had adventurous careers in many countries and wrote or lectured on a variety of subjects from mathematics to the art of Raphael and the cults of Priapus.

Marten van HEEMSKERCK (1498–1574)

From 1532 to 1536 this Dutch Mannerist painter was in Rome where he made his immortal drawings of ancient and later buildings and antiquities of all descriptions. These survive in two sketchbooks in Berlin. As would be expected from a Hollander, Heemskerck was particularly successful in noting the landscape, the romantic decay of his Roman ruins, and their attendant works of sculpture.

Louis LA GUÈRE (or Laguerre) (1663–1721)

This French painter, whose Late Baroque frescoes cover ceilings and walls in a number of English palaces and country houses, restored Mantegna's *Triumph of Caesar.*

Luciano LAURANA (about 1420/25–1479)

Laurana, a Dalmatian painter and architect, worked for FEDERIGO da Montefeltro on the Palazzo Ducale at Urbino and on the related buildings in the years from 1465/66 to about 1472. His imaginatively classical architecture was much influenced by study of ancient and early medieval buildings in Rome.

Charles LEBRUN (1619–1690)

Under Louis XIV, Lebrun directed artistic policy in France and through the Academy dictated how all aspects of painting should be handled by court artists. His style grew out of conflicting interests during his years in Italy. He studied under Poussin and from the works of Roman decorators such as Pietro da Cortona; his large battle-pieces owe much to the latter.

Pirro LIGORIO (about 1500–1583)

A Neapolitan, Ligorio's activities were archaeological and architectural. In the latter sphere he worked in the Mannerist style for Popes and nobles in Rome and in the Alban Hills. He compiled a *corpus* of tangible archaeological knowledge—plans, copies of inscriptions, minor antiquities, and coins. His notes survive in manuscripts and copies scattered throughout the libraries of Europe, from Naples to Oxford. He was perhaps the first person to attempt

an encyclopedia of archaeology and epigraphy, but has been much criticized for taking excessive textual liberties with fragmentary inscriptions. See generally, E. Mandowsky and C. Mitchell, *Pirro Ligorio's Roman Antiquities*, Studies of the Warburg Institute, vol. 28 (London, 1963).

Filippino LIPPI (about 1457–1504)

In 1488, Filippino began six years of work on a fresco cycle in the Caraffa Chapel of S. Maria sopra Minerva in Rome. He was much taken at this time with Roman ruins and fragments of sculpture, and they appear in the painting of his last two decades in a balder version of the way Mantegna employed them throughout his career. Filippino is otherwise remembered as the son of Fra Filippo Lippi and the associate of Botticelli.

Paolo Alessandro MAFFEI

Domenico DE ROSSI published Maffei's *Raccolta di statue antiche e moderne* in 1704. Later editions appeared in 1742 and 1825, the latter with notes by Carlo Fea. The plates, 163 in number, still exist in Rome.

Giovanni (Johannes) MARCANOVA (1410–1467)

A scholar of Padua, Marcanova's fame rests on his *Quaedam antiquitatum fragmata,* which formed a basis of the *Corpus Inscriptionum Latinarum*. Marcanova's illustrations of his various manuscripts are often based on drawings by his contemporary CIRIACO d'Ancona. He was a close friend of FELICIANO and Mantegna.

Anton Raphael MENGS (1728–1779)

From Dresden, Mengs made his fame in Rome and Spain. He and WINCKELMANN admired each other, and Mengs' *Parnassus* (1761) in the Villa Torlonia-Albani was the first Neoclassic, as opposed to Baroque, ceiling. Mengs was influenced by the discoveries at Herculaneum. Compared with David, however, he was a precursor of Neoclassicism rather than a fully developed participant in the new movement. His portraits are very fine.

Bernard de MONTFAUCON (1655–1741)

This learned Abbé pursued two antiquarian careers. He was the father of medieval studies in France. He wrote a fifteen-volume *corpus* of all knowledge to be derived from ancient works of art and artifacts: *L'Antiquité expliquée et représentée en figures* (Paris, 1719–1724). Although the interpretive descriptions are fanciful, the illustrations are very important. A German edition also appeared. Montfaucon wrote on manuscripts and the manuscript tradition in classical studies; his publications on religious subjects were also extensive.

Paul NASH (1889–1946)

Trained in London, Nash returned from the First World War (in which he served as a war artist) to a career as painter, designer and book-illustrator. His art was full of poetic imagination, a quality which placed him among the Surrealists in the last decade of his career. He repainted the First part of Mantegna's *Triumph of Caesar* at Hampton Court.

PASITELES (about 100–40 B.C.)

From Magna Graecia, Pasiteles settled in Rome and wrote five books on famous works of art. As a sculptor he seems to have worked from models and casts of older masterpieces. None of his works survive, but his eclectic style can be glimpsed from the signed work of his pupil STEPHANOS and of STEPHANOS' pupil Menelaos. Pasiteles was one of those who furnished the intellectual as well as the artistic stimulus to Neo-Atticism. His atelier made replicas of their own creations, and a number of these have been found in Italy. The superficially archaic or Greek Transitional severity of these works provided the first (and only) glimpse many Renaissance artists had of the Greek styles behind the art of the Greco-Roman copyists.

Giovanni Battista PASSERI (about 1612–1679)

Although a painter, the Roman Passeri made his mark as a historian of the art of his contemporaries. His *Vite* first appeared in print in 1772, but it had been known earlier from handwritten versions in Naples, Paris, and Vienna. His clarity of thought and his grasp of Baroque trends has made his work invaluable.

Claude PEIRESC (1580–1637)

Peiresc, who lived in southern France and studied antiquity avidly, owned the lost Carolingian copy of the *Chronograph of A.D. 354*. He corresponded with Cassiano dal POZZO and allowed him to make the

APPENDIX II

Barberini (Vatican) and other copies of this important late antique illuminated manuscript. Peiresc's fame rests not in publications but, like CIRIACO d'Ancona two centuries previously, in travels and correspondence.

Giovanni Battista PIRANESI (1720–1778)

A Venetian architect, Piranesi spent his years in Rome (from 1740) producing volumes of etchings of Roman ruins, romantic structures based on these ruins, sculptures and minor antiquities, and ornament after the antique. The intelligentsia of northern Europe derived a substantial part of its image of ancient Rome from his work. English, French, and German collectors also bought the antiquities he had made fashionable, especially marble candelabra and urns. Architects such as Sir John Soane incorporated Piranesi's romantic views and fancies of design into their buildings.

Cassiano dal POZZO (1589–1657)

A vast literature has now grown up about this unselfish antiquarian and connoisseur, who lived in Rome as archaeological advisor to the Barberini family at the height of their power. He formed the vast collection of drawings after the antique now at Windsor, in the British Museum, and elsewhere. Artists made good use of this *Museum Chartaceum*. He was a champion of Nicolas Poussin and other painters, and he was in the forefront of the scientific investigations of his day.

MARCANTONIO RAIMONDI (about 1480– about 1530)

A Bolognese, Raimondi worked in his native region, and for over a decade from about 1510 in Rome. He was a prolific engraver, circulating the designs of Dürer, Michelangelo, Raphael, and other artists among his contemporaries. He also prepared a number of plates after ancient sculptures, particularly sarcophagi and historical reliefs (the Arch of Constantine).

Thomas REGNAUDIN (1622–1706)

The son of a stoneworker from Moulins, he rose to become a professor of sculpture at the Academy in Paris (1658) and Vice-Rector in 1694. He visited Rome in 1670. Regnaudin did a number of statues and reliefs of classical subjects for Versailles, the Tuileries, and the Louvre. Versailles also contains many of his direct copies after the antique, such as a statue of Faustina as Ceres.

Hubert ROBERT (1733–1808)

During eleven years in Rome from 1754, Robert learned the type of ruin painting championed by Panini. He introduced a lighter, sometimes almost humorous, version of Panini's art to France where he became very successful. He applied Panini's techniques to non-antique, non-Roman subjects, painting the formal gardens of Versailles during demolition and such caprices as the principal gallery of the Louvre in ruins. Hubert Robert and Fragonard were friends who made many stylistic if not subjective exchanges in their art. Like Fragonard, he outlived his age of patronage, dying at a time when a classicism alien to his own light romantic concept of ancient Rome was the accepted standard.

DE ROSSI

A family firm of publishers with two branches in Rome in the seventeenth and early eighteenth centuries, they issued a number of editions of engravings, based mainly on the *Antiquarum Statuarum Urbis Romae* of DE CAVALLERIIS. The principal members in the early Baroque period were Giuseppe and Giovanni Domenico de Rossi.

Joachim von SANDRART (1606–1688)

In Rome at the beginning of the Baroque period, this antiquarian-artist from Frankfurt drew a number of ancient sculptures in the years 1627 to 1635 and prepared the catalogue of the Giustiniani marbles, issued in 1631. His *Sculpturae veteris admiranda* appeared at Nuremberg in 1680. Sandrart's paintings—religious subjects and portraits—hang in many German galleries. A number of other members of his family were artists.

Giuliano da SANGALLO (or SAN GALLO) (1445–1516)

This member of the large and talented Florentine family is important because of his important volume of drawings after the antique and of architectural designs based on ancient remains, Cod.Vat.Barb.Lat. 4424, published by Ch. Huelsen (*Il libro di Giuliano da Sangallo*, Vatican, 1910). These drawings were made during his second Roman period (1504 to

166

1507). A number of Sangallo drawings are known only from copies made by students, such as the sketchbook in the Fogg Museum of Art in Cambridge.

Giulio SANUTO (worked about 1540–1580)

A Venetian engraver, Sanuto circulated the work of Michelangelo, Bronzino, Titian, and Domenico Campagnola.

STEPHANOS (about 80–20 B.C.)

Stephanos, a pupil of PASITELES and also an academic eclectic, signed a statue of a youth now in the Villa Torlonia-Albani in Rome. This youth is a modern (i.e., Greco-Roman) version of an Attic ephebe of about 480 B.C. The type is found in two instances combined with a widely copied female of superficially post-Pheidian style. The groups are known as "Orestes and Electra," and thus the fully developed female with thin, "wet" drapery is known as the "Electra" type. She appears continually in European art from Mantegna's time.

Wilhelm TISHBEIN (1751–1829)

Tishbein and his pupils prepared the illustrations for the publication of Sir William Hamilton's second collection of vases. Titled *Collection of Engravings from Ancient Vases mostly of Pure Greek workmanship,* the four volumes came out from 1791 to 1795. Tishbein often "corrected" the archaic style to conform to Neoclassic taste, but his outline drawings gave contemporary artists a good idea of the potentials of Greek and South Italian vases. He was a prolific painter and is represented in the principal galleries of Germany.

Filippo della VALLE (1697–1768)

Born in Florence, Della Valle settled in Rome in 1724 as a pupil of Camillo Rusconi. He was one of the most successful sculptors of the last phase of the Baroque in Italy. He worked principally in the Lateran (*Temperance,* in the Corsini Chapel), St. Peter's, and lesser Roman churches, and was responsible for two statues on the Fontana Trevi.

Giorgio VASARI (1511–1574)

Vasari, from Arezzo, wanted very badly to be remembered as a painter worthy of Michelangelo and Raphael, but his immortality stems from his biographies of artists from the Pisani to his contemporaries.

P.–E. VISCONTI

Last of a brilliant Italian family of archaeologists who organized and catalogued the Vatican and other collections in Rome, Visconti published his *Catalogo del Museo Torlonia di sculture antiche* in 1880. Don Alessandro Torlonia allowed no mention of restorations, an all-too-evident feature of the collection. Many of the marbles, such as the Hestia Giustiniani, had been part of Rome's artistic heritage for several centuries.

J. J. WINCKELMANN (1717–1768)

Father of the disciplines of archaeology and especially the history of art, as they are known to the twentieth century, Winckelmann was the oracle of Neoclassic taste. His writings bridged the gap between antiquities and artistic practice at the time when MENGS, Canova, and David were making Greece and Rome live again in the paintings and sculpture of Neoclassic Italy, France, and England. Winckelmann was a Bavarian, and his doctrines were embraced in his native land and in Italy where he served as librarian to the enlightened Cardinal Alessandro Albani. His approach to Greek art sums up what the artists around him strove to represent: "noble simplicity and calm grandeur."

Postclassical Paintings and Sculpture

(Artists, Dates, and Present Locations of works mentioned in the text)

In most instances a traditional or median date is given. Fresco cycles and sets of paintings are not necessarily listed separately by title. The works are given under each artist in the order in which they appear in the text. Locations in parenthesis are those of works now destroyed or lost.

APPENDIX III

NOTES
INDEX

Abbreviations

ActaA	Acta Archaeologica
AJA	American Journal of Archaeology
AM	Mitteilungen des Deutschen Archäologischen Instituts, Athenische Abteilung
ArtB	Art Bulletin
ArtQ	Art Quarterly
BMC	British Museum Catalogues
BMMA	Bulletin of the Metropolitan Museum of Art, New York
BullComm	Bullettino della Commissione Archeologica Communale di Roma
BullMusImp	Bullettino del Museo dell'Impero Romano
BWPr	Winckelmannsprogramm der Archäologischen Gesellschaft zu Berlin
CIL	Corpus Inscriptionum Latinarum
GBA	Gazette des beaux-arts
JdI	Jahrbuch des K. Deutschen Archäologischen Instituts
JHS	Journal of Hellenic Studies
JRS	Journal of Roman Studies
JWarb	Journal of the Warburg and Courtauld Institutes
JOAI	Jahreshefte des Oesterreichischen Archäologischen Instituts
MAAR	Memoirs of the American Academy in Rome
MJb	Münchener Jahrbuch der bildenden Kunst
MonPiot	Monuments et mémoires, Fondation E. Piot
Num Chron	Numismatic Chronicle
NumCirc	Spink and Son, Numismatic Circular
PAPS	Proceedings of the American Philosophical Society
PBSR	Papers of the British School at Rome
RA	Revue archéologique
RendPontAcc	Atti della Pontificia Accademia Romana di Archeologia, Rendiconti
RM	Mitteilungen des Deutschen Archäologischen Instituts, Römische Abteilung
TAPS	Transactions of the American Philosophical Society

Notes

No attempt has been made to cite museum handbooks for specific paintings and sculptures. In most cases they do exist, often in frequently revised editions.

Preface

Books and articles on the survival of antiquity are collected most exhaustively in H. Ladendorf, *Antikenstudium und Antikenkopie* (Vorarbeiten zu einer Darstellung ihrer Bedeutung in der mittelalterlichen und neueren Zeit), *Abhandlung der Sächsischen Akademie der Wissenschaften zu Leipzig*, Phil.-hist. Klasse, 46 (1953), 121–161. The second edition (Berlin: Akademie-Verlag, 1958) contains a considerably enlarged bibliography, arranged by topics, on pp. 121–183. The plates of this book should also be studied. More recent works are listed in Ladendorf's "Antico," *Enciclopedia Universale dell'Arte* (Rome, 1960), I, 455–457.

The following books have been extremely useful in forming the general ideas set forth here: R. Krautheimer and T. Krautheimer-Hess, *Lorenzo Ghiberti* (Princeton, 1956), pp. 337ff.; P. P. Bober, *Drawings after the Antique by Amico Aspertini, Sketchbooks in the British Museum*, Studies of the Warburg Institute, 21 (London, 1957); R. Wittkower, *Gian Lorenzo Bernini, The Sculptor of the Roman Baroque* (London, 1955); W. Oakeshott, *Classical Inspiration in Medieval Art* (London, 1959); A. von Salis, *Antike und Renaissance; über Nachleben und Weiterwirken der alten in der neueren Kunst* (Erlenbach-Zürich, 1947).

I. The Survival of the Ancient World

These chapters are not a catalogue of motifs used and reused by artists since the Pisani in the thirteenth century. Anyone armed with Salomon Reinach's *Répertoire de la statuaire grecque et romaine* or the same author's *Répertoire des reliefs grecs et romains*, exhaustive collections of line drawings of ancient sculptures, can list these motifs with relative ease. Conversely, it is necessary to observe but *not* to catalogue the ways ancient works of art survived the Dark Ages or were rediscovered in the Renaissance. The Census of drawings after antiquity conducted jointly by the Warburg Institute in London and the Institute of Fine Arts in New York has this vast undertaking well in hand. See P. P. Bober, "The Census of Antique Works of Art Known to Renaissance Writers," *Studies in Western Art, Acts of the Twentieth International Congress of the History of Art* (New York, 1963), pp. 82–90.

1. Bober, *Aspertini*. Reinach's *Répertoire de la statuaire* was published in Paris from 1897 to 1931; his *Répertoire des reliefs* appeared in three volumes (Paris, 1909–1912).

2. Bober, *Aspertini, passim*. H. von Hülsen, *Römische Funde* (Berlin-Frankfurt, 1960), provides a series of short articles on the dates and circumstances of discovery of all the traditional paintings and sculptures of Rome, with illustrations from contemporary sources. A chronology of excavations (pp. 253ff.) is very helpful.

3. T. Ashby, *PBSR*, 8 (1916).

4. On the revaluation of Ligorio: E. Mandowsky, *RendPontAcc*, 28 (1955), 335–358; E. Mandowsky and C. Mitchell, *Pirro Ligorio's Roman Antiquities*, Studies of the Warburg Institute, 28 (London, 1962), esp. ch. V, "Ligorio's Materials and Methods as an Antiquary."

5. E. Strong, *Art in Ancient Rome* (New York, 1928), II, 206, fig. 581; C. Vermeule, *ArtB*, 38 (1956), 36, note 19; C. Vermeule, *The Goddess Roma in the Art of the Roman Empire* (Cambridge, Mass., 1959), p. 107, no. 56.

6. Architectural reliefs and inscriptions were also brought from Ostia to Pisa as building material.

7. A. Levi, *Sculture greche e romane del Palazzo Ducale di Mantova* (Rome, 1931), p. 77.

8. C. Vermeule, *PAPS*, 102 (1958), 193.

9. B. Ashmole, *JWarb*, 19 (1956), 179–191.

10. E. Loeffler, *ArtB*, 39 (1957), 1ff. The sarcophagus is Los Angeles, County Museum no. A.5832.47–35, a gift of the Hearst Foundation. The scenes, from left to right as visible in the photograph, illustrate the four cardinal virtues by which a Roman official directed his life. The official as an officer riding into battle symbolizes *Virtus* or military valor; the same officer pardoning barbarians as he stands on a small podium exemplifies *Clementia* or mercy to the unfortunate vanquished; the scene of sacrifice stands for *Pietas* or devotion to the state religion; and the marriage ceremony represents *Concordia* or a happy family life. In scenes one and three the official's

own, bearded Antonine head survives; in the second and fourth symbolic episodes his missing head has been replaced by that of the emperor Trajan. The Dal Pozzo–Albani drawings of the middle seventeenth century show the relief without these heads.

11. Inv. no. 10.104; Cumont, *Symbolism funéraire*, pp. 325f., pl. 35; Reinach, *Répertoire de reliefs*, II, 207, no. I; C. Vermeule, *TAPS*, 50 (1960), 9, on Dal Pozzo, Franks, fol. 2, no. 2. The action of the sarcophagus moves from left to right. At the left front are the Capitoline divinities, Minerva, Jupiter, and Juno, the last perhaps intended as a general portrait of the deceased. Next to her, a Siren still contests, with double flutes, and beyond, amid Muses, two others carry on the one-sided contest, the first Siren in song and the second with a lyre. At the right front four Muses are scourging three Sirens. The style of carving, combination of high polish, and extensive drilling belong to the years around 220.

12. Dal Pozzo, Franks, fol. 12, no. 13; C. Robert, *Die antiken Sarkophagreliefs* (Berlin, 1900), II, 154, no. 141.

13. C. Vermeule, *Archaeology*, 8 (1955), 12ff., fig.

14. A. Michaelis, "Römische Skizzenbücher Marten van Heemskercks . . . ," *JdI*, 6 (1891), 153f., fig. 4; C. Hülsen and H. Egger, *Die Römischen Skizzenbücher von Marten van Heemskerck* (Berlin, 1913), pp. 39f., fol. 72 r.; E. Wind, *Pagan Mysteries in the Renaissance* (New Haven, 1958), pp. 147ff., figs. 72ff., where the documentation is extensive, as with other citations of this book.

15. P. G. Huebner, "Detailstudien zur Geschichte der antiken Roms in der Renaissance," *RM*, 26 (1911), 288f.; O. Fischel, *Raphael* (London, 1948), II, pl. 185b.

16. S. Stucchi, "L'Arco detto «di Portogallo» sulla Via Flaminia," *BullComm*, 73 (1949–1950), 101ff.; H. Stuart Jones, ed., *The Sculptures of the Palazzo dei Conservatori* (Oxford, 1926), pp. 38, 266f.

17. Acc. no. 59.336; Museum of Fine Arts, *Calendar of Events (December* 1959), 1ff., fig.; *Annual Report* (1959), p. 28, fig.

18. F. Castagnoli, "Due archi trionfali della Via Flaminia presso Piazza Sciarra," *BullComm*, 70 (1942), 57–75.

19. British Museum, Franks no. 366; C. Vermeule, *ArtB*, 38 (1956), 32f.

20. C. Vermeule, *Time*, 65 (30 May 1955), 4, fig. Strangely enough, in his biography of Marcantonio, Vasari writes: "An earlier design by Raphael of the Judgment of Paris into which he had capriciously introduced the chariot of the sun, wood, water and river nymphs, vessels, prows and other things was boldly engraved by Marcantonio, to the wonder of Rome."

21. See K. Friederichs, *Berlins antike Bildwerke* (Dusseldorf, 1871), II, *passim*.

22. *PAPS*, 102 (1958), 203–208.

23. A. Blunt, *Art and Architecture in France, 1500–1700* (Baltimore, 1954), p. 193.

24. M. Lazzaroni and A. Muñoz, *A. Filarete, scultore e architetto del sec. XV* (Rome, 1908), pl. III; *AJA*, 61 (1957), 240, note 117.

25. M. Bieber, *The Sculpture of the Hellenistic Age*, 1st ed. (New York, 1955), p. 134 (note 69 gives a bibliography); H. Sichtermann, *Laokoon* (Bremen, 1957); S. Howard, *AJA*, 63 (1959), 365ff., has tried to show that the restoration of the elder son, on the right, is incorrect. Howard suggests that he should face at ninety degrees to the rear of his father. The Laocoön group has been overhauled; most of Montorsoli's restorations have been removed; and the right arm of Laocoön has been recomposed in the group. See F. Magi, *Il ripristino del Laocoonte, Atti della Pontificia Accademia Romana di Archeologia*, serie 3, memorie 9, 1 (Vatican City, 1960), *passim*; G. M. A. Richter, *Gnomon*, 34 (1962), 287ff., and further references.

26. Museum of Fine Arts, Boston, *Annual Report* (1958), pl. facing p. 1; Paola Barocchi, *Il Rosso Fiorentino* (Rome, 1950), p. 251.

27. A. Blanco, Museo del Prado, *Catalogo de la Escultura* (Madrid, 1957), pp. 40f.; G. M. A. Richter, *A Handbook of Greek Art* (London, 1959), pp. 128ff., fig. 190.

28. H. Stuart Jones, ed., *The Sculptures of the Museo Capitolino* (Oxford, 1912), p. 123, galleria no. 50, pl. 21.

29. *The Celebrated Collection of Ancient Marbles of the Marquess of Lansdowne*, Christie's 5 March 1930, p. 42, no. 61, plate. For bibliographic details see S. Howard, *JWarb*, 25 (1962), 330ff.

30. C. Vermeule, "Classical Antiquities in Sir John Soane's Museum, London," *Archaeology*, 6 (1953), 70ff.

31. A. Michaelis, *Ancient Marbles in Great Britain* (Cambridge, 1882), pp. 78ff., with special reference to the activities of Thomas Jenkins in Rome.

32. *Ibid.*, pp. 145f.

33. See, in this respect, the architectural reconstructions used by Ingres and Hippolyte Flandrin: N. Schlenoff, "Ingres and the Classical World," *Archaeology*, 12 (1959), 19ff.

34. P.-E. Visconti, *Catalogo del Museo Torlonia di sculture antiche* (Rome, 1880); see the comments and bibliography supplied by S. Reinach, *Répertoire de la statuaire*, II, sec. 1, xxviii.

35. M. Cagiano de Azevedo, *Il gusto nel restauro* (Rome, 1948). A recent essay deals with the important related topic of the *way* in which antiquities have been illustrated by various ages: W. Züchner, "Über die Abbildung," *BWPr*, 115 (1959).

36. W. Klein, *Vom antiken Rokoko* (Vienna, 1921); see Bieber, *Sculpture of the Hellenistic Age*, pp. 136ff., for a less rigid definition of the relations between the Hellenistic baroque and the Hellenistic rococo.

37. See G. Vasari, *Le Vite*, ed. G. Milanesi (Florence, 1878), II, 557f.; G. H. Chase, *Catalogue of Arretine Pottery* (Boston, 1916), pp. 4ff.

38. *PAPS*, 102 (1958), 203–208. See generally, R. M. Cook, "The History of the Study of Vase-Painting," *Greek Painted Pottery* (London, 1960), ch. XV, pp. 288–330.

39. See the note on early travelers to Crete, J. D. S. Pendlebury, *The Archaeology of Crete, An Introduction* (London, 1939), pp. 16ff.; A. Michaelis, *A Century of Archaeological Discoveries* (London, 1908), pp. 206ff. For Egyptian antiquities before 1800, see E. Iversen, *The Myth of Egypt and its Hieroglyphs in European Tradition* (Copenhagen, 1961).

40. The stele was most likely found in one of the nearby Roman villas dotting the Alban Hills, but some have suggested that the Greek monks who founded the Abbey brought the relief from Calabria or that Cardinal Bessarion of Trebizond and Constantinople (about 1403–1473) brought the monument from the Greek East; see G. M. A. Richter, "A Stemmed Plate and A Stele," *AM,* 71 (1956), 140–144, pls. Iff., and bibliography. See also H. Möbius, "Drei griechische Grabreliefs in Oberitalien," *AM,* 71 (1956), 113–123, for other Greek stelai obviously imported to Italy in the Renaissance.

41. Pertinent Dal Pozzo drawings include:

British Museum, Franks no. 419 (*TAPS,* 50, 1960, 29), Italo-Etruscan statue of a votary with a patera and incense-box; cf. D. K. Hill, *Catalogue of Bronze Sculpture in the Walters Art Gallery* (Baltimore, 1949), pp. 63f., no. 127.

Dal Pozzo–Windsor Castle no. 8612, Archaic Etruscan statuette of a warrior with helmet, short cuirass and spear (missing) in raised right hand, shield (missing) on left arm; cf. the examples in E. Q. Giglioli, *L'Arte etrusca* (Milan, 1935), pl. 222.

No. 8613, a similar warrior, with spear preserved, and an Etruscan Turan or Aphrodite with conical cap and pointed shoes. The first is now in the Vatican Library (first case from Cortile della Pigna); for the second, cf. De Ridder, *Bronzes antiques du Louvre* (Paris, 1913), I, 40f., nos. 225, 232.

42. As, for example, in the side panels of the frame of Andrea della Robbia's *Coronation of the Virgin,* in Assisi, S. Maria degli Angeli (M. Cruttwell, *Luca and Andrea della Robbia* [London, 1902], p. 183) and the frame of the *Madonna and Child* by Sano di Pietro (1406–1481) in Detroit, Institute of Arts, the gift of Sir Joseph Duveen. A motif most preferred in the wooden frames for late Quattrocento and High Renaissance paintings is the series of palmettes from Attic red-figure vases, especially the lips of kraters, of about 500 to 465 B.C.; see H. Kenner, "Zur Achilleis des Aischylos," *Wiener Jahreshefte,* 33 (1941), 1ff., especially figs. 1, 2. The design begins about 540 B.C. on the necks of Attic black-figure amphorae and continues into the second half of the fifth century. It is found on Etruscan black-figure vases, as for instance on the rim of a late-sixth-century column-krater in Boston (99.530; A. Fairbanks, *Catalogue of Greek and Etruscan Vases* [Cambridge, Mass., 1928], p. 199, no. 572).

By contrast, the frame of the *Adoration of the Child,* by Filippino Lippi, in the Toledo (Ohio) Museum of Art, depends on architectural decoration found in the Roman Forum; the archaistic masks and palmettes from the frieze at the Jiturna Spring near the Temple of Castor and Pollux are reproduced along the top.

43. Michaelis, *Ancient Marbles in Great Britain*, pp. 429f.; K. Schefold, *Die Bildnisse der antiken Dichter, Redner und Denker* (Basle, 1943), pp. 174f.

44. W. Dennison, "A New Head of the So-Called Scipio Type: An Attempt at its Identification," *AJA,* 9 (1905), pp. 11ff.; C. Vermeule, *Allen Memorial Art Museum, Bulletin* (Oberlin), 17 (1959), 7–13.

II. Forerunners of the Renaissance

1. K. Weitzmann, *Illustrations in Roll and Codex: A Study of the Origin and Method of Text Illustration* (Princeton, 1947); K. Weitzmann, "Observations on the Milan Iliad," *Nederlands Kunsthistorisch Jaarboek,* 5 (1954), 241ff. (with this see R. Bianchi Bandinelli, "Virgilio Vaticano 3225 e Iliade Ambrosiana," 225f.); K. Weitzmann, *Ancient Book Illumination* (Cambridge, Mass., 1959); a further bibliography is found in pages 139f. of the latter.

2. Hanns Swarzenski demonstrated this in an unpublished lecture delivered at the Warburg Institute in May 1958. E. Panofsky, *Renaissance and Renascences in Western Art* (Stockholm, 1960), is a mine of medieval (and later) classicism.

3. Oakeshott, *Classical Inspiration,* pp. 41ff.

4. Bober, *Aspertini,* pp. 16ff.

5. K. Weitzmann, *Die byzantinische Buchmalerei des 9 und 10 Jahrhunderts* (Berlin, 1935); K. Weitzmann, *Greek Mythology in Byzantine Art* (Princeton, 1951); A. Goldschmidt and K. Weitzmann, *Die byzantinischen Elfenbeinskulpturen des X-XIII Jahrhunderts* (Berlin, 1930–1934).

6. G. Highet, *The Classical Tradition* (New York, 1957), p. 10. The Franks casket is carved in whalebone; the basic publication is O. M. Dalton, *Catalogue of the Ivory Carvings of the Christian Era in the British Museum* (London, 1909), pp. 27ff., no. 30, pls. XVIIIf., where it is termed "Northumbrian Eighth Century."

7. C. Vermeule, "Herakles Crowning Himself: New Greek Statuary Types and their Place in Hellenistic and Roman Art," *JHS,* 77 (1957), 296ff.

8. C. Vermeule, *Gnomon,* 29 (1957), 372; Vermeule, *AJA,* 61 (1957), 243f.

9. S. Reinach, *Répertoire de reliefs,* I, 103ff.; E. H. Freshfield, "Notes on a Vellum Album containing some original sketches of public buildings and monuments drawn by a German artist who visited Constantinople in 1574," *Archaeologia,* 72 (1922), 87ff.

The survival of myths and history in illuminated manuscripts is treated briefly but instructively by M. Kenway, "The Ancient World Through Mediaeval Eyes," *Archaeology*, 9 (1956), 82–86. A northern European bronze of the late twelfth century, a man struggling with a lion, can be equally Herakles or Samson; H. Swarzenski, *Monuments of Romanesque Art, The Art of Church Treasures in North-Western Europe* (Chicago, 1954), pl. 217, fig. 510.

10. R. Delbrueck, *Spätantike Kaiserporträts* (Berlin, 1933), pp. 219ff. (Column of Marcianus); P. W. Lehmann, "Theodosius or Justinian? A Renaissance Drawing of a Byzantine Rider," *ArtB*, 41 (1959), 39–57; also C. Mango and P. W. Lehmann, *ArtB*, 41 (1959), 351–358.

11. C. D. Sheppard, Jr., "A Chronology of Romanesque Sculpture in Campania," *ArtB*, 32 (1950), 319ff. The opportunity to consider problems in Campanian Romanesque sculpture has been broadened by new books on the subject: C. A. Willemsen and D. Odenthal, *Apulia, Imperial Splendor in Southern Italy* (New York, 1959), provides good plates and a bibliography, p. 252ff.; so also, H. Decker, *Italia Romanica, Die hohe Kunst der Romanischen Epoche in Italien* (Vienna, 1958). J. Pope-Hennessy, *Italian Gothic Sculpture* (London, 1955), pp. 1ff., discusses the sculpture against the background of the Pisani.

12. C. R. Morey, *Mediaeval Art* (New York, 1942), pp. 222ff.

13. Cf. nos. 567 and 568 and other unnumbered fragments in the Antiquario of the Villa Adriana; P. Gusman, *Villa Hadriana* (Paris, 1908), pp. 250f., fig. 413.

14. Stuart Jones, *Sculptures of the Museo Capitolino*, pp. 182ff.; M. R. Scherer, *Marvels of Ancient Rome* (New York, 1955), p. 140.

15. F. P. Johnson, *Lysippos* (Durham, N.C., 1927), pp. 186ff.

16. K. Clark, *The Nude, A Study in Ideal Form* (New York, 1956), pp. 94f., fig. 74.

17. H. von Heintze, "Der Feldherr des grossen ludovisischen Schlachtsarkophages," *RM*, 64 (1957), 69ff. and bibliography; the sarcophagus was not discovered until 1620.

18. This is partly because characteristic techniques were revived; excessive use of the drill is one of these.

19. Sheppard, "Chronology of Romanesque Sculpture in Campania," 319ff., and fig. 9.

20. G. H. Chase, *Greek and Roman Antiquities, A Guide to the Classical Collection* (Boston, 1950), pp. 113ff., fig. 139; L. D. Caskey, *Catalogue of Greek and Roman Sculpture* (Cambridge, Mass., 1925), pp. 176f., no. 99.

21. C. Vermeule, *AJA*, 63 (1959), 162, pl. 35, fig. 8.

22. C. Vermeule, "Greek Art in Transition to Late Antiquity," *Greek, Roman and Byzantine Studies*, 2 (1959), 16ff.

23. V. Poulsen, *Les portraits grecs* (Copenhagen, 1954), pp. 25ff.; G. M. A. Richter, *Greek Portraits II. To what extent were they faithful likenesses?*, Collection Latomus, 36 (1959), 29, 39.

24. The Tyrannicides in Naples came from the Farnese collection in Rome, where they were known at least in the Cinquecento, in the Palazzo Medici (Madama) in Rome: Michaelis, *JdI*, 6 (1891), 161f., no. h, fig. 6.

25. C. Vermeule, "Eastern Influences in Roman Numismatic Art A.D. 200–400," *Berytus*, 12 (1956–1957), 86ff., pl. 8.

26. G. Kaschnitz-Weinberg, "Bildnisse Friedrichs II von Hohenstaufen," *RM*, 60/61 (1953/54), 1–21.

27. G. Swarzenski, *Nicolo Pisano* (Frankfurt am Main, 1926); Pope-Hennessy, *Italian Gothic Sculpture*, pp. 3ff., 175ff.; E. Carli, *Nicola Pisano* (Milan, 1954), is a small picture book with excellent illustrations, especially details.

28. Morey, *Mediaeval Art*, p. 312.

29. J. Pope-Hennessy, *Italian Renaissance Sculpture* (London, 1958), p. 355, pl. 142.

30. G. Lippold, *Handbuch der Archäologie*, III, part 1 (Munich, 1950), 281f.

31. Rubens rightly identified him as such in the drawing of the end of the sarcophagus, in the Art Institute, Chicago: *Drawings and Oil Sketches by P. P. Rubens from American Collections* (Cambridge, Mass., 1956), p. 13, no. 5, pl. II.

32. On the subject see H. Stothart, "Two Attic funerary lions of the fourth century," *Bulletin J. Paul Getty Museum of Art*, 1 (1957), 18ff.

33. A. Bush-Brown, *ArtB*, 34 (1952), 42ff.

34. G. Rowley, *Ambrogio Lorenzetti* (Princeton, 1958), I, 3.

35. Rowley, *Lorenzetti*.

36. H. Mattingly, *Coins of the Roman Empire in the British Museum* (London, 1923), I, 241, no. 212, pl. 44, 1. On coins of later emperors Securitas wears the himation about her lower limbs and a chiton draped loosely around her waist and brought up to the right shoulder.

37. Rowley, *Lorenzetti*, I, 95; II, figs. 141, 168.

38. *Ibid.*, I, 96; II, figs. 142 (mosaic in Tripoli), 189.

39. See *PAPS*, 102 (1958), 208ff. and references; *Speculum*, 35 (1960), 481. Cassiano dal Pozzo's copies of the lost manuscripts show shading and a sense of space that cannot have been introduced by the seventeenth-century copyist.

40. Rowley, *Lorenzetti*, I, 95; II, figs. 143 (Menander relief in Princeton), 180. This part of the fresco is badly damaged.

III. The Italian Renaissance to 1500

1. See generally, "Il mondo antico nel Rinascimento," *Atti del V Convegno Internazionale di Studi sul Rinascimento* (Florence, 1958).

2. P. A. Underwood, "Palaeologan Narrative Style and an Italianate Fresco of the Kariye Djami," *Studies in the History of Art, Dedicated to William E. Suida on his Eightieth Birthday* (London, 1959), pp. 7ff. (with general remarks on the cultural exchanges between Byzantium and the West in the century from 1350). For a Greek view of the latter, see D. J. Geanakoplos, "A Byzantine Looks at the Renaissance," *Greek and Byzantine Studies*, 1 (1958), 157ff.

3. Krautheimer and Krautheimer-Hess, *Lorenzo Ghiberti*, pp. 279f.

4. P. Gusman, *L'Art décoratif de Rome* (Paris, 1912), II, pl. 93.

5. The identification of the "Hercules Master" (Krautheimer, *Lorenzo Ghiberti*, p. 52f.) as the young Niccolò di Piero Lamberti and as Lorenzo di Giovanni d'Ambrogio has been proposed by Charles Seymour, Jr., "The Younger Masters of the First Campaign of the Porta della Mandorla, 1391–1394," *ArtB*, 41 (1959), 1–17.

6. Krautheimer, *Lorenzo Ghiberti*, pp. 282f.

7. Caskey, *Catalogue of Greek and Roman Sculpture*, p. 26, no. 14.

8. A good Roman example is in the Musées Royaux in Brussels: Krautheimer, *Lorenzo Ghiberti*, fig. 103.

9. *Ibid.*, p. 281.

10. A. J. B. Wace, *RA* (1949), II, 1089; on the Renaissance appreciation of the *Spinario*, see Clark, *The Nude*, pp. 379f. Copies of the *Spinario* continue to be discovered; one now in the Baltimore Museum of Art was found in the excavations at Daphne-Yakto (*Antioch-on-the-Orontes*, II, *The Excavations 1933–36*, p. 170, no. 104, pl. 2).

11. Krautheimer, *Lorenzo Ghiberti*, pp. 281f: E. Schmidt, *Festschrift Paul Arndt* (Munich, 1925), pp. 96ff.

12. E. B. Laurence, *MAAR*, 6 (1927), 127ff., presents a number of excellent illustrations in publishing the Garrett manuscripts of Marcanova, in Princeton.

13. See, especially, G. Nicco, *L'Arte*, 32 (1928), 126ff.

14. Pope-Hennessy, *Italian Renaissance Sculpture*, pp. 344ff.

15. The antiquities in Mantegna's two *St. Sebastians* bear this out (see note 61).

16. J. M. C. Toynbee, *The Hadrianic School* (Cambridge, 1934), pp. 77f., pl. XXV, 1.

17. I. S. Ryberg, *MAAR*, 22 (1955), 166, pl. LIX, fig. 95.

18. E. Espérandieu, *Recueil général des bas-reliefs de la Gaule romaine*, XI (Paris, 1938), no. 7723.

19. Krautheimer, *Lorenzo Ghiberti*, pp. 289f.

20. Ghirlandaio's *Birth of the Virgin* in S. Maria Novella, Florence, includes a "maenad" at the right and an Attic amorino sarcophagus as a frieze in the background; Toynbee, *Hadrianic School*, p. 228, pl. LV, 1 and parallels.

21. Pope-Hennessy, *Italian Renaissance Sculpture*, pp.

5ff: H. W. Janson, *The Sculpture of Donatello* (Princeton, 1957), *passim*.

22. Pope-Hennessy, *Italian Renaissance Sculpture*, p. 6.

23. *Ibid.*, p. 7.

24. *Ibid.*, p. 10.

25. G. M. A. Richter, *Ancient Italy* (Ann Arbor, Mich., 1955), p. 79, fig. 243; Clark, *The Nude*, pp. 91f., 385.

26. Pope-Hennessy, *Italian Renaissance Sculpture*, pp. 11f.

27. C. Vermeule, "Greek Numismatic Art, 400 B.C. to A.D. 300," *Greek and Byzantine Studies*, 1 (1958), 99f.; G. F. Hill and E. S. G. Robinson, *A Guide to the Principal Coins of the Greeks* (London, 1932), pl. 19, fig. 48.

28. Pope-Hennessy, *Italian Renaissance Sculpture*, pp. 24f.

29. I. Lavin, "The Sources of Donatello's Pulpits in San Lorenzo. Revival and Freedom of Choice in the Early Renaissance," *ArtB*, 41 (1959), 19–38.

30. The frieze of putti above the principal scenes is taken from various ancient sarcophagi, including the example known to Ghirlandaio.

31. Lavin, "Donatello's Pulpits," fig. 12. These reliefs and their histories are collected in H. von Rohden and H. Winnefeld, *Architektonische Römische Tonreliefs* (Berlin-Stuttgart, 1911), pp. 157ff., pls. 27, 140, figs. 291f., etc. One was drawn for Cassiano dal Pozzo and was known at least as early as 1600, if not much earlier.

32. M. Collignon, *Le Parthenon* (Paris, 1914), pp. 67f. Ciriaco's career is discussed in the section on Mantegna.

33. S. Reinach, *Répertoire de reliefs* (Paris, 1912), II, 109. An early Cinquecento (or earlier) drawing of the relief is in the collection of Professor Benjamin Rowland, Jr., of Cambridge, Mass.; the drawing is dated 1496. There are other, less complete, reliefs of the type: see G. M. A. Richter, *Catalogue of Greek Sculptures in the Metropolitan Museum of Art* (Cambridge, Mass., 1954), pp. 141f.

34. G. A. Mansuelli, *Galleria degli Uffizi, Le sculture* (Rome, 1958), I, 232f., no. 251. It was in Rome about 1550, to the right of the front door of the church of S. Maria in Aracoeli.

35. Those in the large panels and in the small friezes over the side arches.

36. Reinach, *Répertoire de reliefs*, III, 141, no. 5.

37. Lateran Room I, no. 27; and (lost) Windsor no. 8430 = British Museum Franks, no. 31; *Galleria Giustiniani* II, pl. 91; etc.: Fr. Cumont, *Recherches sur le symbolisme funéraire des romains* (Paris, 1942), pl. XXV, 2; O. J. Brendel, *ArtB*, 37 (1955), 119, gives a bibliography for the Meleager sarcophagi involved in such scenes.

38. Lavin, "Donatello's Pulpits."

39. E.g., Dal Pozzo (Windsor) no. 8682, which is close to Vatican, Chiaramonti XLVII-4-1964 and Montfaucon I, pl. 170 (Spon).

40. R. Offner, "New Light on Masaccio's Classicism," *Studies Dedicated to William E. Suida*, pp. 66–72.

41. Besides the general debt to the mosaics of S. Maria Maggiore, *The Tribute Money* contains at least one specific borrowing from an ancient statue. The Apostle (Judas) at the extreme right seemingly wears a Renaissance cape, but it is really a Greek pallium or himation seen in profile. The model for the figure was a statue, such as the well-known example in Copenhagen, drawn from the left side. This statue was evident in Rome at least as early as the sixteenth century (cf. Dal Pozzo, Windsor no. 8813; *ArtB*, 38 (1956), 43, fig. 19 and bibliography); the statue came to the Ny Carlsberg Glyptotek from the Palazzo Patrizi.

42. Inv. no. 22.3; W. G. Constable, *Summary Catalogue of European Paintings* (Boston, 1955), p. 65. The pendent St. Paul, not present in *The Tribute Money*, has a head of Plato, or some similar, long-bearded philosopher.

43. Cf. P. J. Riis, *An Introduction to Etruscan Art* (Copenhagen, 1953), fig. 105; *Kunst und Leben der Etrusker* (Cologne, 1956), pl. 62 (top row of heads in the front panel of a Volterra urn).

44. G. Hafner, *Späthellenistische Bildnisplastik* (Berlin, 1954), nos. RIO, NK11, etc.

45. K. Clark, *Piero della Francesca* (London, 1951).

46. One can also compare the small male torso in Boston, a copy of work of about 475–450 B.C.: Caskey, *Catalogue of Greek and Roman Sculpture*, pp. 135f., no. 65.

47. Clark, *Piero della Francesca*, p. 206, pl. 98.

48. See Lippold, *Handbuch der Archäologie*, III, 281f.; Johnson, *Lysippos*, pp. 197ff., gives a list of fifty replicas or versions, in the direction of the Farnese Hercules or in mirror reversal.

49. For instance, the standing Discobolus of Naukydes is met with in miniature in a marble in the collection of C. Ruxton Love, Jr., of New York; a small marble belonging to Benjamin Rowland, Jr., in Cambridge, is a mirror reversal (see *JHS*, 77 (1957), 287, esp. note 18).

50. L. Venturi, *Piero della Francesca*, ed. Skira (Geneva, 1954), pp. 46ff. For a discussion of the subject, see also Clark, *Piero della Francesca*, pp. 19f.

51. Lippold, *Handbuch der Archäologie* III, 264; R. Lullies and M. Hirmer, *Greek Sculpture* (London, 1957), pls. 208ff.

52. More often in sculptured relief than in painting. Masaccio's *The Tribute Money* is a landmark in respect to painting.

53. As the relief in the Palazzo dei Conservatori: Stuart Jones, *Catalogue*, p. 160, no. 9a., pl. 59, and its counterpart in the Palazzo Rospigliosi. For the bronze relief in Naples, and its parallels, see G. M. A. Richter, *Collection Latomus*, 36 (1959), 20, fig. 22.

54. The example in London, Sir John Soane's Museum, will suffice: Robert, *Die antiken Sarkophagen-Reliefs*, III, 479ff.

55. E. H. Gombrich, *JWarb*, 8 (1945), 7–60 and bibliography.

56. Giulio Carlo Argan, *Botticelli*, ed. Skira (Lausanne, 1957); on p. 140 there is a list of the many important monographs on Botticelli.

57. Cagiano, *Le Antichità di Villa Medici*, cover illustration and pp. 44f., no. 16, pl. XVII and fig. 24.; Wind, *Pagan Mysteries*, pp. 100ff., figs. 22ff., esp. fig. 24.

58. Johnson, *Lysippos*, pp. 55ff.; Wind, *Pagan Mysteries*, pp. 111f., figs. 30f.

59. The scenes in the two Vatican Virgils come to mind.

60. Something which G. Rowley has admirably demonstrated in his study of Ambrogio Lorenzetti.

A sense of the sculptural basis or treatment of Botticelli's figures is stronger in one of his few drawings than in his painting. The famous "Angel" in the Uffizi is an amply draped, youthful figure turning in profile to the right. As personal as any work of the artist, this study portrays careful scrutiny of an Antonine Roman draped figure with copyist's free use of the running drill in the folds of the drapery. See *Italian Drawings, Masterpieces of Five Centuries*, Exhibition Organized by the Uffizi and Circulated by the Smithsonian Institution, 1960–61, pp. 17f., no. 14; Y. Yashiro, *Sandro Botticelli* (London-Boston, 1925), III, pl. 263.

61. P. Kristeller, *Andrea Mantegna* (London, 1901); E. Tietze-Conrat, *Mantegna* (London, 1955), with a full catalogue of those works by and ascribed to the artist; G. Fiocco, *Mantegna* (Milan, n.d.), color plates of the Ovetari Chapel; K. Clark, "Andrea Mantegna," *Journal of the Royal Society of Arts*, 106 (1957–58), 663–680, devotes a lecture, with illustrations, to the antiquarian flavor (or lack of same) of Mantegna, especially his Eremitani frescoes and the Hampton Court cartoons. Mantegna has now enjoyed the full scholarly reappraisal of a major exhibition in Mantua: *Andrea Mantegna, Catalogo della Mostra*, by G. Paccagnini, *et al.* (Mantua, 1961), in two editions; C. Gilbert, "The Mantegna Exhibition," *The Burlington Magazine* (January 1962), pp. 5–9.

62. For a splendid general appraisal of this intellectual climate, see C. Mitchell, "Archaeology and Romance in Renaissance Italy," *Italian Renaissance Studies*, ed. E. E. Jacob (London, 1960), pp. 455–483.

63. Similar to the glass cameo in the Metropolitan Museum, New York: G. M. A. Richter, *Catalogue of Engraved Gems, Greek, Etruscan and Roman* (Rome, 1956), no. 633 (Achilles and Troilos) and references.

64. P. D. Knabenshue, *ArtB*, 41 (1959), 59–73.

65. *Ibid.*

66. T. E. Mommsen, "Petrarch and the Decorations of the Sala Virorum Illustrium in Padua," *ArtB*, 34 (1952), 95–116; reprinted in *Medieval and Renaissance Studies* (Ithaca, N.Y., 1960), ch. 8.

67. Surviving segments of the Arch of Augustus can be added, including the Victory in Copenhagen, from one of the spandrels: C. Vermeule, *Gnomon*, 25 (1953), 472.

68. The same armor is seen in Mantegna's book illuminations: M. Meiss, *Andrea Mantegna as Illuminator; An Episode in Renaissance Art, Humanism and Diplomacy* (Cambridge, 1957), *passim*.

69. Reinach, *Répertoire de reliefs*, III, 315, no. 4. For Mantegna's inscriptions after the antique, see M. Meiss, "Toward a More Comprehensive Renaissance Palaeography," *ArtB*, 42 (1960), 97ff., esp. 105.

70. Mansuelli, *Galleria degli Uffizi, Le sculture*, I, no. 221; cf. also no. 235.

71. Soane Museum no. 1486M (*Cat.*, no. 305); Dal Pozzo (Windsor) no. 8331. Cf. the sarcophagus in Pisa: Reinach, *Répertoire de reliefs*, III, 108, no. 4.

72. Ch. Huelsen, *The Roman Forum* (Rome, 1906), pp. 59–66.

73. Huelsen, *Roman Forum*, pp. 154–161.

74. Many parallels exist in and from Rome; see generally, A. N. Zadoks Jitta, *Ancestral Portraiture in Rome and the Art of the Last Century of the Republic* (Amsterdam, 1932).

75. The baker's name was Vergilius Eurysaces and his tomb, dated by some as early as 50 B.C., has been the subject of many monographs: see *Cambridge Ancient History, Plates*, IV (1934), 72f. and bibliography.

76. Mantegna's circle, with their interest in inscriptions, obviously supplied these.

77. One of the few examples of a signature in Greek (other than Pisanello's Byzantine medallions and El Greco) between 1400 and 1780.

78. F. Hauser, *Die neu-attischen Reliefs* (Stuttgart, 1889), pp. 173ff.

79. Mansuelli, *Galleria degli Uffizi*, pp. 172f., under no.. 153.

80. For a comparative head, part of a statue, one has the Julio-Claudian lady represented as Cybele, from the Villa Mattei and now in the J. Paul Getty Museum, Malibu, California, *Bulletin*, 1 (1957), 22ff.

81. *MAAR*, 6 (1927), plates. In the *Triumph of Caesar* the majestic sweep combined with overabundance of detail is almost better grasped in the several sets of chiaroscuro woodcuts by A. Andreani (1540–1610) after Mantegna's cartoons.

82. The sculptor of the set of Aurelian reliefs in the Conservatori made the compensation for the angle of view in his compositions and individual figures. Bernini exploited this technique in the dramatic fashion of the Baroque in his *Pasce Oves Meas* relief in St. Peter's (see Chapter VI).

83. D. E. Strong, *PBSR*, 21 (1953), 142ff.; Vermeule, *AJA*, 61 (1957), 240.

84. G. M. A. Richter, *The Sculpture and Sculptors of the Greeks* (New Haven, 1950), p. 200.

85. I. S. Ryberg, *MAAR*, 22 (1955), fig. 96b.

86. G. Moretti, *Ara Pacis Augustae* (Rome, 1948), pp. 13ff. (excavations of 1568).

87. Kristeller, *Andrea Mantegna*, pp. 290f., fig. 104.

88. C. Vermeule, *ArtB*, 38 (1956), 54; P. G. Huebner, *RM*, 26 (1911), 288ff.

89. E.g., F. Gnecchi, *I medaglioni romani* (Milan, 1912), II, pl. 61, no. 7 (Marcus Aurelius), pl. 67, no. 8 (Faustina II).

90. Chase, *Greek and Roman Antiquities*, pp. 81ff., fig. 93.

91. Mansuelli, *Galleria degli Uffizi*, nos. 77, 78.

92. The puteal in Madrid connects the figure with Athena in the scene of her birth, in the lost center of the East pediment of the Parthenon: C. Picard, *Manuel d'archéologie grecque, La sculpture* (Paris, 1939), II, 486ff., fig. 200.

93. G. M. A. Richter, *Greek Portraits, A Study of their Development*, Collection Latomus, XX (Berchem-Brussels, 1955), p. 24.

94. S. B. Platner, *The Topography and Monuments of Ancient Rome* (Boston, 1904), pp. 414f.; revised by T. Ashby as *A Topographical Dictionary of Ancient Rome* (Oxford, 1929), pp. 484ff.

95. G. F. Hill, *A Corpus of Italian Medals of the Renaissance before Cellini* (London, 1930), I, 6ff.

96. Hill, *Italian Medals*, p. 7, note 1; G. A. Dell'Acqua, *I grandi maestri del disegno, Pisanello* (Milan, n.d.).

97. See A. E. Popham and P. Pouncey, *Italian Drawings in the Department of Prints and Drawings in the British Museum, The Fourteenth and Fifteenth Centuries* (London, 1950), p. 136, under no. 223; A. E. Popham and J. Wilde, *Italian Drawings of the XV and XVI Centuries . . . at Windsor Castle* (London, 1949), no. 26, fig. 10. For Pisanello and drawings after the antique, see generally B. Degenhart and A. Schmitt, "Gentile da Fabriano in Rom und die Anfänge des Antikenstudiums," *MJb*, 11 (1960), 59ff., esp. 91ff.

98. Hill, *Italian Medals*, p. 10, no. 32; II, pl. 6.

99. *Ibid.*, p. 12, no. 42; II, pl. 10.

100. *Ibid.*, pp. 37ff.; p. 39, nos. 163f.; II, pl. 31.

101. *Ibid.*, pp. 82ff.

102. *Ibid.*, p. 85, nos. 340ff.; II, pl. 55. The obverses show portraits of the poet Giovanni Gioviano Pontano, author of a poem *Urania*.

103. Hill, *Italian Medals*, pp. 110ff., no. 423; II, pl. 80. The attribution is discussed by Hill; the medallion was very popular, surviving in a large number of impressions. For the flame as a light to Cupid's "blindness," see E. Panofsky, *Studies in Iconology, Humanistic Themes In The Art of The Renaissance* (New York, 1939), pp. 110–128.

104. Hill, *Italian Medals*, pp. 186f., nos. 731–736; II, pls. 122–124.

105. The types seen most frequently are studied by J. Bayet, *RA* (1949), I, 34ff. Paduan copies exist of the Kimonian and later dekadrachms of Syracuse.

106. As Boston no. 59.181 (Mazzini Collection, *Cata-*

logue no. 742; Cohen, no. 260 var.; cf. *BMC*, pl. 46, 4, rev.).

107. See *BMC*, I, 250ff., nos. 259ff., pl. 45; Suetonius, *Nero*, 12; etc.

108. As *BMC*, II, 269, nos. 221ff., pl. 51, no. 5.

109. Bober, *Aspertini*, pp. 45f. and bibliography; Reinach, *Répertoire de reliefs*, III, 168, nos. 1–4; Amelung, *RM*, 24 (1909), 181ff., pl. V.

110. As Toynbee, *The Hadrianic School*, pl. 43, no. 1 (in the Lateran); pl. 56, no. 2 (Campo Santo, Pisa, and therefore available in the Quattrocento).

111. As *BMC*, III, pls. 81, no. 11, 86, no. 4; so also the DECURSIO sestertii of Nero.

112. Hill, *Italian Medals*, pp. 195ff., nos. 754, 755; II, pl. 127.

113. See H. Mattingly, *et al.*, *The Roman Imperial Coinage*, IV, part II (London, 1938), 169ff.

114. K. Kluge and K. Lehmann, *Die Antiken Grossbronzen* (Berlin, 1927), II, 85f.; H. von Roques de Maumont, *Antike Reiterstandbilder* (Berlin, 1958), pp. 55ff.

115. R. Delbrueck, *Spätantike Kaiserporträts*, pp. 110ff.; from p. 10 on one finds all the testimonia, numismatic and otherwise.

116. As F. Gnecchi, *I medaglioni romani* (Milan, 1912), pl. 106 (bronze medallions of Gordianus III, A.D. 238–244).

117. As *ibid.*, pls. 95, no. 2 (Caracalla); 103, no. 6 (Gordianus III).

118. Hill, *Italian Medals*, pp. 238ff.

119. Pope-Hennessy, *Italian Renaissance Sculpture*, pp. 101f., fig. 139; fig. 138.

120. *Ibid.*, pp. 102, 320, pl. 91.

121. Pouring satyr in the Museum of Fine Arts, Boston: Chase, *Greek and Roman Antiquities*, p. 86, fig. 97. Cf. the bronze statuette of a fluting and dancing satyr (Marsyas) formerly in the Melchett collection (and parallels): E. Strong, *Catalogue of the Greek and Roman Antiques in the Possession of Lord Melchett* (Oxford, 1928), pp. 22ff., no. 16, pls. XXI–XXVI (as a torso, very close to the Apollo). A headless "Narcissus," really a booted Sylvanus or Vertumnus, among the Greco-Roman statuettes in Boston also illustrates Bertoldo's source.

122. Pope-Hennessy, *Italian Renaissance Sculpture*, p. 102, fig. 140.

123. Hill, *Italian Medals*, no. 911; II, pl. 147.

124. Gnecchi, *I medaglioni romani*, II, pl. 75, no. 6 (Lucius Verus, A.D. 161–169); pl. 104, nos. 7f. (Gordianus III). This design was popular in the commemoration of successes on the eastern frontiers, where the reclining personifications are the Tigris and the Euphrates.

IV. The Age of Raphael and Michelangelo

1. Bober, *Aspertini*, pp. 16ff. S. J. Freedberg, *Painting of the High Renaissance in Rome and Florence* (Cambridge, Mass., 1961) should be consulted in connection with painters studied in this chapter.

2. A subject developed with appropriate detail by I. Bergström, *Revival of Antique Illusionistic Wall-Painting in Renaissance Art*, Göteborgs Universitets Årsskrift, LXIII (1957), 1. 59 pp. For the Galatea, see also Clark, *The Nude*, pp. 111f.

3. For the history of archaeology's development as a science, from antiquity to modern times, see A. Rumpf, *Archäologie*, I. Einleitung, *Historischer Überblick* (Berlin, 1953).

4. See T. Ashby, *JRS*, 9 (1919), 172f.

5. See, generally, K. Clark, *Leonardo da Vinci* (Baltimore, 1958), and references; L. Goldscheider, *Leonardo da Vinci, Life and Work, Paintings and Drawings* (London, 1959), provides superb illustrations.

6. See Reinach, *Répertoire de la statuaire*, I, 98. Michelangelo also used the Uffizi sarcophagus as an iconographic source, in his drawing of the *Fall of Phaeton*: J. Wilde, *Italian Drawings in the Department of Prints and Drawings in the British Museum, Michelangelo and his Studio* (London, 1953), pp. 91ff., no. 55, pl. LXXXI.

7. G. Q. Giglioli, "Il 'Regisole' di Pavia," *BullMusImp*, 11 (1940), 57–66; the statue was destroyed by a rioting mob in 1796.

8. L. Laffranchi, "Due monumenti dell' 'adventus augusti': il Regisole di Pavia ed il Marc'Aurelio capitolino," *Numismatica* (1942), pp. 3–4, 5ff.; A. C. Levi, *Barbarians on Roman Imperial Coins and Sculpture*, American Numismatic Society, Numismatic Notes and Monographs, 123 (New York, 1952), p. 24, pl. VI, no. 5.

9. Clark, *Leonardo*, fig. 42.

10. In the rockwork of the "Rometta." Other sections have been found in the modern excavations and reconstructed on the site.

11. Clark, *Leonardo*. Paintings and mosaics known in the early Cinquecento may have reënforced the contributions of Roman sarcophagi and architectural friezes. About this time, perhaps just after the Laocoön's discovery in 1506, Andrea Riccio created two similar designs in the reliefs of the Waldeck Casket, now in Munich: H. Weihrauch, "Ein unbekanntes Frühwerk von Andrea Riccio," *Pantheon*, 18 (1960), 222–232.

12. O. Fischel, *Raphael*, trans. B. Rackham, 2 vols. (London, 1948), esp. ch. XII, pp. 188ff.

13. See T. Ashby, *PBSR*, 7 (1914), 1ff.

14. Something evident in the variant copies of fourth-century originals and in the patently Pergamene frescoes from the Basilica at Herculaneum; see *JHS*, 77 (1957), 295–298.

15. Just as, in the late Antonine and Severan periods, Roman mosaicists extracted Greek fourth-century compositions for the floors of their villas.

16. His drawings, a number of which are in the Louvre, are readily recognizable; he was drawn to Bacchic sarcophagi.

17. Fischel, *Raphael*, p. 191. One of these sarcophagi is on the terrace of the Renaissance garden in the Museum of Fine Arts, Boston.

18. For the sarcophagus, see Reinach, *Répertoire de la statuaire*, I, 1, no. 1; Fischel, *Raphael*, pp. 89, 191, II, fig. 80. For the *extispicium* relief: Toynbee, *Hadrianic School*, p. 244 and bibliography; E. Michon, " 'Extispicium' devant le temple de Jupiter Capitolin," *MonPiot*, 32 (1932), 61–80. The fragment with Victory is in the collection of Valentin de Courcel, Paris. It was recorded in drawings before becoming separated from the main relief in the Cinquecento; it only reappeared in the south of France about forty years ago.

19. The courtyard of the Casa Galli as sketched by Heemskerck and the torso are discussed by A. Michaelis, *JdI*, 6 (1891), 153f., fig. 4. In this view (figure 53) the antiquities from left to right are: the Romano-Egyptian sphinx studied by Raphael (see p. 64), a reclining fountain nymph (on the column), fragments of trapezophori (on the wall), a Polykleitan torso (against the wall), a Roman garland sarcophagus, a headless River God, Michelangelo's *Bacchus*, the half-draped torso of a Roman emperor in heroic guise, the end of a large sarcophagus, and the torso used by Raphael for his Hermes. The front of a Rape of Proserpina sarcophagus (compare figure 82) is let into the crumbling wall above.

20. Michaelis, *JdI*, 153f.; sphinxes of this type existed in other Roman collections.

21. Levi, *Sculture greche e romane del Palazzo Ducale di Mantova*, pp. 73f., no. 164, pl. LXXXIII. This is not to be confused with the somewhat similar, now lost, *letto di Policleto*, which was also widely used. See L. Goldscheider, *Michelangelo Drawings* (London, 1951), figs. 143–146; Clark, *The Nude*, p. 408.

22. Where it is identified tentatively as the Medici Venus, although the restorations are different.

23. Chase, *Catalogue of Arretine Pottery*, pp. 4ff.

24. S. Aurigemma, *The Baths of Diocletian and the Museo Nazionale Romano* (3rd ed., Rome, 1955), p. 20, no. 13, pl. 8.

25. The Dioscuri, seen from the back, were popular artists' exercises in the years 1500 to 1700.

26. See Chapter I, note 26; also Clark, *The Nude*, p. 393.

27. Acc. no. 57.702; Museum of Fine Arts, Boston, *Annual Report 1957*, p. 11f., fig.; *Bulletin*, 57 (1959), 76ff.; Exhibition Catalogue: *Gustave Courbet, 1819–1877* (Boston, 1960), p. 31 (no. 2), 124. In creating this figure, Courbet combined an early photographer's model posed in a classic manner with a reminiscence of a Nereid sarcophagus which he had sketched in the Louvre in his youth.

28. In definitions of space, silhouetting of figures, rendering of angels' wings, and use of color. On the role exercised by the Ravenna mosaics (and early Christian art in general) in the formation of early Renaissance pictorial language, see F. Hartt, *ArtB*, 41 (1959), 179f.

29. Fischel, *Raphael*, p. 197.

30. *Ibid.*, II, pls. 103, 221.

31. See, generally, P. G. Hamberg, *Studies in Roman Imperial Art* (Uppsala, 1945), pp. 162ff.

32. See Chapter I, note 21.

33. Fischel, *Raphael*, p. 195; II, pls. 219b, 223. A. H. Smith, *Catalogue of Greek and Roman Sculpture in the British Museum*, III (London, 1904), nos. 1699, 1700 (where the provenience is given as Monte Cagnolo, in 1773).

34. Picard, *Manuel d'archéologie grecque*, III, 874ff., fig. 395; Strong, *JHS*, 28 (1908), no. 5.

35. Fischel, *Raphael*, p. 196; II, pl. 218b.

36. G. M. A. Hanfmann, *The Season Sarcophagus in Dumbarton Oaks* (Cambridge, Mass., 1951), no. 298, fig. 141.

37. *AJA*, 61 (1957), 241; G. Rodenwaldt, *BWPr*, 82 (1925), 13f., figs. 9f.

38. Observations based on the plates, and text, of C. de Tolnay, *Michel-Ange* (Paris, 1951); G. Kleiner, *Die Begegnungen Michelangelos mit der Antike* (Berlin, 1949), is useful, and C. H. Morgan, *The Life of Michelangelo* (New York, 1960), is a masterpiece of pleasant but precise writing.

39. The group in the Uffizi, coming from the Cesi collection in Rome, can be traced as far back as that in Naples: Mansuelli, *Galleria degli Uffizi*, pp. 135f., no. 101; so also the Daphnis from the Della Valle collection: p. 137, no. 102.

40. Mansuelli, *Galleria degli Uffizi*, p. 140, no. 108; pp. 140f., no. 109, is suggested as one of two seen by Vasari in the Pitti. As has been stressed elsewhere, Roman copies of such Hellenistic rococo figures have been found in great numbers, and several variations exist in more than one copy.

41. See, for full details, P. F. Norton, "The Lost Sleeping Cupid of Michelangelo," *ArtB*, 39 (1957), 251ff. This is not to be confused with the standing figure labeled Apollo, now in the Bargello, Florence: W. R. Valentiner, "Michelangelo's 'Cupid' for Jacopo Gallo," *ArtQ*, 21 (1958), 251–274.

42. See G. Rodenwaldt, *JdI*, 51 (1936), 82ff.

43. As the Amazon sarcophagus in the Museo Capitolino: Amelung, *Die Sculpturen des Vaticanischen Museums*, II, Belvedere no. 49, pl. 13.

44. Cf. *AJA*, 63 (1959), 160f., pl. 36, fig. 1 and references (a head in Lincoln, from Lord Yarborough's collection).

45. See Bieber, *Sculpture of the Hellenistic Age*, pp. 74ff.

46. See *AJA*, 60 (1956), 347 and references. De Tolnay long ago noted a connection between Michelangelo's *David*, Nicolo Pisano's *Fortitudo* of the pulpit in the Baptistery at Pisa, and the Hercules on a third-century sarcophagus in the Museo Nazionale Romano: "Michelangelostudien (Die Jugendwerke)," *Jahrbuch der Preuszischen Kunstsammlungen*, 54 (1933), 108–109. This is another case of coincidental derivation from a common source. Nicolo Pisano no doubt derived his *Fortitudo* from a Roman sarcophagus, as the filling details behind the

figure suggest. The Roman sarcophagus-designer found his model in a work of the school of Pergamon. Michelangelo may have seen the *Fortitudo* and certainly studied Roman sarcophagi, but he also had access to good Roman copies of Pergamene originals executed on the same colossal scale of the *David*.

47. I proposed this connection in a paper read to the Wedgwood Seminar; C. Vermeule, "The Portland Vase Before 1650," *The Third Annual Wedgwood International Seminar* (Boston, 1958), pp. 59–70.

48. F. R. Walton, "Michelangelo and the Parthenon 'Theseus,'" *Classical Association of New England, Annual Bulletin*, 54 (1959), 16f., lecture no. 5 (4 April 1959); F. R. Walton, "Adam's Ancestor," *Archaeology*, 13 (1960), 253–258. The connections between Ciriaco and Michelangelo are rightly minimized by Clark, *The Nude*, p. 412.

49. See *The Burlington Magazine* (June 1959), pp. 222ff., fig. 12. The same is true of the reclining River God (torso) in the British Museum (Smith, *Catalogue of Sculpture*, III, no. 1727, fig. 12), acquired with the Towneley collection.

50. O. Marucchi, *Guida del Museo Lateranense* (Rome, 1922), pp. 102ff., fig. 28; Clark, *The Nude*, p. 374. G. V. Gentili, *La villa romana di Piazza Armerina* (2nd ed., Rome, 1954), p. 54; cf. pl. 24, etc.

51. The Medici-Riccardi tondi and their Greco-Roman prototypes, where identified, are illustrated on pls. 5–11 of E. Kris, *Steinschneidekunst in der Italienischen Renaissance* (Vienna, 1929), vol. II.

52. Caskey, *Catalogue of Greek and Roman Sculpture*, pp. 59ff., no. 25.

53. Lippold, *Die Skulpturen des Vaticanischen Museums*, II, 1, no. 542, pl. 37.

54. See B. M. Felletti Maj, *Museo Nazionale Romano, I ritratti* (Rome, 1953), nos. 265–268, and references. L. Goldscheider, *Michelangelo, Paintings, Sculptures, Architecture* (London, 1954), pp. 20f. See further, D. J. Gordon, "Giannotti, Michelangelo and the Cult of Brutus," *Fritz Saxl 1890–1948* (London, 1957), pp. 281–296.

55. Wind, *Pagan Mysteries*, pp. 129ff., figs. 3ff.

V. Mannerism and the Organization of Classical Antiquity

1. On Mannerism and the antique, see Bober, *Aspertini*, pp. 16ff.

2. A number of examples from Roman painting are illustrated in A. Maiuri, *Roman Painting*, ed. Skira (Geneva, 1953), esp. pp. 121ff. The influence of Nereid sarcophagi and friezes is discussed by F. Eichler in "Mantegnas Seekentauren und die Antike. Ein römischer Fries mit Meerthiasos," *Festschrift Karl M. Swoboda* (Vienna, 1959), pp. 91ff.

3. F. Hartt, *Giulio Romano*, 2 vols. (New Haven, 1958).

4. See D. Posner, "Charles LeBrun's *Triumphs of Alexander*," *ArtB*, 41 (1959), 237ff.

5. *AJA*, 60 (1956), 336.

6. For the frieze in Mantua, see *ArtB*, 38 (1956), 33, note 7.

7. E. Loeffler, *ArtB*, 39 (1957), 3, fig. 16, made the identification.

8. See, generally, S. J. Freedberg, *Parmigianino, His Works in Painting* (Cambridge, Mass., 1950); L. Fröhlich-Bum, *Parmigianino und der Manierismus* (Vienna, 1921). Both works illustrate the Uffizi drawing of the head of Laocoön's elder son.

9. The ancient source of Michelangelo's Pietà may have been also a now-lost torso, with an extra hand under the left shoulder, which Episcopius published in *Paradigmata* (The Hague, 1671, pl. 27). W. Klein suggested that this very Hellenistic work was the ephebe of Aristonidas, discussed by Pliny the Elder in *Natural History* (34, 140; see W. Klein, "Zu Aristonidas," *JOAI*, 10, 1907, 243ff.). The Michelangelo drawing is illusrated in L. Goldscheider, *Michelangelo Drawings*, pl. 43.

10. B. Schweitzer, "Zum Antikenstudium des Angelo Bronzino," *RM*, 33 (1918), 45ff.

11. A. McComb, *Agnolo Bronzino, His Life and Works* (Cambridge, Mass., 1928). On the allegory in London ("Venus, Cupid, Jealousy, Time," etc.), see also Panofsky, *Studies in Iconology; Humanistic Themes in the Art of the Renaissance*, pp. 86–91.

12. Bieber, *Sculpture of the Hellenistic Age*, pp. 77f., 79f., figs. 268ff., 278ff.; C. Vermeule, *Bulletin of the J. Paul Getty Museum of Art*, 1, no. 2 (1959), 2–10; K. Schefold, *Meisterwerke griechischer Kunst* (Basel-Stuttgart, 1960), pp. 99f., 280f., no. 392. The head of Penthesilea exists in at least two replicas.

13. E. H. Lawrence, *Medals by Giovanni Cavino, The 'Paduan'* (New York, 1883). See also the H. M. F. Schulman Sale Catalogue (18–19 March 1960, New York), pp. 102ff., under nos. 5148–5176.

14. The observations on these three artists are based on G. F. Hill, *The Gustave Dreyfus Collection, Renaissance Medals* (London, 1931); see also *Renaissance Bronzes from the Kress Collection* (Washington, 1951).

15. The group is discussed in detail in Vermeule, "An Imperial Medallion of Leone Leoni and Giovanni Bologna's Statue of the Flying Mercury," *NumCirc*, 60 (1952), 505ff.

16. An important article by O. J. Brendel, "Borrowings from Ancient Art in Titian," *ArtB*, 37 (1955), 113ff., from which the several quotations immediately following are taken, forms the basis for any observations on that artist's connections with antiquity. See also, with reference to the artist's greatest composition, A. Pope, *Titian's Rape of Europa* (Cambridge, Mass., 1960).

17. I. S. Ryberg, *MAAR*, 22 (1955), 90ff., fig. 42b; C. Vermeule, *Berytus*, 13 (1959), 19; V. Poulsen, *ActaA*, 29 (1958), 189f. and further bibliography.

18. Hülsen, *Römische Antikengärten*, p. 23, no. 76. Others are collected in Reinach, *Répertoire de la statuaire*, II, 436f., esp. no. 8 (once in Rome and thence, by

BAROQUE IN ITALY: EXPLOITATION OF ANTIQUITY

way of the dealer-restorer Cavaceppi, to England). See also *ibid.*, IV, 267, nos. 4 (Ny Carlsberg Glyptotek no. 169), 5 (Vienne: Espérandieu, *Recueil* III, p. 404), and 6 (for which see the discussion by Mrs. Strong, *JHS* 28, 1908, 22f.). The last was in the Cook collection at Richmond near London.

19. The four small, cassone-shaped paintings in the Museum of Fine Arts present four mythological "romances": *Venus and Jupiter* (60.125), *Diana and Acteon* (59.260), *Atalanta and Meleager* (129.61), and the *Venus and Adonis* or *Olympus* (128.61). See *The Holford Collection, Dorchester House* (London, 1927), I, 41; MFA., *Annual Report* (1959), pp. 49ff.; MFA, *Calendar of Events* (October 1961), p. 2; MFA, *Annual Report* (1961), 63ff.

20. H. Tietze, *Tintoretto, The Paintings and Drawings* (Oxford-New York, 1948); E. Newton, *Tintoretto* (London, 1952). J. Maxon, "Tintoretto's use of the antique," *The Connoisseur*, 151, no. 607 (September 1962), 59ff.

21. Discussed in full by P. F. Norton, *ArtB*, 39 (1957), 251ff.

22. Bieber, *Sculpture of the Hellenistic Age*, shown in figure 263, on the left of Milchhöfer's reconstruction of the Niobid group; Lippold, *Handbuch der Archäologie*, III, 1, p. 333.

23. Caskey, *Catalogue of Greek and Roman Sculpture*, pp. 52ff., under no. 22. Rhys Carpenter (*Greek Sculpture, A Critical Review* [Chicago, 1960], pp. 155f.) discusses the Boston Leda. He also suggests that the Boston Cybele is Agorakritos' cult statue for the Metroön shrine in the Athenian Agora.

24. Bieber, *Sculpture of the Hellenistic Age*, p. 142, fig. 595.

25. C. Vermeule, *AJA*, 63 (1959), 313, in connection with the unpublished replica (head) in the Hammond Museum, Gloucester, Mass.; Lippold, *Handbuch*, p. 140.

VI. Baroque in Italy: Grandiose Exploitation of Antiquity

1. E. Panofsky and F. Saxl, *Metropolitan Museum Studies*, 4 (1932–33), 278.
2. The observations on painters and sculptors of Baroque Rome in this chapter draw heavily on the pertinent parts of R. Wittkower, *Art and Architecture in Italy 1600 to 1750* (Baltimore, 1958). Quotations are from this work, unless otherwise noted.
3. See generally, C. Vermeule, "Aspects of Scientific Archaeology in the Seventeenth Century: Marble Reliefs, Greek Vases, Manuscripts, and Minor Objects in the Dal Pozzo–Albani Drawings of Classical Antiquities," *PAPS*, 102 (1958), 193–214; and "The Dal Pozzo–Albani Drawings of Classical Antiquities in the British Museum," *TAPS*, 50 (1960), part 5.
4. Wittkower, *Art and Architecture in Italy*, pp. 13f. Information about the Giustiniani and their collection of paintings has been gathered by L. Salerno, "The Picture Gallery of Vincenzo Giustiniani. I: Introduction,"

The Burlington Magazine (January 1960), pp. 21–27; "II: The Inventory, Part I" (March 1960), pp. 93–111. The presence of Giustiniani marbles in North America stems chiefly from the fact that a Mrs. Frederick Ferris Thompson bought 38 statues or reliefs from the Giustiniani collection through the dealer Sangiorgi in Rome. The Metropolitan Museum received 17 pieces and Vassar and Williams colleges 4 each, from her gift in 1903. A much-restored section of a Severan mythological or hunting-scene sarcophagus is in Tilden Park, Yonkers, New York.

5. Wittkower, *Art and Architecture in Italy*, pp. 31ff.
6. See J. Pope-Hennessy, *The Drawings of Domenichino in the Collection of H. M. the King at Windsor Castle* (London, 1948), pp. 37ff., no. 115. Yet, there is no evidence Domenichino was at all moved by the splendid Pheidian grave stele of a youth reading from a scroll, walled up in the Abbey at Grottaferatta: K. Schefold, *Meisterwerke griechischer Kunst* (Basel, 1960), pp. 81f., no. 308a.
7. Stuart Jones, *Museo Capitolino*, p. 274, no. 1 (Zeus), and p. 278, no. 5 (Asklepios), pls. 65, 67; they are said to have been found at Porto d'Anzio (Antium) in 1718, in the exedra of a villa. Domenichino has used a standing Zeus or Asklepios as his model, but he has turned his "idol" into a half-standing, half-seated figure, swathed in billowing drapery. A number of Seicento sculptors did the same, taking an ancient torso and radically altering the original posture in restoration.
8. *Einzelaufnahmen*, no. 2359; *CIL*, VI, no. 432; F. Matz and F. von Duhn, *Antike Bildwerke in Rom*, no. 3773. Renaissance drawings of this very Greek relief are discussed in connection with Dal Pozzo, British Museum, Franks, no. 367 (see *TAPS*, 50 [1960], part 5, 26, fig. 84).
9. Collected by W. Fuchs, *Die Vorbilder der Neuattischen Reliefs, JdI, Ergänzungsheft*, 20 (1959), *passim*. The Cowper relief in Los Angeles, in reverse, is a particularly close parallel.
10. Wittkower, *Art and Architecture in Italy*, pp. 96–129 and Wittkower, *Gian Lorenzo Bernini*. This section has also benefited from reading Karen Kriendler's "Bernini and the Antique," an honors thesis in the Department of Art at Smith College, 1962.
11. Wittkower, *Art and Architecture in Italy*, p. 111.
12. Stuart Jones, *Museo Capitolino*, pp. 212f., no. 79, pl. 52.
13. C. Vermeule, "Hellenistic and Roman Cuirassed Statues," *Berytus*, 13, fasc. 1 (1959), 58, no. 208 in catalogue.
14. *AJA*, 60 (1956), 343, pl. 110, fig. 24.
15. Reinach, *Répertoire de reliefs*, III, 323f.; Th. Schreiber, *Die Hellenistischen Reliefbilder* (Leipzig, 1894), pls. IIIff.
16. Bieber, *Sculpture of the Hellenistic Age*, p. 81 and references.
17. Reinach, *Répertoire de la statuaire*, I, 323, no. 7.
18. Michaelis, *Ancient Marbles in Great Britain*, p. 314.

189

19. Stuart Jones, *Museo Capitolino*, pp. 134ff., nos. 61, 61A, pl. 22.

20. For the Cortona volume in Toronto, see G. Brett, Royal Ontario Museum, *Bulletin of the Division of Art and Archaeology* (December 1957), no. 26, pp. 4–10.

21. Cortona's sketchbook in Toronto includes at least eight drawings of scenes on the Column of Trajan and drawings after the Polidoro da Caravaggio frescoes on the façades of the Palazzo Milesi and the Palazzo Bufalo in Rome.

22. D. M. Robinson, *AJA*, 59 (1955), 28, pl. 21; *The David Moore Robinson Bequest of Classical Art and Antiquities, A Special Exhibition* (Fogg Art Museum, Harvard University, May 1 to September 20, 1961), p. 27, no. 211.

23. According to Winckelmann: Wittkower, *Art and Architecture in Italy*, p. 173.

24. J. B. Ward Perkins, "The Shrine of St. Peter and its Twelve Spiral Columns," *JRS*, 42 (1952), 21ff.

25. Stuart Jones, *Museo Capitolino*, pp. 86f., Galleria, no. 4, pl. 23 (actually the upper half of a seated Aphrodite); cf. the Cesi "Juno," pp. 340f., no. 2, pl. 85.

26. See F. Noack, in Thieme-Becker, *Allgemeines Lexikon der Bildenden Kunstler* (Leipzig, 1911), V, 472. Mrs. Sheila Rinehart has helped with attributions of the *Museum Chartaceum* drawings.

27. See A. M. Clark, "Five Roman Masters of the Settecento," *Bulletin of the Rhode Island School of Design, Museum Notes* (May 1959), pp. 3f. for an excellent statement of Maratta's influence.

28. Wittkower, *Art and Architecture in Italy*, pp. 221f.

29. The choice of Poussin's works and the quotations are based in the main on A. Blunt, *Art and Architecture in France, 1500–1700* (Baltimore, 1954), pp. 182–195. The publication of the Exposition Nicolas Poussin, held in the Louvre from May through July 1960, illustrates over 120 paintings and a number of drawings. The catalogue by Professor Blunt provides all necessary information about the dates, histories, and previous publications of the paintings and drawings discussed here: Musée du Louvre, *Exposition Nicolas Poussin*, 2nd ed. corrected (Paris, 1960), 354 pp. and plates. In writing this section I am not unaware of the fact that the dates of few of Poussin's paintings are absolute. The Paris exhibition has already produced important articles on this subject, and no doubt others will follow in the coming years. See D. Mahon, "Poussin's Early Development: an Alternative Hypothesis," *The Burlington Magazine* (July 1960), pp. 288–304, where dates different from those given here are discussed, and "Poussin Studies XI: Some Addenda to the Poussin Number," *The Burlington Magazine* (September 1960), pp. 393–402, where Blunt has added changes of his own. Finally, mention must be made of *Nicolas Poussin*, ed. A. Chastel, 2 vols. (Paris, 1960), an encyclopedia of Poussin lore resulting from the colloquium held September 19–21, 1958; an article by Charles

Picard discusses the Roman sarcophagi studied by Poussin. There is now also a wealth of material in E. Panofsky, *A Mythological Painting by Poussin in the National Museum, Stockholm* (Stockholm, 1960).

Poussin made many drawings after the antique, but few have been identified with certainty. Several of these were shown in the 1960 Exposition. H. Malo, *Chantilly, Musée Condé, Cent-deux dessins de Nicolas Poussin* (Paris, 1933) presents a number. If many attributions are not correct, at least the types of drawing in this collection are indicative of Poussin's archaeological tastes, from statues, to sarcophagi, to minor antiquities, including scenes on engraved gems. So also the additional drawings illustrated by Blunt in "Poussin et les cérémonies religieuses antiques," *La revue des arts, Musées de France* (1960), pp. 3–18.

The documents and parallels assembled by W. G. Constable and R. B. K. McLanathan in connection with the painting *Achilles on Skyros* in Boston (46.463) have been of great help; much of this information was published by the latter in MFA, *Bulletin*, 45 (1947), 1–11. See also the exhibition catalogue, *The Greek Tradition in Painting* (Baltimore Museum of Art, 15 May–25 June 1939).

30. Raphael and Titian in similar scenes had taken up the obvious relation of Meleager's funeral on Roman sarcophagi to the lowering of Christ's body into the sepulcher.

31. A set of colored drawings of the Nilotic and mythological scenes exist in Dal Pozzo's collection in the Royal Library at Windsor.

32. W. Friedlaender, *The Drawings of Nicolas Poussin* (London, 1939), pp. 25f., no. 46, pl. 30. Poussin's timelessness in transforming classical form into controlled shapes, regardless of their representational sources, is suggested in a recent article: T. Reff, "Cézanne and Poussin," *JWarb*, 23 (1960), 150–174. See also, C. G. Dempsey, "Poussin and Egypt," *ArtB*, 45 (1963), 109–119.

33. Blunt, *Art and Architecture in France*, pp. 266–270.

34. Mansuelli, *Galleria degli Uffizi, Le sculture*, I, 94ff., no. 62, fig. 64. Mansuelli gives the history of the head in great detail; Giovanni Bologna restored it in 1579, the piece having been very likely brought from Rome in the previous decade.

35. See Stuart Jones, *Palazzo dei Conservatori*, pp. 249f., no. 100, pl. 96 (as actually by Ruggero Bescapè of Milan in 1594; at least according to Aldrovandi, Michelangelo did admire it.

36. P. Francastel, *Girardon* (Paris, 1928).

37. "Hellenistic and Roman Cuirassed Statues," *Berytus*, 13 (1959), 20, no. E 2.

VII. Rococo, Ancient and Modern

1. Panini's importance has been weighed recently in a major monograph by F. Arisi, *Gian Paolo Panini* (Piacenza, 1961) and in an article by R. P. Wunder, *Journal*

of the *Walters Art Gallery*, 17 (1954), 9ff., with bibliography. The romance of ancient Rome in the eighteenth century forms the principal theme of the essay by Robert C. Smith, in *The Ruins of Rome*, catalogue of the exhibition held at the University Museum (Philadelphia, 1960–61). I contributed a short essay, "The Ancient Marbles," in connection with a catalogue of seventeen specimens typical of those found in the Rome of Panini and Piranesi.

2. A. Hyatt Mayor, *Giovanni Battista Piranesi* (New York, 1952); *Piranesi* (Northampton, Mass.: Smith College Museum of Art, 1961), with a catalogue, bibliography, and essays by Philip Hofer, Karl Lehmann, and Rudolf Wittkower.

3. *A New Description of Sir John Soane's Museum* (London, 1955), p. 42.

4. Bieber, *Sculpture of the Hellenistic Age*, pp. 136ff.; Klein, *Vom antiken Rokoko, passim*; Klein, *JdI*, 19–20 (1919), 252ff.; G. M. A. Richter, "Was Roman Art of the First Centuries B.C. and A.D. Classicizing?," *JRS*, 48 (1958), 10–15, including efforts to discard the theories of cyclic development in Hellenistic art.

5. The material on the sculptors can be found in E. M. Dacier and H. Carles, *L'Art au XVIIIème siècle en France* (Paris, 1951). Among many exhibition catalogues, that published in 1935 by the Metropolitan Museum, New York, provides the best critical text and series of useful references: *French Painting and Sculpture of the XVIII Century*. Among monographs on single sculptors, see L. Réau, *Etienne-Maurice Falconet*, 2 vols. (Paris, 1922); S. Rocheblave, *La vie et l'oeuvre de Jean-Baptiste Pigalle* (Paris, 1919). Two other general catalogues should be cited: *Exposition de l'art français au XVIIIe siècle* (Copenhagen: Charlottenborg Palace, 1935); Burlington Fine Arts Club, *French Art of the Eighteenth Century* (London, 1914). Also *The Age of the Rococo, Art and Culture of the Eighteenth Century* (Munich, 15 June–15 September 1958); A. Schönberger and H. Soehner, *The Age of Rococo* (London, 1960); this catalogue is particularly strong in the decorative arts of central Europe.

6. Johnson, *Lysippos*, pp. 104ff.

7. Bieber, *Sculpture of the Hellenistic Age*, pp. 136f., and note 2.

8. Much in this section has been drawn from E. and J. de Goncourt, *French XVIII Century Painters* (London, 1948). The works of Fragonard are catalogued and illustrated in G. Wildenstein, *The Paintings of Fragonard* (London, 1960). Drawings were very important in this century; K. T. Parker, *The Drawings of Antoine Watteau*, (New York, 1932) is most helpful. On Chinoiserie in the Rococo, see H. Honour, *Chinoiserie, The Vision of Cathay* (London, 1961).

9. A. Venuti, *Vetera monumenta quae in hortis Caelimontanis et in aedibus Matthaeiorum adservantur*, III (Rome, 1779), pl. II, no. 1; Reinach, *Répertoire de reliefs*, III, 303, no. 4.

10. C. Vermeule, *AJA*, 60 (1956), 336; M. Borda, *La scuola di Pasiteles* (Bari, 1953), pp. 58ff.

11. Numerous studies exist; see recently, *French Drawings from American Collections, Clouet to Matisse, A Special Loan Exhibition* (New York: The Metropolitan Museum of Art, 1959), pp. 53f., no. 51, pl. 60 and refs.

12. *French Drawings from American Collections*, p. 57, no. 58, pl. 49.

13. *Monumenta Mattheiana*, III, pl. XXVII, fig. 11.

14. J. Fleming, "Cardinal Albani's Drawings at Windsor: Their Purchase by James Adam for George III," *The Connoisseur*, 142, no. 573 (December 1958), 164ff.; and *Robert Adam and his Circle in Edinburgh and Rome* (London, 1962).

15. Dal Pozzo-Albani (Windsor) no. 8100.

16. *Ibid.*, no. 8709.

17. In illustration of this archaeological climate, D. von Bothmer discusses the manner in which French Rococo artists reached Neo-Attic and, ultimately, fifth-century motifs through the newly discovered frescoes at Herculaneum: "The Classical Contribution to Western Civilization," *BMMA* (April 1949), pp. 205ff., esp. 216f. Comparisons between Rococo reliefs and the ancient copies after the maenads of Kallimachos are particularly striking.

VIII. Neoclassicism and the French Empire

1. The best general work is M. Praz, *Gusto Neoclassico* (Florence, 1940; 2nd ed., Naples, 1960). The literature on the repercussions of Pompeii and Herculaneum in European taste is vast; among recent contributions, see C. F. Mullett, "Englishmen Discover Herculaneum and Pompeii," *Archaeology*, 10 (1957), 31–38; C. Dahl, "Recreators of Pompeii," *Archaeology*, 9 (1956), 182–191.

2. E. Bassi, *La Gipsoteca di Possagno* (Venice, 1957); E. Bassi, *Canova* (Bergamo, 1943); E. Bassi, *Il Museo Civico di Bassano, I disegni di Antonio Canova* (Venice, 1959). See also *The Age of Canova, An Exhibition of the Neo-Classic* (Providence: Rhode Island School of Design, 1957), esp. p. 8. A group of the preliminary *bozzetti* are collected in E. Lavagnino, *Canova e le sue "invenzioni"* (Rome, 1954).

3. H. Honour, "Antonio Canova and the Anglo-Romans. Part 1: The First Visit to Rome," *The Connoisseur* (June 1959), pp. 241ff.; "Part 2: The First Years in Rome," *The Connoisseur* (January 1960), pp. 225ff. In "Bronze Statuettes by Giacomo and Giovanni Zoffoli," *The Connoisseur* (November 1961), pp. 198–205, Honour chronicles and catalogues the work of artists producing accurate small replicas of antique statues in the second half of the eighteenth century. These bronzes certainly helped cultivate a pan-European taste for monumental creations by Canova and Thorvaldsen. Some silversmiths even made models in a variety of media of columns, obelisks, fountains, triumphal arches, the Pantheon, and the Colosseum. It is interesting to observe in the printed list of works offered

for sale about 1795 by Giovanni Zoffoli how many statu-
ettes copied those antiquities most influential in Canova's
work. The Apollo Belvedere heads the (alphabetical) list;
the Medici Venus leads in her class.

4. Inv. no. 26.122; from Podio Publio, Bologna; *Bulletin,
Annual Report* (February 1927).

5. See C. Vermeule, *AJA*, 63 (1959), 161; M. F. Squarcia-
pino, *BullComm*, 73 (1953), 205ff.

6. G. Cultrera, *Dioniso e Leone* (Rome, 1911), *passim;*
S. B. Luce, *Catalogue of the Mediterranean Section* (Phila-
delphia, 1921), p. 175, no. 35; Reinach, *Répertoire de la
statuaire*, V, 341, no. 6.

7. Picard, *Manuel d'archéologie grecque, La sculpture,*
III, 439ff., esp. figs. 175f.

8. L. Budde, *Jugendbildnisse des Caracalla und Geta*
(Münster, 1951), *passim.*

9. Michaelis, *Ancient Marbles in Great Britain*, pp. 599f.,
no. 5.

10. Toynbee, *The Hadrianic School*, p. 244; Strong, *La
scultura romana*, p. 149, pl. XXXII.

11. J. Chittenden and C. Seltman, *Greek Art* (London,
1947), no. 155, pls. 44f; Picard, *Manuel d'archéologie
grecque, La sculpture* III, 874ff., fig. 395.

12. E. Langlotz, *Phidiasprobleme* (Frankfurt, 1947), pl.
25; and *Aphrodite in den Gärten* (Heidelberg, 1954), *pas-
sim;* also M. J. Milne, *AJA*, 60 (1956), 201–205.

13. A. Blanco, Museo del Prado, *Catalogo de la Escul-
tura*, no. 28E, pls. X, XI; Lippold, *Handbuch der Archäo-
logie*, III, 163f.

14. See generally, Richter, *The Sculpture and Sculptors
of the Greeks*, pp. 199ff.; A. W. Lawrence, *Classical Sculp-
ture* (London, 1929), pp. 158ff. There has been much dis-
cussion in recent years of just how the Tyrannicides stood
in antiquity; the literature is collected by C. Kardara,
"The Tyrannicides Once More," *AJA*, 64 (1960), 281.

15. See the comprehensive guide, *Thorvaldsens Museum*
(Copenhagen, 1953), which includes a biography and list
of works.

16. E. Kai Sass, "The Classical Tradition in Later
European Portraiture, with Special Regard to Thorvald-
sen's Portraits," *Acta Congressus Madvigiani* (Copenhagen,
1954; published 1957), pp. 71ff., esp. 98ff.; *AJA* 64 (1960)
112f.

17. R. Cantinelli, *Jacques-Louis David, 1748–1825* (Paris,
1930); M. Florisone, Catalogue of the exhibition "David,"
Orangerie (Paris, 1948).

18. E. Wind, "The Sources of David's *Horaces*," *JWarb*,
4 (1940–41), 124ff. E. Hamilton Hazlehurst, "The Artistic
Evolution of David's *Oath*," *ArtB*, 42 (1960), 59ff., finds
the compositional sources in Domenichino and Poussin,
the two artists most suited to form the background of
David's classicism.

19. Cantinelli, *David*, p. 60; Montfaucon, *L'Antiquité
expliquée*, supplement IV, pl. 15.

20. As Reinach, *Répertoire de reliefs*, II, 402 and refer-
ences. The most important of these reliefs is in Athens,
National Museum, from Oropos (Photo Alinari no. 24389).
There are several Neoclassic forgeries of this scene in ivory,
bronze, and other media suitable to the minor arts. One
in the first medium, designed to look like a Greek mirror-
case, was seen in the London art market in 1955.

21. G. Wildenstein, *Ingres* (London, 1954), gives a full
catalogue; Alain, *Ingres* (Paris, 1949), provides handsome
illustrations; N. Schlenoff, "Ingres and the Classical
World," *Archaeology*, 12 (1959), 16ff.; A. Mongan, "Ingres
and the Antique," *JWarb*, 10 (1947), 1–13; A. Mongan,
"Three Drawings by Ingres," *ArtQ*, 18 (1955), 184f.; P.
Jacobsthal, "Ingres, dessinateur des antiques," *GBA*, 71
(1929), 75ff.

As in the case of David, and Neoclassic painters in gen-
eral, Ingres is not studied as a painter of portraits, con-
sidered by many his greatest talent. In relation to antiq-
uity, and the history of archaeology, I cannot refrain from
mentioning his drawing of Lucien Bonaparte, seated on a
Roman cinerarium, with the Quirinal in the background
(formerly in a Swiss collection and now on loan in the
Museum of Fine Arts, Boston).

The illustrations in Wildenstein's book give a thorough
view of how often Ingres painted and drew the same com-
position. For example, there are no less than five painted
versions of the *Antiochus and Stratonice*.

22. In speaking of the Fogg drawing for the earlier ver-
sion of *Virgil Reading the Aeneid*, Miss Mongan has noted
that the archaeologically correct features of Augustus de-
rive from an ancient marble in the Toulouse Museum.
See R. West, *Römische Porträt-Plastik* (Munich, 1933), I,
111–123.

23. The antique sources of David's *Paris and Helen*
and the antiquities filling the scene have been analyzed
in great detail by E. Coche de la Ferté and J. Guey,
"Analyse archéologique et psychologique d'un tableau de
David: 'Les amours de Paris et d'Hélène,' " *RA*, 40 (1952),
129–161.

24. On the artistic development of modern coins and
medals in relation to machine production, see C. H. V.
Sutherland, *Art in Coinage, The Aesthetics of Money from
Greece to the Present Day* (London, 1955), pp. 193–209;
C. H. V. Sutherland, *Journal of the Royal Society of Arts*,
no. 4954 (24 June 1955), pp. 541–554; C. Vermeule, *Num
Chron* (1955), p. 260.

25. *Mostra di Benedetto Pistrucci, Catalogo* (Rome, De-
cember 1955–January 1956). The basic studies of Pistrucci
are the articles reprinted by L. Forrer, Sr., in his *Bio-
graphical Dictionary of Medallists*, vols. IV, VI, VIII (Lon-
don, 1909–1930).

26. For this cameo, see *Berytus*, 13 (1959), 28f., H 2,
pl. XXV, fig. 75; Delbrueck, *Spätantike Kaiserporträts*, pp.
130f., figs. 32f. and bibliography.

INDEX

(See also the biographies in Appendix II and the list of artists and their works in Appendix III.)

INDEX

Apollo, Hermes, 66; Eros of Centocelle and Eros in Louvre, 81, 100, 130, 135; marble Faun, 141; compared to DAVID, 144

PUGET, Pierre (1620–1694): failure at Louis XIV's court, 113; Pergamene style, 1, 140; career, 1, 115; work, 115, 124, 155

Pupienus (238): co-Emperor with Balbinus, 56

Pythagoras, type, 76

Quercia, Jacopo della (1374/5–1438): premature monumentality of his classicism, 34

RAIMONDI, Marcantonio (about 1480–1530), 166; circulates RAPHAEL's *Judgment of Paris*, 8, 65, 89

RAPHAEL (1483–1520), 5, 10, 62, 72, 77, 84, 87, 95, 97, 99, 102, 103, 110; relation of his High Renaissance style to ancient painting, 60, 62, 107; work, 63; style manifest in GIULIO Romano's *Triumph of Vespasian and Titus*, 78; influence on POUSSIN, 111; work admired by INGRES, 148

RAVELLO: cathedral, 22

RAVENNA, San Vitale: Julio-Claudian relief, "apotheosis" of Augustus, 86; mosaic of Abraham and *Three Angels*, 39; throne "of Poseidon," 47

REGNAUDIN, Thomas (1622–1706), 166; executes nymphs for GIRARDON's *Apollon servi par les nymphes*, 117

REMBRANDT van Ryn (1606–1669): inherits TINTORETTO's decorative spirit, 91

RENI, Guido (1575–1642): work, 99; influence on POUSSIN, 110

Revett, Nicholas, architect and traveler to Greece, 132. *See also* Stuart

RHODES, School of, 60, 128

Riario, Cardinal Raffaello: owned Michelangelo's *Cupid*, 68

Riccio (died 1532): craftsman in bronze, 34

Richelieu, Cardinal, 112, 118

RICHMOND, Virginia: Museum of Fine Arts, 114

Rimini: fortifications on medallion, 53

ROBERT, Hubert (1733–1808), 166; as follower of PANINI, 121

Rococo, French: impact, 13, 122; summation, 131, 156

Rococo, Hellenistic: theories and history of, 2, 13, 70, 100, 122, 131, 156

RODIN, Auguste (1840–1917): *Thinker*'s pose likened to RAPHAEL's Hercules, 63; and classicism, 158

Roma Barberini: restored by MARATTA, from a Venus Felix, 2, 10, 108; used by DAVID, 145

ROME, Ancient sites and monuments: Ahenobarbus base (Paris, Louvre and Munich), 121; Anaglypha Traiani, in Roman Forum, 89; Ara Pacis Augustae or Ara Pietatis Augustae influences MANTEGNA's *Triumph of Caesar*, 50; Arch of the Argentarii, vista in MANTEGNA's Louvre *St. Sebastian*, 45; Arch of Claudius, 7.—Arch of Constantine, 22, 24, 34, 37, 42, 48, 74, 76, 80, 88, 94, 106, 112, 121, 135, 144; in MANTEGNA's work, 44, 46, 49.—Arch of Drusus, recalled in MANTEGNA's *St. James*, 45; Arch of Janus, 121; Arch of Lucius Verus, 19.—Arch of Septimius Severus, 74; influence of reliefs on DONATELLO, 37; in MANTEGNA's work, 44, 46, 48.—Arch of Titus, 28, 78; in MANTEGNA's work, 44, 50.—Arch of Trajan, 34; Arco di Portogallo, 7; *Aula Regia*, frieze influences MANTEGNA, 50; Basilica Aemilia, 45.—Basilica Julia: in *St. James*, 45; in Louvre *St. Sebastian*, 46.—Basilica of Maxentius, 22, 24, 121; Baths of Constantine, 22; Campus Martius, Iseum and Sarapeum, 64, 127.—Caracalla, Baths of, 2, 22; in *St. James*, 45.—Castel Sant'Angelo (Mausoleum Hadriani), 4, 49, 50, 83, 110; Cesi Base (Museo Capitolino), 34; Colosseum in GIULIO Romano's work, 74, 121.—Column of Marcus Aurelius, 13, 24, 43, 74, 76, 78, 80, 112; influence of reliefs on DONATELLO, 37; siege machinery copied by MANTEGNA, 49.—Column of Trajan, 24, 35, 50, 74, 78, 80, 104, 111, 112, 121; Dioscuri of Monte Cavallo, 8, 24; Domus Flavia, 22; Domus Severiana, 22; Forum (Campo Vaccino), 24, 33, 37; Forum of Augustus, 89; Forum of Trajan, 109; Forum Transitorium, 86; Hadrianeum, 111; Juturna Fountain (behind Basilica Julia), frieze from area in MANTEGNA's *St. Christopher*, 45; Library of Augustus, in Louvre *St. Sebastian*, 46; Marcus Aurelius, bronze statue, 8, 56; Mausoleum of Augustus, 75; Palatine, 2; Pantheon, contains RAPHAEL's tomb, 66; Pons Aelius (Ponte Sant'Angelo), 75, 100, 102; River god on Capitol, 84, 92; Tabularium, 22; Temple by the Tiber, 121; Temple of Antoninus Pius and Faustina, 89, 112; Temple of Castor, 121; Temple of Herodes Atticus, 85; Temple of Jupiter Capitolinus, 138; Temple of Saturn, 121; Theatre of Marcellus, 22, 82; Tomb of Caius Cestius, 75, 89, 121; Tomb of Scipio, 51; Tomb of the Baker, 45; Vatican pyramid, 75; Via Flaminia (Corso), 7

ROME, medieval and later: Campidoglio, 3, 97, 119 (Trofei di Mario).—Casa Galli sculptures in court: torso, 63; Egyptian sphinx, 64.—Casa Santacroce, 66; Casa Sassi, 66; Casino Ludovisi, 99; Casino Rospigliosi, 99; Colonna Gallery, 7; Farnesina, 60, 65, 97; House of Cola di Rienzi, 20; Lateran Hospital, *conclamatio* sarcophagus, 137.—Lateran Museum: Hellenistic mythological reliefs, 102; Nereid sarcophagus, 128; "Plotinus" sarcophagus, 28; Sophocles (influences MASACCIO), 39; statue of "Livia," 80.—Lateran Palace, 2.—Museo Capitolino: Aphrodite, 114, 118; Bust of Homer, 109; "Carinus," 101; Cesi Juno, 108; cinerarium, 129; Dying Gaul, 14, 101; Herakles and Hydra, restored by ALGARDI, 103; Leda, 93; Mars Ultor, 55, 80; Muse, 108; Venus, 24, 114, 118, 138; statues of Zeus and Asklepios, 98, 104, 106.—Museo Nazionale Romano: Ares Ludovisi, restored by BERNINI, 103; Barberini mosaic, from Palestrina (returned to site), 114, 127; Ludovisi battle sarcoph-

INDEX

ILLUSTRATIONS

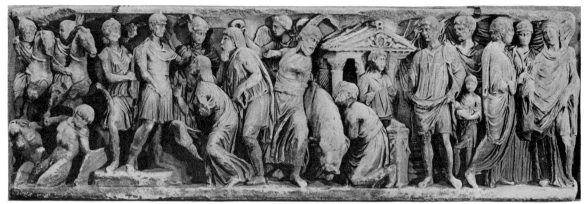

1. Sarcophagus with Scenes from the Life of a Roman General. Los Angeles County Museum

2. Andrea Mantegna: Triumph of Scipio. London, National Gallery

3. Sarcophagus with Contest of Muses and Sirens. New York, Metropolitan Museum of Art

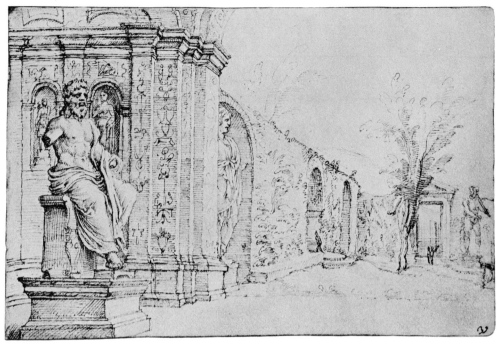

4. *M. van Heemskerck: Garden of the Villa Madama, Rome*

5. *Upper Half of the Villa Madama Zeus.
Paris, Louvre*

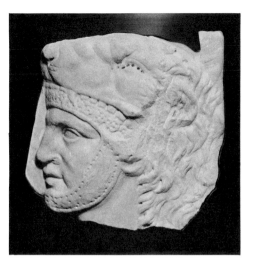

6. *Fragment of Roman Triumphal Relief. Head of a Signifer. Boston, Museum of Fine Arts*

7. *Sarcophagus with Judgment of Paris. Rome, Villa Medici*

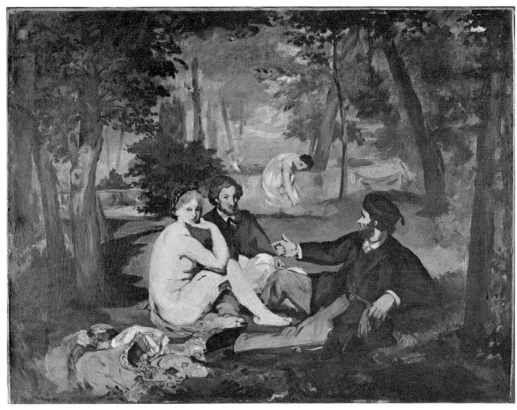

8. *Manet: Déjeuner sur l'herbe. London, Courtauld Institute Gallery*

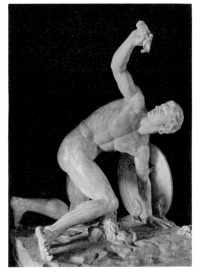

9. *Monnot's restoration of Myron's Discobolus as a Falling Gladiator. Rome, Museo Capitolino*

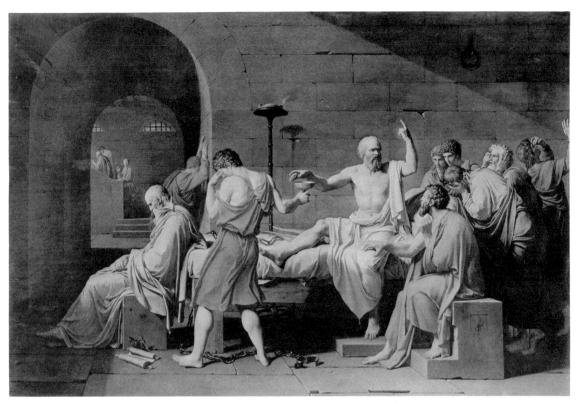

10. *David: Death of Socrates (1787). New York, Metropolitan Museum of Art*

11. *Archaistic Statue of a Woman. Boston, Museum of Fine Arts*

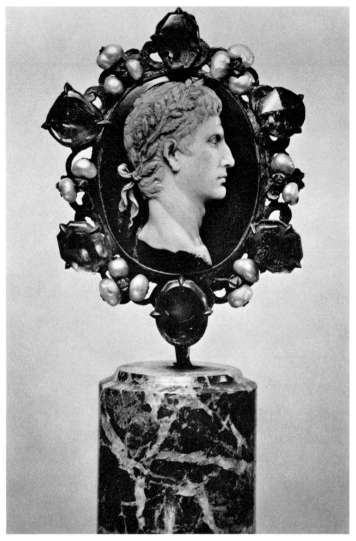

12. *Augustus, Roman cameo in a medieval mounting. Paris, Bibliothèque Nationale*

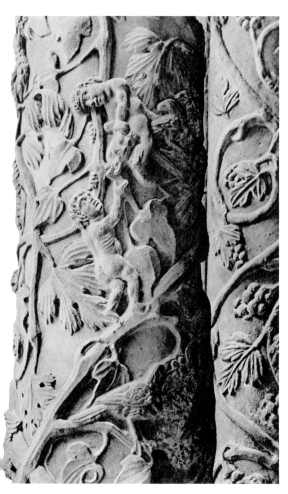

13. *Putti in Vine Scroll. Detail from columns in the Cloister at Monreale, Sicily*

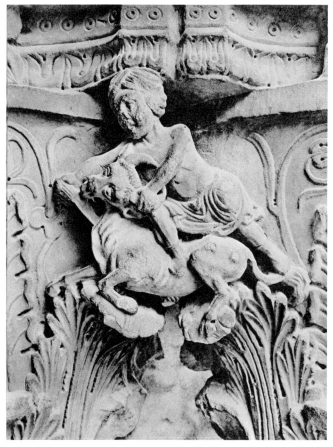

14. *"Victory" Slaying a Bull. Detail of a capital. Monreale, Duomo Santa Maria la Nuova*

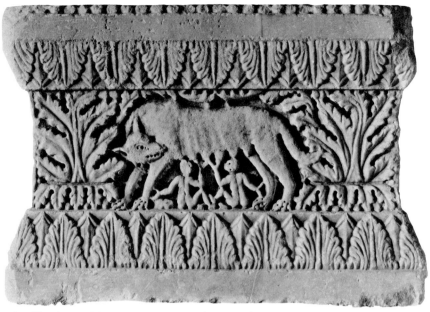

15. *Pillar base with Wolf and Twins. Italian, about* A.D. *1200. Boston, Museum of Fine Arts*

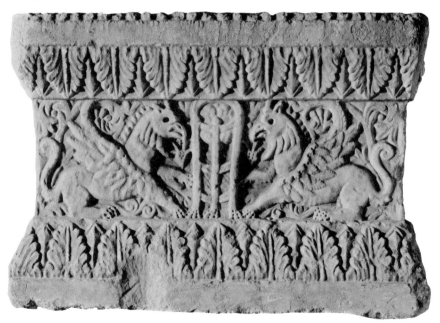

16. *Pillar base with Griffins at Tripod. Reverse Side of Previous*

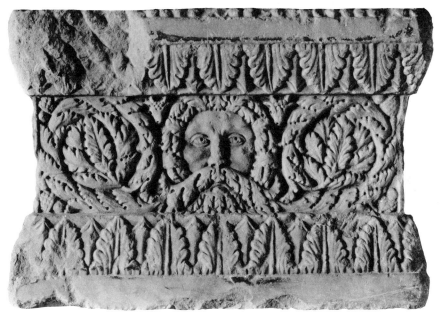

17. *Pillar base with Mask in Foliage. One Side of Previous*

18. *Section of Architectural Relief. Flavian Period; from Torre Annunziata, near Naples. Boston, Museum of Fine Arts*

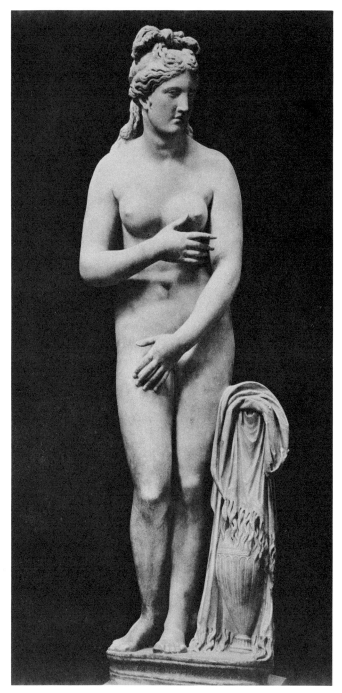

19. *Capitoline Venus.*
 Rome, Museo Capitolino.

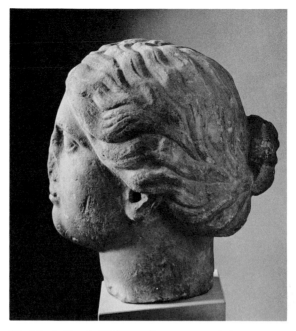

20. *Ideal Head. Thirteenth-century and from near Capua. Hamburg, Museum für Kunst und Gewerbe*

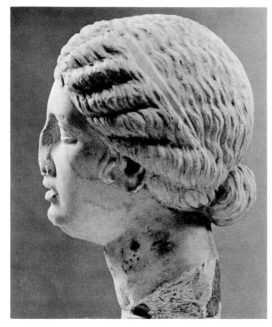

21. *Head, perhaps of a Julio-Claudian Lady. Boston, Museum of Fine Arts*

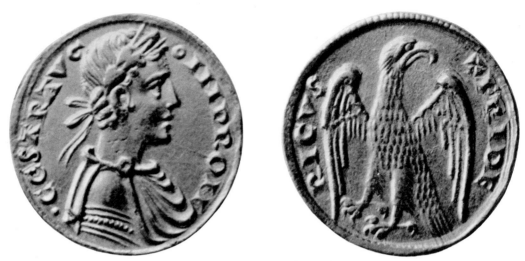

22. *Friedrich II Hohenstaufen. Gold Augustale,* A.D. *1231–1250*

23. *Dal Pozzo–Albani drawing of the Phaedra and Hippolytus sarcophagus in Pisa. London, British Museum*

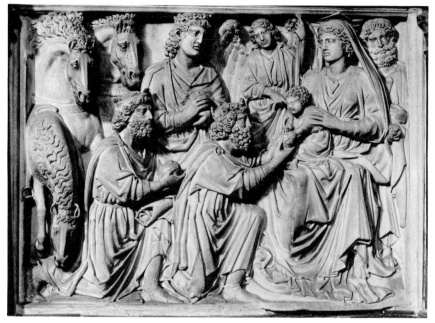

24. *Nicolo Pisano: Adoration of the Magi. Pisa, Pulpit of the Baptistery*

25. *Nicolo Pisano: Paradise. Siena, Pulpit of the Cathedral*

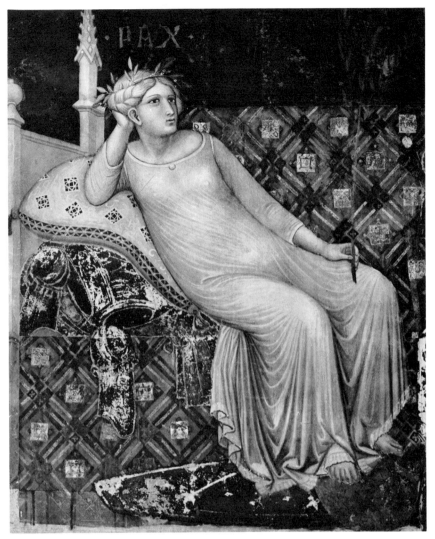

26A. *Ambrogio Lorenzetti: Pax. Siena, Palazzo Comunale*

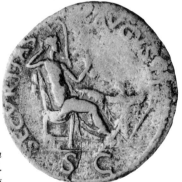

26B. *Securitas Seated. Reverse of a Bronze As of Nero* (A.D. *66–68*). *Boston, Museum of Fine Arts*

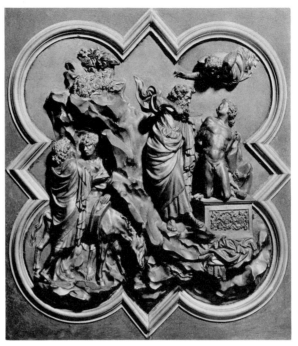

27. *Ghiberti: Sacrifice of Isaac. Florence, Museo Nazionale (Bargello)*

28. *Statue of a Youth. Greek, style of about 475* B.C. *Boston, Museum of Fine Arts*

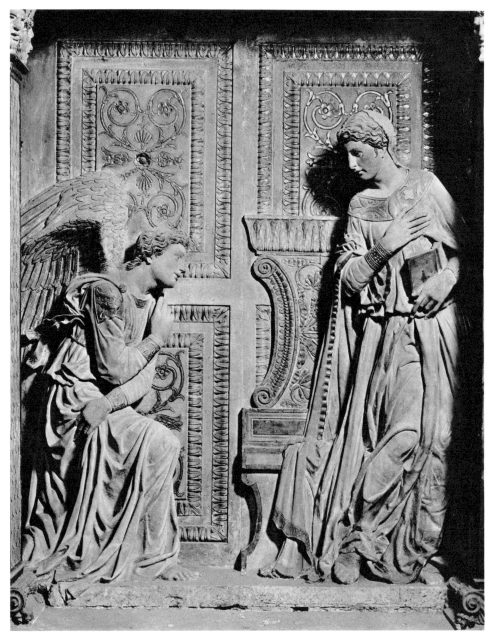

29. *Donatello: Cavalcanti Annunciation. Florence, S. Croce*

30. *Donatello: Virgin and Child.*
Padua, S. Antonio

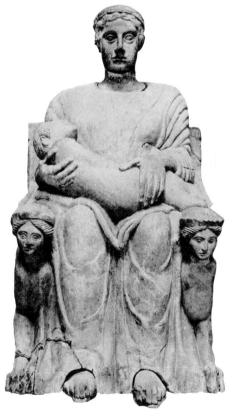

31. *Enthroned woman with child. Etruscan ciner-*
arium from Chiusi, about 425 B.C. *Florence,*
Museo Archeologico

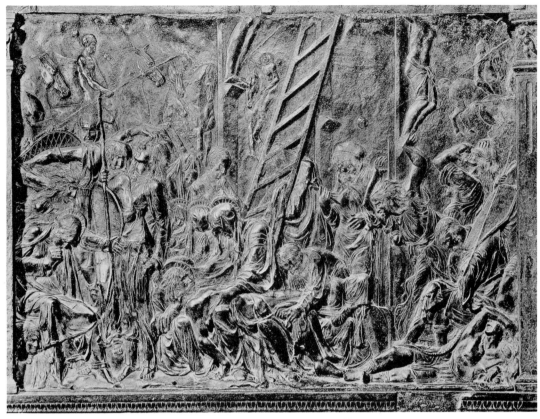

32. *Donatello: Lamentation. Florence, San Lorenzo, North Pulpit*

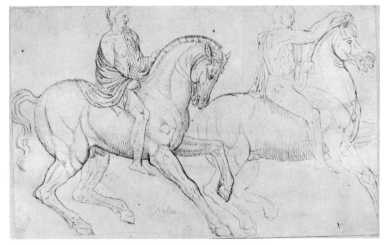

33. *Cinquecento drawing of a Greco-Roman relief in the Parthenon style. Cambridge, Massachusetts, Collection of Benjamin Rowland, Jr.*

34. Masaccio: The Tribute Money. Florence, S. Maria del Carmine

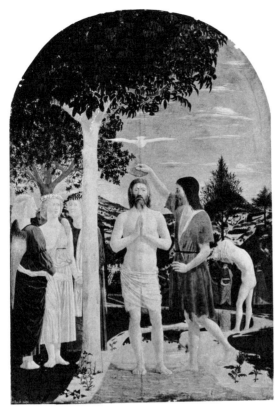

35. *Piero della Francesca: Baptism of Christ.
London, National Gallery*

36. *Roman copy of a Polykleitan statue.
Boston, Museum of Fine Arts*

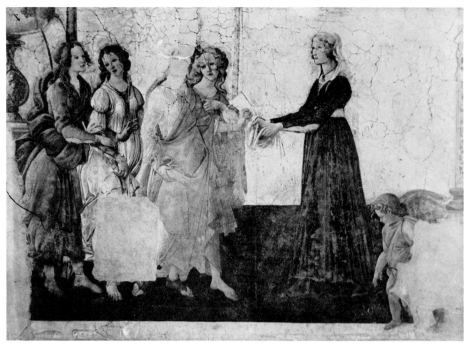

37. *Botticelli: Giovanna degli Albizzi and the Cardinal Virtues. Paris, Louvre*

38. *Neo-Attic relief with three Horae. Santa Barbara, California, Museum of Art*

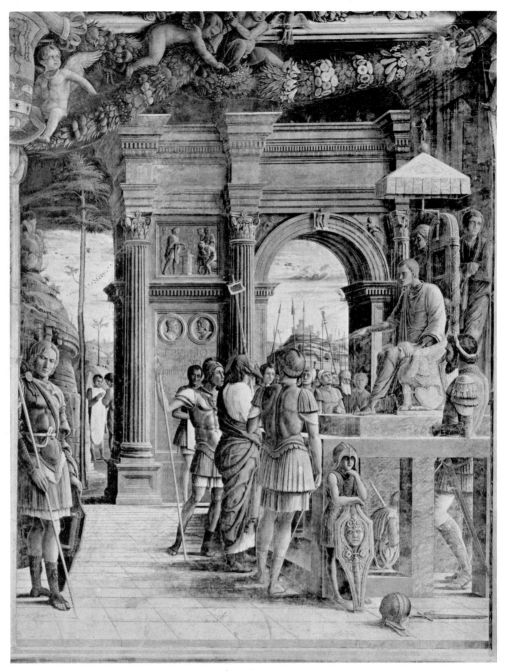

39. *Mantegna: Trial of St. James. Padua, Eremitani*

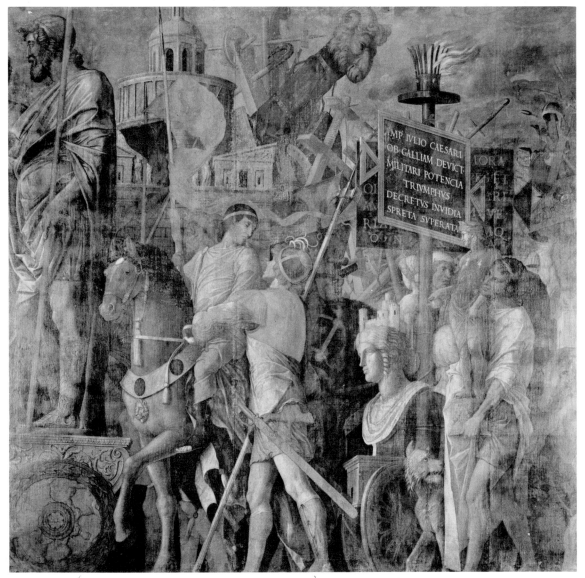

40. *Mantegna: Triumph of Caesar. Second Part. Hampton Court Palace*

41. *Pisanello: Medallion of Leonello d'Este, 1444. Boston, Museum of Fine Arts*

42. *Giovanni Boldù: Medallion of Caracalla, 1466. Boston, Museum of Fine Arts*

43. *"Medalist of the Roman Emperors": Nero. Washington, D.C., National Gallery of Art*

44. *Bertoldo di Giovanni: Medallion of Mohammad II. Washington, D.C., National Gallery of Art*

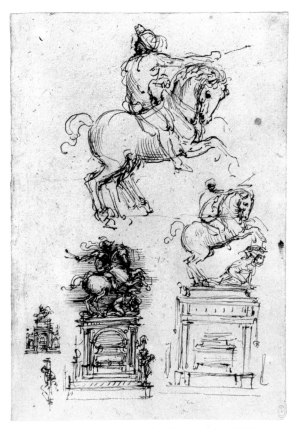

45. *Leonardo da Vinci: Study for the Trivulzio Monument, 1511–1512. Windsor, Royal Library*

46. *Trajan spearing a fallen barbarian. Reverse of a bronze sestertius. Boston, Museum of Fine Arts*

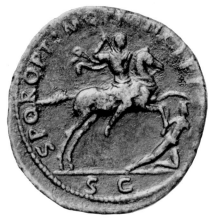

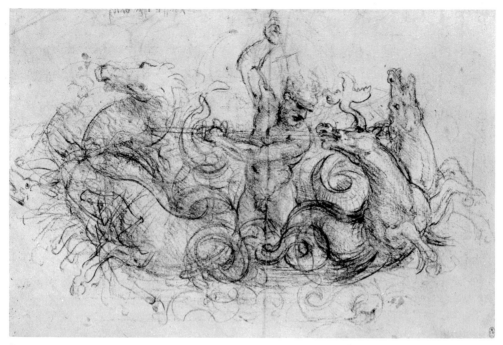

47. *Leonardo da Vinci: Study for Neptune in his Chariot, 1504. Windsor, Royal Library*

48. *Dal Pozzo–Albani drawing of sections of the curved frieze from Villa Adriana. Windsor, Royal Library*

49. *Raphael: Council of the Gods. Rome, Farnesina*

50. *Raphael: Marriage of Cupid and Psyche. Rome, Farnesina*

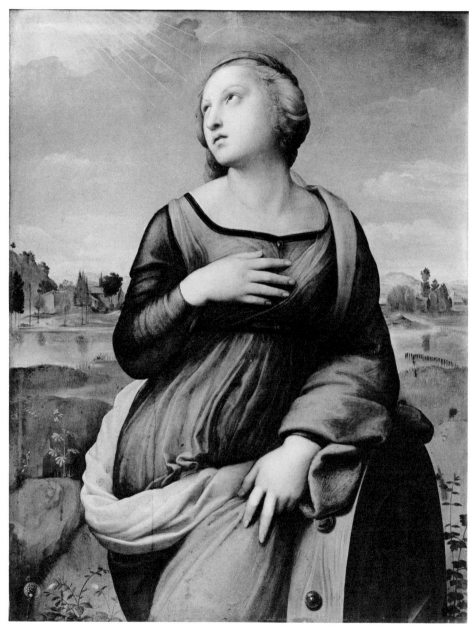

51. *Raphael: Saint Catherine. London, National Gallery*

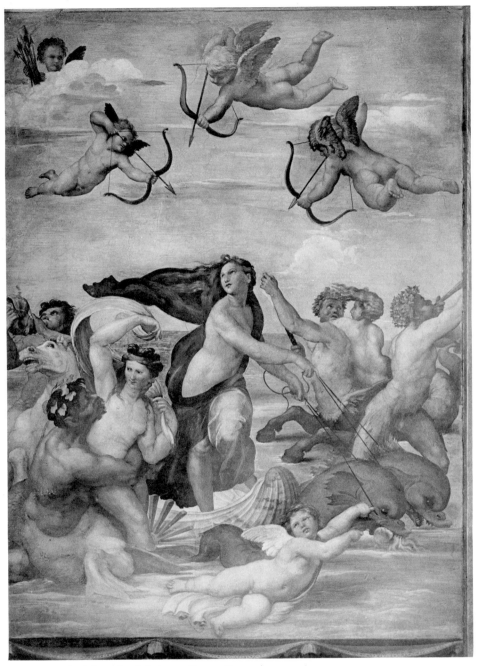

52. *Raphael: Triumph of Galatea. Rome, Farnesina*

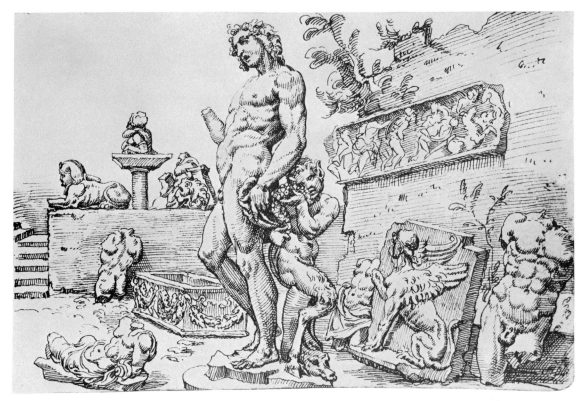

53. *M. van Heemskerck: Courtyard of the Casa Galli, Rome. Michelangelo's Bacchus in the foreground.*

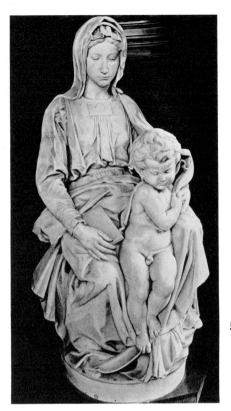

54. *Michelangelo: Madonna and Child.*
Bruges, Notre-Dame

55. *Seated Cupid.*
Stratfield Saye House (Hampshire),
Collection of the Duke of Wellington

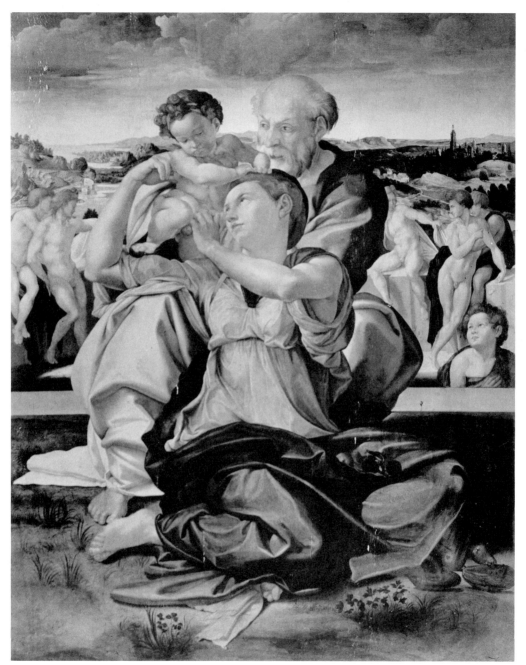

56. *Early (Flemish?) copy after Michelangelo's Doni Madonna. Boston, Museum of Fine Arts*

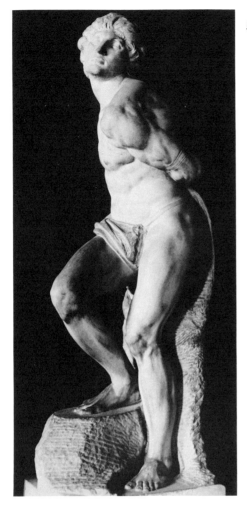

57. *Michelangelo: Rebellious Slave. Paris, Louvre*

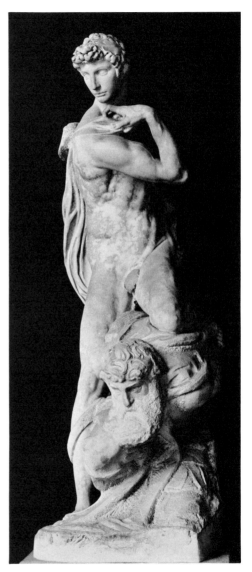

58. *Michelangelo: Victory and Vanquished (Virtue Triumphant over Vice). Florence, Palazzo Vecchio*

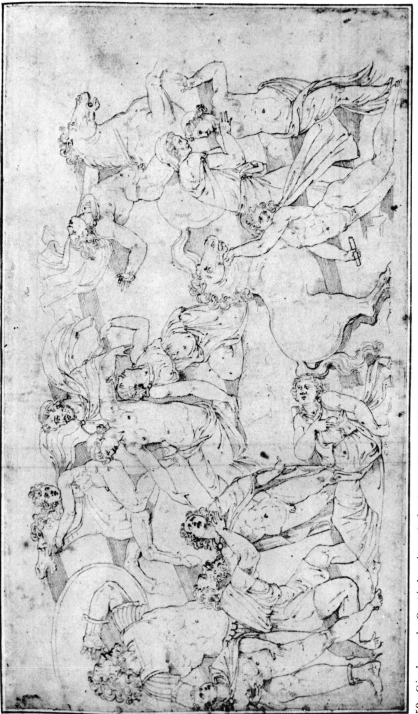

59. *Girolamo da Carpi drawing of the front of a Niobid sarcophagus at Wilton House (Wiltshire). London, British Museum*

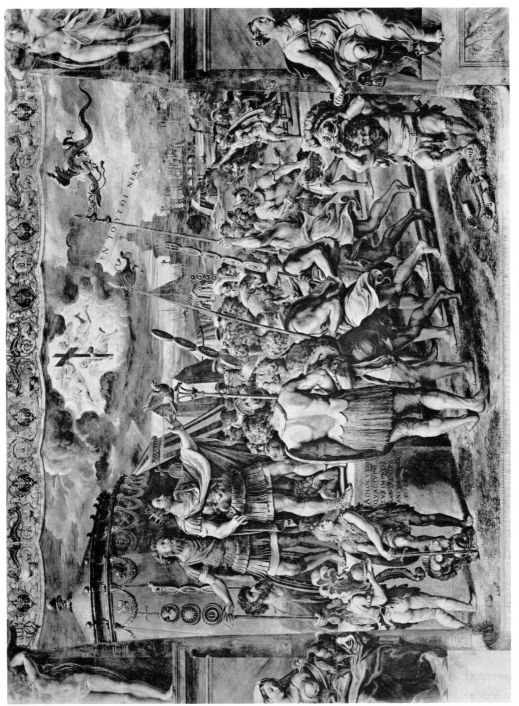

60. Raphael, Giulio Romano: *The Vision of Constantine. Vatican, Sala di Costantino*

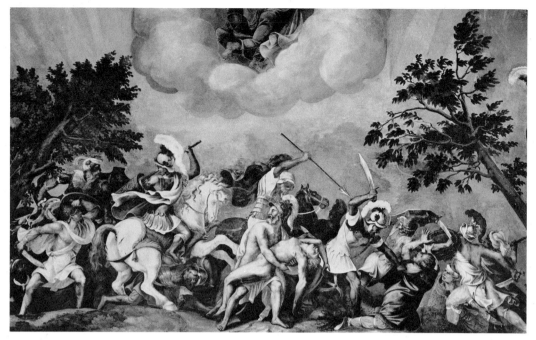

61. *Giulio Romano: Battle around the Body of Patroclus. Mantua, Palazzo Ducale*

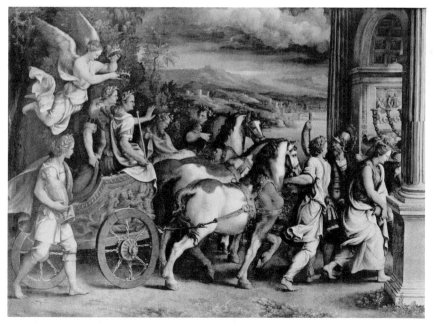

62. *Giulio Romano: Triumph of Titus and Vespasian. Paris, Louvre*

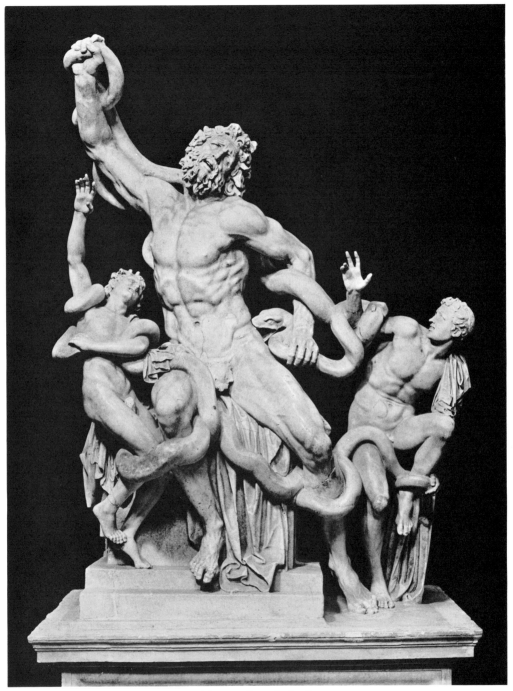

63. *The Laocoön Group, former condition. Vatican, Belvedere*

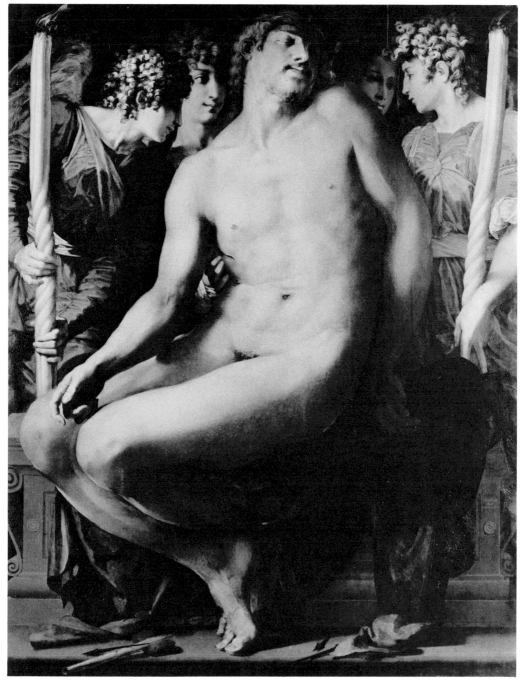

64. *Rosso: Dead Christ with Angels. Boston, Museum of Fine Arts*

65. *Bronzino: Holy Family.*
Florence, Palazzo Pitti

66. *Parmigianino: Madonna, Child,*
St. Zachary, the Magdalen, and the Infant St. John.
Florence, Uffizi

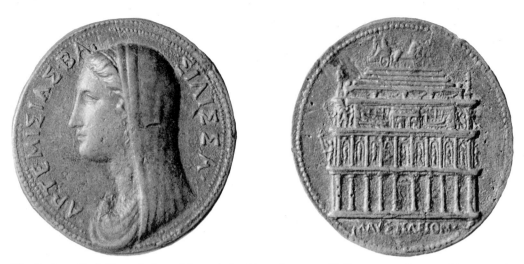

67. *Cavino: Medallion of Artemisia and the Mausoleum at Halicarnassus. Boston, Museum of Fine Arts*

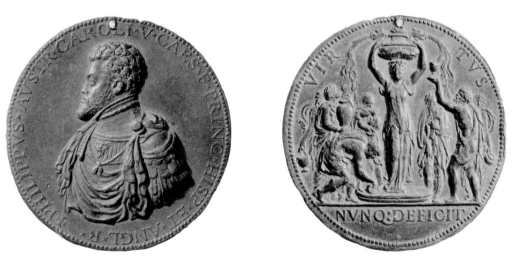

68. *Leone Leoni or Da Trezzo: Medallion of Philip II. Cambridge, Massachusetts, Busch-Reisinger Museum*

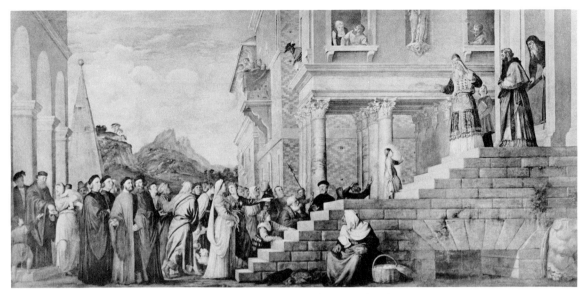

69. *Titian: Presentation of the Virgin at the Temple. Venice, Accademia*

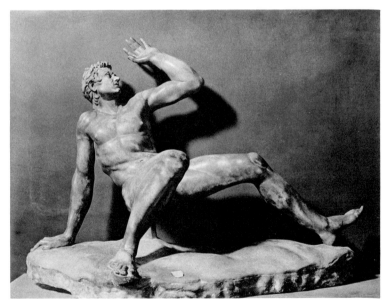

70. *Falling Gaul. Roman copy of a Pergamene work of about 200* B.C. *Venice, Museo Archeologico*

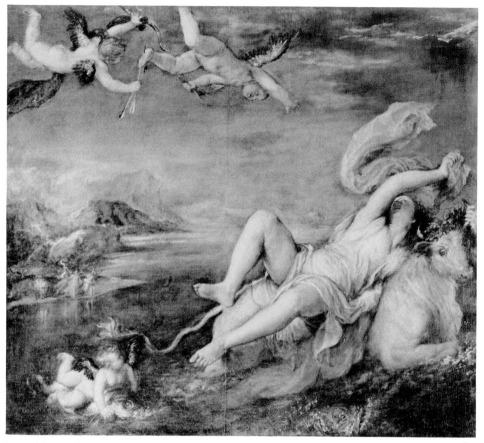

71. *Titian: The Rape of Europa. Boston, Isabella Stewart Gardner Museum*

72. *Hellenistic fountain figure
of Eros with jug on shoulder.
Paris, Art Market*

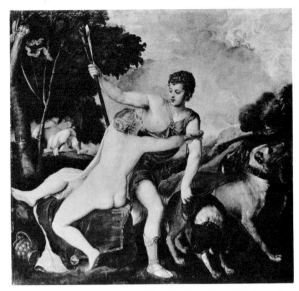

73. *Titian: Venus and Adonis. London, National Gallery*

74. *Ara Grimani, Early Imperial Period. Venice, Museo Archeologico*

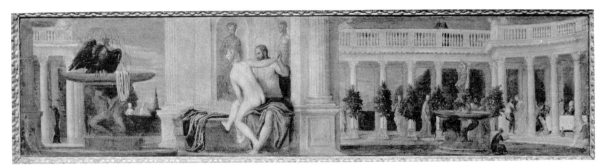

75. *Paolo Veronese: Venus and Jupiter. Boston, Museum of Fine Arts*

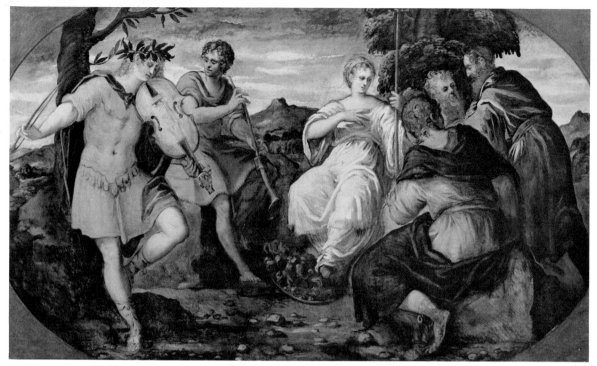

76. *Tintoretto: Apollo and Marsyas. Hartford, Wadsworth Atheneum*

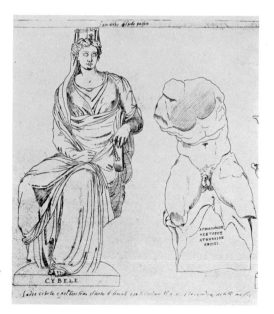

77. *Giovannantonio Dosio: Seated Cybele,*
 Belvedere Torso

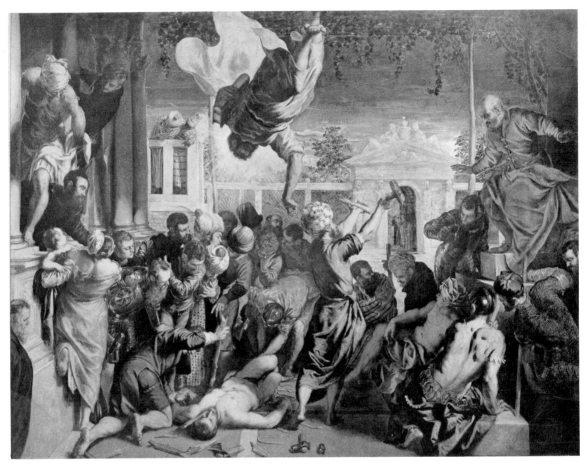

78. *Tintoretto: Saint Mark Freeing a Slave. Venice, Accademia*

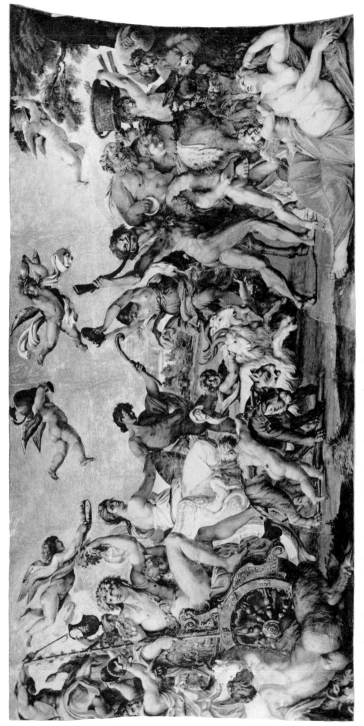

79. A. Carracci: Triumph of Bacchus and Ariadne. Rome, Palazzo Farnese

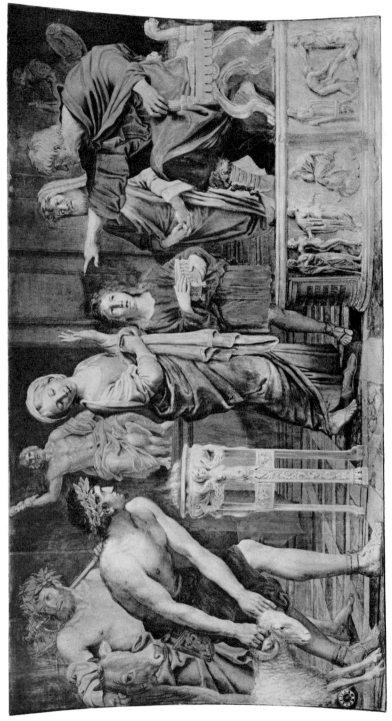

80. Domenichino: S. Cecilia before the Judge. Rome, S. Luigi dei Francesi

81. *G. Reni: Aurora. Rome, Palazzo Pallavicini–Rospigliosi*

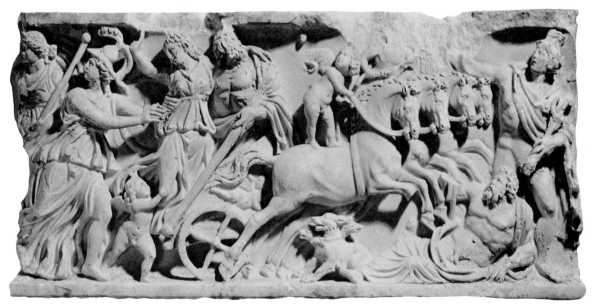

82. *Sarcophagus with scenes of the Rape of Persephone. Karlsruhe, Museum*

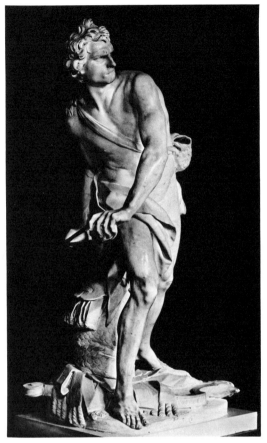

83. *Bernini: David. Rome, Villa Borghese*

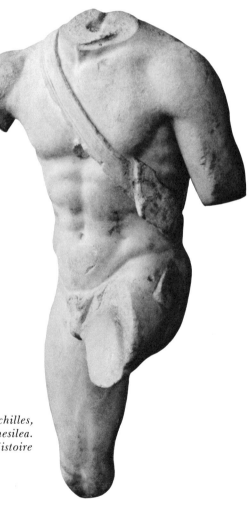

84. *Torso of Achilles,*
from the group of Achilles and Penthesilea.
Geneva, Musée d'Art et d'Histoire

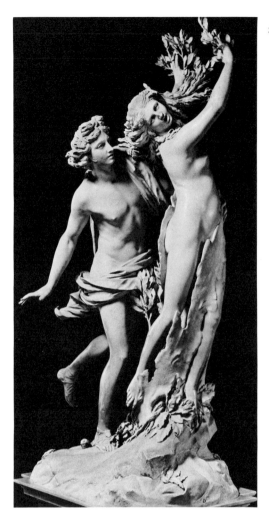

85. *Bernini: Apollo and Daphne. Rome, Villa Borghese*

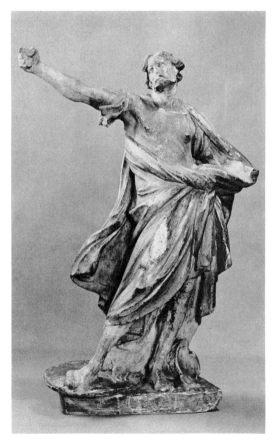

86. *Bernini: Terracotta bozzetto for St. Longinus. Cambridge, Massachusetts, Fogg Art Museum*

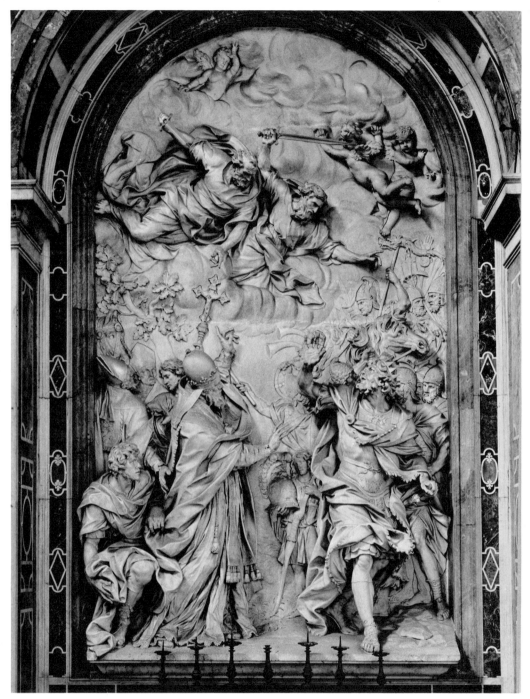

87. *Algardi: Leo and Attila. Vatican, St. Peter's*

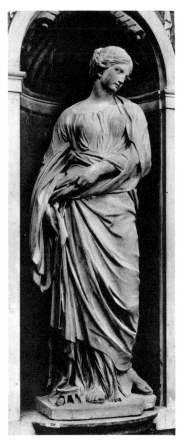

88. *Duquesnoy: S. Susanna.*
Rome, S. Maria di Loreto

89. *Two views, perhaps by Girolamo da Carpi, of the statue known as the Cesi Juno. London, British Museum*

90. *C. Maratta: Maenad from a Relief in Rome,*
Villa Torlonia-Albani.
Windsor, Royal Library

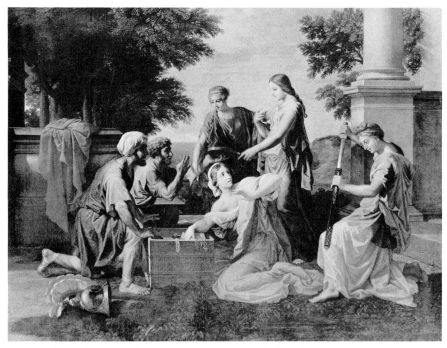

91. *Poussin: Achilles on Skyros. Boston, Museum of Fine Arts*

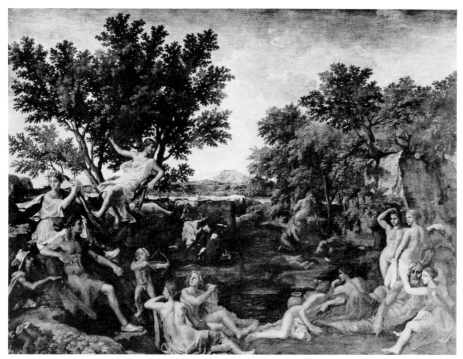

92. *Poussin: Apollo and Daphne. Paris, Louvre*

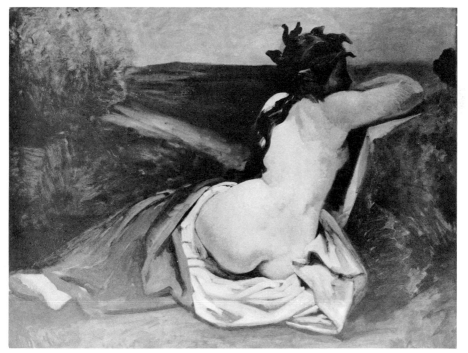

93. *Courbet: Reclining Nude. Boston, Museum of Fine Arts*

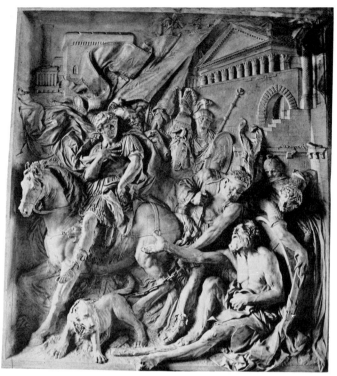

94. *Puget: Alexander and Diogenes. Paris, Louvre*

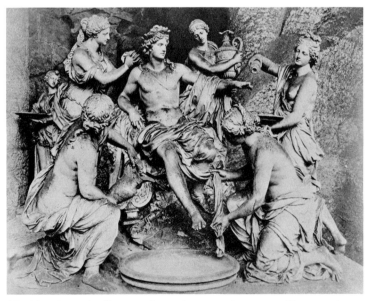

95. *Girardon: Apollon servi par les nymphes. Versailles, Gardens*

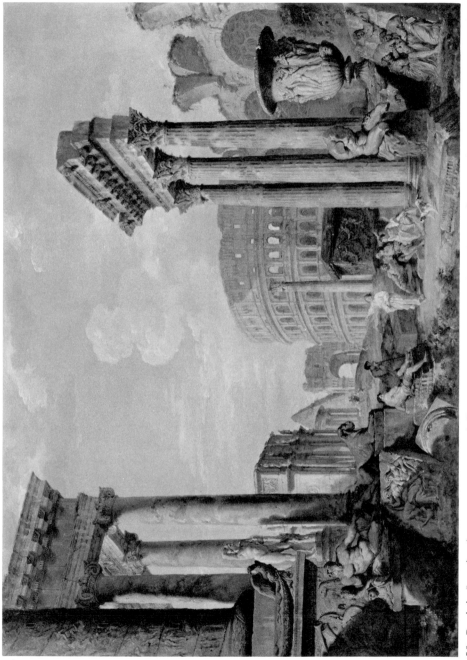

96. *Panini: Imaginative rearrangement of Roman monuments. London, Art Market* (1959)

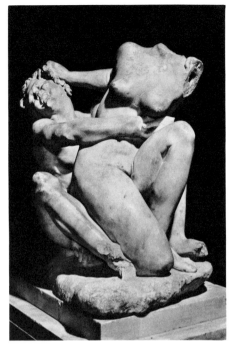

97. *Satyr and Hermaphrodite. Rome, Museo Nuovo Capitolino*

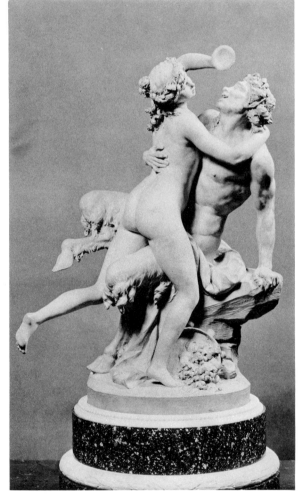

98. *Clodion: Nymph and Satyr. New York, Metropolitan Museum of Art*

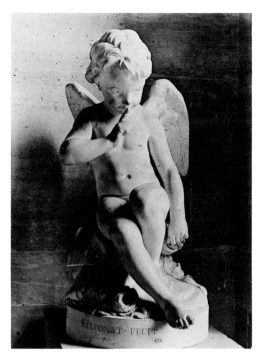

100. *Falconet: L'Amour menaçant.*
Paris, Louvre

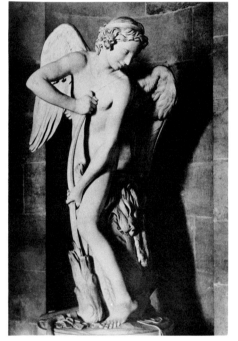

99. *Bouchardon: Cupid fashioning his*
Bow from the Club of Hercules.
Paris, Louvre

101. *J. B. Pigalle: Mercury.*
New York, Metropolitan Museum of Art

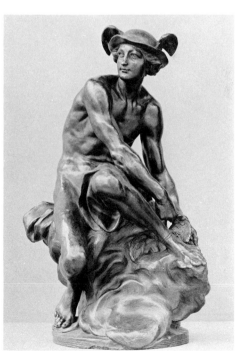

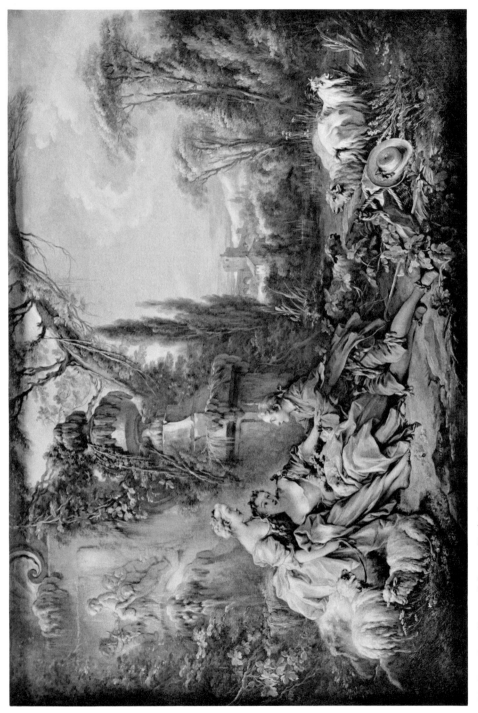

102. *Boucher: Pastoral Scene. Paris, Louvre*

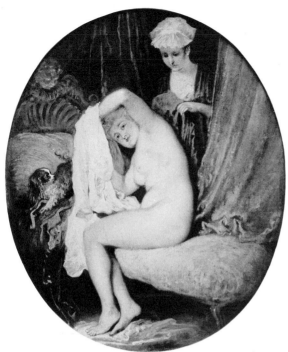

103. *Watteau: A Lady at her Toilet.*
London, Wallace Collection

104. *Crouching Aphrodite.*
Windsor Castle, from Osborne House

105. *Boucher: The Bath of Diana. Paris, Louvre*

106. *Nymph from the Hellenistic group*
"Invitation to the Dance."
Florence, Uffizi

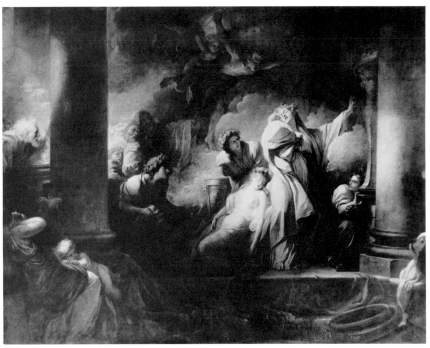

107. *Fragonard: Corésus and Callirhoé. Paris, Louvre*

108. *Fragonard: Invocation to Love. Cleveland Museum of Art*

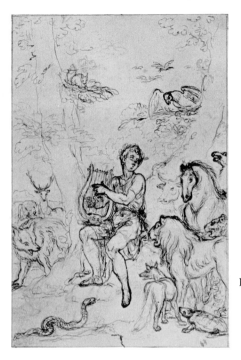

109. *Gravelot: Orpheus and the Beasts.*
Philadelphia, Museum of Art

110. *Dal Pozzo–Albani drawing of a lost Roman relief, Orpheus and*
the Beasts. Windsor, Royal Library

111. *Canova: Apollo Crowning Himself.*
Possagno, Gipsoteca Canoviana

112. *Torso of a Warrior, Fifth-century Type.*
Detroit, Institute of Arts

113. *Canova: Perseus. Vatican, Belvedere*

114. *The Apollo Belvedere. Vatican, Belvedere*

115. *Canova: Hebe. Forlì, Pinacoteca Comunale*

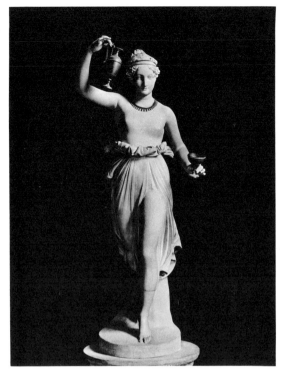

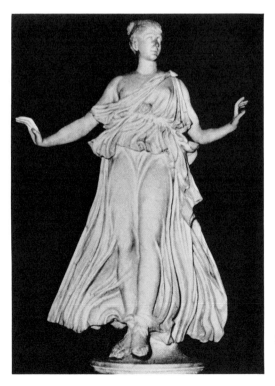

116. *Dancing Nymph, Hellenistic type. Florence, Uffizi*

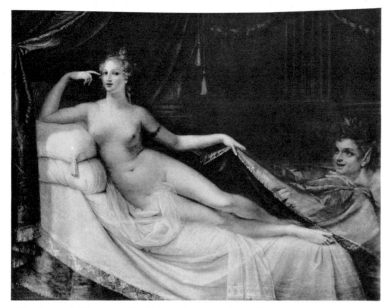

117. *Canova: Venus and a Satyr. Possagno, Casa Canoviana*

118. *Canova: Monument to Giovanni Volpato.*
Rome, SS. Apostoli

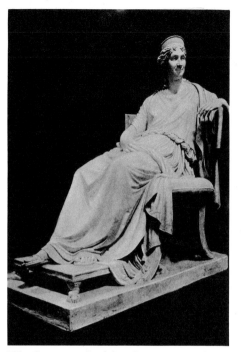

119. *Canova: Letizia Bonaparte. Possagno, Gipsoteca Canoviana*

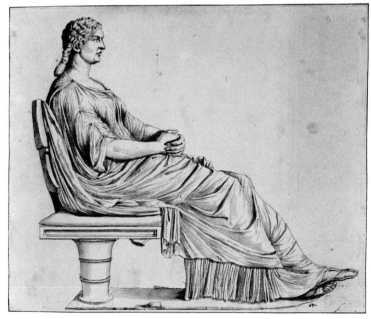

120. *Dal Pozzo–Albani drawing of the so-called Agrippina in Naples. Windsor, Royal Library*

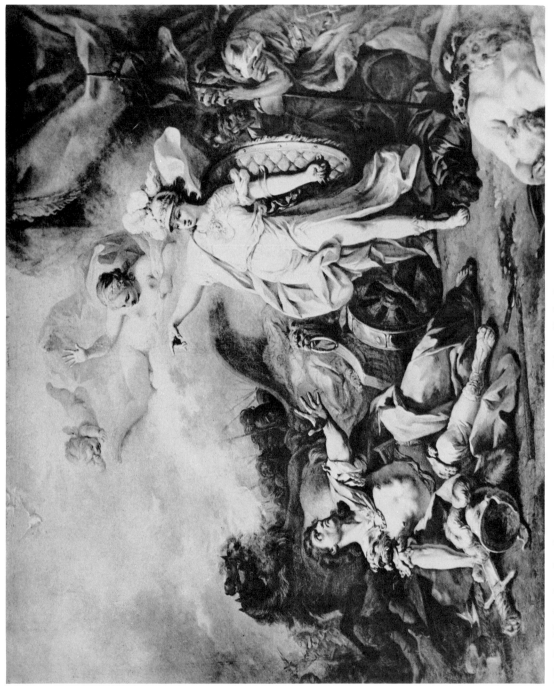

121. *David: Combat de Minerve contre Mars secouru par Vénus. Paris, Louvre*

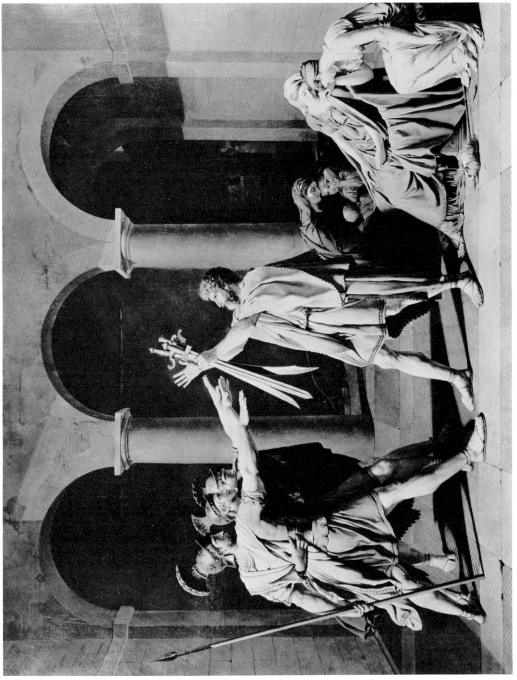

122. *David: Oath of the Horatii. The Toledo Museum of Art*

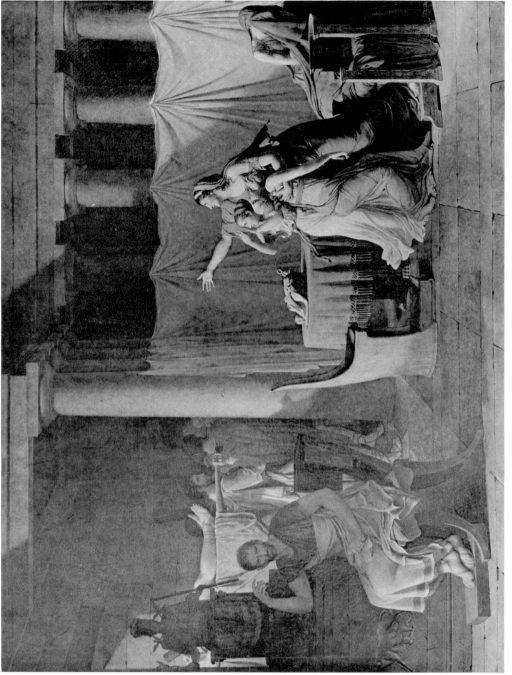

123. David: *The Lictors Bringing to Brutus the Bodies of his Sons. Paris, Louvre*

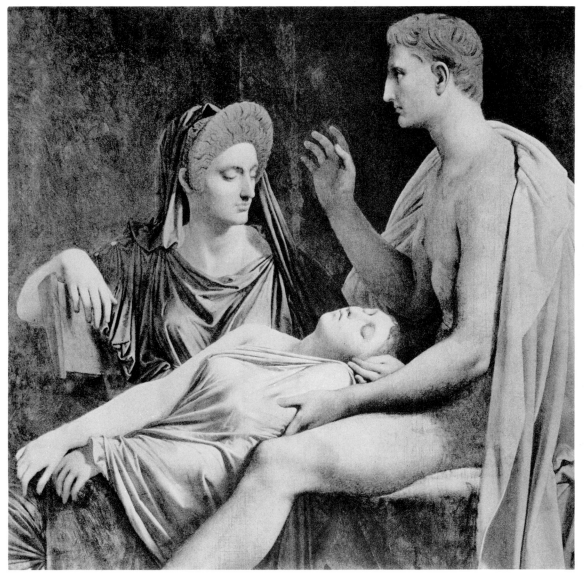

124. *Ingres: Virgil Reading the Aeneid. Brussels, Museum*

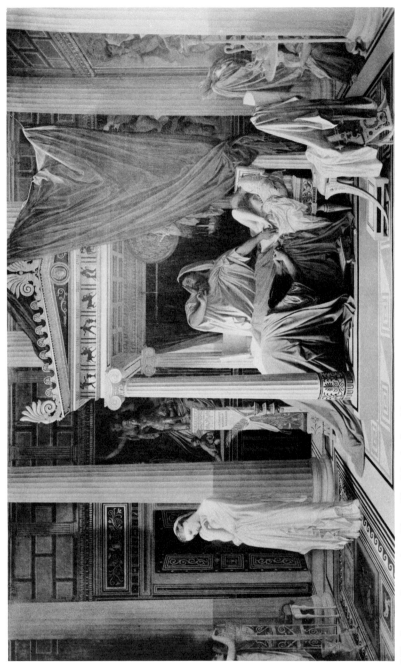

125. *Ingres: Stratonice. Chantilly, Musée Condé*

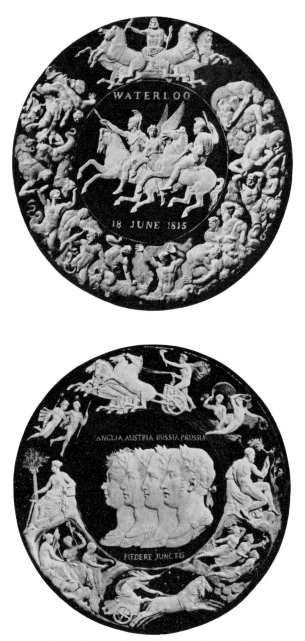

126. *Pistrucci: Models for the Waterloo Medal, 1815.*
Rome, Museo della Zecca

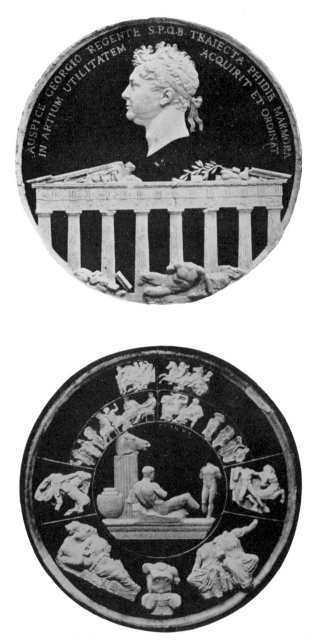

127. *Pistrucci: Medallion commemorating the acquisition of the Parthenon marbles, 1816. Rome, Museo della Zecca*

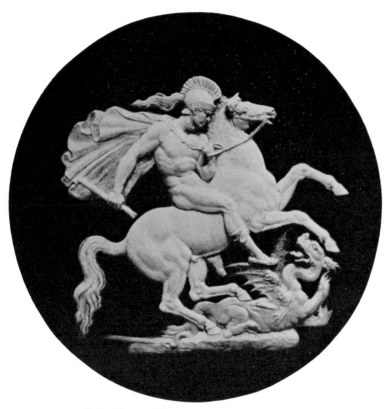

128. *Pistrucci: St. George and the Dragon.*
Rome, Museo della Zecca